DAVID BAILEY

Locations
The 1970s Archive

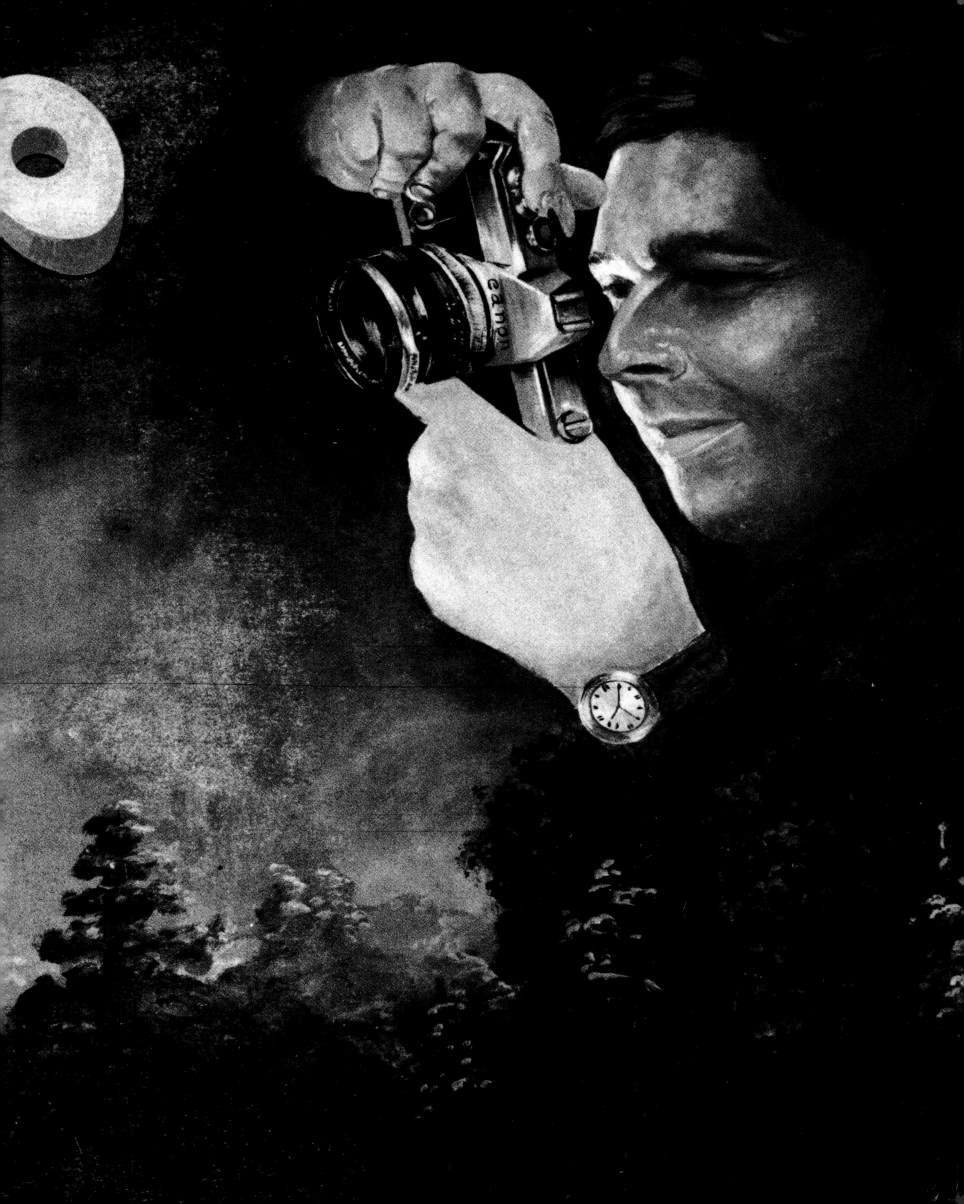

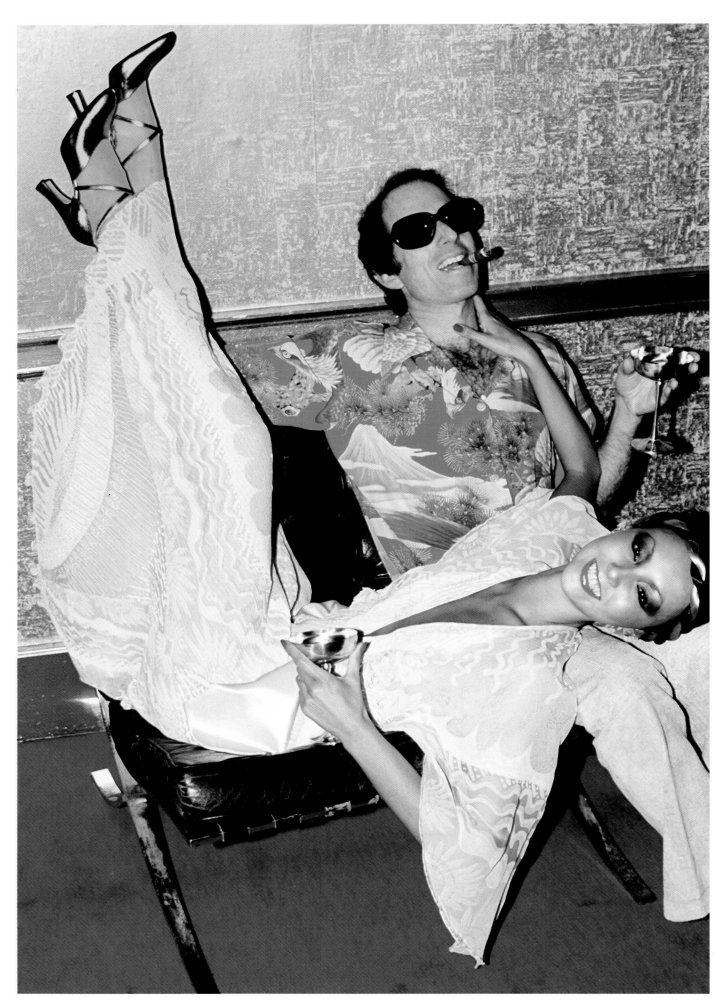

Vogue March 15th 1976 **(Sandy Lieberson and Marie Helvin)**

MARTIN HARRISON

DAVID BAILEY
Locations
The 1970s Archive

With 293 photographs, 59 in colour

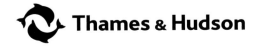
Thames & Hudson

Design: Martin Harrison
Design Production: Tony Waddingham

Note: In picture captions throughout this volume, photographs intended
for reproduction are dated according to the issue of the relevant periodical.
In all other cases the date refers to the month or year in which the
photograph was made. On occasion the specific image selected for this
volume differs, to a greater or lesser extent, from the frame originally
chosen for reproduction; this is indicated by the legend 'variant published'.

British Library Cataloguing-in-Publication Data
A catalogue record for this book is available from the British Library

ISBN 0-500-54273-2

Paper: Phoenixmotion Xantur 150 gsm from Scheufelen, Germany

Printed and bound in Germany by Steidl

Contents

12 **Changing**

60 **Connecting**

118 **Flying**

182 **Ritzing**

236 **Relocating**

257 Acknowledgments

258 Index

Turkey: *Vogue* May 1970 (variant published)

Changing

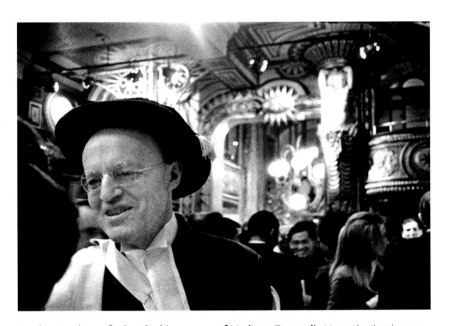

London: Lord Longford at the bicentenary of Madame Tussaud's *Vogue* April 15th 1970

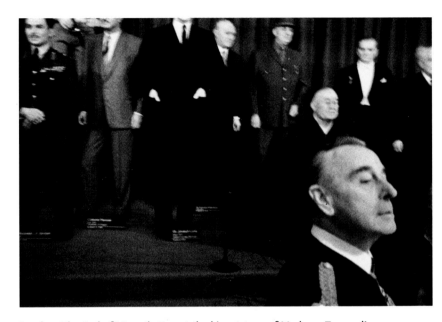

London: The Earl of Mountbatten at the bicentenary of Madame Tussaud's
Vogue April 15th 1970 (variant published)

Lives and careers are seldom marked out in neat ten-year divisions. There are, however, strong grounds for suggesting that David Bailey, who had achieved international renown in the Sixties, was determined to consign to history the decade of his rise, and to reinvent himself as a photographer in the Seventies. His book *Goodbye Baby and Amen*, published in 1969, had been conceived as both a bitter-sweet summation and a firm valediction. In 1970, restless and still ambitious, he was determined to pursue new directions. His photographs had epitomized, with their pared-down graphic directness, the high-octane but brittle glamour of the Sixties. That brief moment, however, had passed, and Bailey recognized intuitively that as complexity replaced former certainties he must expand his range in response to the new decade.

Bailey's Seventies were framed at either end of the decade by two very different foreign trips that demonstrate the extent of the change.

In February 1970 he travelled to Turkey on a major assignment for *Vogue*; the incorporation of intimate narratives and spectacular landscapes announced a radical shift in his fashion photography. And in July 1979, when he flew to Hong Kong to undertake an extensive reportage of the plight of the Vietnamese 'Boat People', he was lending his name to a more explicitly political cause than he would have contemplated in the Sixties. In between these events Bailey directed three important television documentaries, published three further books of his photographs, founded *Ritz* newspaper and fulfilled his long-held aim to become a kind of camera-toting Sir Richard Burton of his times.

While Bailey transformed himself in the Seventies, photography in Britain was simultaneously undergoing a major transition as it strove to achieve the status of an independent art form that it was already widely

accorded in the USA. In 1971, when the exhibition *Snap!* at the National Portrait Gallery, London, featured Bailey's photographs alongside the cartoons of Gerald Scarfe and paintings by David Hockney, it was the first occasion on which contemporary photographs had been hung in a national museum in Britain. In the following year Bailey was awarded the Fellowship of the Royal Photographic Society, in 1975 he was elected a Fellow of the Society of Industrial Artists and Designers – evidently the Sixties rebel was proving to be of greater substance than some of his peers had cared to admit – and in 1973 his first one-man show, *Bailey Until Now*, was mounted by London's newly opened Photographers Gallery.

London: graffiti 8/1971

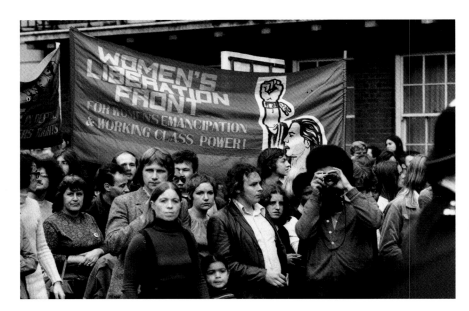

London: Women's Liberation rally 8/1971

From a present-day perspective it might be assumed that the honours and continued success mellowed Bailey, that he was becoming almost an establishment figure. In fact he continued to attract controversy throughout the Seventies. In January 1973 Ross McWhirter, spokesman for the moral crusade, succeeded in having an IBA injunction slapped on Bailey's television documentary on Andy Warhol; by the time the ban was rescinded the press had had a field day with 'TV Sex Shocker' headlines. Reports in January 1970 that Catherine Deneuve had filed for divorce from Bailey were followed two years later by a headline in *The Sun*, 'My Ex-Wife and the Other Man's Baby', a reference to his having flown to Paris to photograph Chiara, Deneuve's child by Marcello Mastroianni: Bailey's knack of maintaining close friendships with his former wives and lovers has continued to impress or surprise many commentators.

Another kind of criticism that had been levelled at his work intensified in the Seventies. The photographer Euan Duff, a near-contemporary of Bailey's, son of CND pioneer Peggy and conspicuously left-wing in his politics, reviewed *Bailey Until Now* in *The Guardian*. He raised an issue that soon became a preoccupation in photographic debate: the distinction between commercial and private work. 'Photographers cannot,' declared Duff, 'switch personal integrity on or off at will.' Partly due to a perception of his life-style and prominent public profile (and not entirely unmotivated by envy), Bailey found himself identified as a chief offender in this respect, particularly when

were scarcely more than the casual snapshots of an indefatigable snapper, and were criticized accordingly; although he made no great claims for these *photos-trouvées*, when Bailey ventured into this territory he may have underestimated the serious admiration with which the legacy of André Kertesz, Robert Frank or Lee Friedlander was increasingly regarded. Bailey has always been at his strongest working in situations or genres in which his own personality could enter the equation; besides fashion and portraiture these categories would extend in the 1980s to encompass still-lifes and both urban and rural landscapes, for which his obviously deep feelings were reflected in meticulous craftsmanship and a dramatic vision.

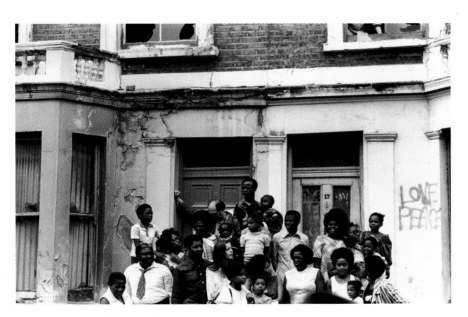

London: Notting Hill Carnival 8/1973

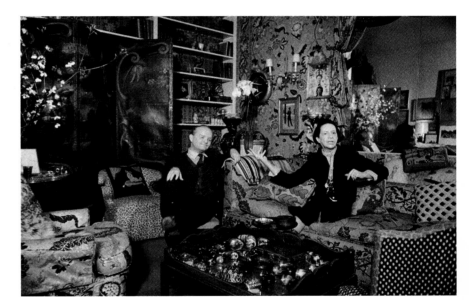

New York: Truman Capote and Diana Vreeland 3/1971

he strayed into the territory of the 'concerned photographers'. Thirty years on, such over-simplistic dichotomies appear naive, and have to a certain extent been overtaken by post-modern plurality; indeed, the current blurring of categorical distinctions has, ironically, seen *le monde chic* eagerly subsumed into the art world. In the Seventies, Bailey was inclined to sidestep the debate, though it is not hard to see that his retort to the effect that it was 'less immoral photographing fashions than pointing his camera at a beggar' was aimed at the photo-journalist fraternity as much as at himself.

In the Seventies, unlike the previous decade, Bailey frequently pointed his camera in both directions and in many others. The photographs published in *Beady Minces* (1973) and *Mixed Moments* (1976) were all done with precision and often wit or compassion. A few, however,

It is difficult to sustain a career in fashion photography beyond ten years, but Bailey was determined, alongside his other activities, to do just that. While maintaining a high level of professionalism in his bread-and-butter work for *Vogue*, he sought to reserve more innovative themes and treatments for important foreign assignments. On the highly regarded and influential trip to Turkey in February 1970 the acting ability and naturalness of the model, Donna Mitchell, were major contributory factors in Bailey's photographs. His tour of the Nile later that year again succeeded in incorporating essential fashion information with sweeping landscape vistas that captured the topography of Egypt. Bailey's model in Egypt, Jean Shrimpton, was drawing to the end of her career and limiting her appearances in *Vogue*, where by this time she was featured as a named personality, anticipating the 'supermodels' of the 1980s. Bailey and

Penelope Tree, with whom he had lived since 1968, parted in 1973, bringing to an end not only a phase in his fashion photography but also a period of closer contact with the ideals of the latter-day Hippie movement. The following year he met Marie Helvin, and she became his third wife when they were married in 1975. Marie was the catalyst for the change that occurred in Bailey's fashion photography at this time, although she did not monopolize his photographs for *Vogue* to the same extent that Jean Shrimpton had in the Sixties: more significant were the personal photographs he took of her, many of which were published in 1980 as the highly successful *Trouble and Strife*. The women Bailey photographed

rue de Crussol studio in Paris, but preferred ultimately the graphic precision of the studio portrait. By 1975 Bailey was working regularly in Paris and Milan, as well as on location further afield, for the French and Italian editions of *Vogue*; they were the most innovative fashion magazines of the time and afforded him creative latitude and the opportunity to compete with his respected peers such as Helmut Newton and Guy Bourdin.

Towards the end of the decade, elements of the Punk revolution began to infiltrate the *haute* end of fashion, often with embarrassing consequences. But 'bad taste' and 'anti-fashion' were common to much fashion photography in the Seventies: the kitsch, overblown aspect to this

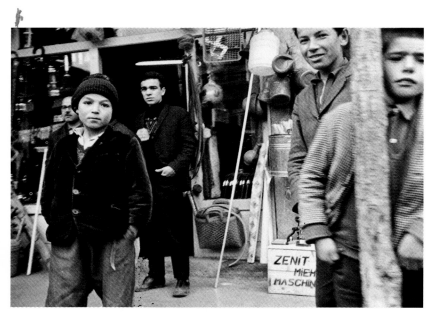

Turkey 2/1970

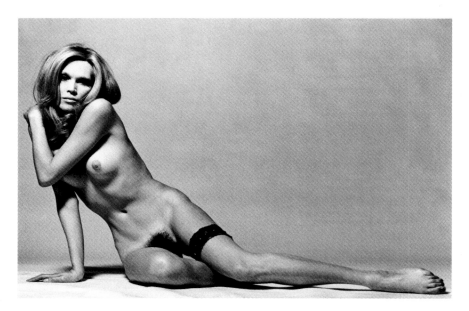

London: Amanda Lear 8/1971

remained the most important source of his inspiration, and Ingrid Boulting, Anjelica Huston and Kim Harris were all prominent in his fashion photographs of the Seventies.

Although, unlike the previous decade, Bailey did not consider publishing them in an anthology, portraits continued to be an important aspect of his work in the Seventies. Many of his sitters were photographed in their natural environment, and as informally as was feasible; one of the most impressive, however, is his photograph of 'Jordan Kalfus and his daughter', which is as formal as Grant Wood's 'American Gothic' (1930), the painting of pioneering Americans that inspired it. But it may be significant that, in retrospect, Bailey is inclined to favour the incisiveness and directness of the posed, studio close-ups; he made a compelling photograph of the artist Sam Szafran, for instance, amid the clutter of his

had been anticipated in a series Bailey photographed for British *Vogue* in April 1971. Actually entitled 'Kitsch Fashion', it set out to violate as many style taboos as it dared. Ironically, it went further than was considered tolerable at that time, and the story was killed. At French *Vogue* certain editors and photographers appeared to be operating a sub-text which was more concerned with challenging contemporary sexual and moral attitudes than with the presentation of fashions. The tone of this assault on readers' expectations was set by the magazine's Christmas 1971 issue, of which Salvador Dalí was the guest editor. Bailey's principal contribution was to photograph a 'crucified' Amanda Lear to illustrate an extract from Ronald Firbank's posthumously published novel, *The Artificial Princess*: in its conflation of past decadences his glistening Pre-Raphaelite nightmare announced a key theme of the Seventies.

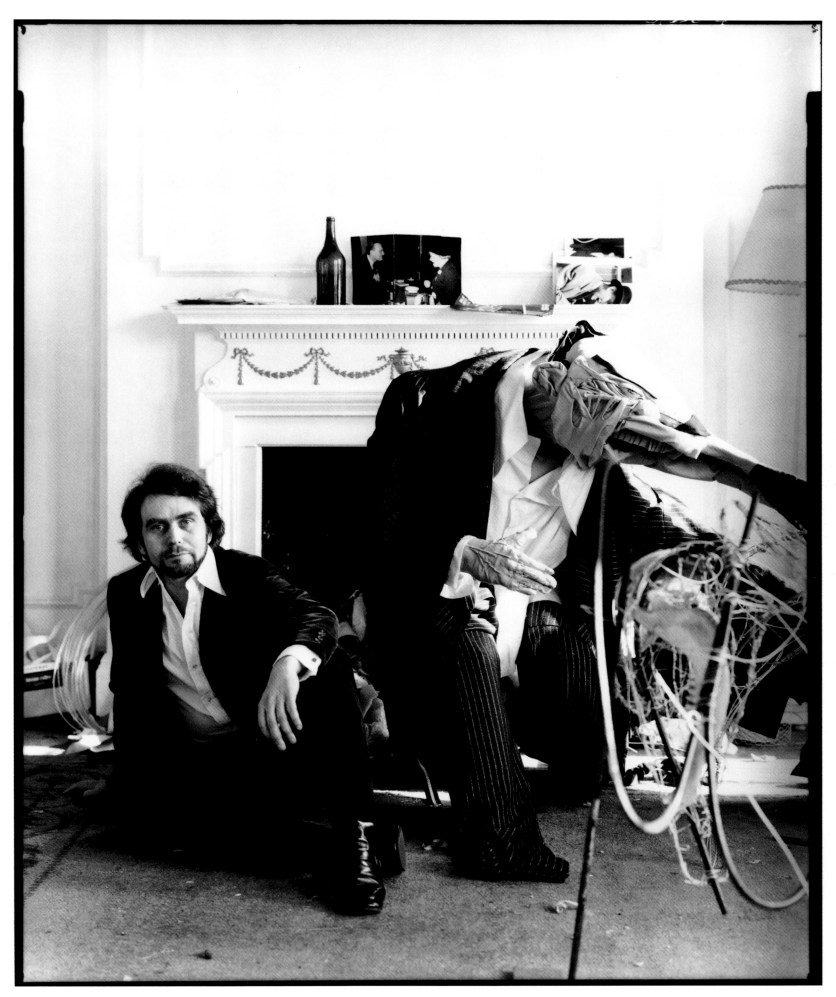

London: Gerald Scarfe *Vogue* April 1st 1971 (variant published)

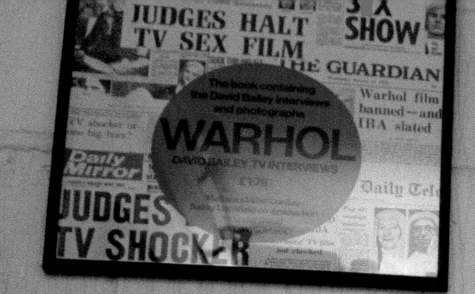

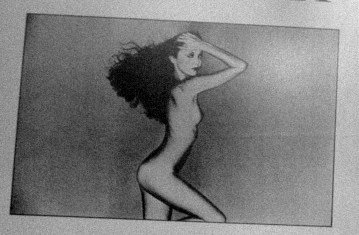

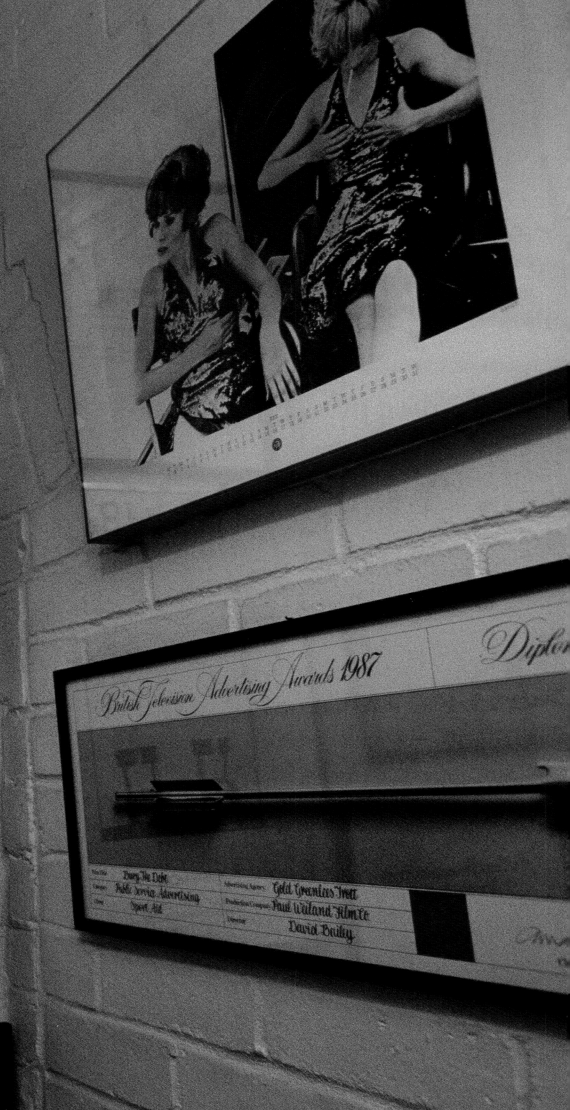

This Diploma is awarded to
David Bailey
who by reason of professional standing and
distinction of work has been elected a
Fellow
of the Society of Industrial Artists and Designers
and is thereby entitled to the use of the affix
FSIA

David Bailey

A FEW MORE
January 14th to February 15th 1975
Weekdays 9.30-5 Saturdays 10-12.00
ASAHI PENTAX GALLERY
6 Vigo Street London W1 (near Piccadilly Circus)
Admission free

BAILEY UP TILL NOW

British Television Advertising Awards 1987 Diplo

	Pay The Debt		Gold Greentees Trott
	Public Service Advertising		
	Sport Aid		Paul Weiland Film Co
			David Bailey

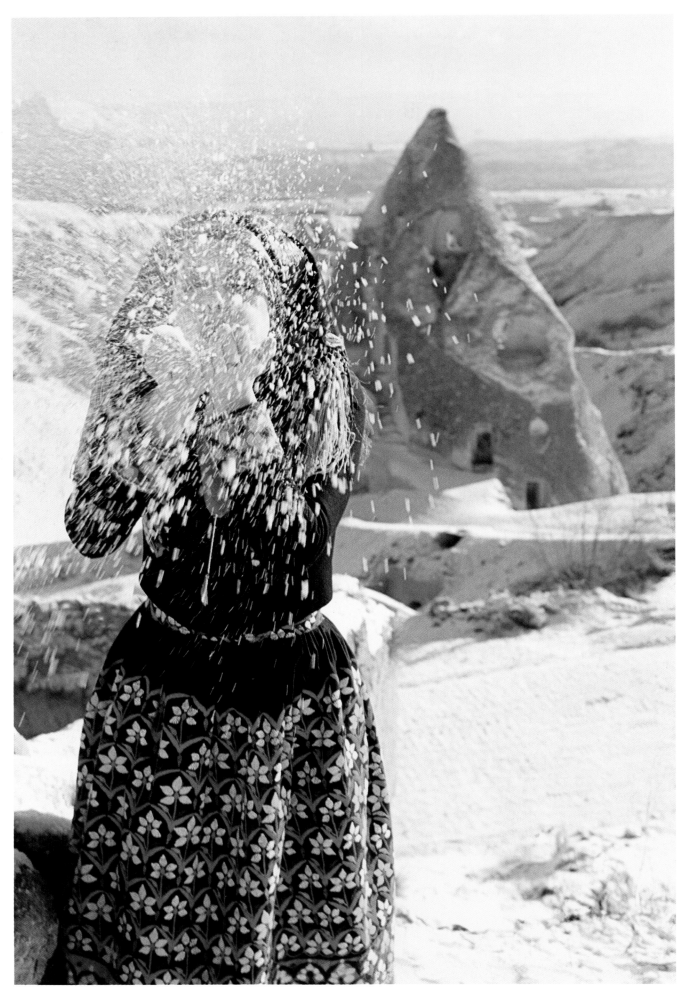

Turkey: *Vogue* May 1970 (variant published)

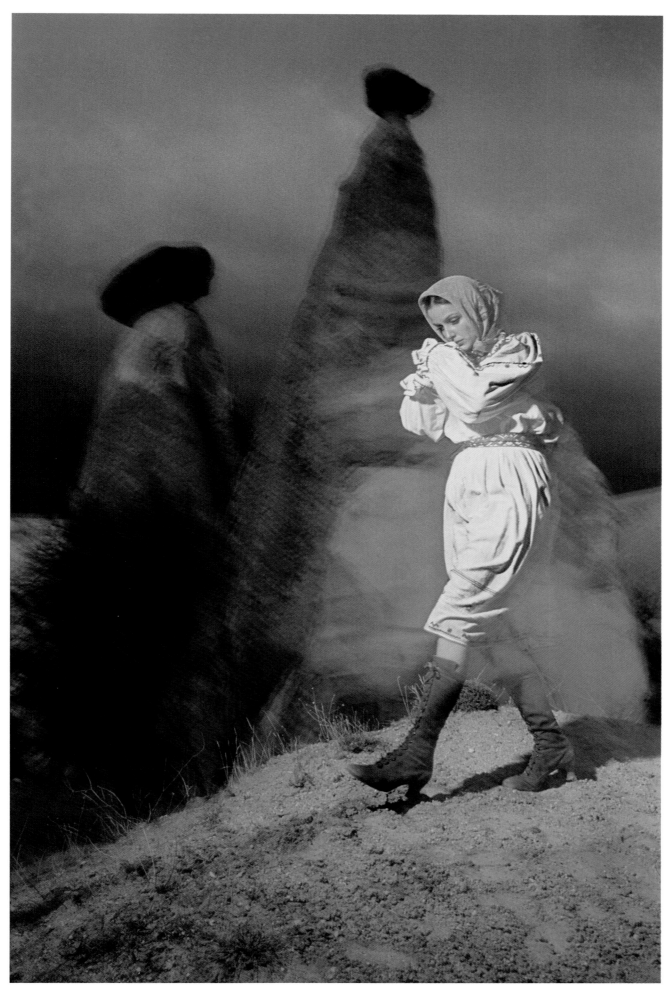

Turkey: Goreme, Central Anatolia (Stone Steeples) *Vogue* May 1970 (variant published)

(above) **Turkey:** *Vogue* May 1970 (variant published)

(opposite) **Turkey: Goreme, Central Anatolia (Stone Steeples)** *Vogue* May 1970

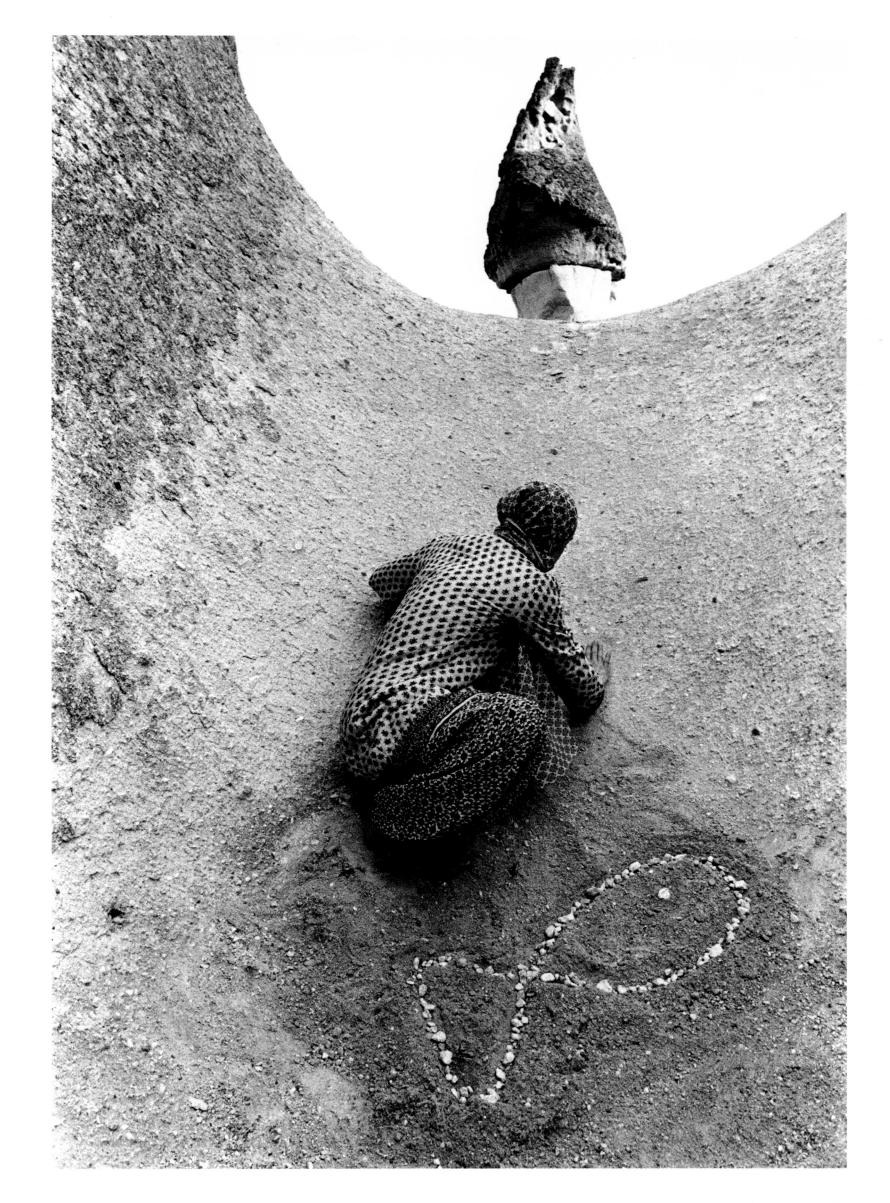

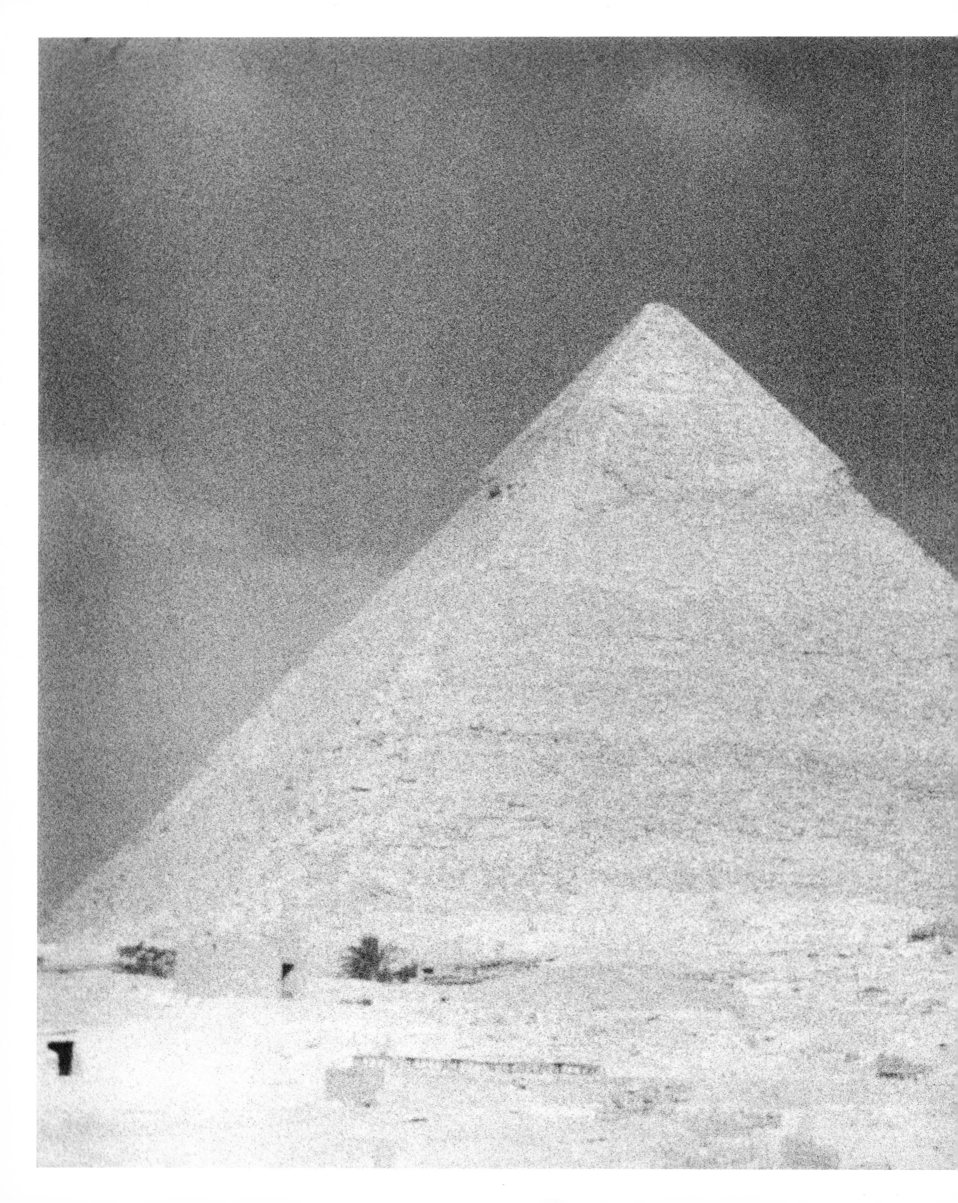

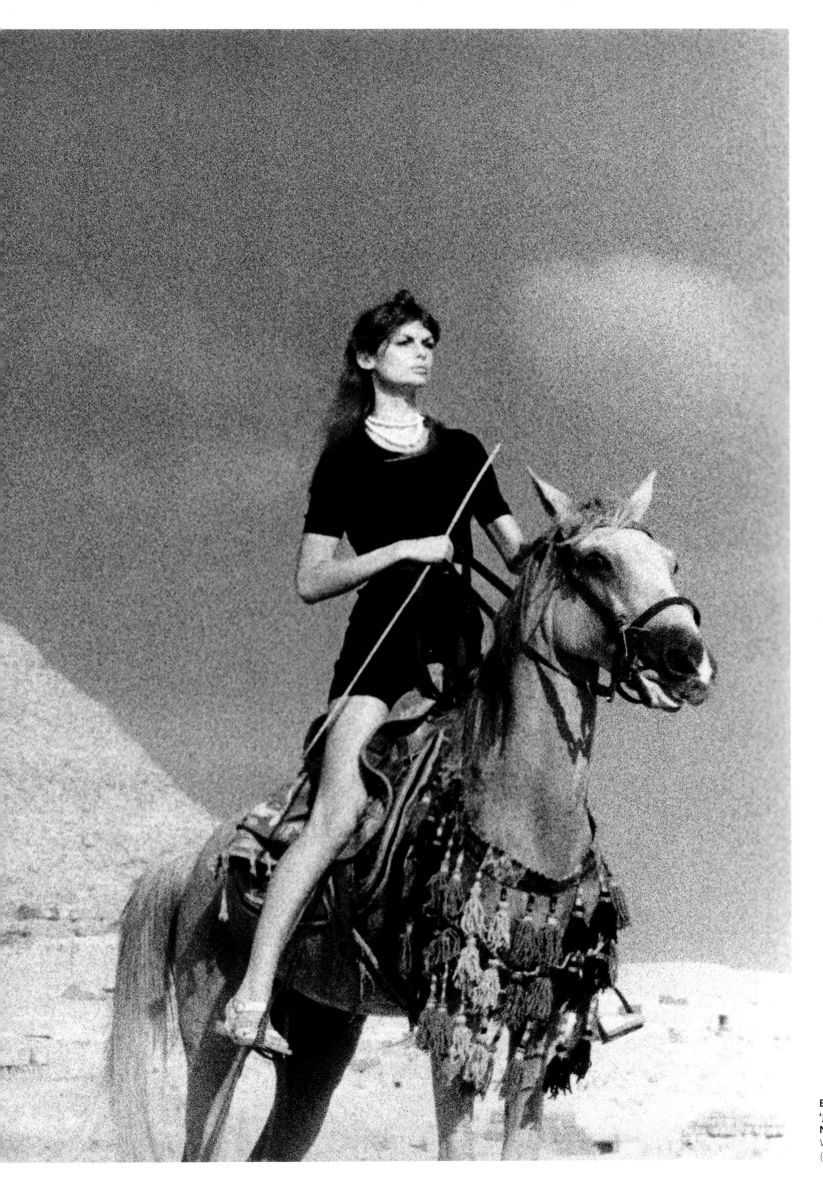

Egypt:
'Jean Shrimpton's
Nile Journey'
Vogue January 1972
(variant published)

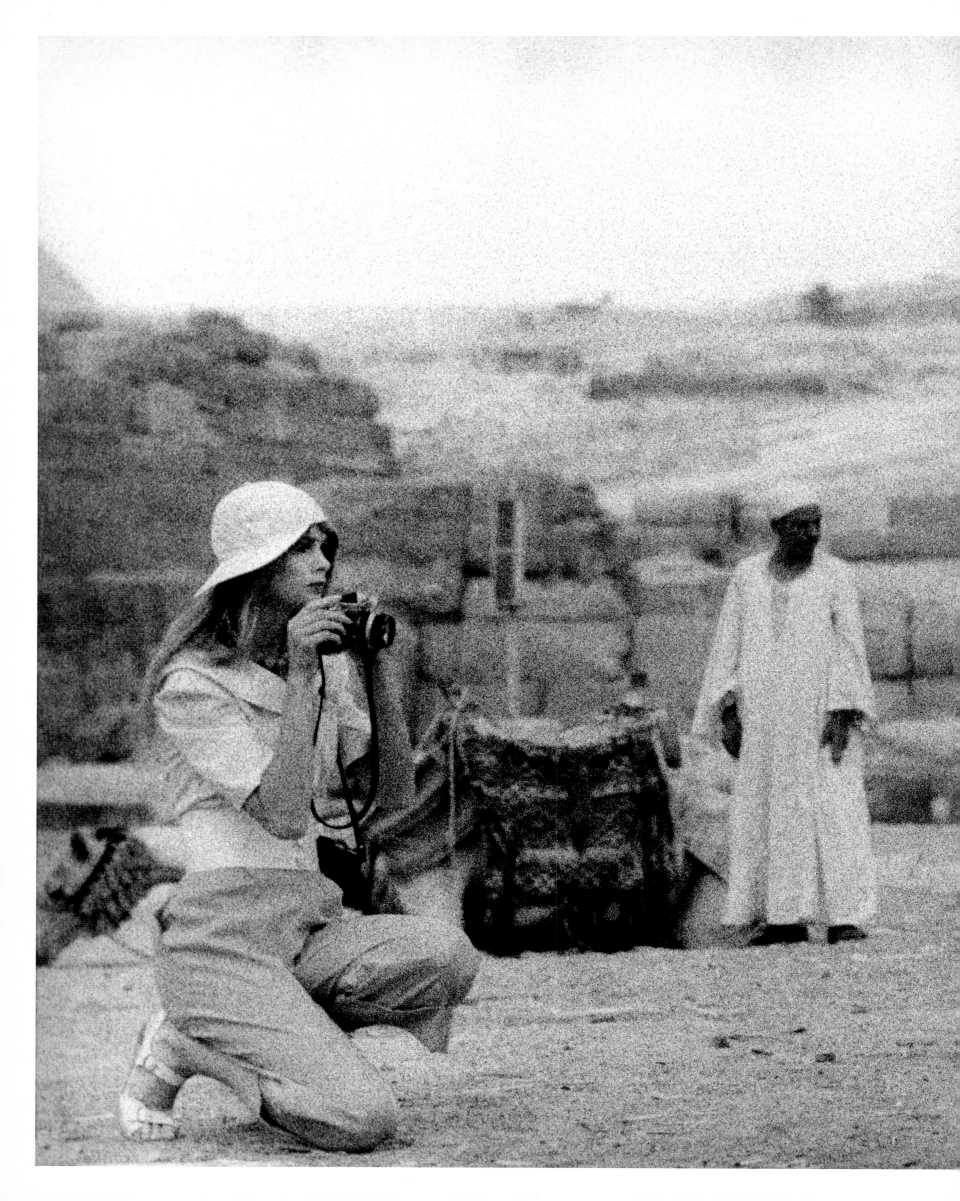

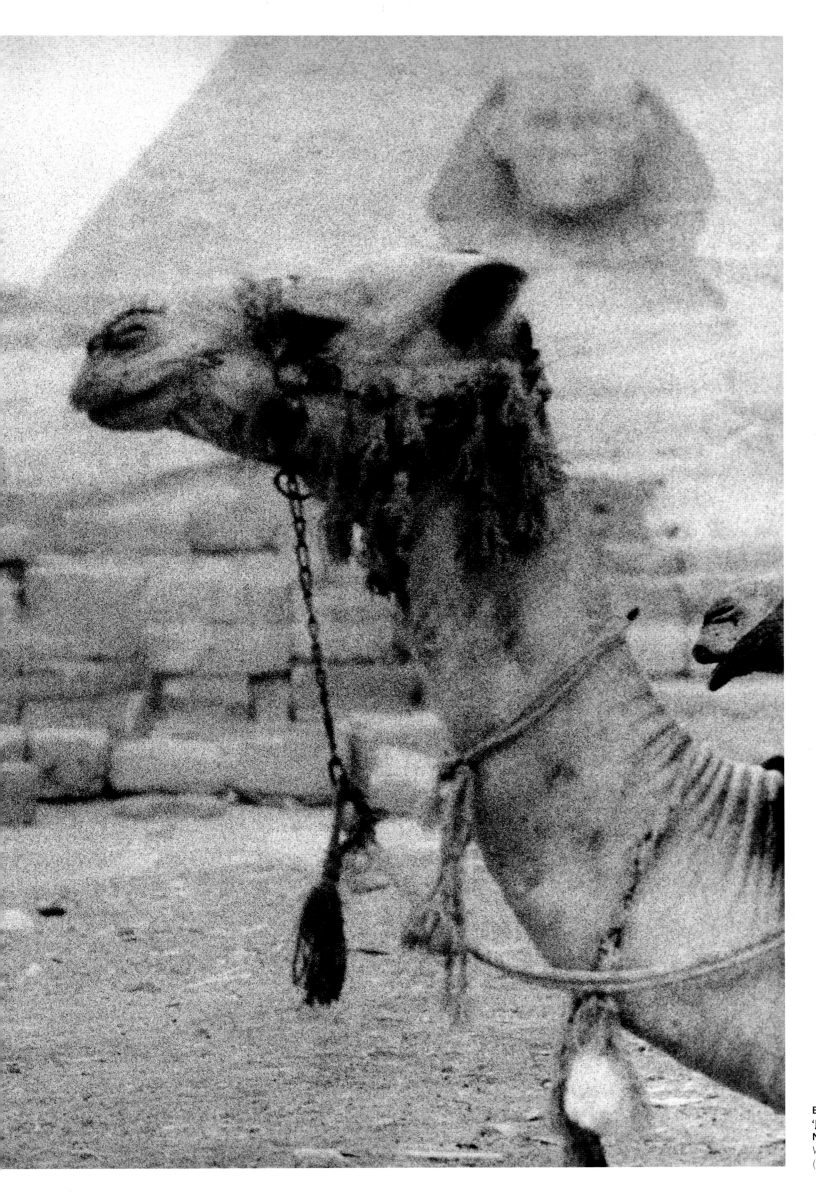

Egypt:
'Jean Shrimpton's
Nile Journey'
Vogue January 1972
(variant published)

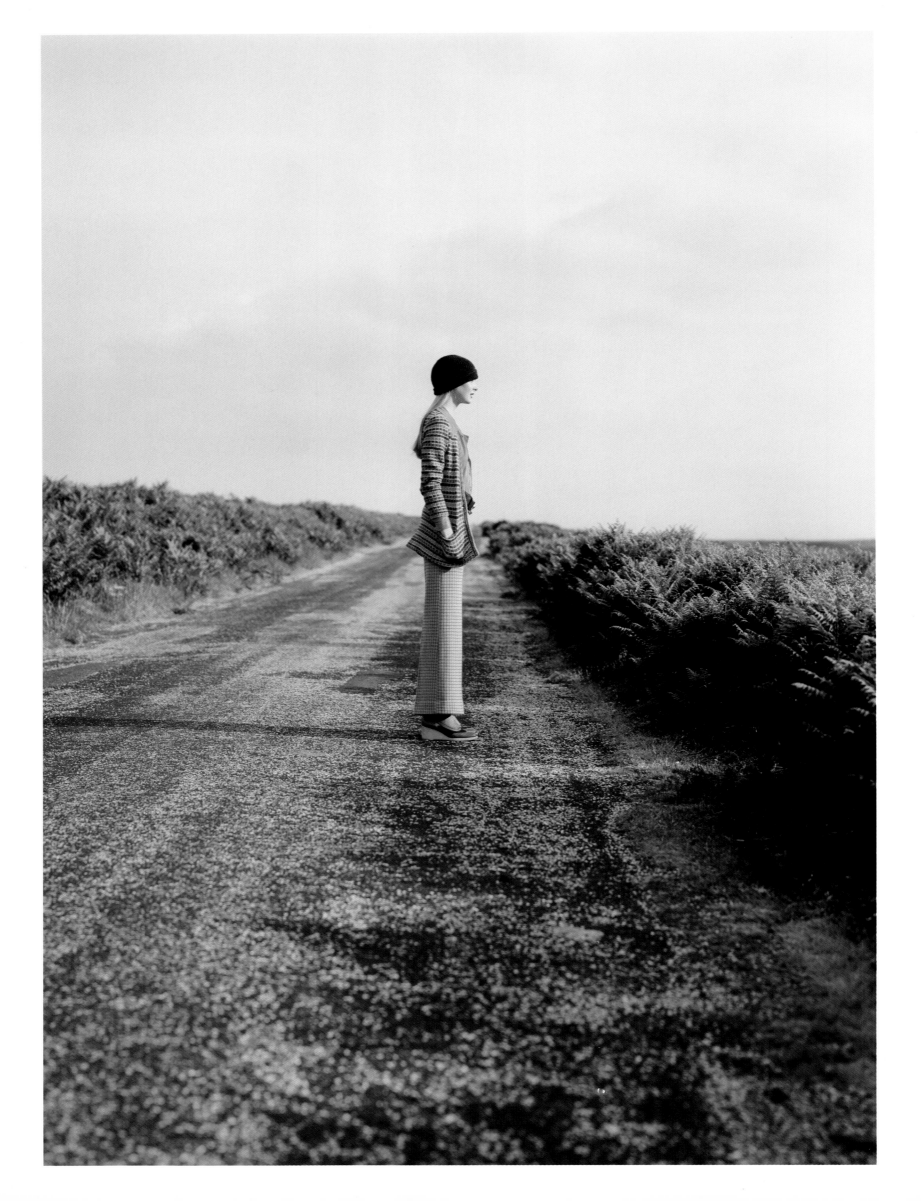

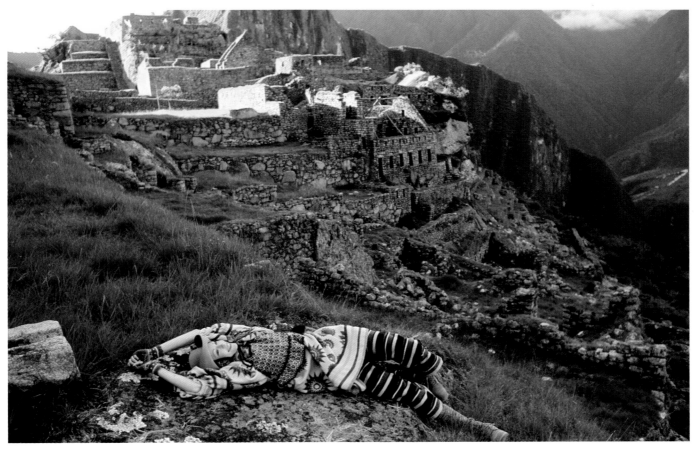

(above) **Peru: Machu Picchu** *Vogue* August 1971 (unpublished)

(opposite) **Dartmoor:** *Vogue* May 15th 1971

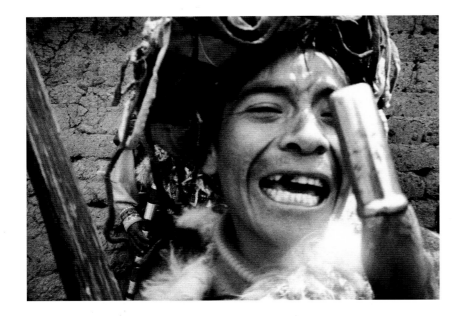

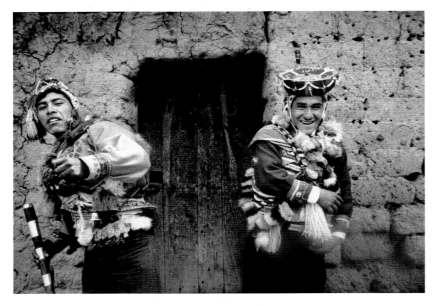

Peru 6/1971

The proliferation of 'ethnic' fashions, mainly as a consequence of the Hippie movement, provided an additional reason to set magazine stories in remote locations. Bailey increasingly saw these assignments as an opportunity to photograph the local inhabitants and their environment.

In these photographs of Peru the comparison between the traditional costumes and the 'ethnic' styles worn by the model, Maudie James, reminds us of the symbolism and metaphorical associations of clothing and its function as both covering and display.

(opposite) **Peru: Arequipa** *Vogue* August 1971 (unpublished)

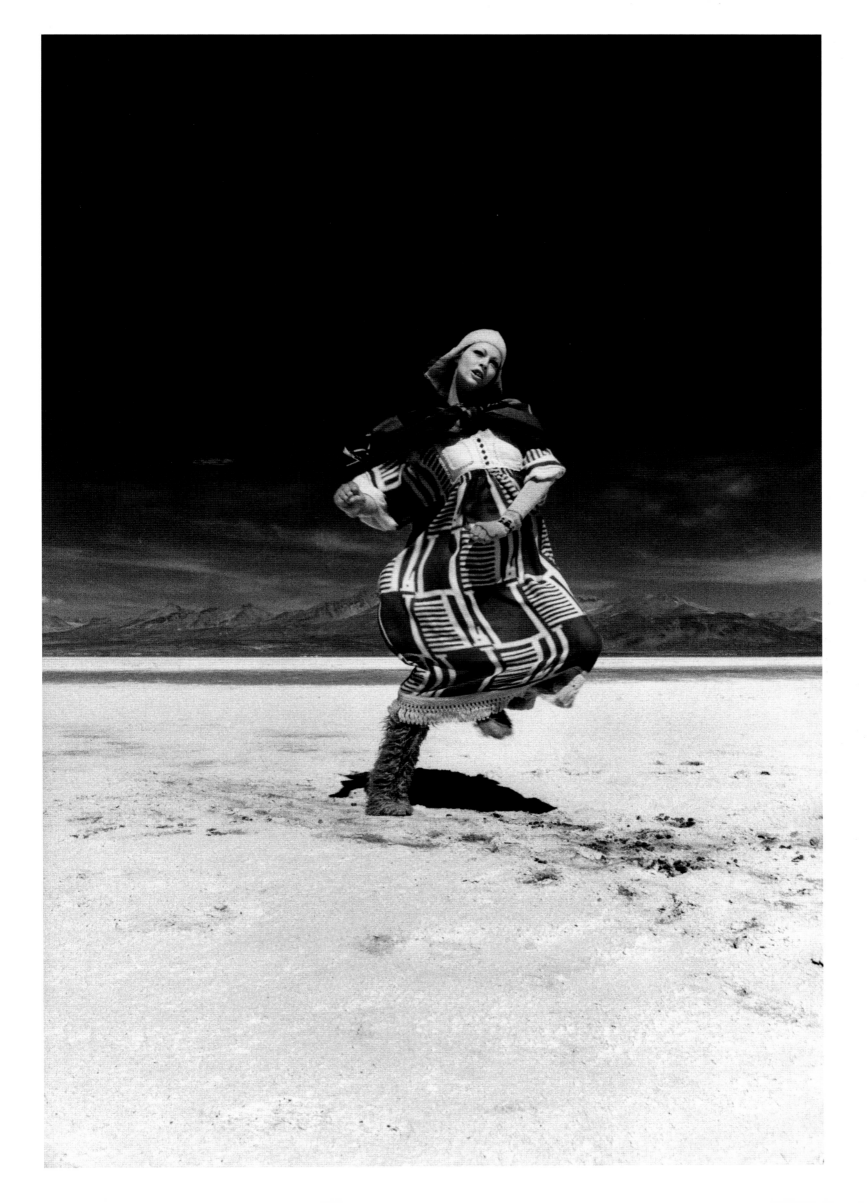

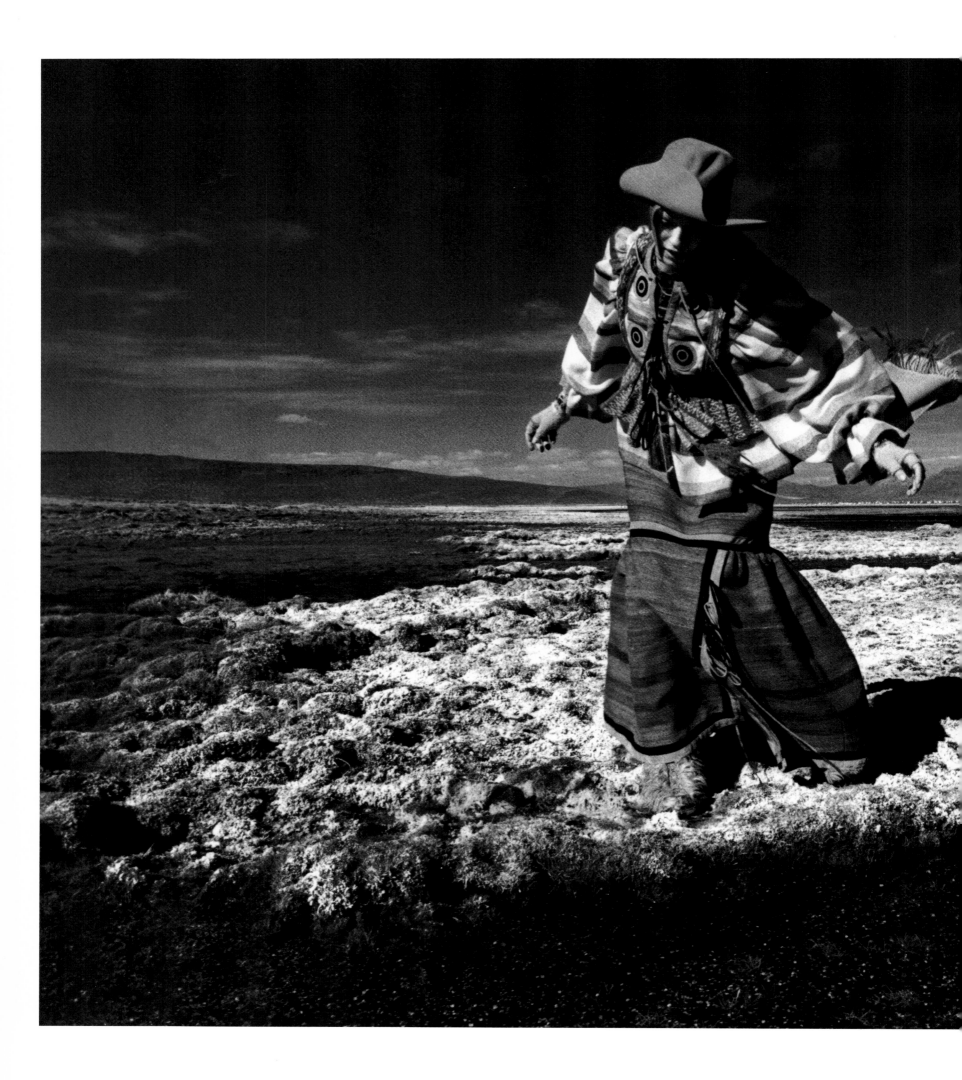

Peru: Arequipa *Vogue* August 1971

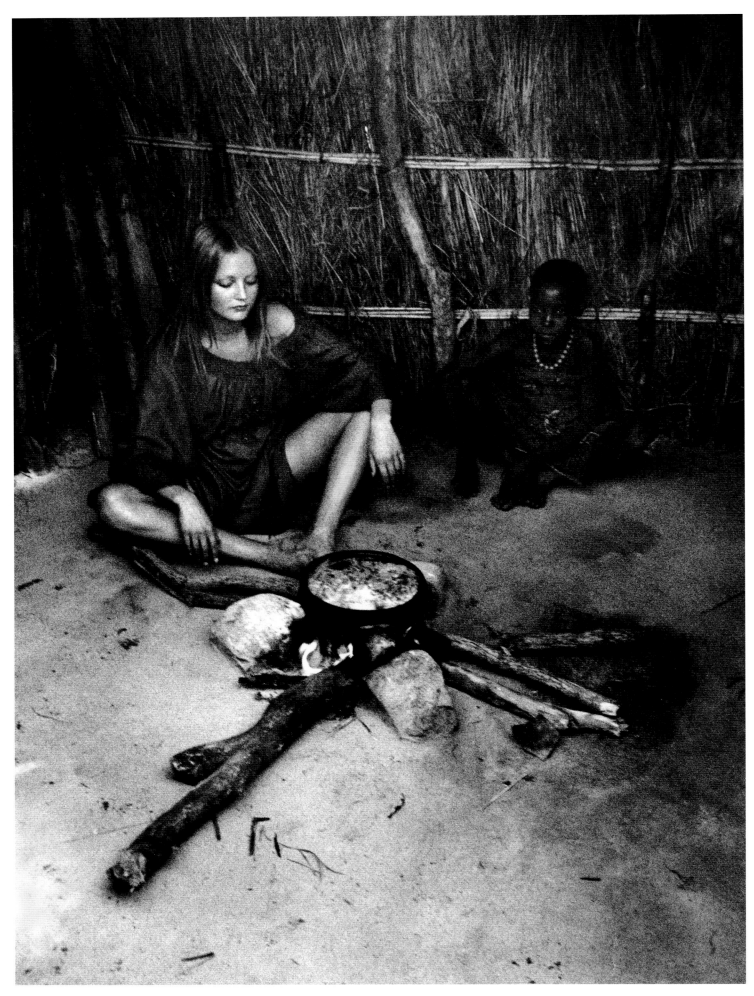

Zambia (Ingrid Boulting): *Vogue* December 1970

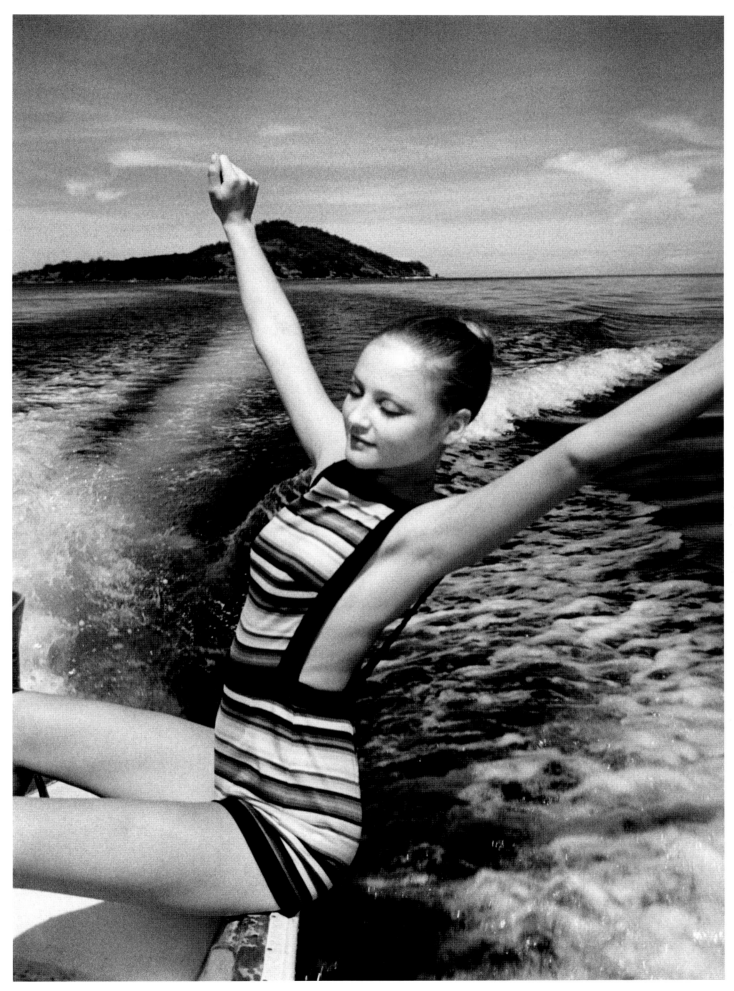

Fiji (Ingrid Boulting): *Vogue* May 1971 (unpublished)

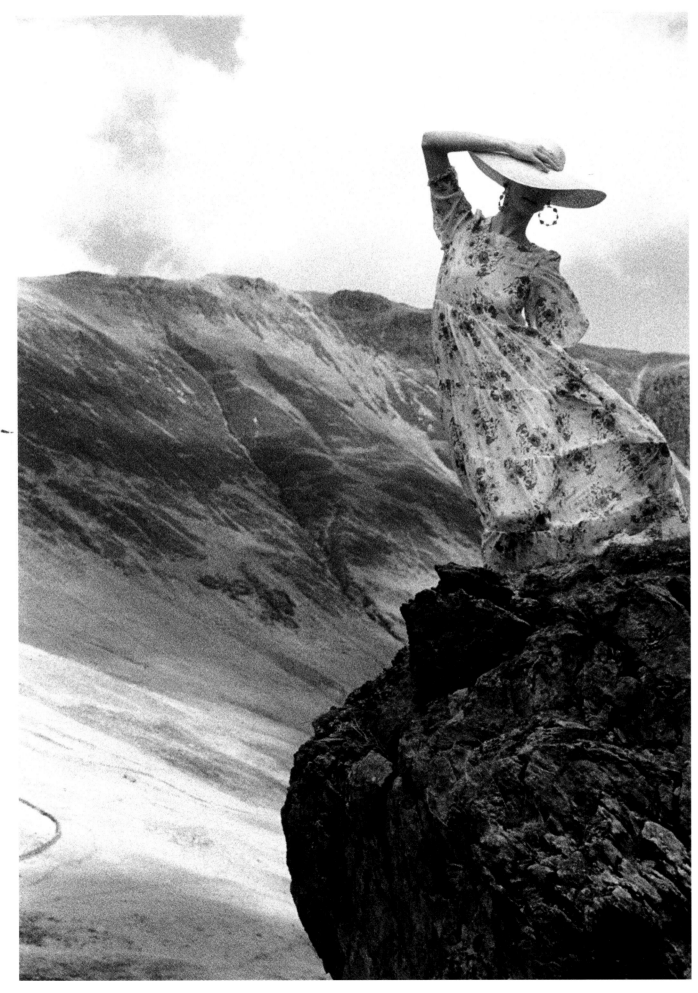

Lake District: *Vogue* July 1972 (unpublished)

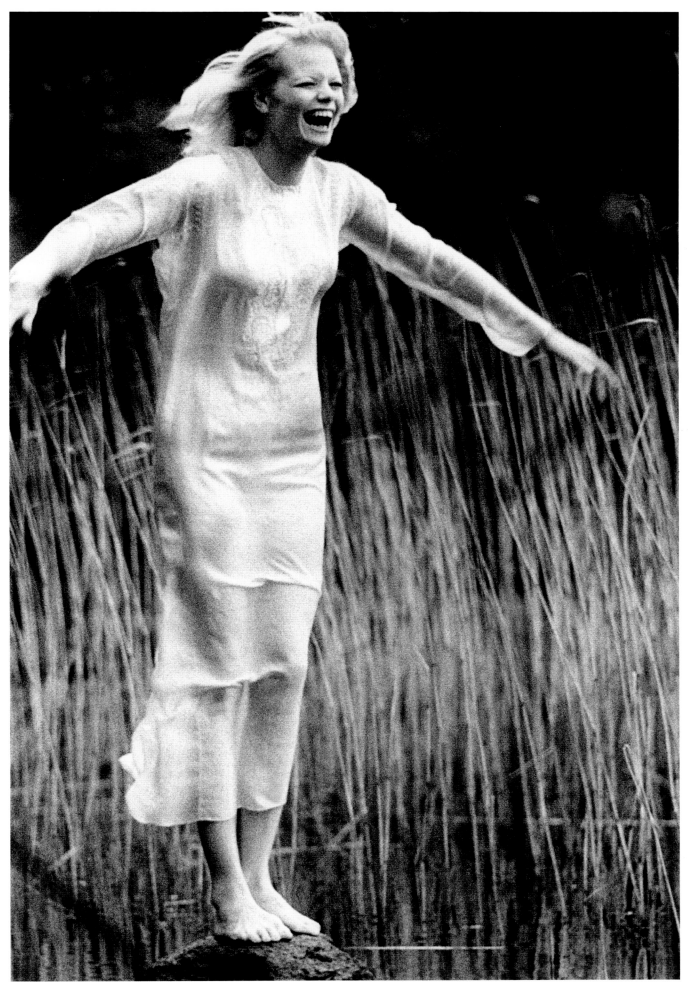

Lake Windermere: *Vogue* July 1972 (variant published)

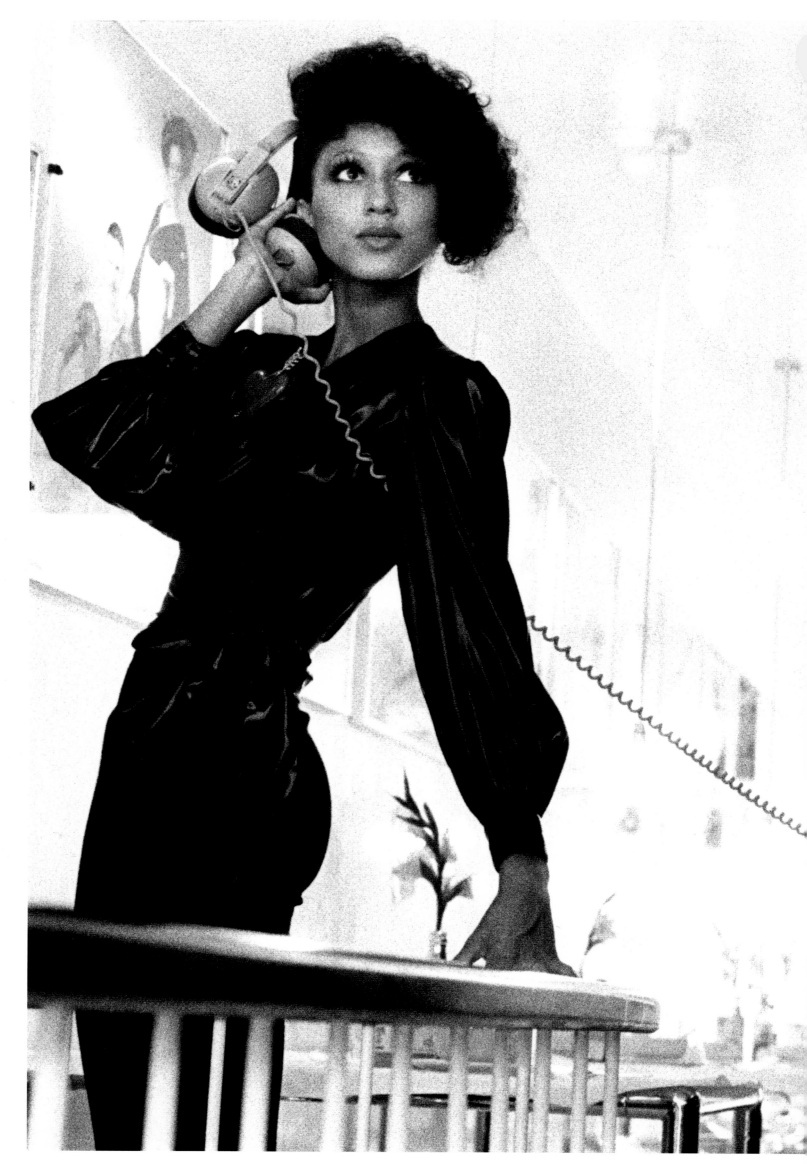

'Kitsch Fashion' 4/1971

'Kitsch Fashion' 4/1971

It's the real thing.

London: *Vogue* August 1972

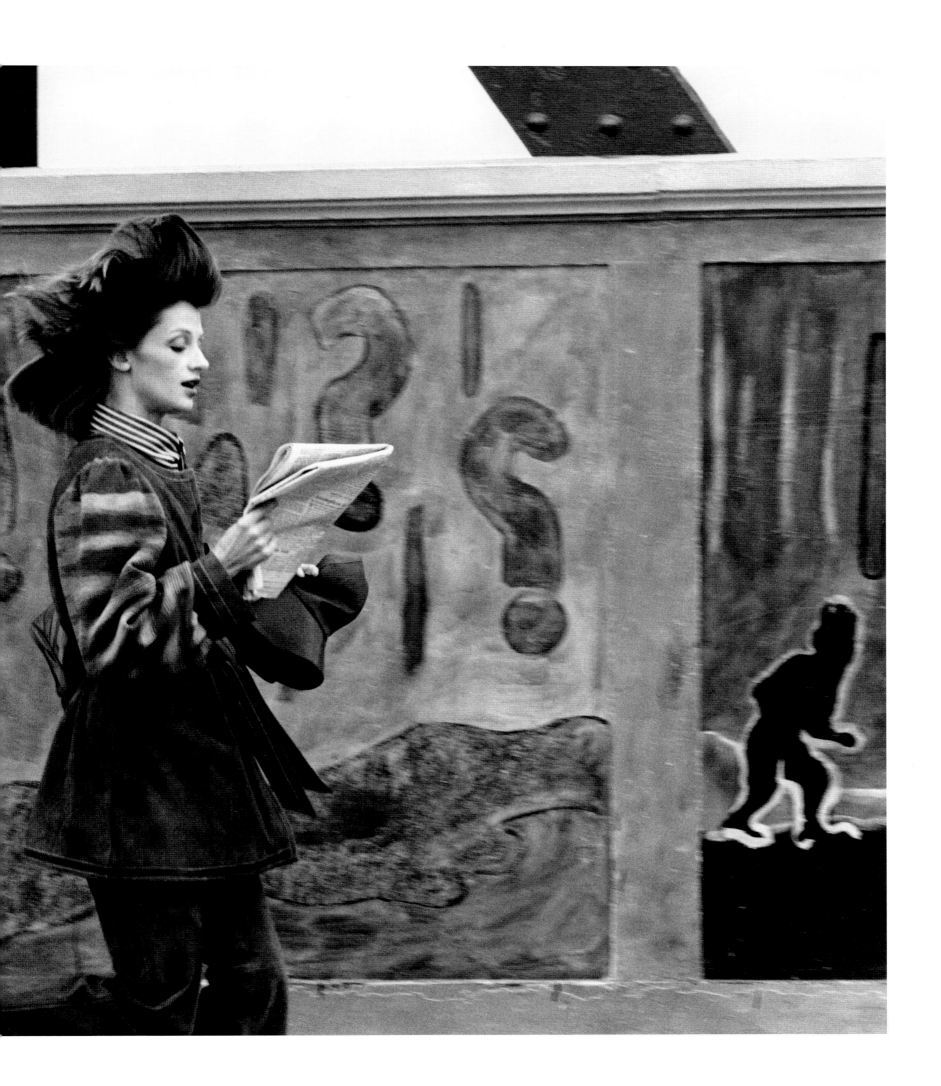

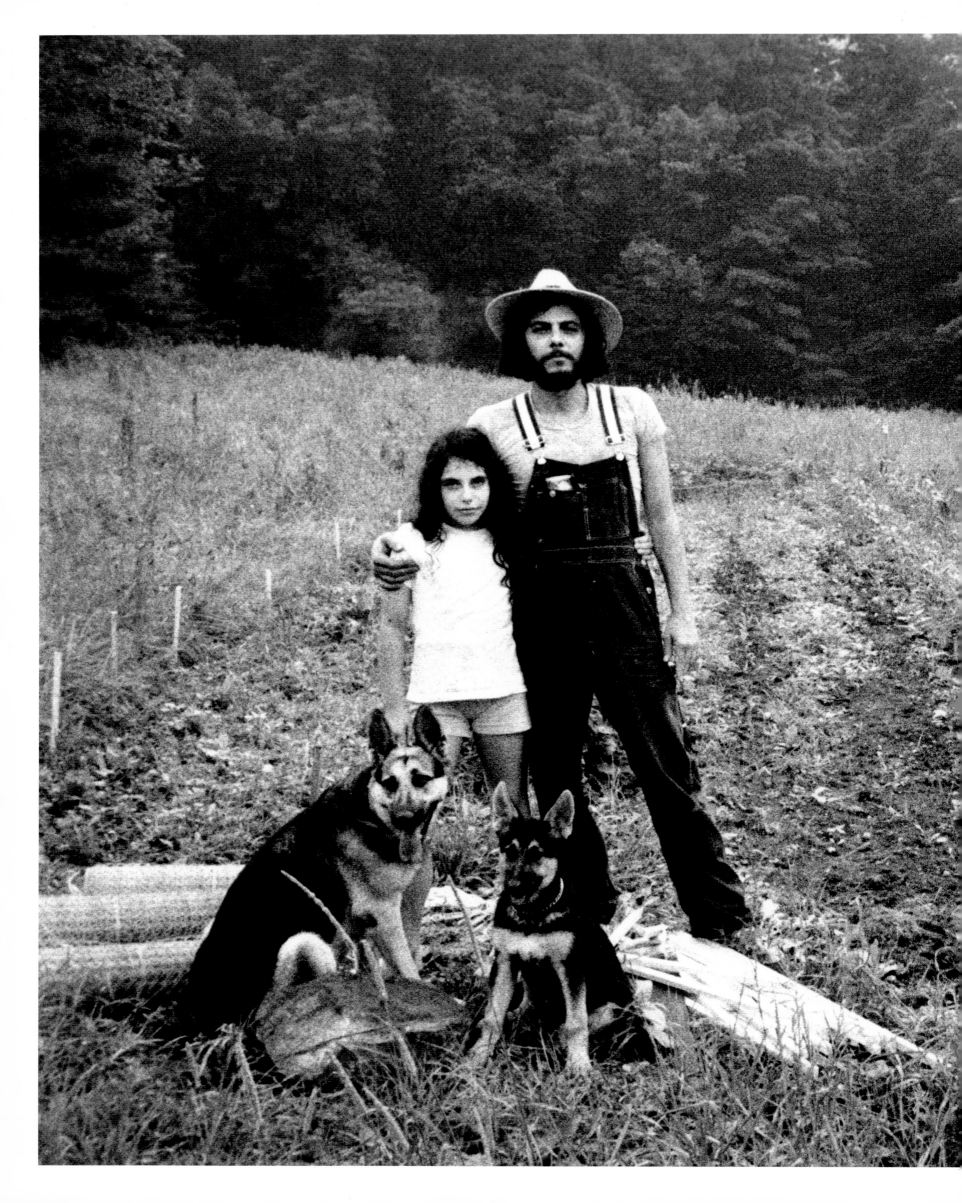

**USA: New Milford, Connecticut,
Jordan Kalfus and his daughter** 7/1970

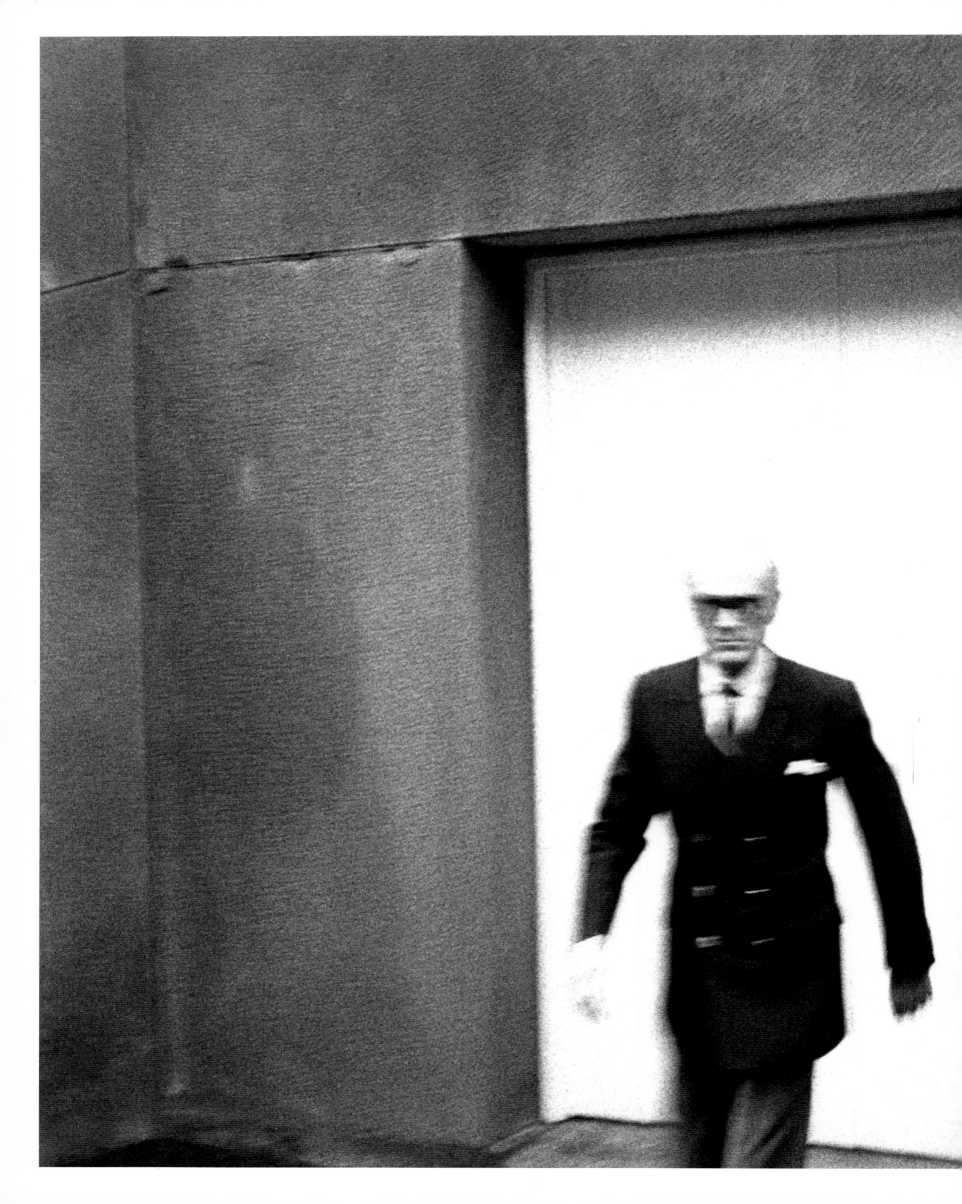

USA: New Canaan, Connecticut,
Philip Johnson 5/1970

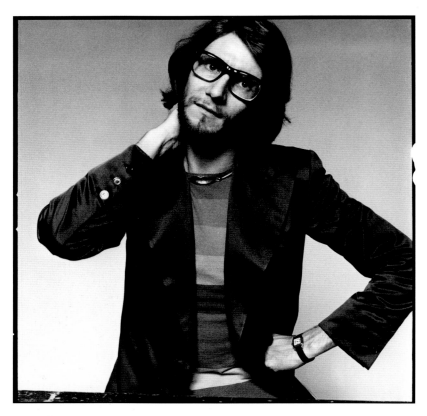

Yves Saint Laurent 12/1970

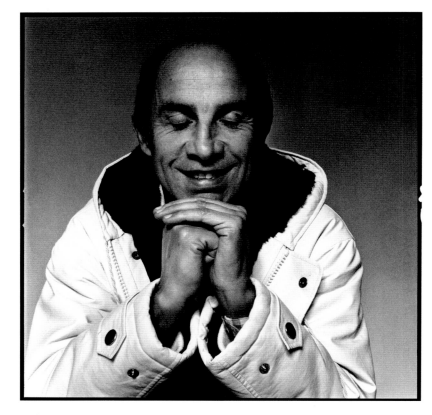

André Courrèges 12/1970

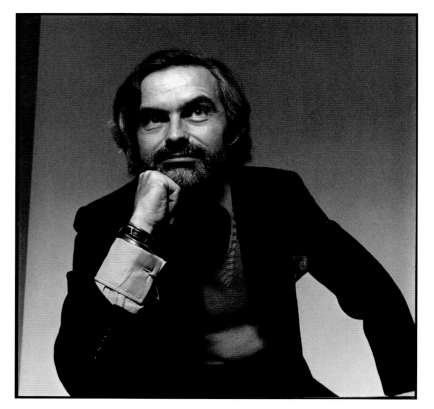

Philippe Guibourgé (Dior) 12/1970

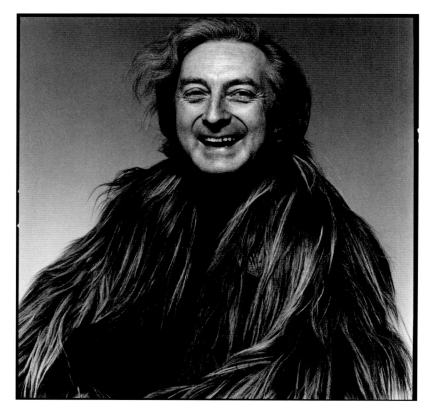

Jules-François Crahay (Lanvin) 12/1970

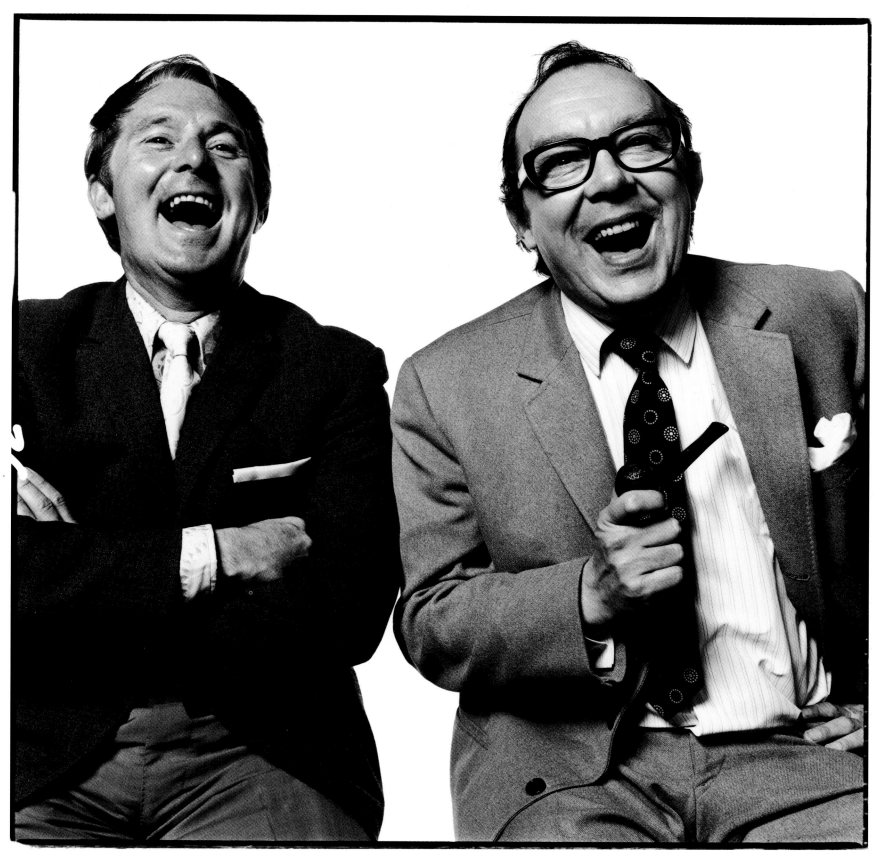

Eric Morecambe and Ernie Wise *Vogue* July 1970 (variant published)

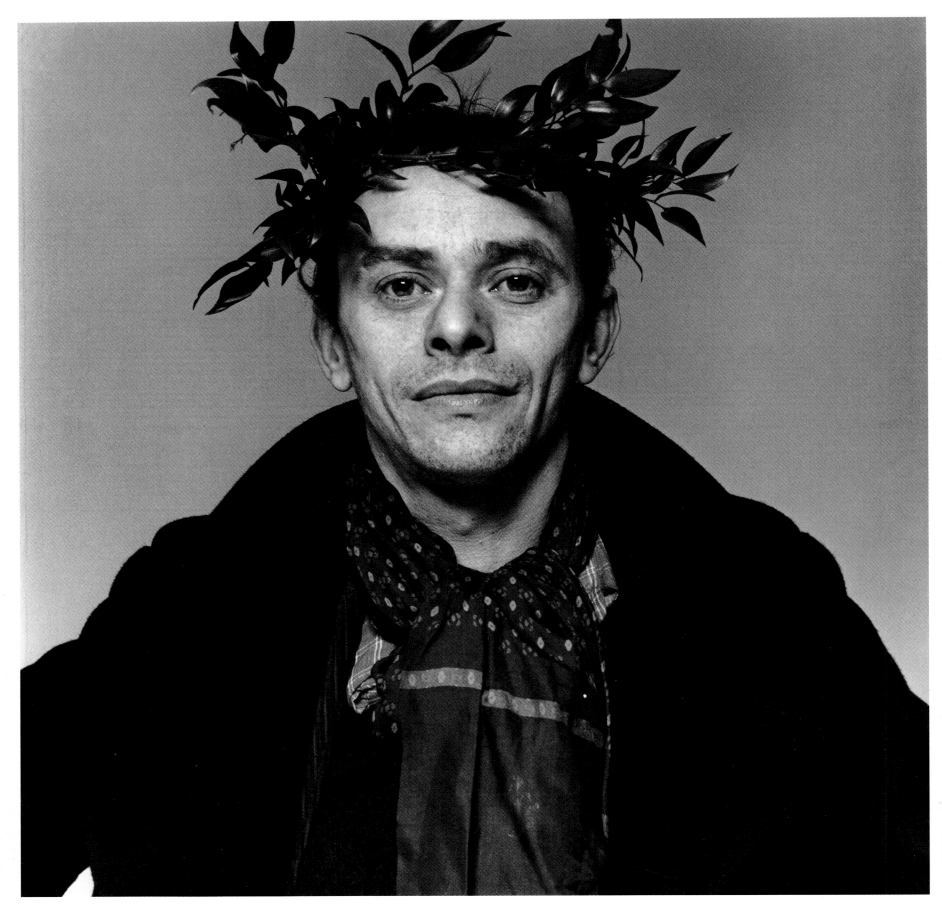

Paris: Sam Szafran 12/1970

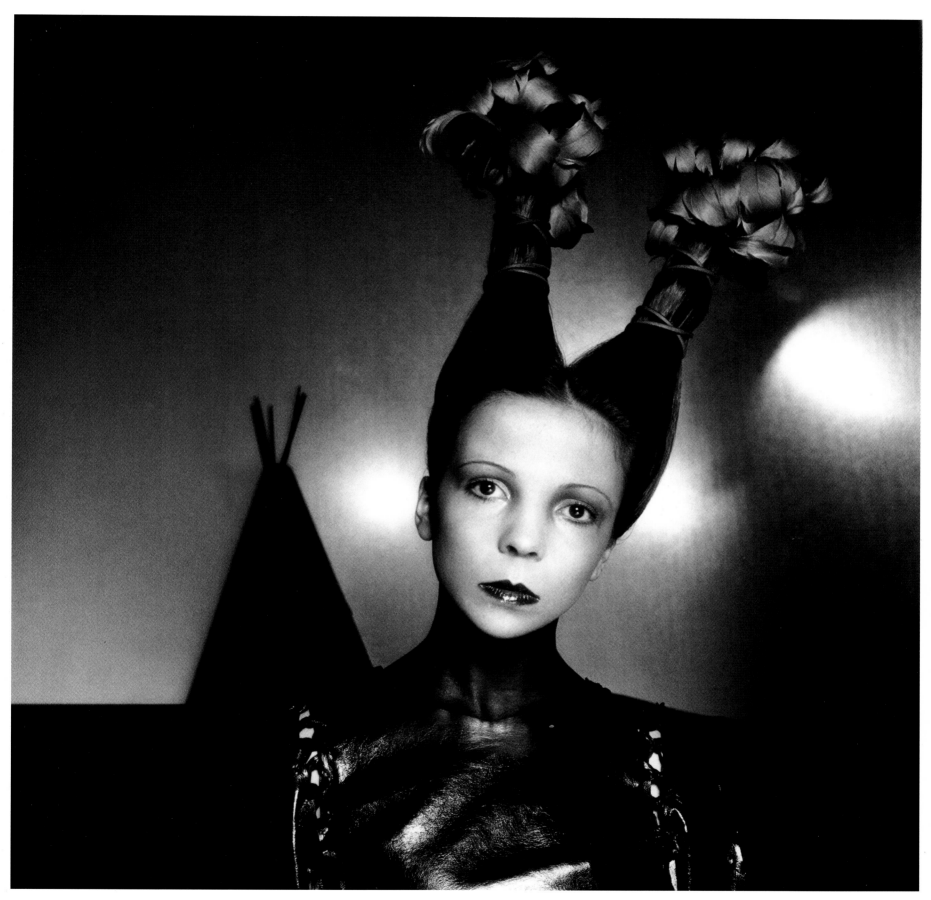

Milan: Penelope Tree and the Wigwam 5/1970 (for Italian *Vogue*)

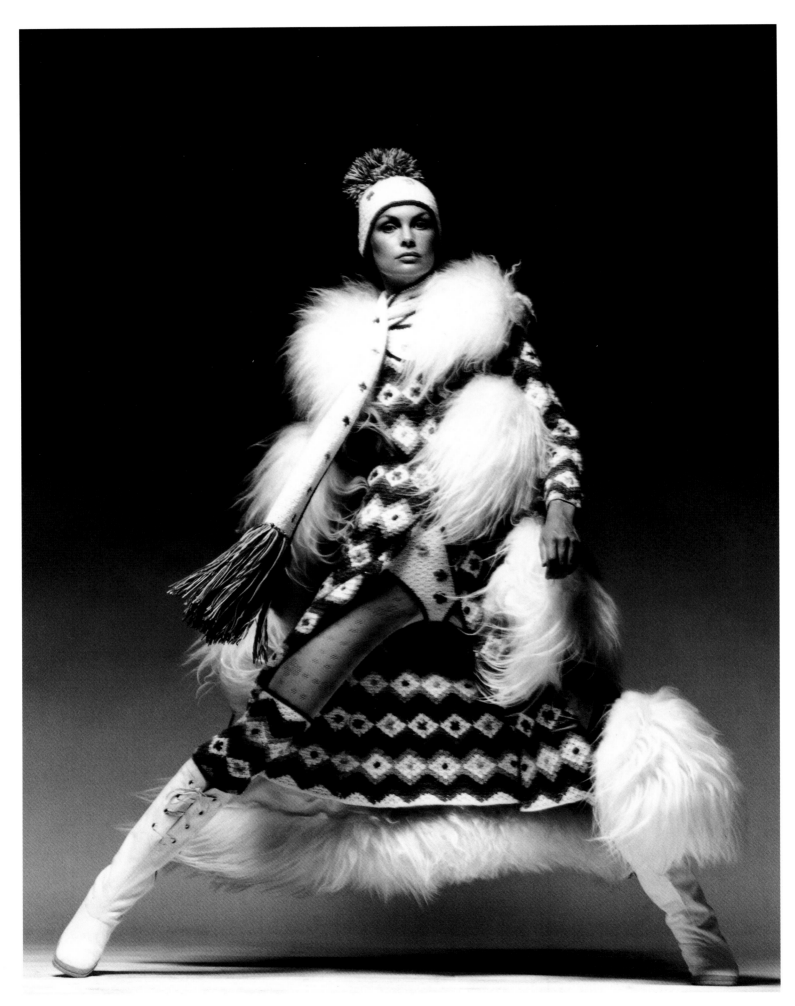

American *Vogue* March 15th 1971 (unpublished)

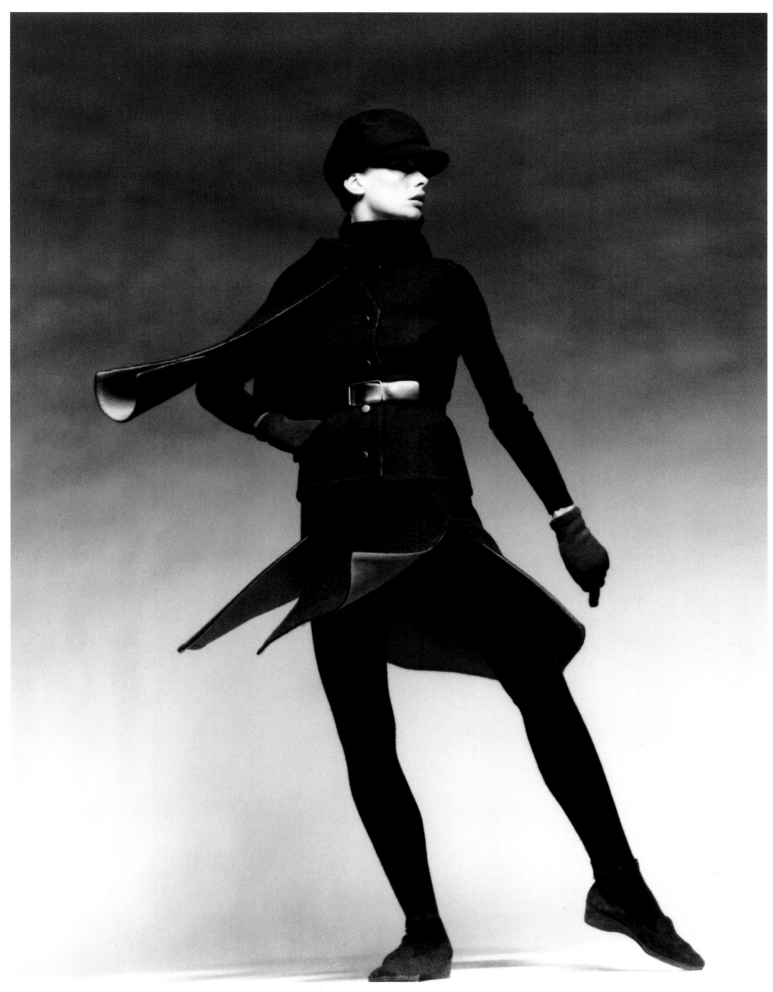

American *Vogue* March 15th 1971 (unpublished)

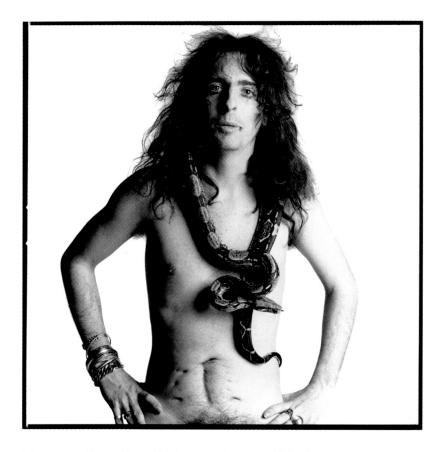

(above) **Alice Cooper** *Vogue* March 1st 1973 (variant published)

(opposite) **John Lennon and Yoko Ono** *Vogue* December 1971 (variant published)

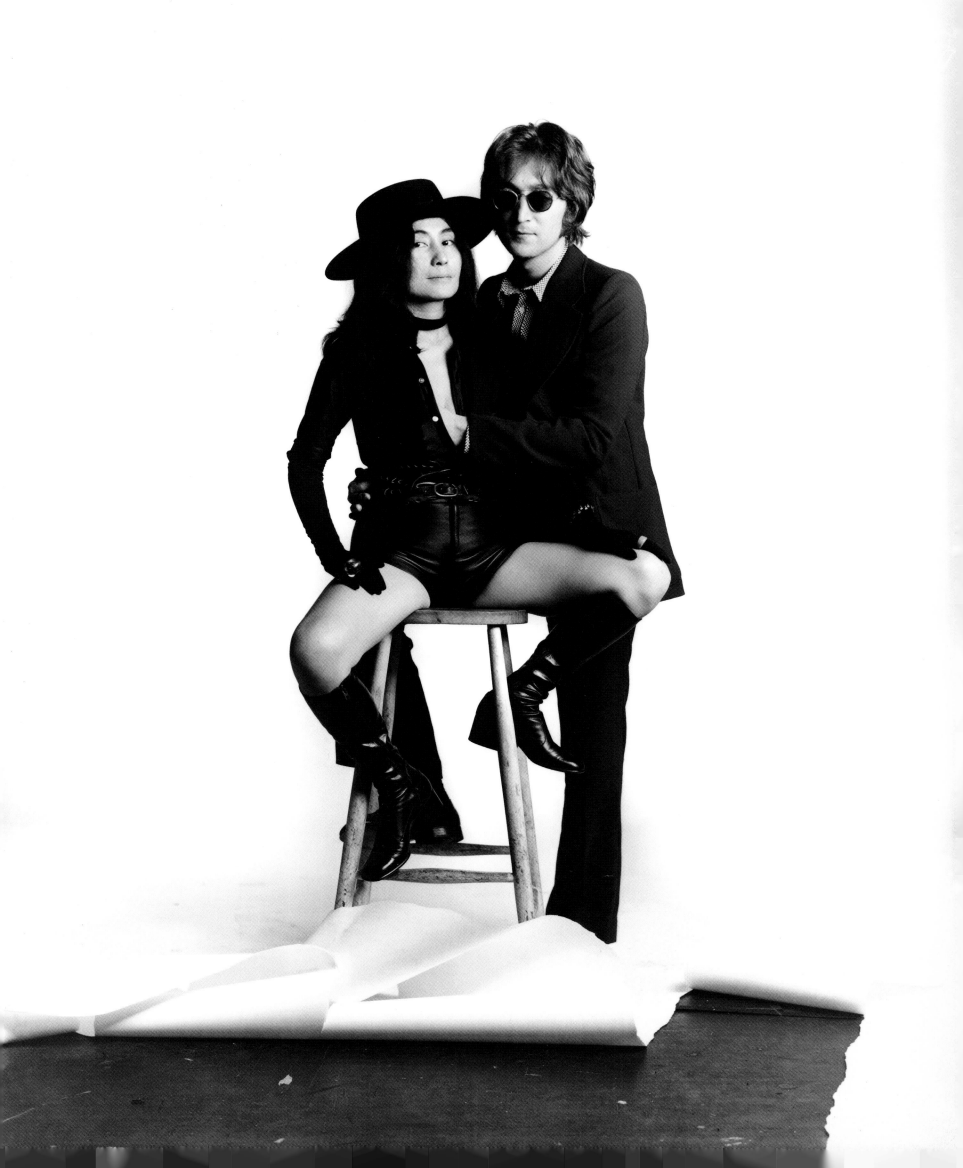

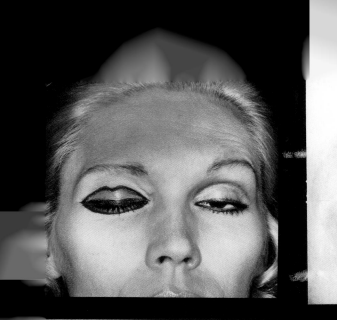
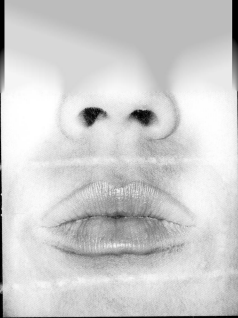

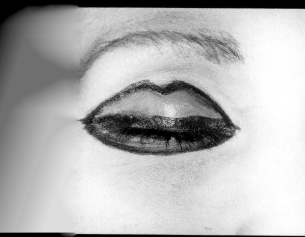
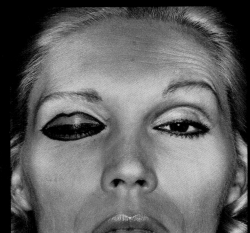

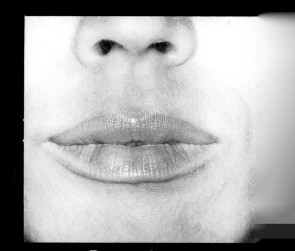

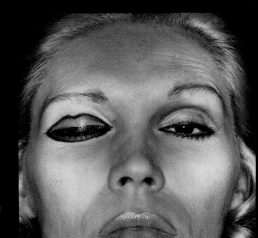

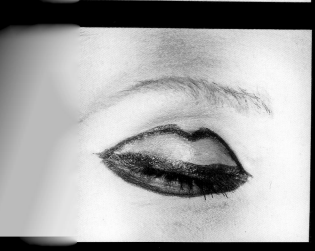
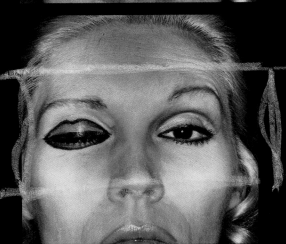

ris: **Amanda Lear** 8/1971

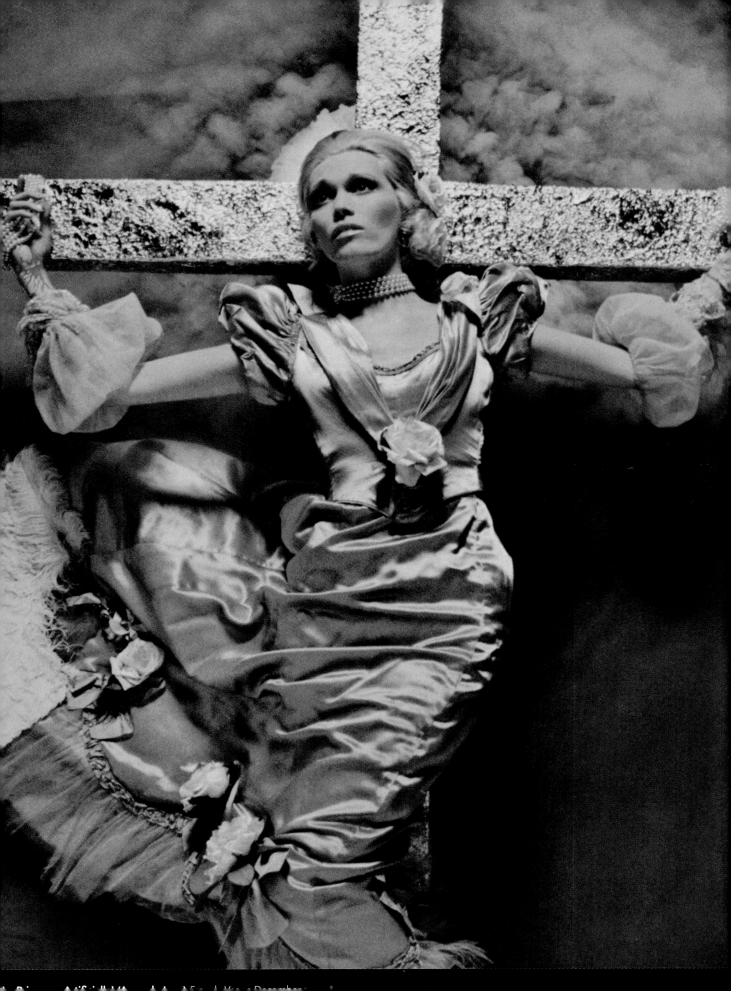

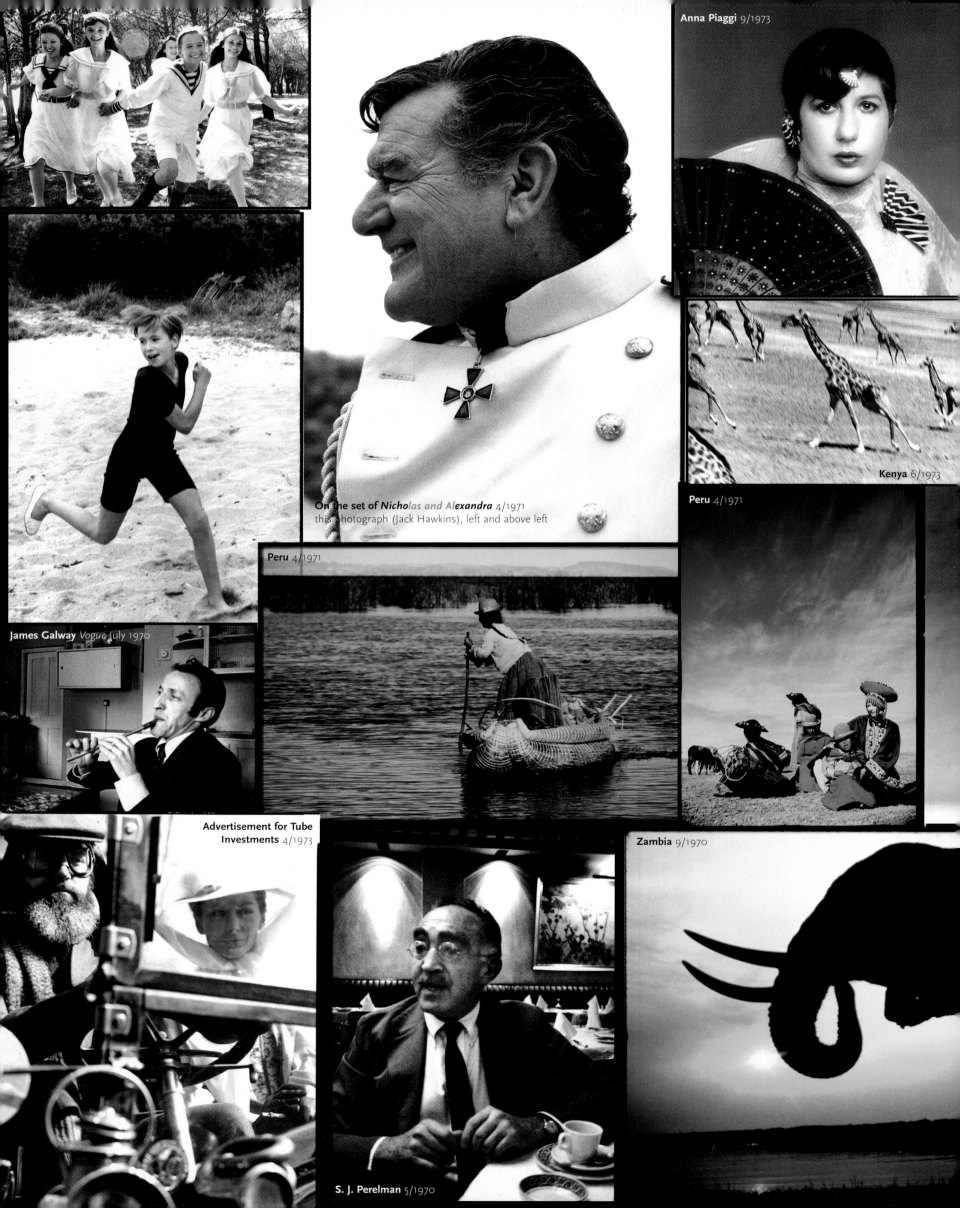

Anna Piaggi 9/1973

On the set of *Nicholas and Alexandra* 4/1971
this photograph (Jack Hawkins), left and above left

Kenya 6/1973

Peru 4/1971

Peru 4/1971

James Galway *Vogue* July 1970

Advertisement for Tube
Investments 4/1973

Zambia 9/1970

S. J. Perelman 5/1970

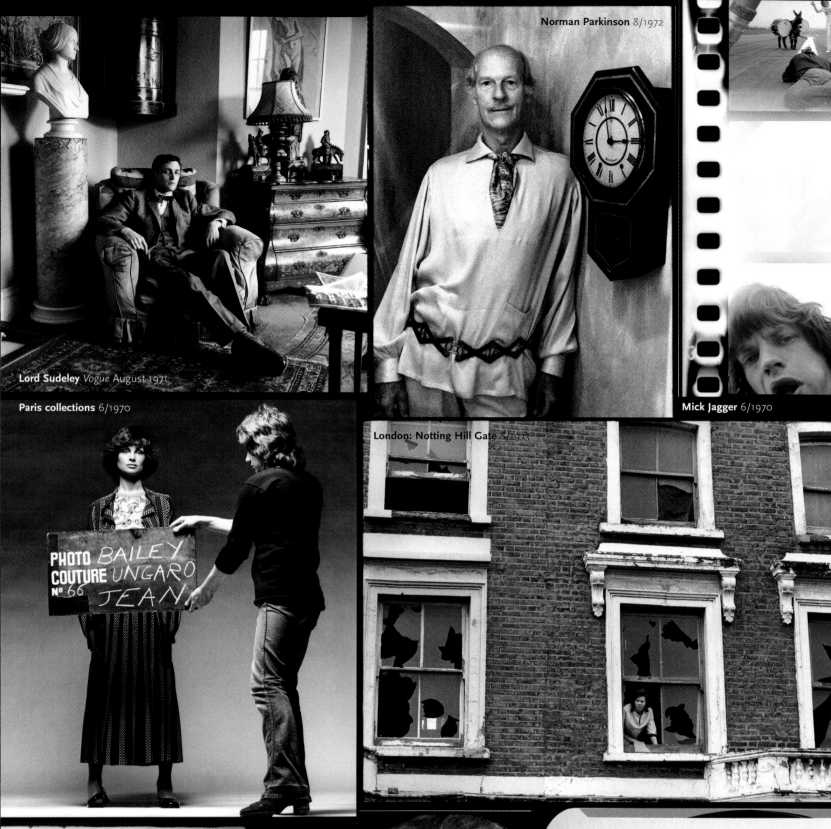

Lord Sudeley *Vogue* August 1971

Norman Parkinson 8/1972

Mick Jagger 6/1970

Paris collections 6/1970

London: Notting Hill Gate 8/1973

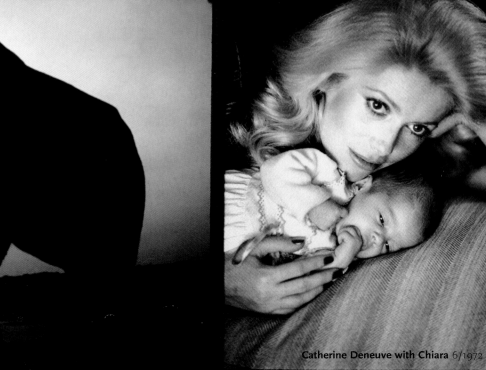

Catherine Deneuve with Chiara 6/1972

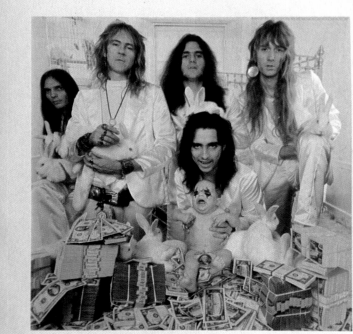

Alice Cooper: *Billion Dollar Baby* album sleeve 12/1972

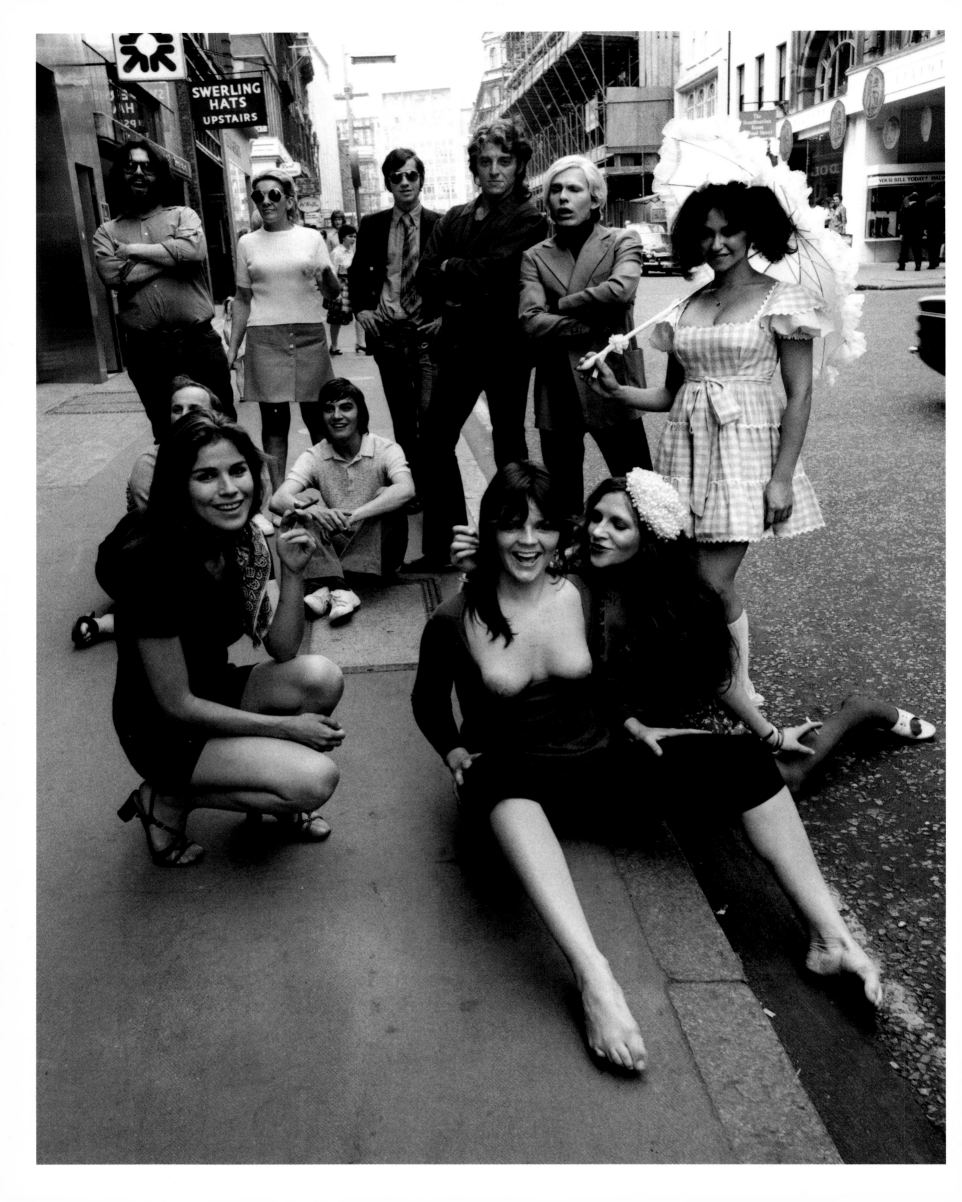

Connecting

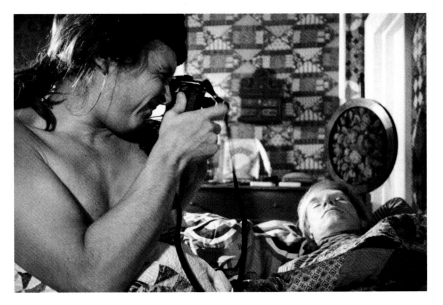

Bailey in bed with Warhol 2/1972

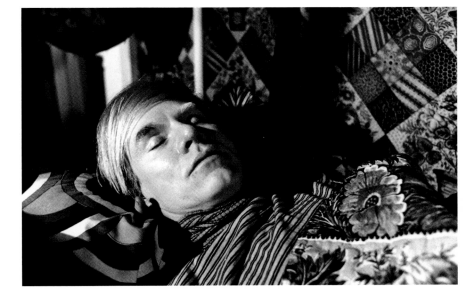

Andy Warhol in bed 2/1972

Beaton by Bailey, broadcast in 1971, was Bailey's first television documentary. Bailey's direction was very much hands-on, and he plays an important part in the film. Beaton seems game, and not to mind the element of send-up of his bemused and somewhat outmoded camp persona. His response to the broadcasting of the film was mixed, however, for while he recognized its entertainment value he regretted its excessive concern with the superficial aspects of his life.

Beaton's wider suspicions about Bailey may have been founded on the belief that he had, in effect, been usurped by the young pretender, for as Francis Bacon commented: 'Bailey's arrival at *Vogue* effectively finished Beaton off.' Filming had begun in October 1970 at a party in Beaton's house in Pelham Place, attended, as Roy Strong observed, by the entire 'in-set' of the period. As Director of the National Portrait Gallery, Roy Strong

conceived the exhibition *Snap!*, which included fifty photographs by Bailey, and which opened in June 1971.

The subject of Bailey's next film was film director Luchino Visconti. Bailey had been friendly since the Sixties with the actor Helmut Berger, and it was Berger who arranged an introduction to the publicity-shy director. Bailey regards this as the least effective of the three documentaries: 'Visconti was completely unforthcoming, and even Helmut was a nightmare.' The trilogy of TV documentaries was completed by his Andy Warhol film, shot in and around New York in February 1972. Warhol appeared to present an ideal subject. He and Bailey had remained close since their first meeting ten years earlier in New York, when Bailey was inspired by the Pop artist's ability to invest iconic significance in ostensibly mundane artifacts. But after having suffered serious injuries in the murder attempt by Valerie Solanas in

London: Andy Warhol and the cast of *Pork* *Vogue* September 1st 1971

1968, the never exactly loquacious Warhol had become, if anything, an even more monosyllabic and unresponsive interviewee. Considering this, Bailey's strategy of mixing intimate close-ups with footage of interviews with members of the Warhol entourage cleverly exploited an elusive subject. The film was an informative record that allowed narcissism and mundanity to tell their own story, and contained episodes of insight and of humour. With hindsight it seems scarcely credible that before screening it was hi-jacked by self-appointed mouthpieces for the moral majority: the two principal flash-points were the 'homosexual undertones' of Warhol and Bailey in bed and Brigid Polk's demonstration of her 'breast paintings'. Ross McWhirter

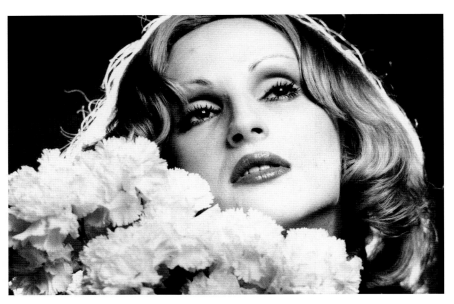

Candy Darling 2/1972

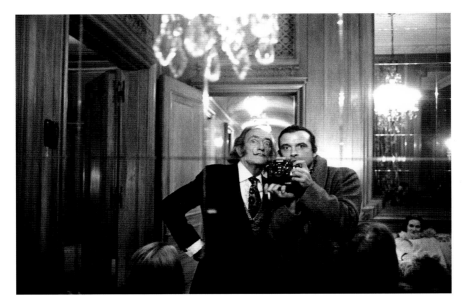

Paris: Salvador Dalí and Bailey 12/1970

and Mary Whitehouse had their day in the sun, and the film was duly banned in January 1973. In limbo, a frustrated Bailey told the *Daily Mail* he almost hoped the ban would not be lifted, since he feared the film would come as a 'terrible anti-climax': he also pondered rhetorically why McWhirter, who was alert enough to hide behind 'rule of law' grounds rather than obscenity, had not spoken out instead against the napalming of innocent people in Vietnam.

The press furore that followed the ban – it was two months before the decision was repealed by three Appeal Court judges – inflated both the public's expectations (as Bailey had predicted) and the audience figures. The repercussions effectively cut short Bailey's career as a director of documentaries. He recalls: 'I remember Lew Grade, who I really liked, kept saying "But I got so much animosity from the Warhol film."'

If Warhol's staff and superstars had been only intermittently articulate, the filming provided Bailey with the opportunity to photograph other luminaries of the New York art world, including John Cage, Roy Lichtenstein, Salvador Dalí and Henry Geldzahler. The fashion photographer Horst, famous in the 1930s but still awaiting the 1980s revival of interest in his sleek neo-classicism, was another fortuitous subject in New York. Bailey has always assiduously photographed fellow artists and photographers, and a new name in fashion photography, whose legendary camera-shyness he overcame in a sensitive portrait was Sarah Moon. His photograph of Peter Beard was taken when they were on a reconnaissance trip in Kenya

Mick Jagger continued to be one of Bailey's closest friends. Not only did Bailey take the striking sleeve photographs for the Rolling Stones' *Goat's Head Soup* album, but he also had exceptional backstage access to the lead singer (exemplified in the unique record of post-gig exhaustion) as well as the opportunity to snap him in off-duty moments.

In February 1974 Marie Helvin was re-introduced to Bailey by fashion editor Grace Coddington (they had worked together in 1971 on the abortive 'Kitsch Fashion' series). Now they clicked and, with her serene, impassive elegance and immaculate symmetry, she became his new muse. Born in Hawaii but of Japanese/Danish descent, her partly Oriental appearance

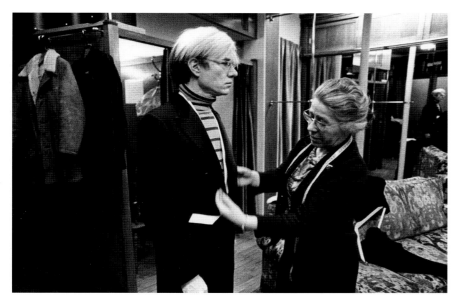

Paris: Warhol measured for a suit 2/1972

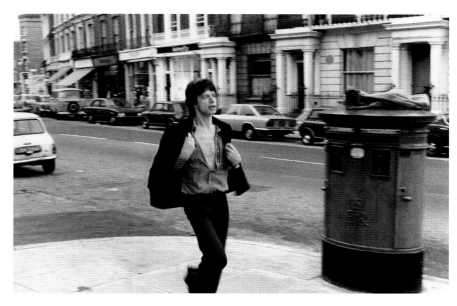

London: Mick Jagger walking in Primrose Hill 7/1973

for *Out of Africa*, the Isak Dinesen book which he and Bailey hoped to make into a film. The art nouveau and art deco revivals prompted the rediscovery of the fashion illustrator Erté (Romain de Tirtoff), who had drawn *Harper's Bazaar* covers as far back as 1915; Bailey's photograph situates the cult figure – then still active in his eighties – in the aptly chic interior of the Hotel Lotti, in Paris. The continuing currency of 1920s designs is also evident in Bailey's photograph of Anjelica Huston in Karl Lagerfeld's apartment.

While the Warhol scandal exercised the media, a new controversy erupted when Bailey's sleeve photograph for Alice Cooper's *Billion Dollar Baby* album (p. 59) was banned in the USA. The problem was not the uncomfortably made-up baby but the use of real dollar bills, which contravened an FBI ruling.

was the perfect vehicle for Bailey's pursuit of the exotic – a fusion of his lifelong fascination with Picasso's paintings of women, with tropical birds, and his childhood response to Walt Disney's animated characters. His burgeoning collection of primitive art was another manifestation of this interest. An early photograph he took of Marie in Australia has the colours of a super-charged parrot (Bailey was a keen psittacophile) and a Disney-esque element in the blow-up turtle. The first *Vogue* series that Bailey photographed on Marie was the Brazil story: 'It was embarrassing for Marie, because people asked how she enjoyed Brazil; in fact I had photographed all of the landscape background scenes there, but Marie modelled the clothes in a projection studio in London.'

Evening News

'Warhol' will shock viewers, claims commentator

COURT BATTLE

BAN TV SEX F

By T. H. JOHNSTON
TELEVISION commentator was

DON'T LET THIS HAPPEN, SAYS THE

WARHOL'S GALLERY

The pictures that you

THESE are the people from the weird and wonderful world of blue-movie maker Andy Warhol. They are the stars of the underground

IBA chiefs rapped— they haven't seen Andy Warhol documentary

JUDGES HALT
TV SEX FILM

SUCK THIS AND SEE
...IF THAT

Night Special

film before any action

HE TIMES

Court of Appeal bans TV screening

WHY YOU DIDN'T SEE IT

Appeal

By FRANK GOLDSWORTHY and JAMES THOMAS

d intervention out the kinky

THE Sun

FORWARD WITH THE PEOPLE by Wednesday, January 17, 1973

FURY AT BAN ON SEX SHOW

By BRIAN WESLEY and IAIN WALKER

THOUSANDS of TV viewers reacted bitterly last

This man Warhol

DAILY EXPRESS

No. 22,573 WEDNESDAY JANUARY 17 1973 Weather: Some rain or sleet Price 3p

'HE GUARDIAN

Wednesday January 17 1973 5p

**The book containing
the David Bailey interviews
and photographs**

WARHOL

DAVID BAILEY TV INTERVIEWS

£1·75

**Mathews Miller Dunbar-
Bailey Litchfield co-production**
18 Endell Street
London WC2H 9BD

Warhol film banned —and IBA slated

By PETER HARVEY

The Court of Appeal last night forbade the Independent Broadcasting Authority to allow ITV channels to screen a film about Andy Warhol, the pop artist director.

TV shocker or one big bore?

CHRISTOPHER FORD contrasts some press views of Warhol before and after the Appeal Court's ban

Daily Mirror

EUROPE'S BIGGEST DAILY SALE
Wednesday, January 17, 1973 No. 21,463

JUDGES
TV SHOCKER

Daily Tel

WEDNESDAY, JANUARY 17, 1973.

Pop art message misfires

By RICHARD LAST
TV Staff

HAD "Warhol" been shown on ITV last night as planned, my sympathies would have been with anyone who watched it to the bitter end.

A Associated Television's controversial documentary "Warhol" was banned by the Appeal Court last night. The ban came four

'ffensive' TV film not checked

By SEAN DAY-LEWIS, TV and Radio Correspondent

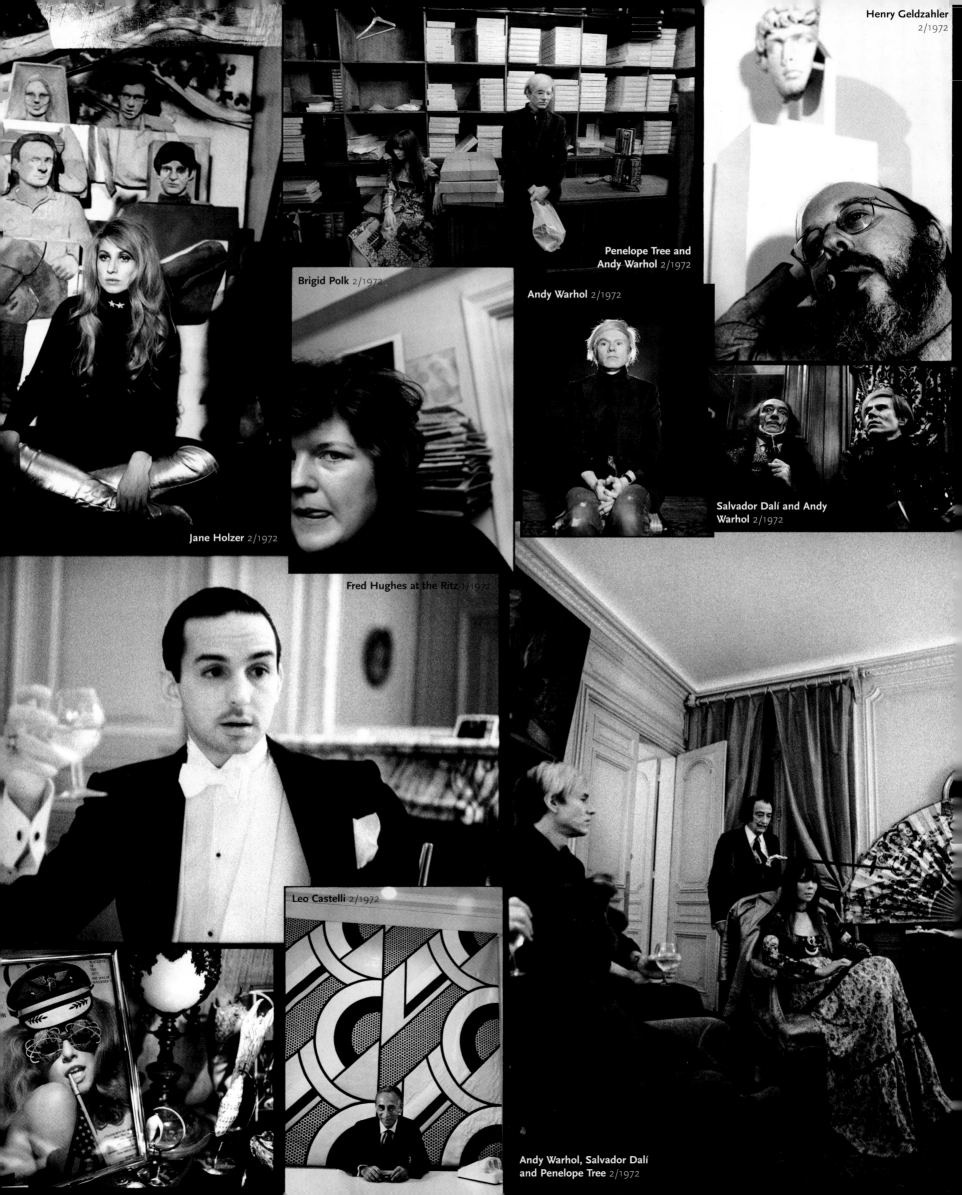

Henry Geldzahler 2/1972

Penelope Tree and Andy Warhol 2/1972

Andy Warhol 2/1972

Brigid Polk 2/1972

Salvador Dalí and Andy Warhol 2/1972

Jane Holzer 2/1972

Fred Hughes at the Ritz 1/1972

Leo Castelli 2/1972

Andy Warhol, Salvador Dalí and Penelope Tree 2/1972

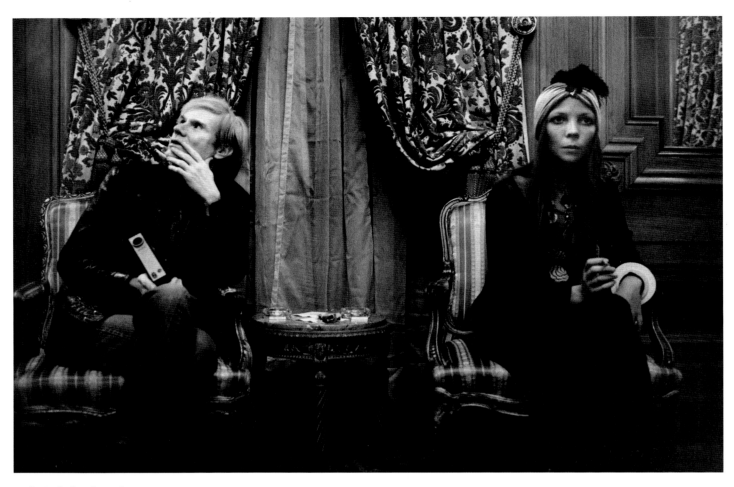

Andy Warhol and Penelope Tree 2/1972

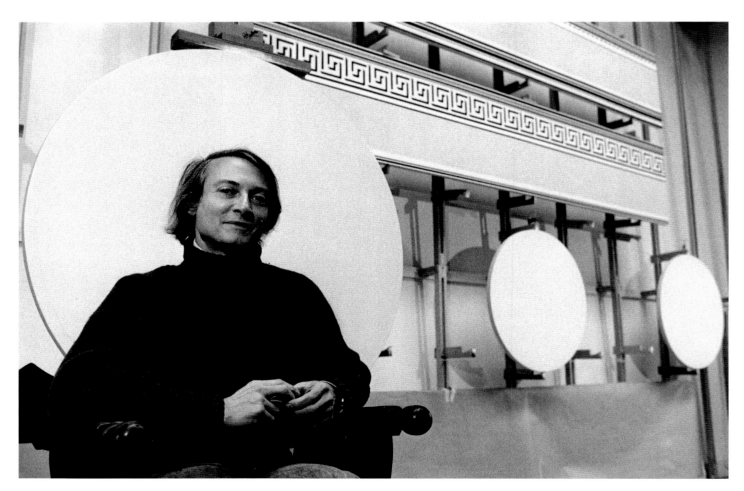

Roy Lichtenstein 2/1972

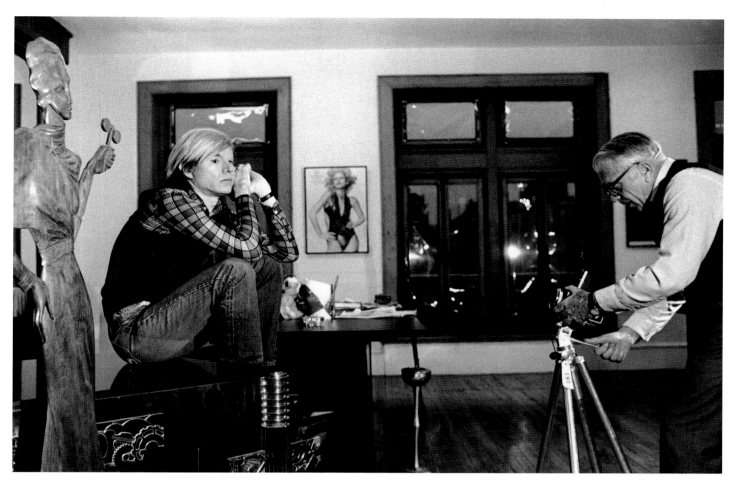

Horst photographing Andy Warhol 2/1972

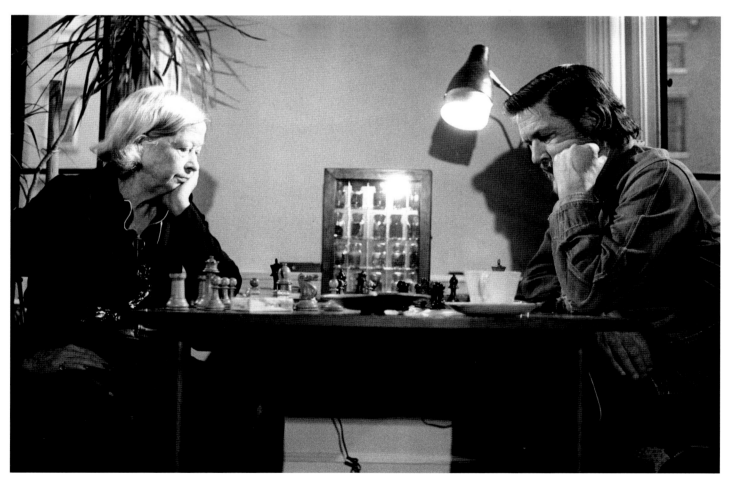

Madame Duchamp and John Cage playing chess 2/1972

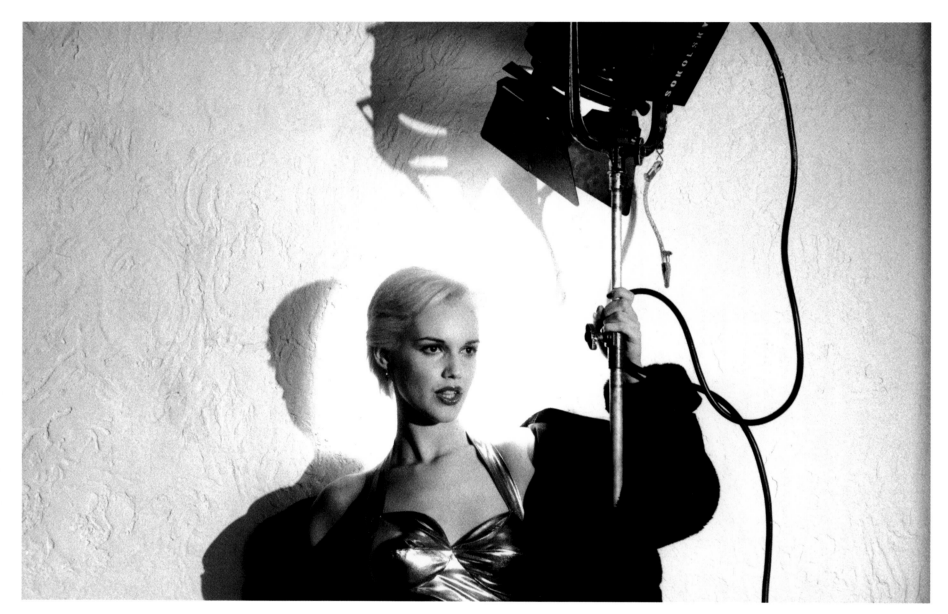

Candy Darling 2/1972

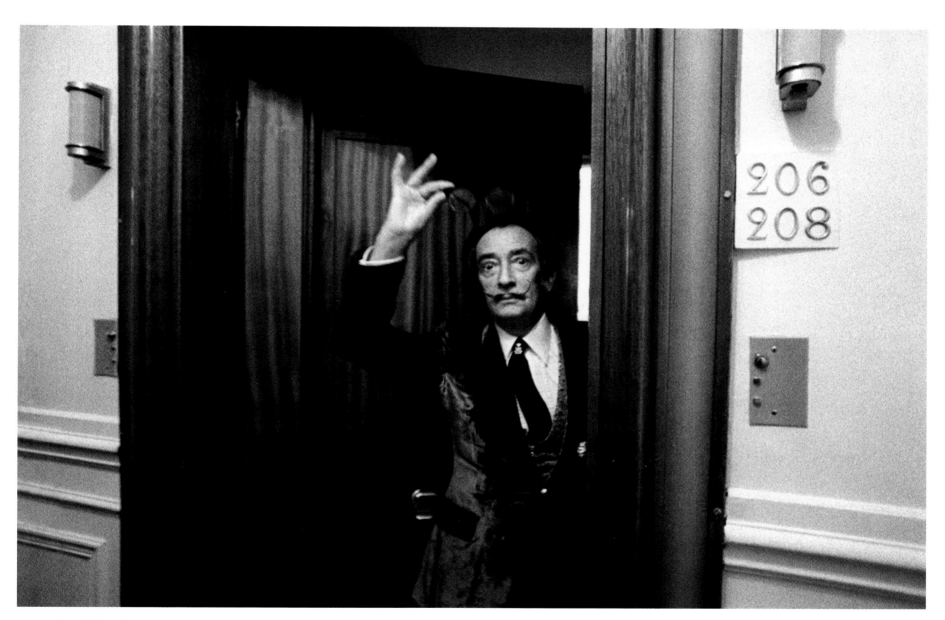

New York: Salvador Dalí 2/1972

Andy Warhol 2/1972

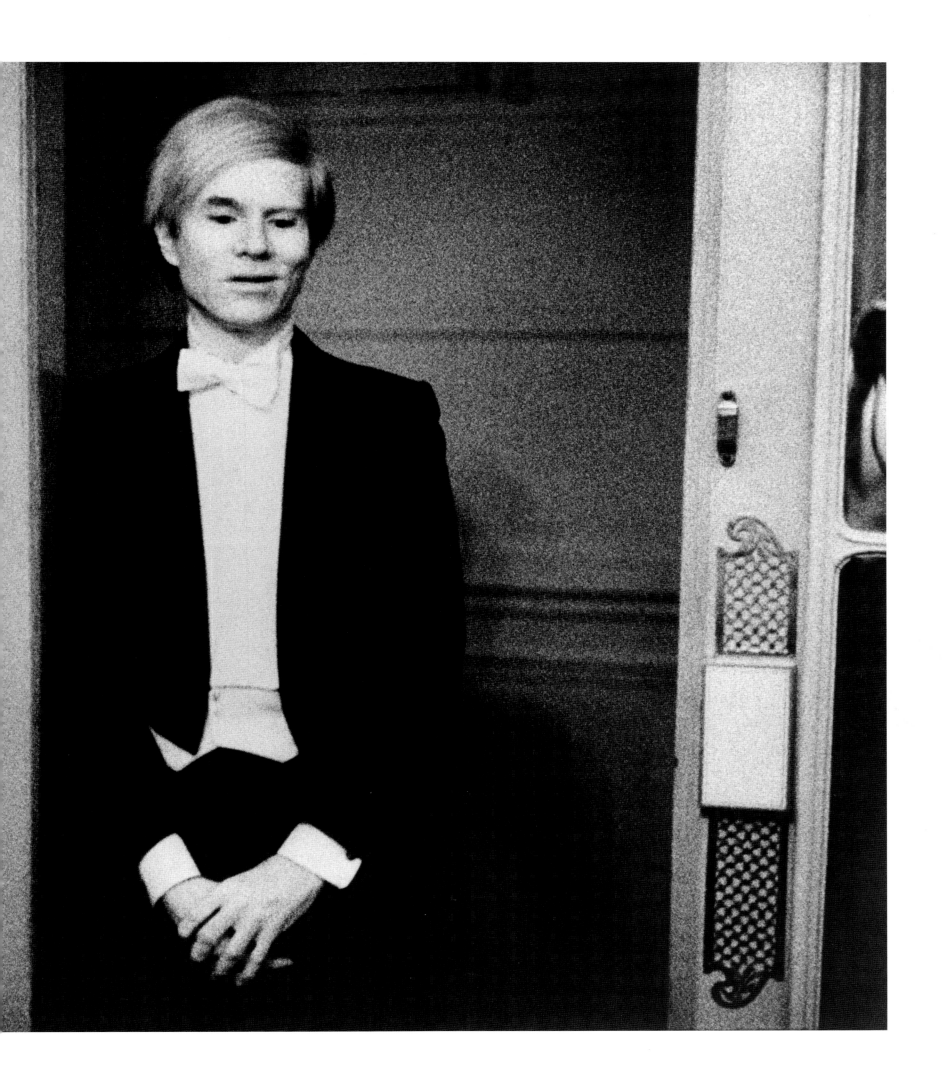

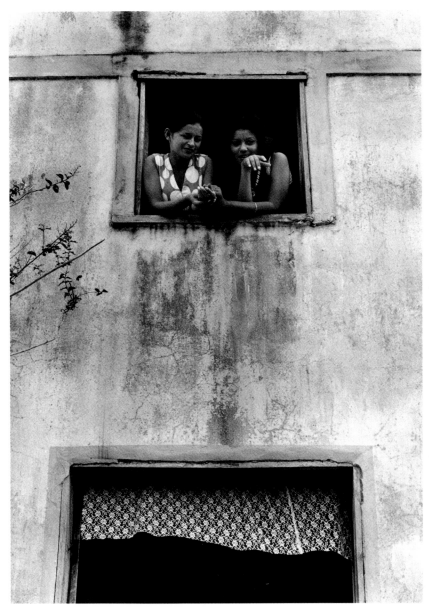

Brazil 1/1974

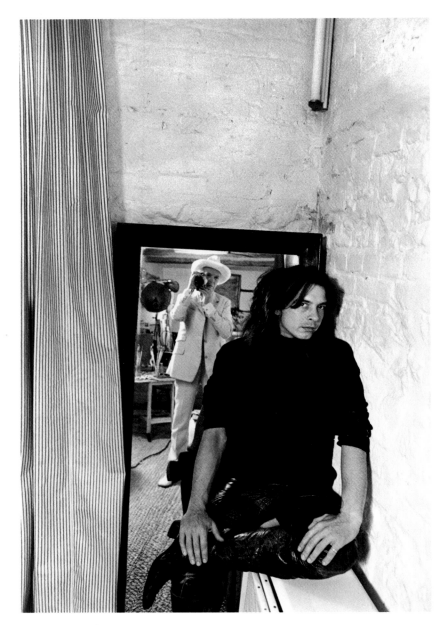

Cecil Beaton and David Bailey (photographed by Beaton) 10/1970

When Bailey was serving in the Royal Air Force in 1957, it was Henri Cartier-Bresson's robed women, *Srinagar, Kashmir* (1948), that most inspired him to take up photography. Cartier-Bresson's work remained a touchstone for Bailey, and was perhaps in the back of his mind when he photographed these Brazilian women, redolent in their windowed framing of the French photographer's *Calle Cuauhtemoctzin, Mexico City, 1934*.

Beaton's 'Self-Portrait with Friend' reprises a *Vogue* feature of 1963, in which these doyens of two generations of *Vogue* photographers paid tribute to one another. Beaton remarked in *The Magic Image* (1975) that Bailey, a 'dark Raeburnesque boy with lots of picturesque gear and an eye for beautiful young girls', had 'stood the test of time', but he also warned against the 'distracting diversions' of film and television.

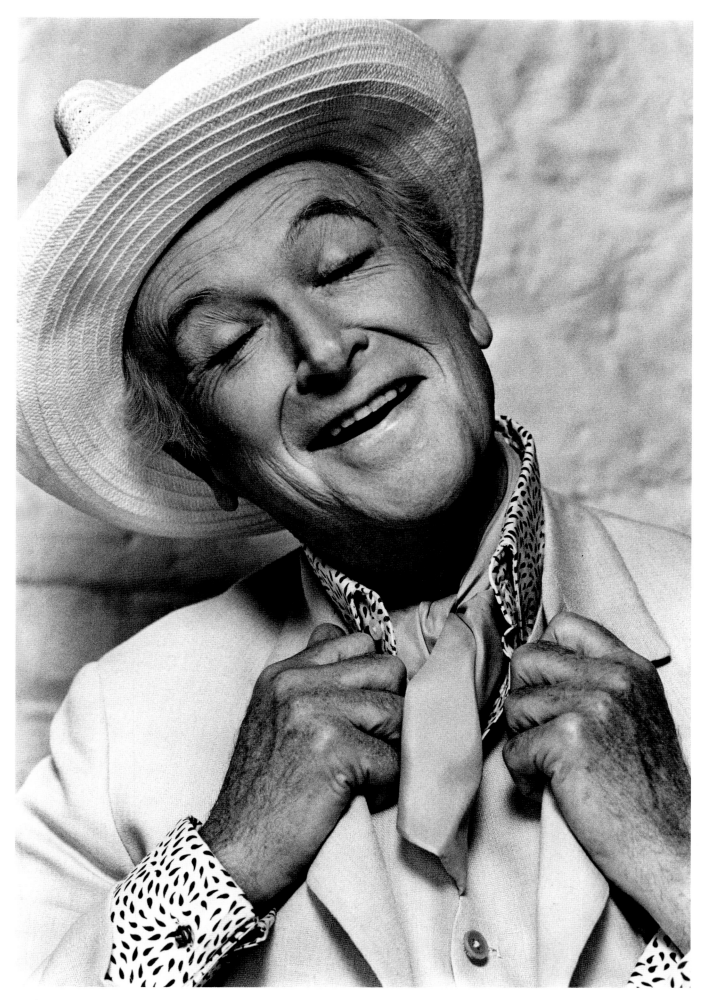

Cecil Beaton 10/1970

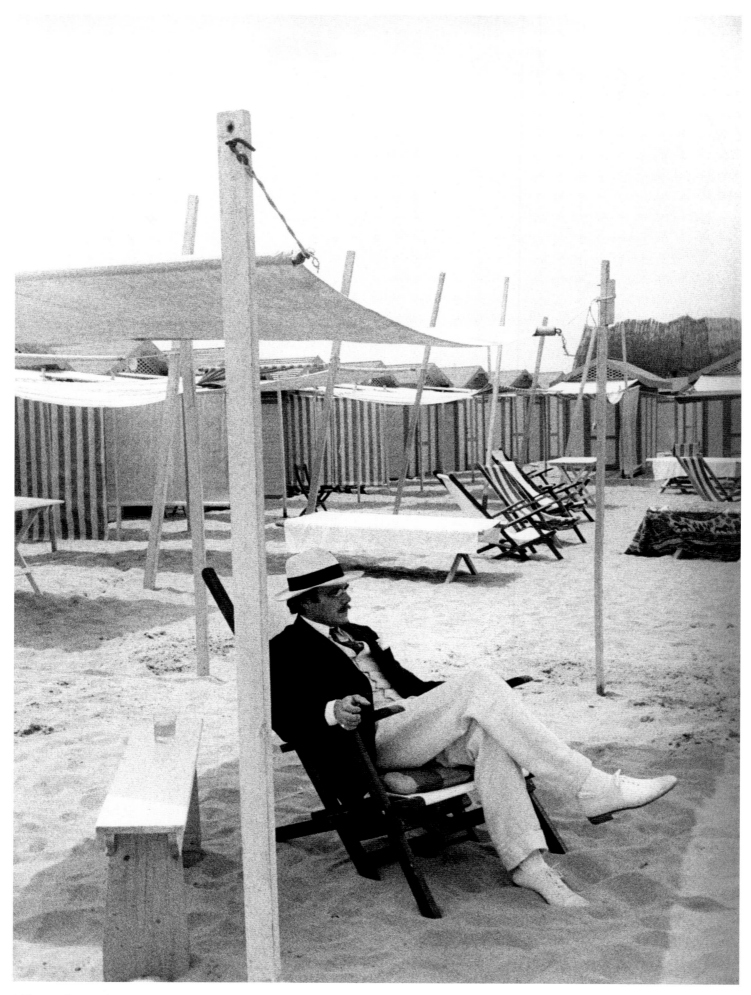

Dirk Bogarde (*Death in Venice*) *Vogue* September 1st 1970

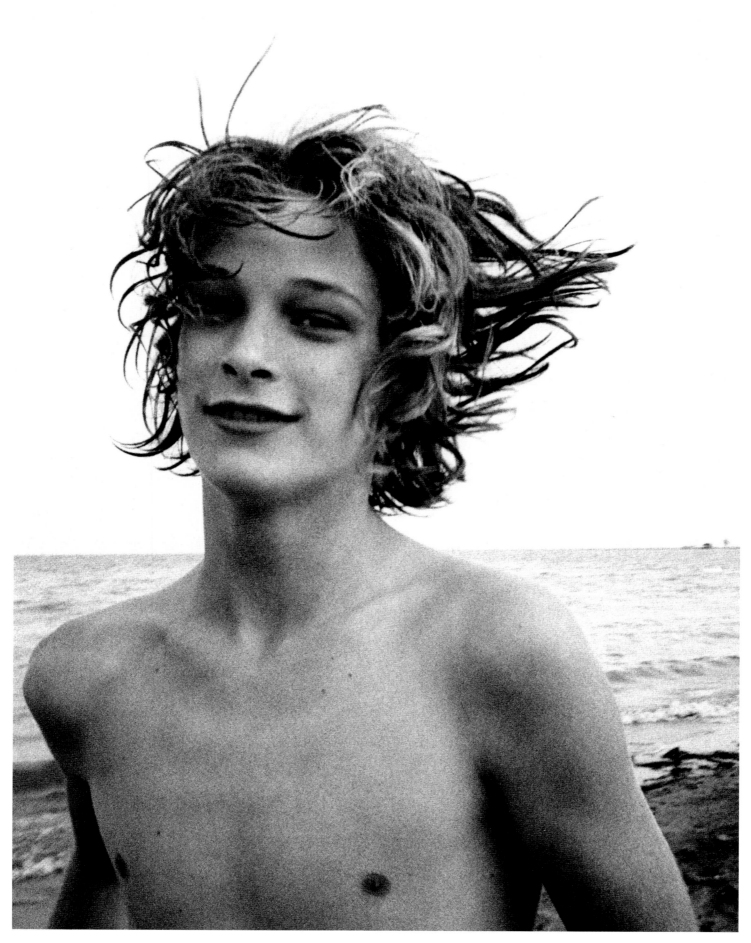

Bjorn Andresen (*Death in Venice*) *Vogue* September 1st 1970

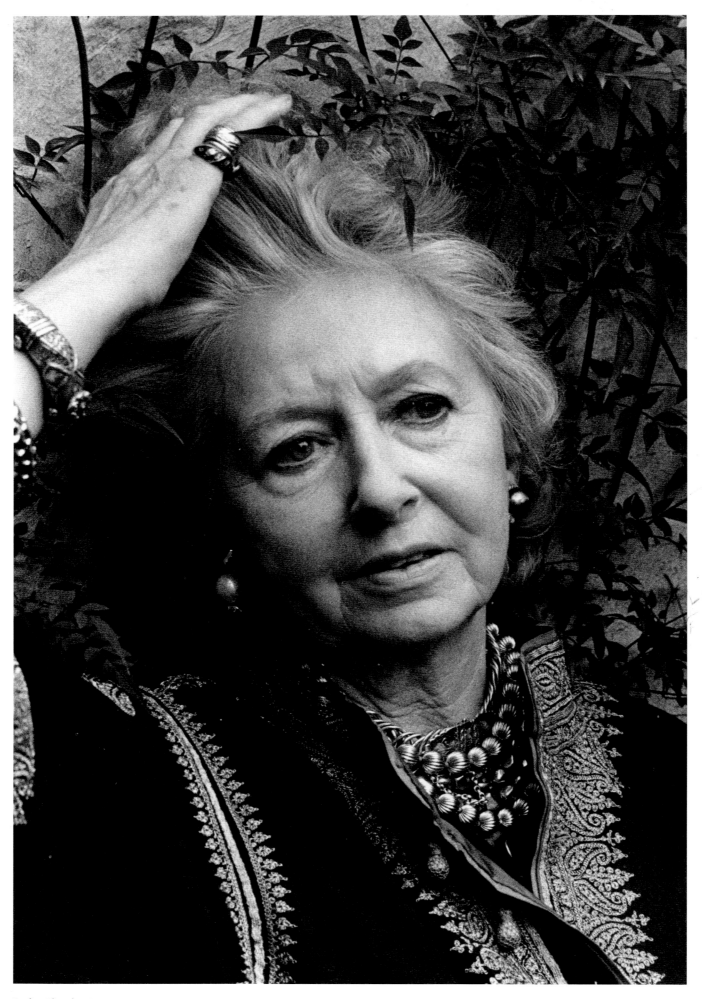

Lesley Blanch 9/1970

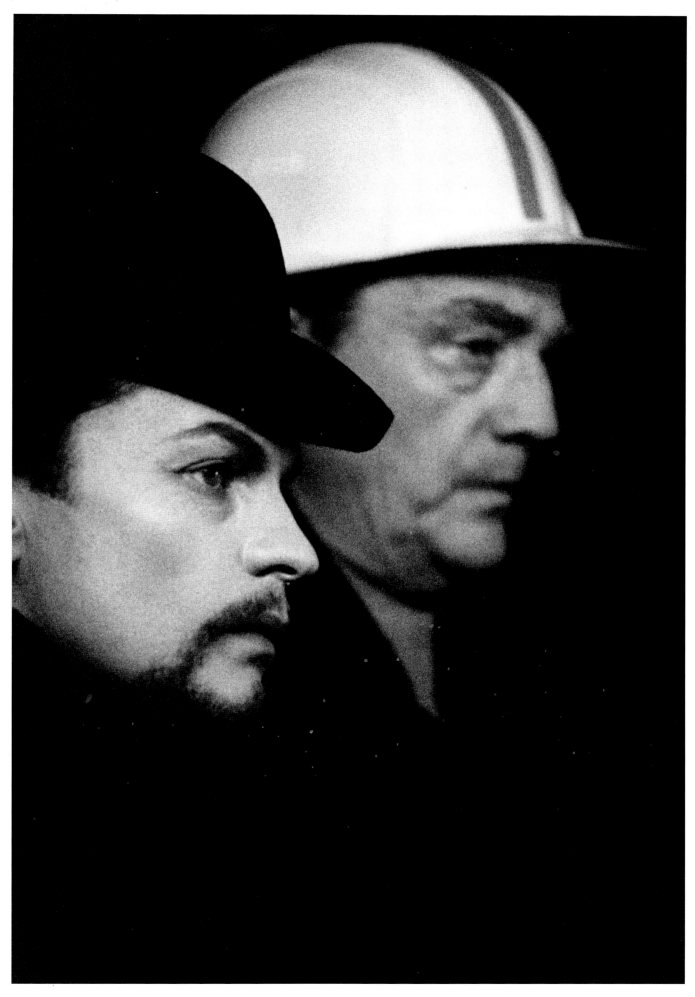

Helmut Berger and Luchino Visconti 2/1972

Ranee of Sarawak *Vogue* March 1st 1970

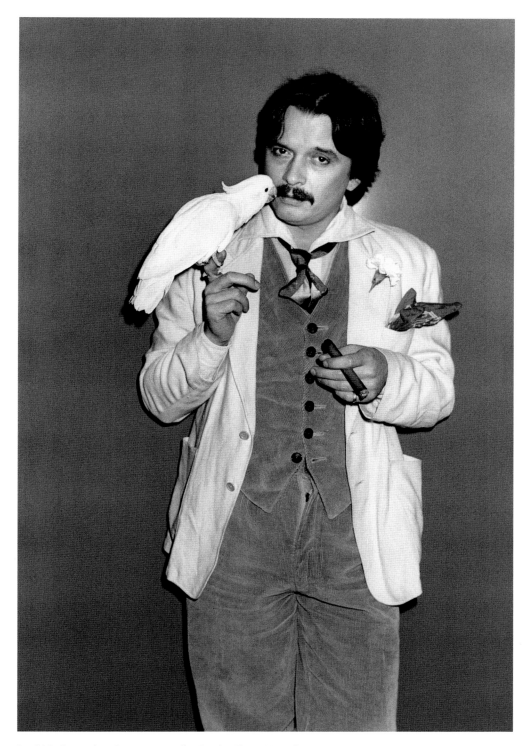

David Bailey and cockatoo 2/1975 (for *Sunday Times Magazine*)

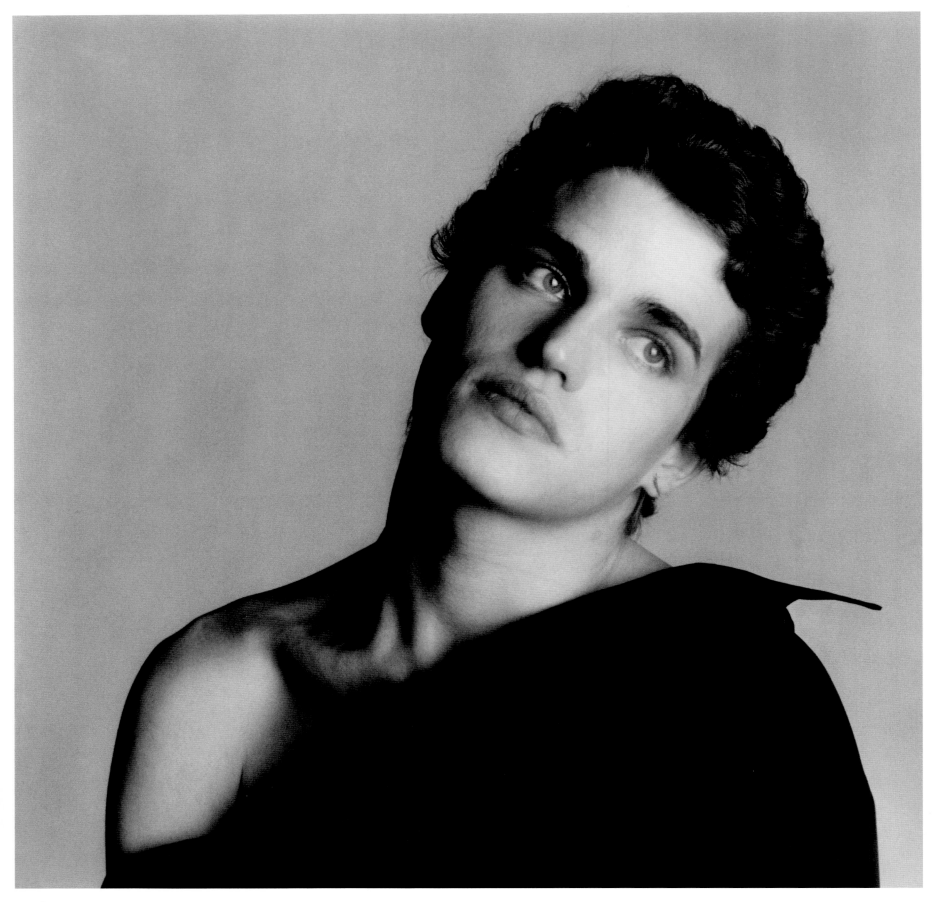

Jay Johnson 3/1972

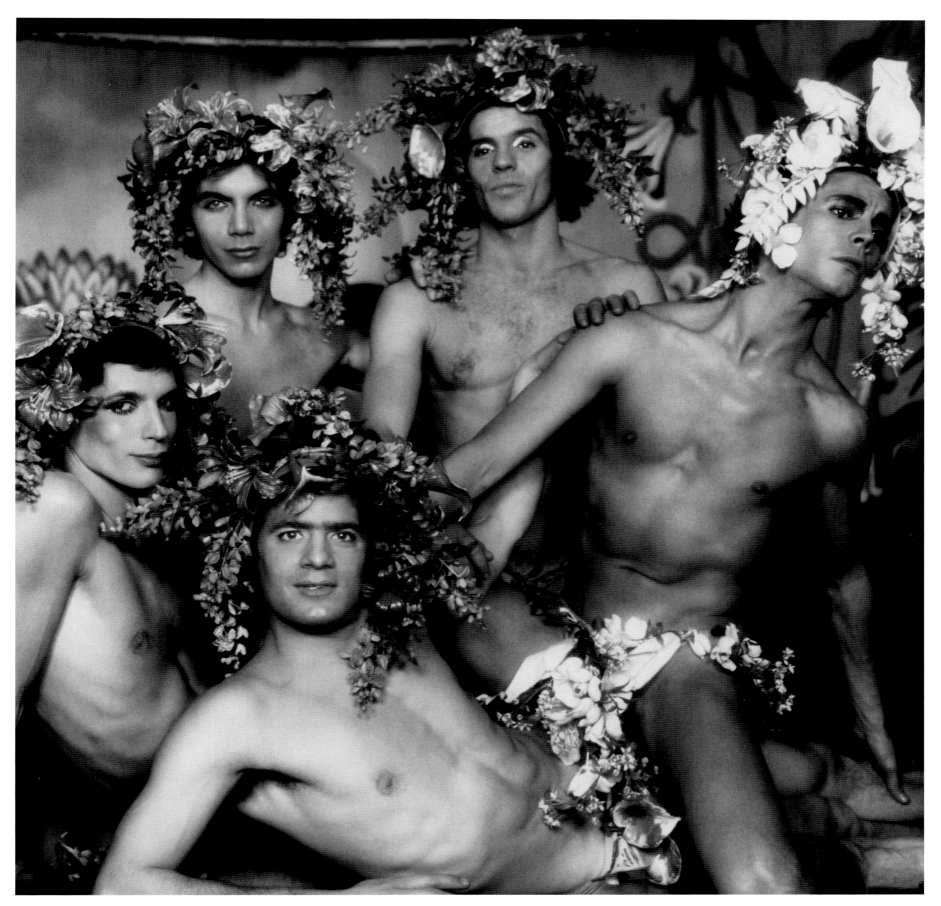

Paris: *La Grande Eugène* *Sunday Times Magazine* April 8th 1973

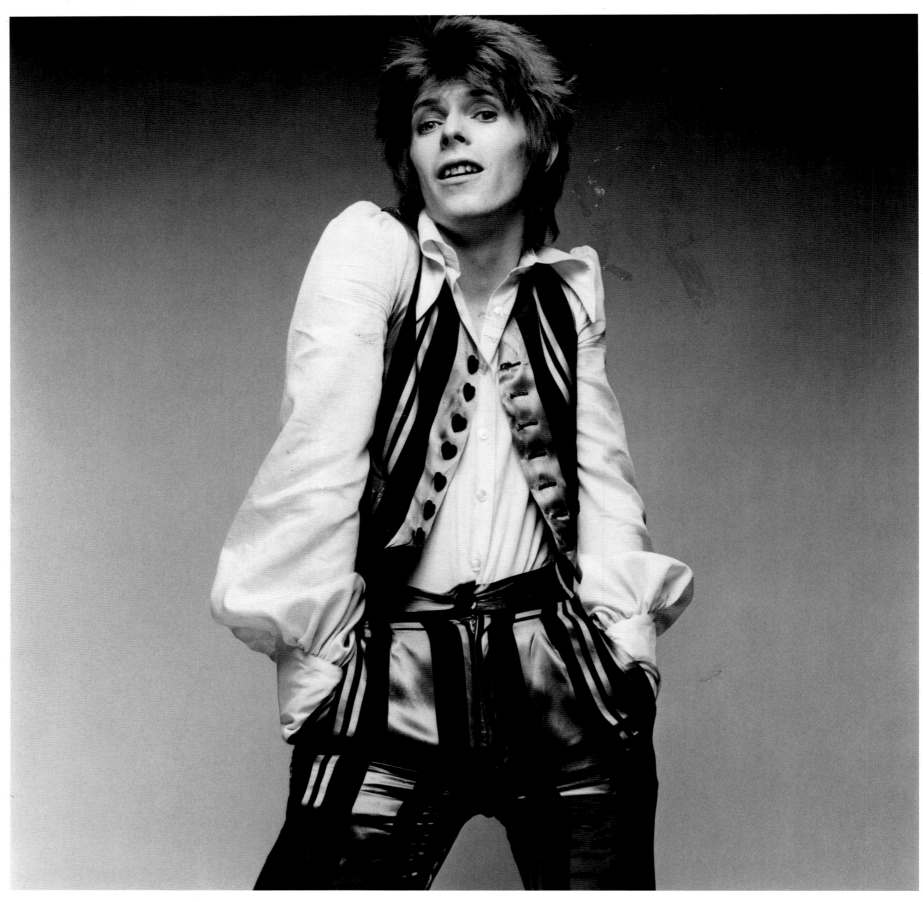

David Bowie 7/1972

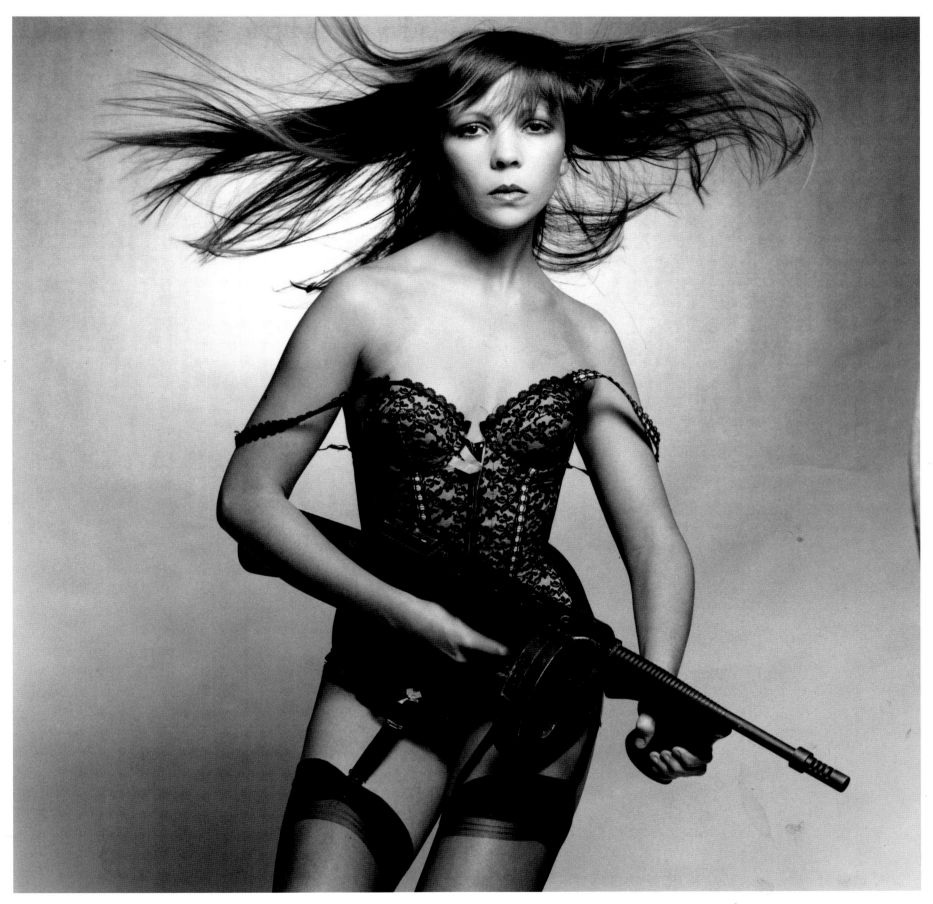

Penelope Tree 10/1970 (photographed as the basis for a screenprint made by Patrick Procktor)

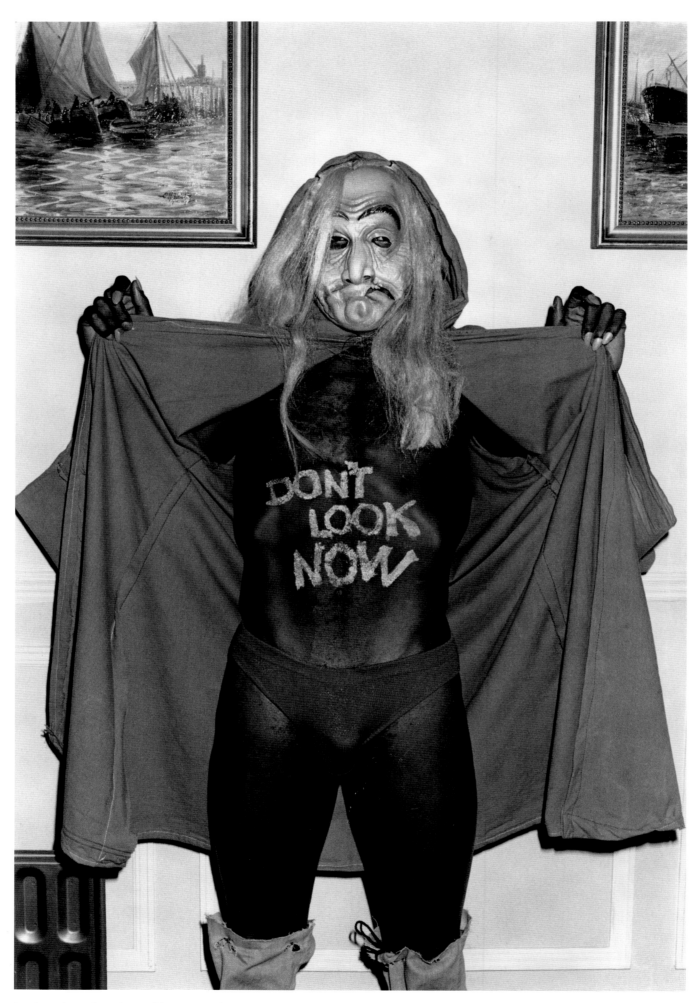

London: Alternative Miss World, 'Don't Look Now' 12/1973

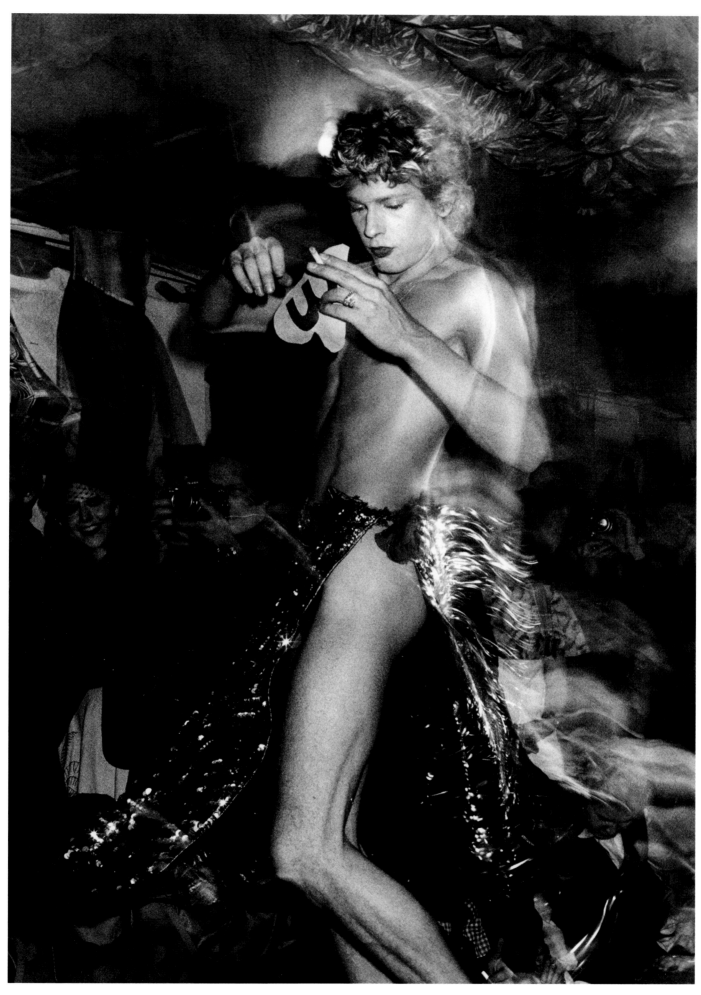

London: Alternative Miss World, 'Miss Holland Park Walk' 12/1973

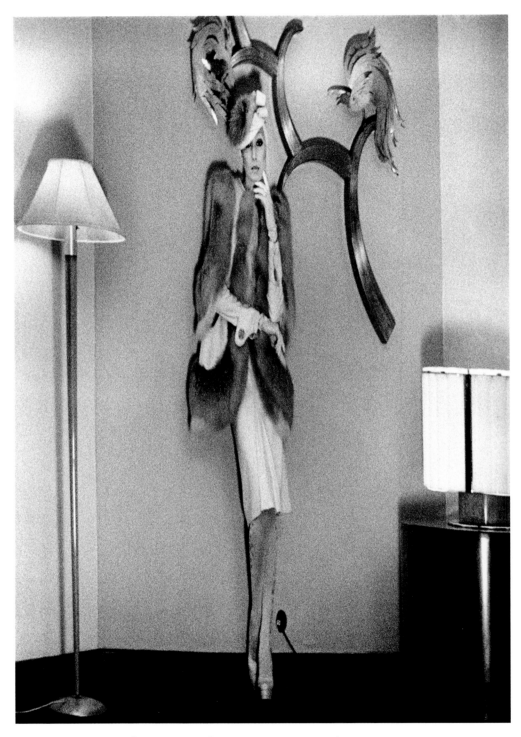

London: Savoy Hotel Parlour Room (Anjelica Huston) *Vogue* September 1st 1973

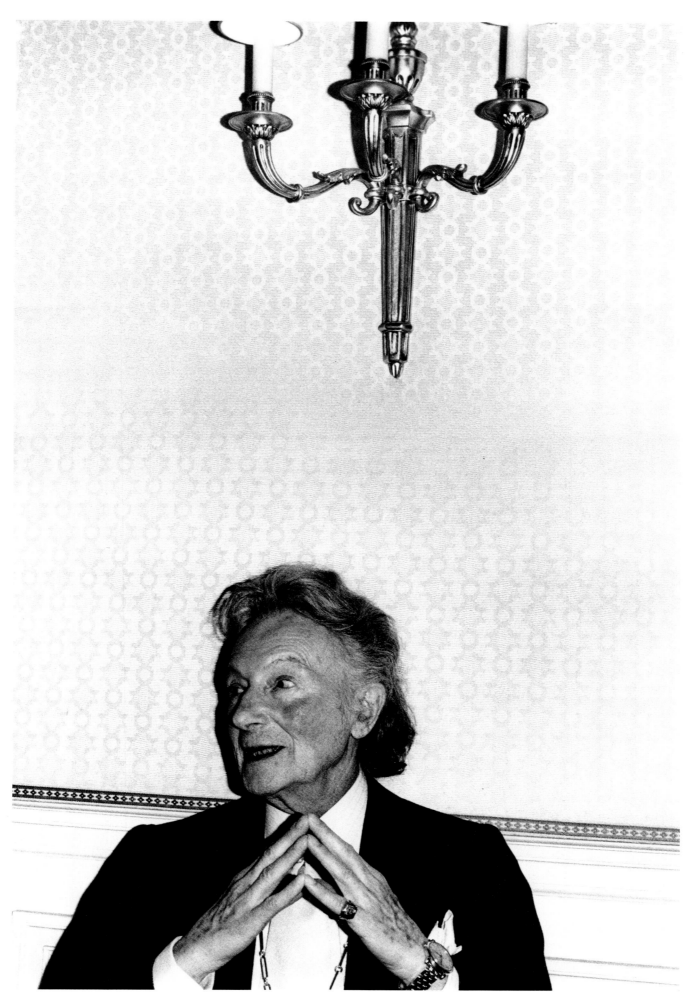

Paris: Erté 5/1973

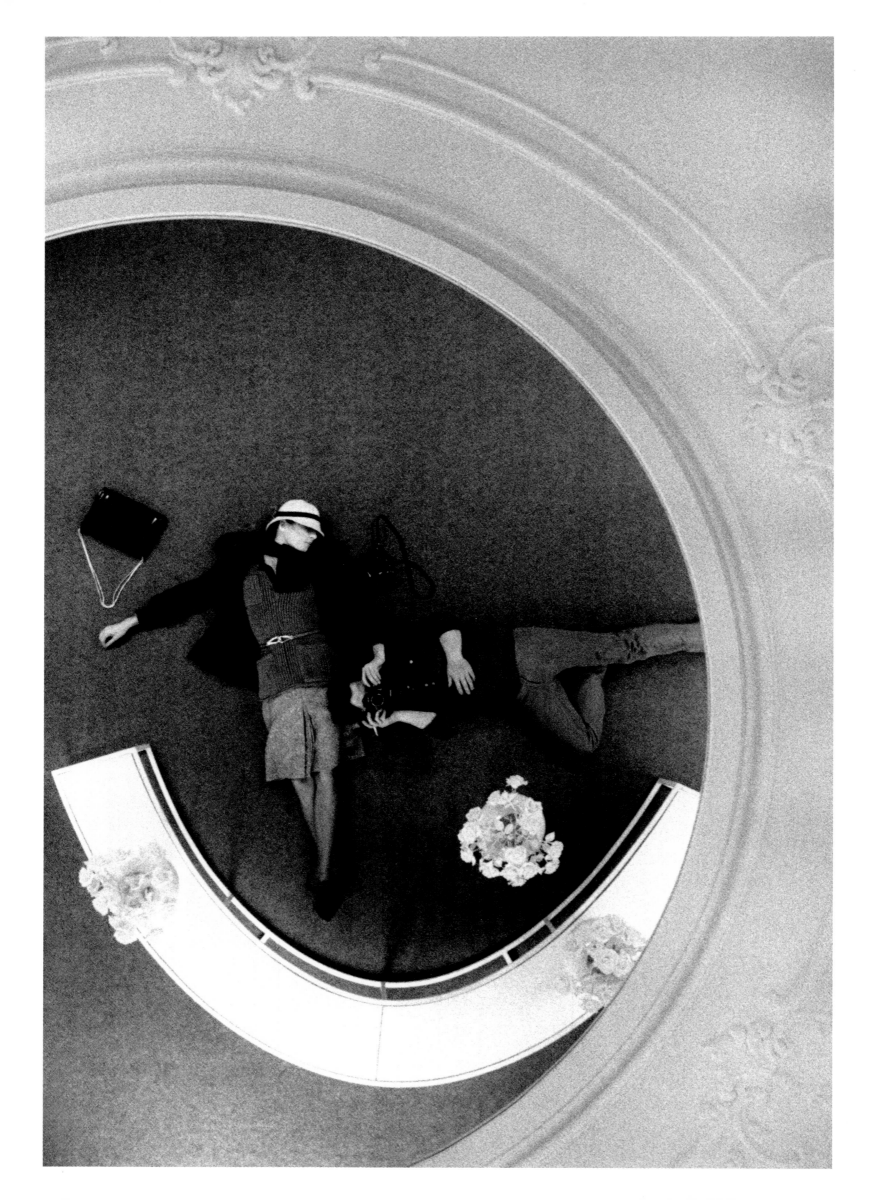

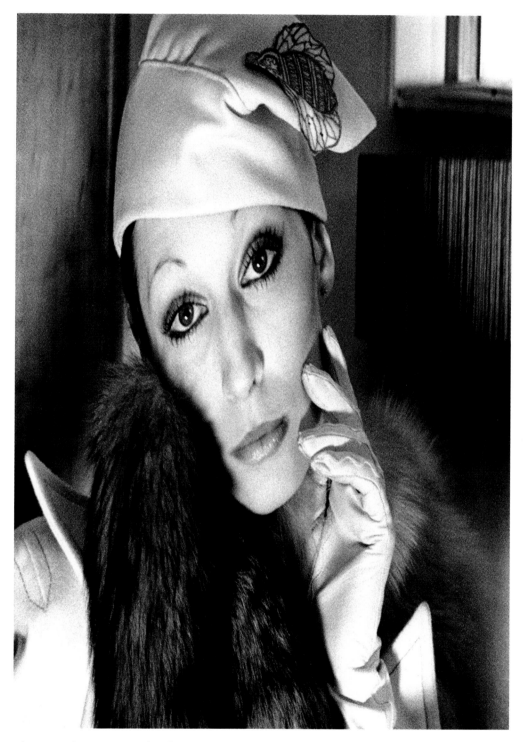

(above) **London: Savoy Hotel Parlour Room (Anjelica Huston)** *Vogue* September 1st 1973

(opposite) **London: Albini's showroom (David Bailey and Anjelica Huston)**
Vogue September 1st 1973 (variant published)

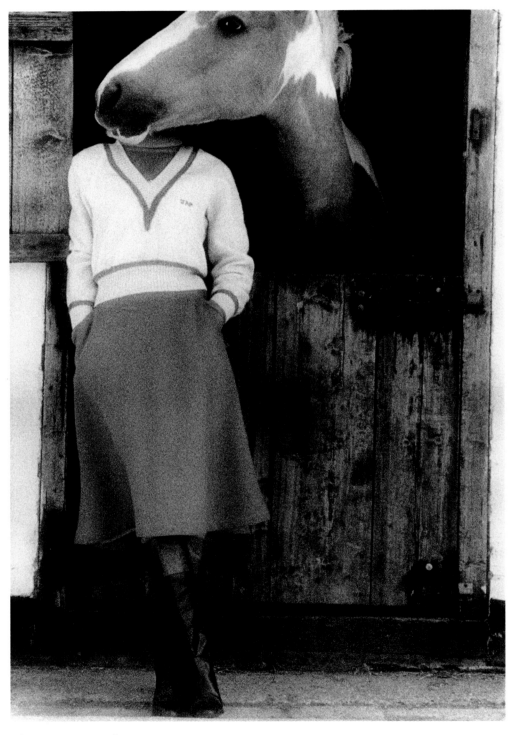

(above) *Vogue* September 1st 1973

(opposite) *Vogue* January 1975

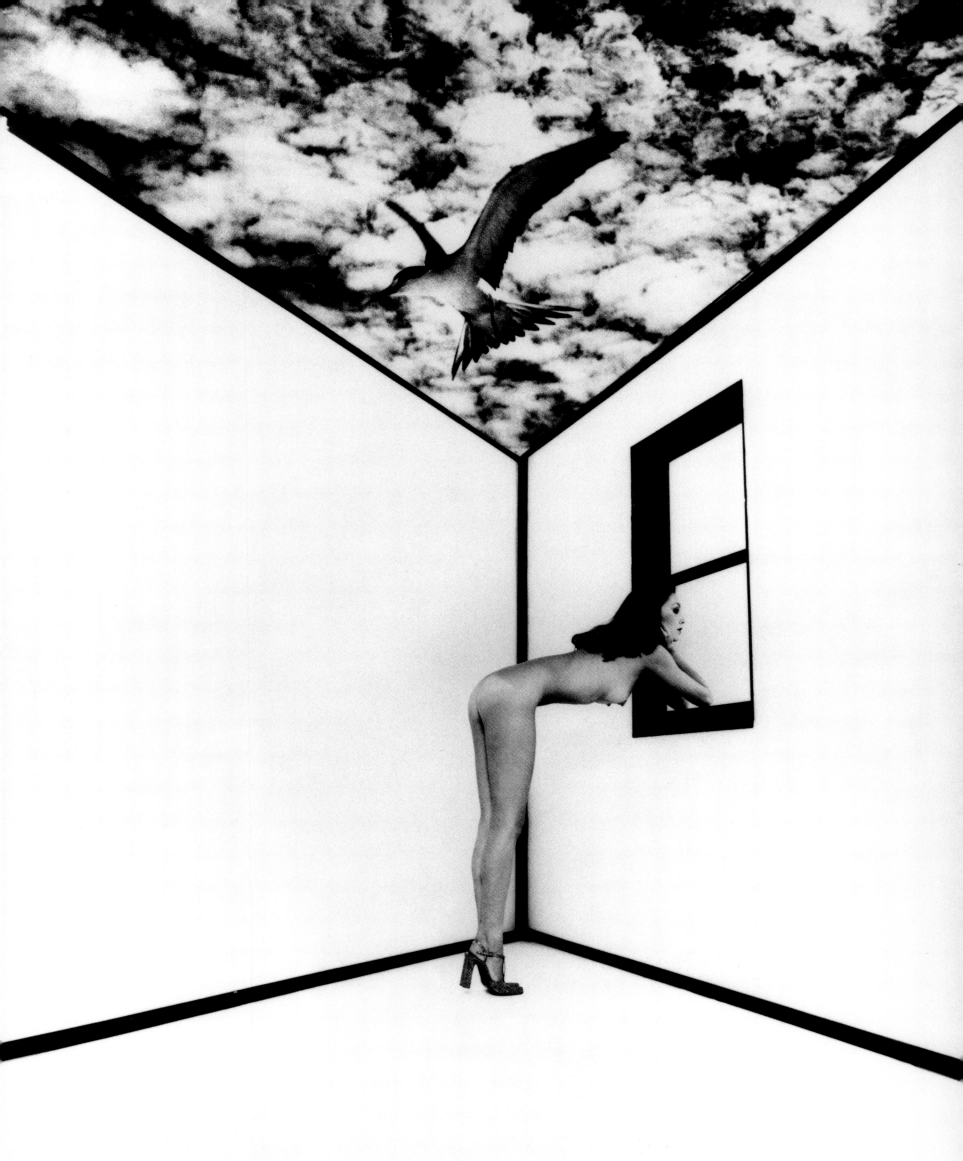

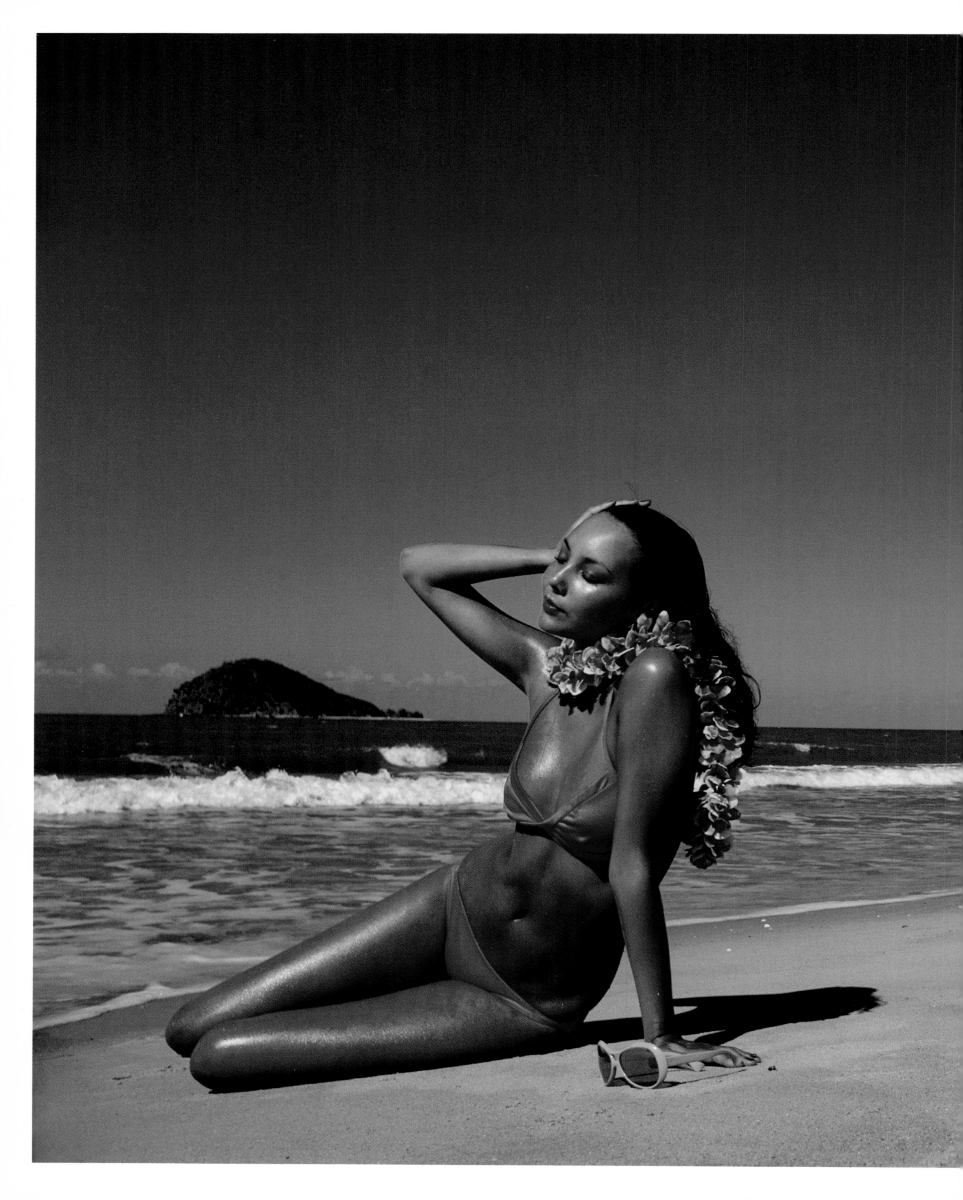

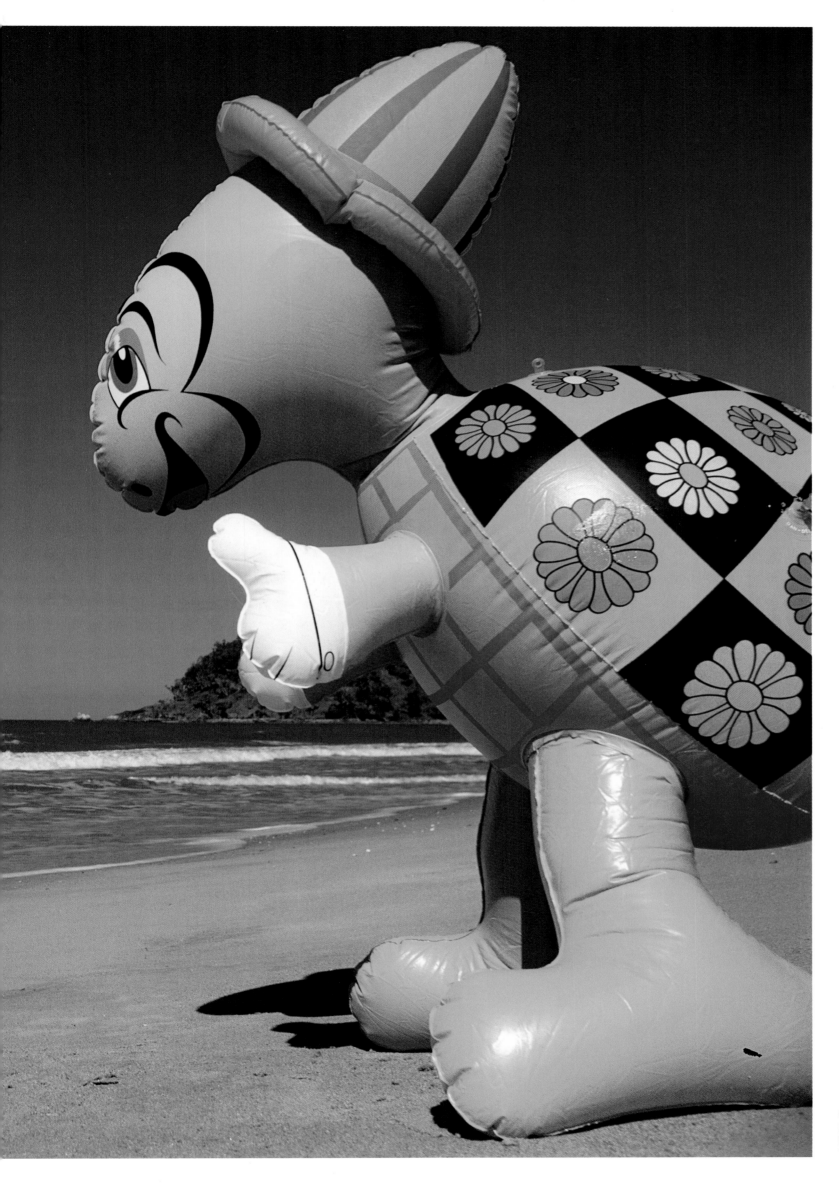

Queensland:
(Marie Helvin and
inflatable turtle)
Vogue January 1975

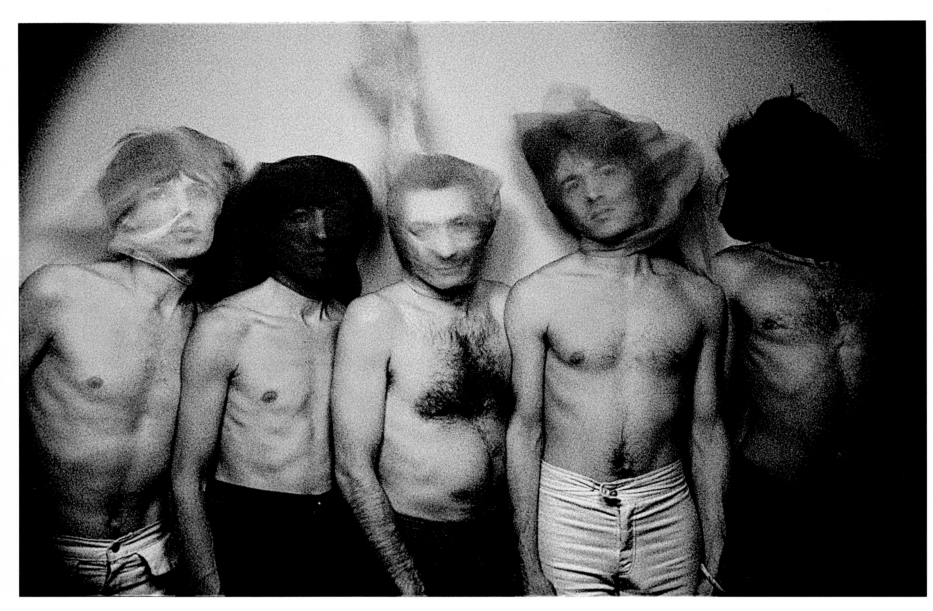

(above) **Rolling Stones (sleeve photograph for *Goat's Head Soup* album)** 1973

(opposite) **Mick Jagger (sleeve photograph for *Goat's Head Soup* album)** 1973

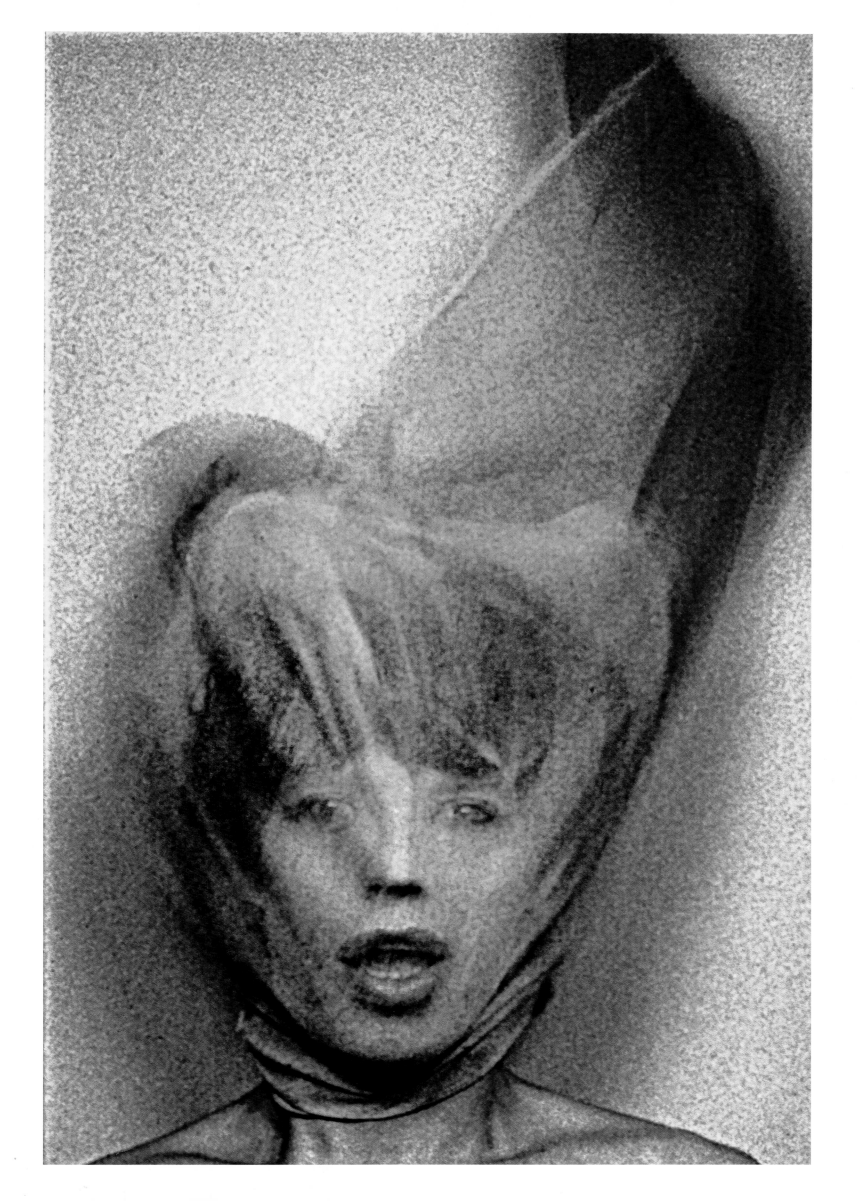

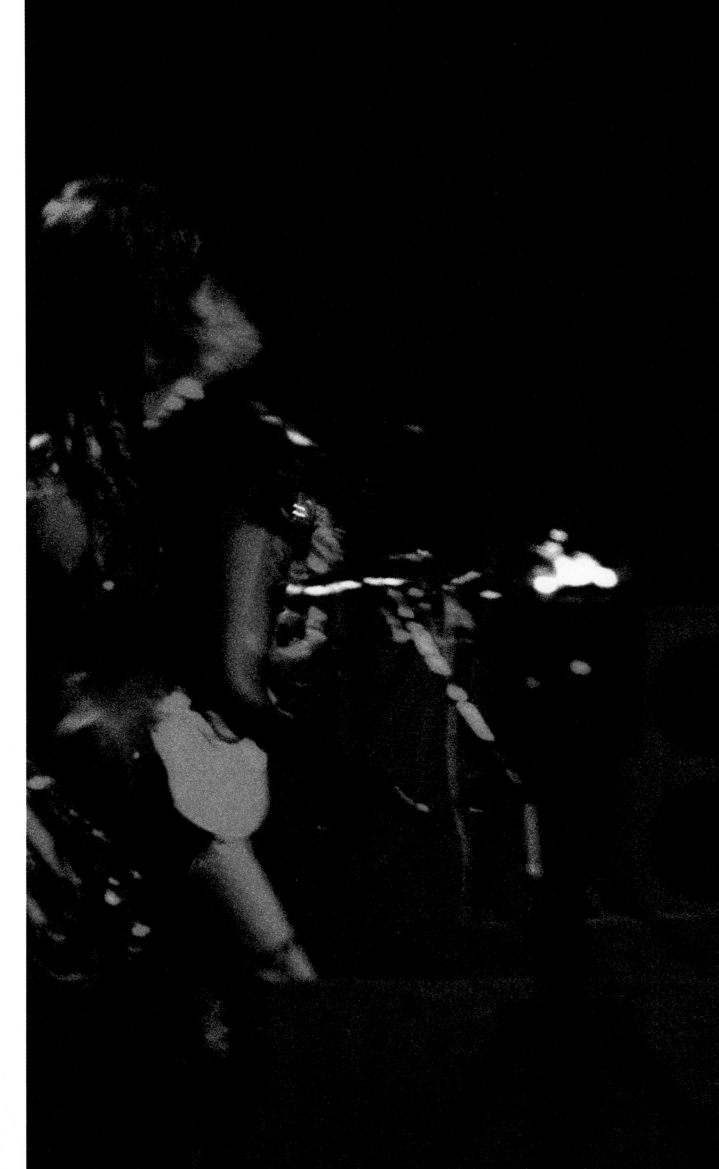

(this spread and following pages)
**Rolling Stones in concert,
Wembley** 9/1973

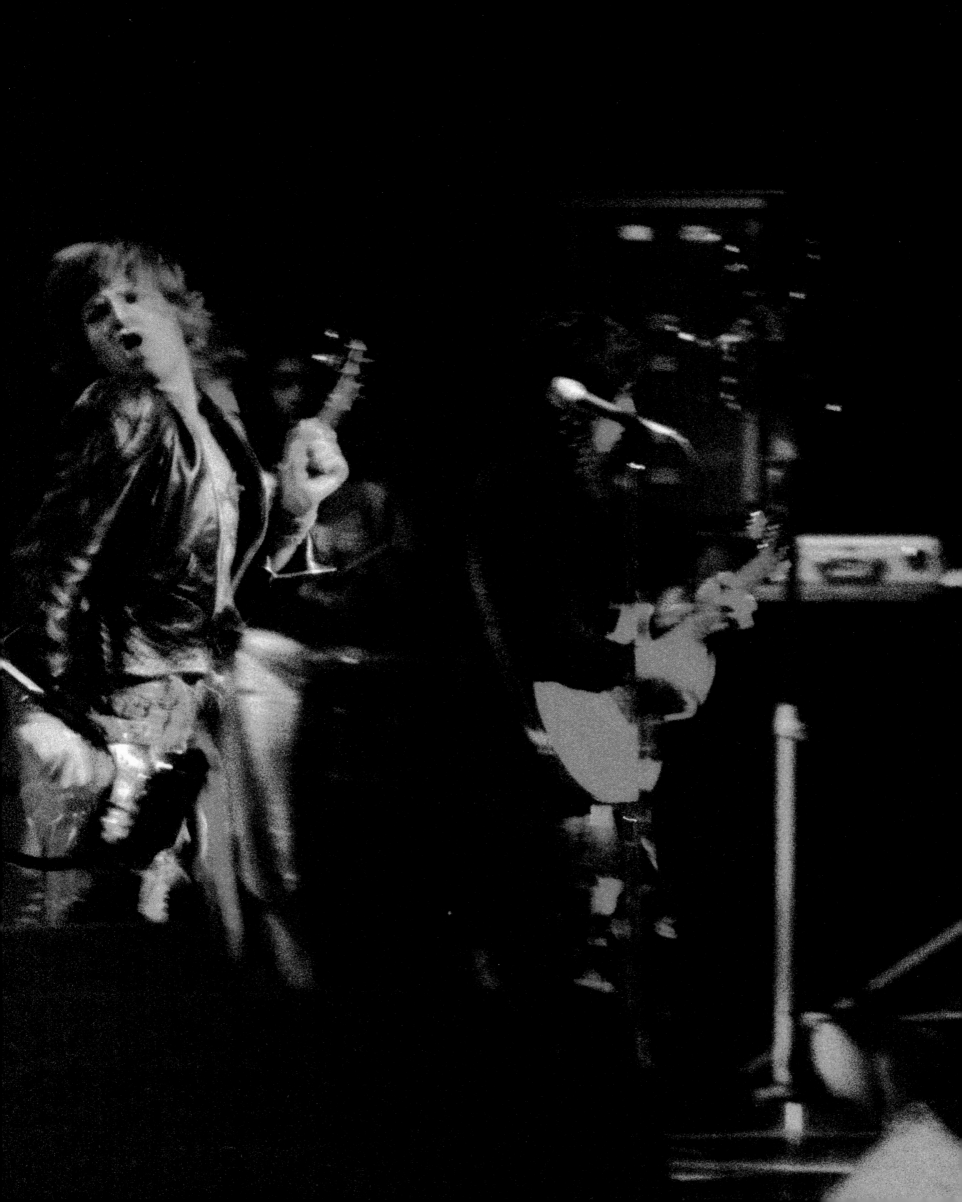

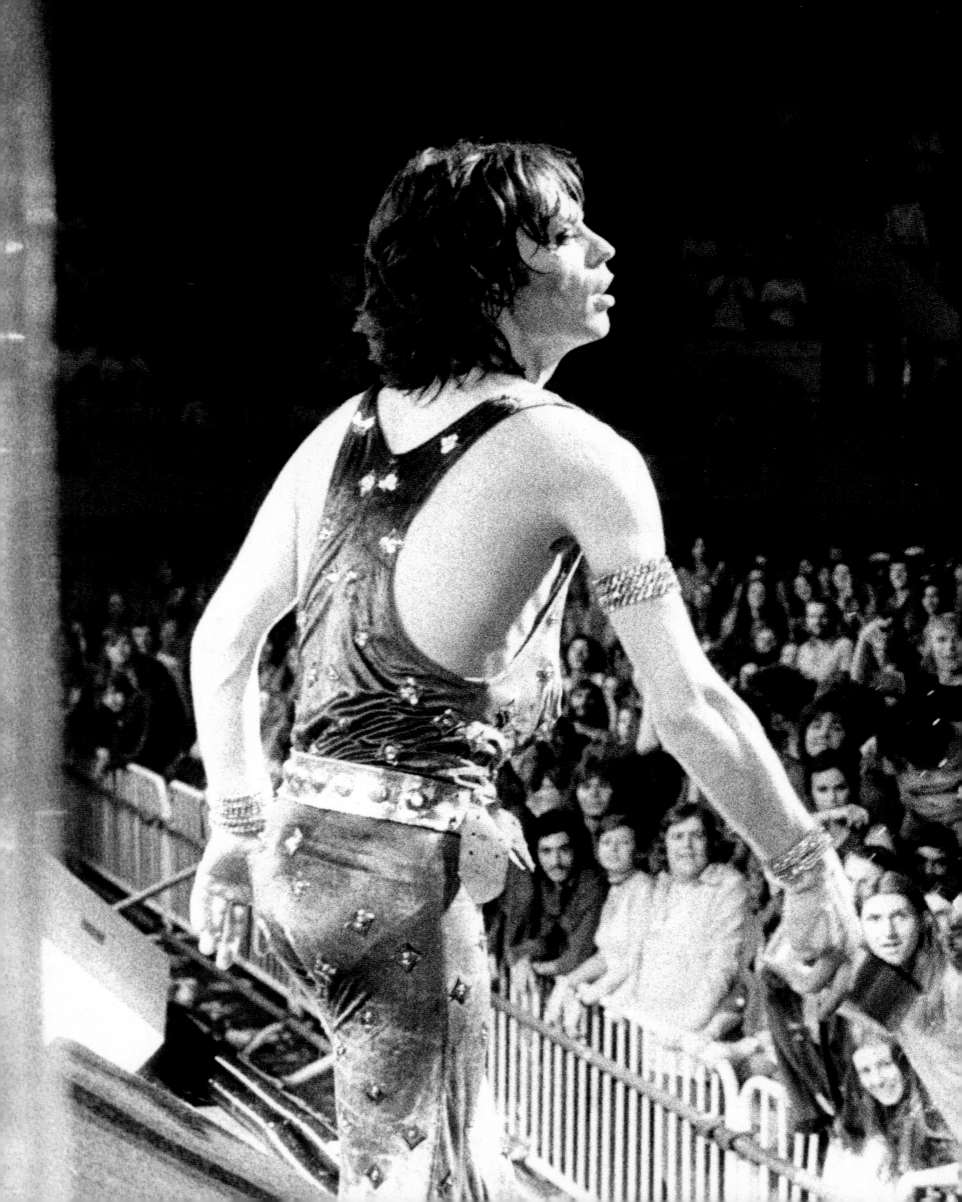

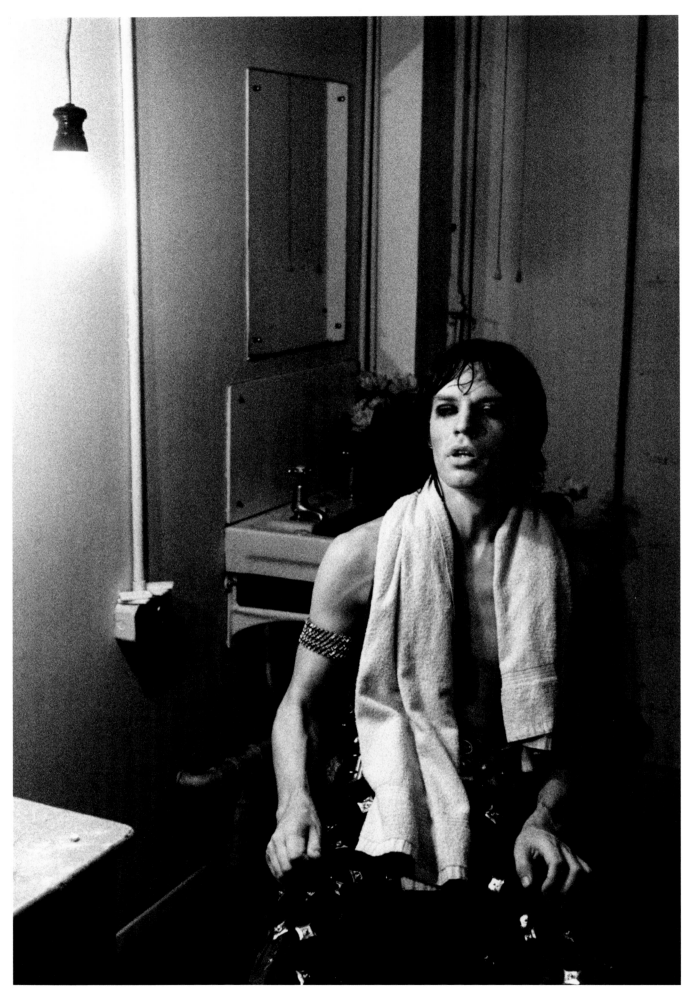

Mick Jagger 9/1973

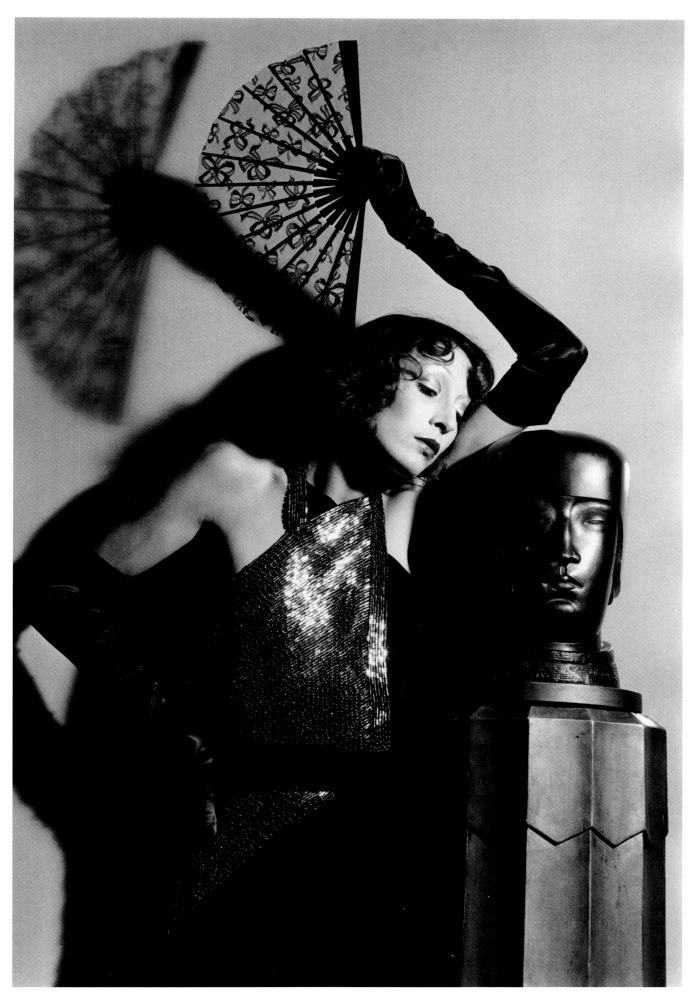

Paris: in Karl Lagerfeld's apartment (Anjelica Huston) *Vogue* September 1st 1973 (colour image published)

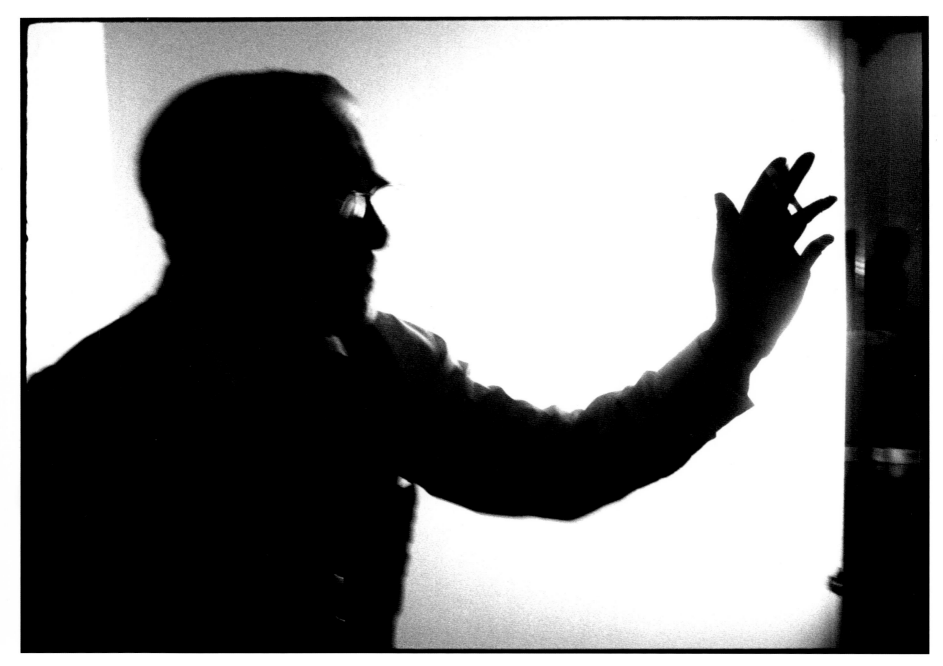

Horst 2/1972

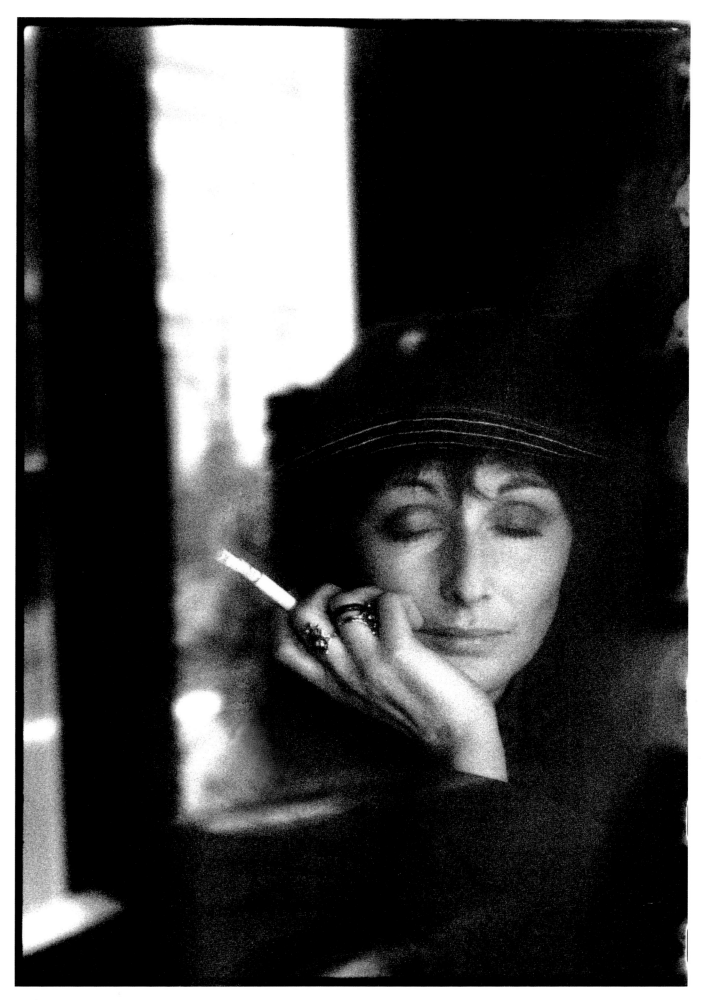

Sarah Moon 9/1972

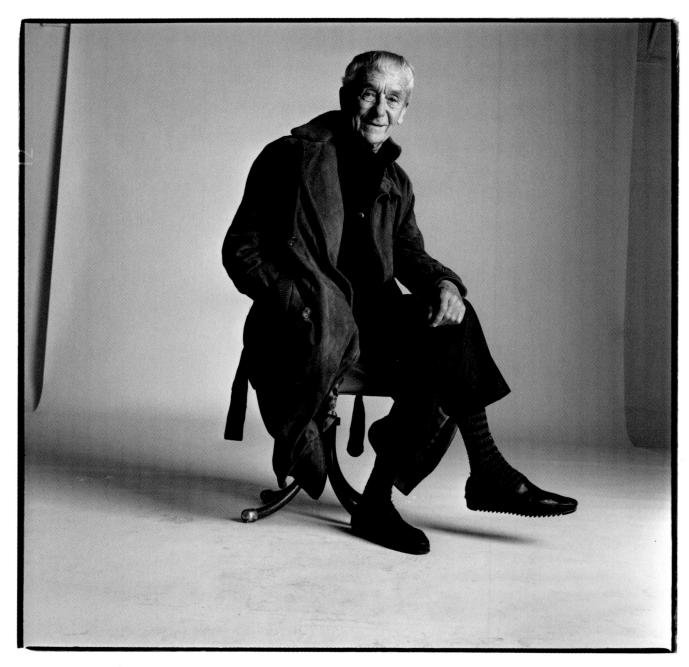

Paris: Jacques-Henri Lartigue 12/1970

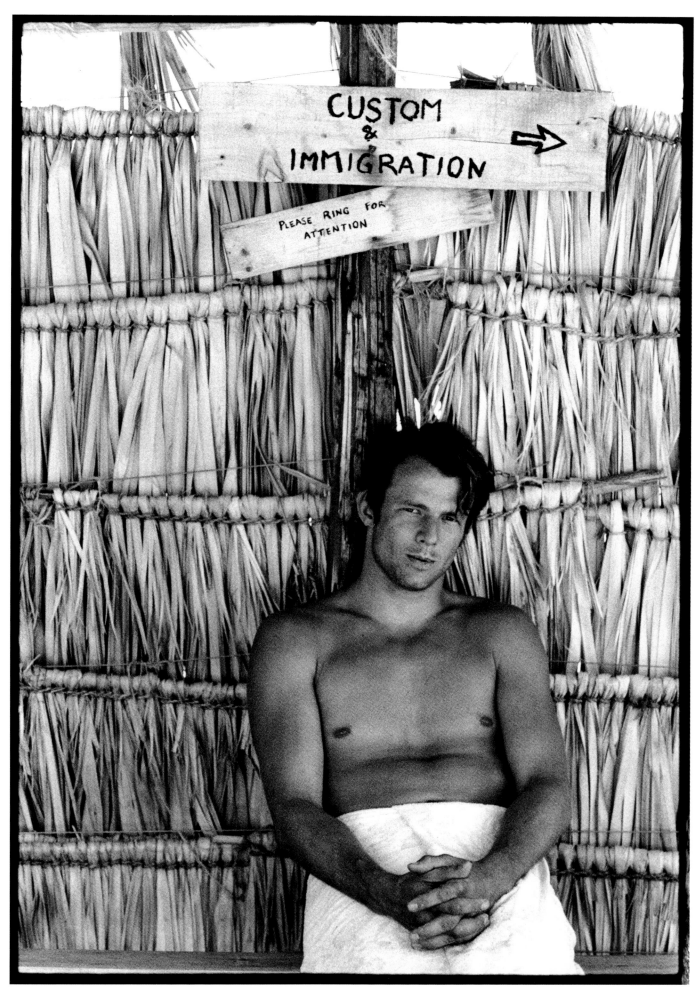

Kenya: Peter Beard 6/1973

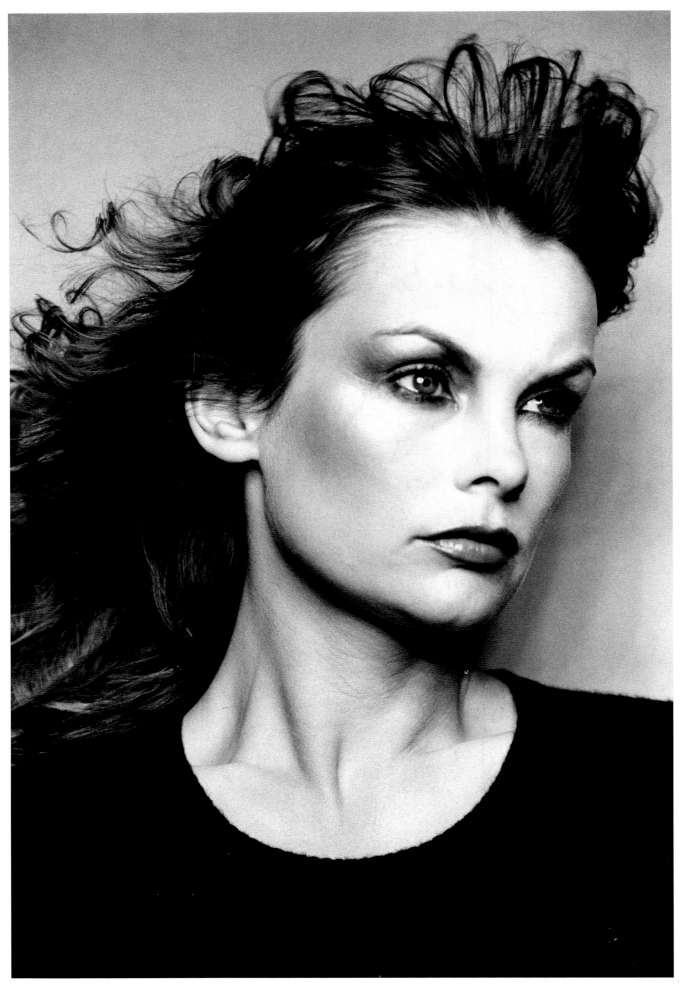

Jean Shrimpton 6/1974

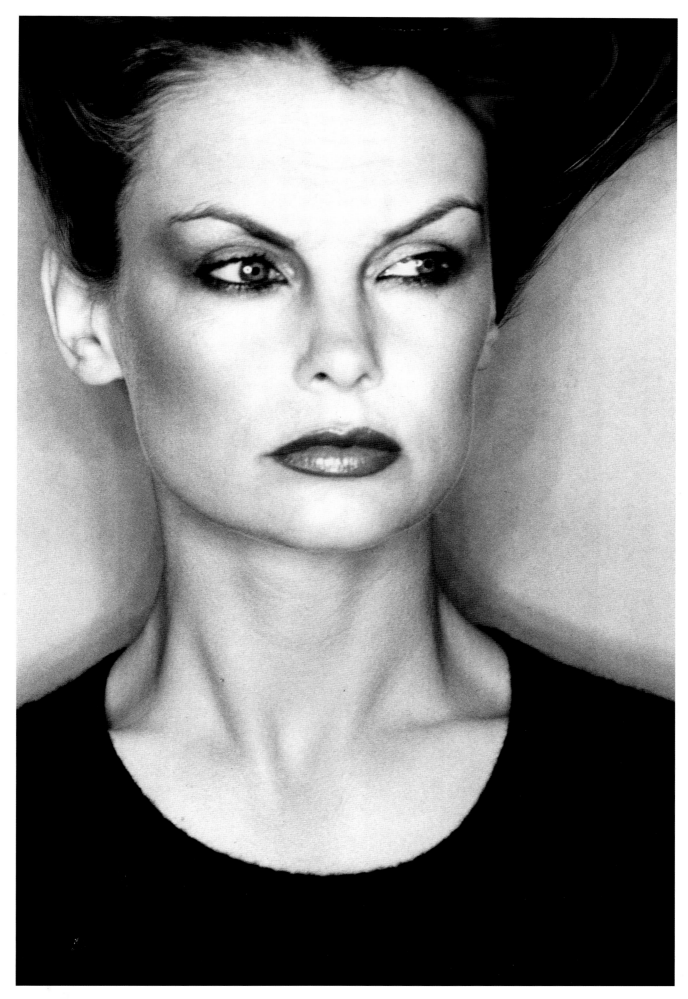

Jean Shrimpton 6/1974

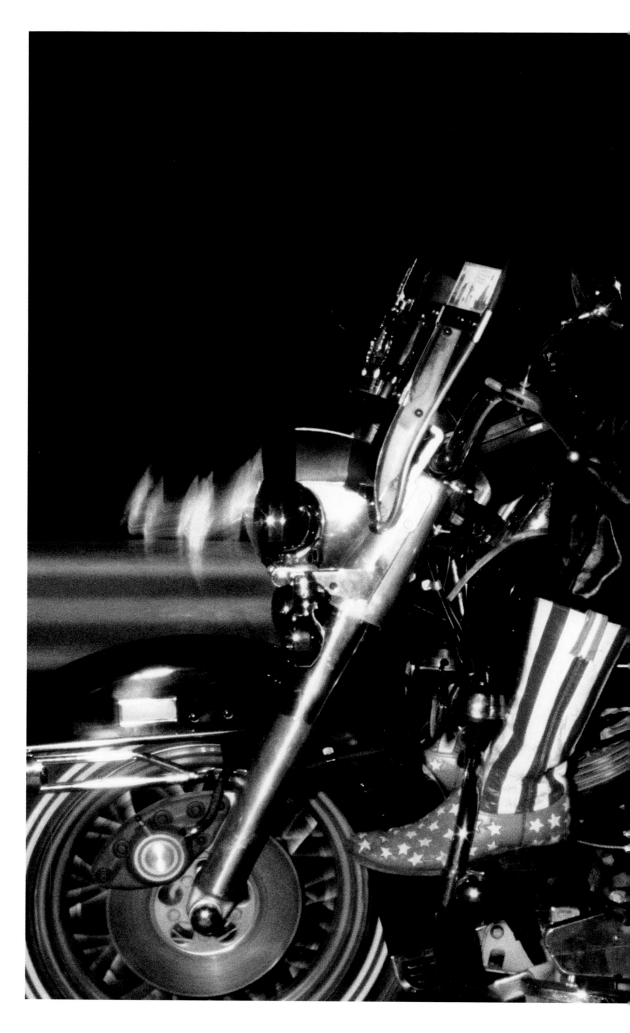

Milan: (Toscani and Anjelica Huston)
Vogue September 1st 1973 (variant published)

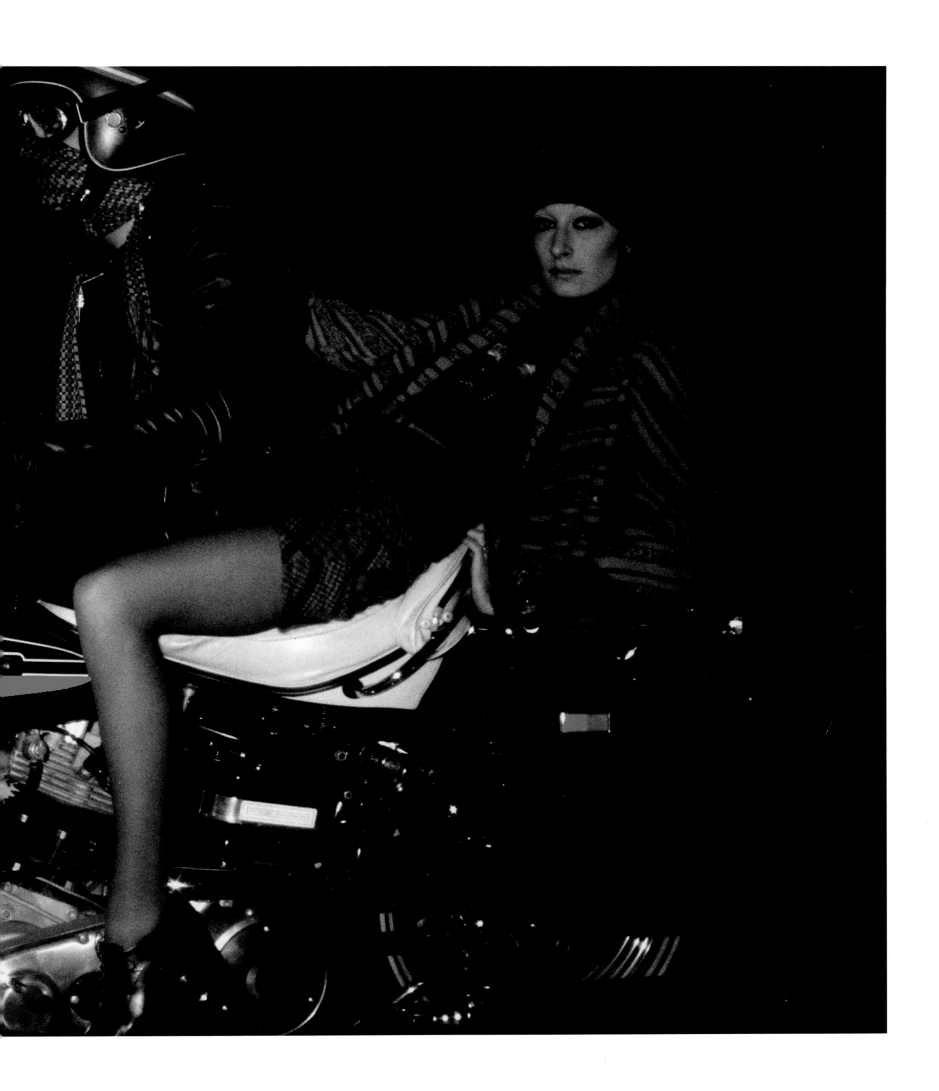

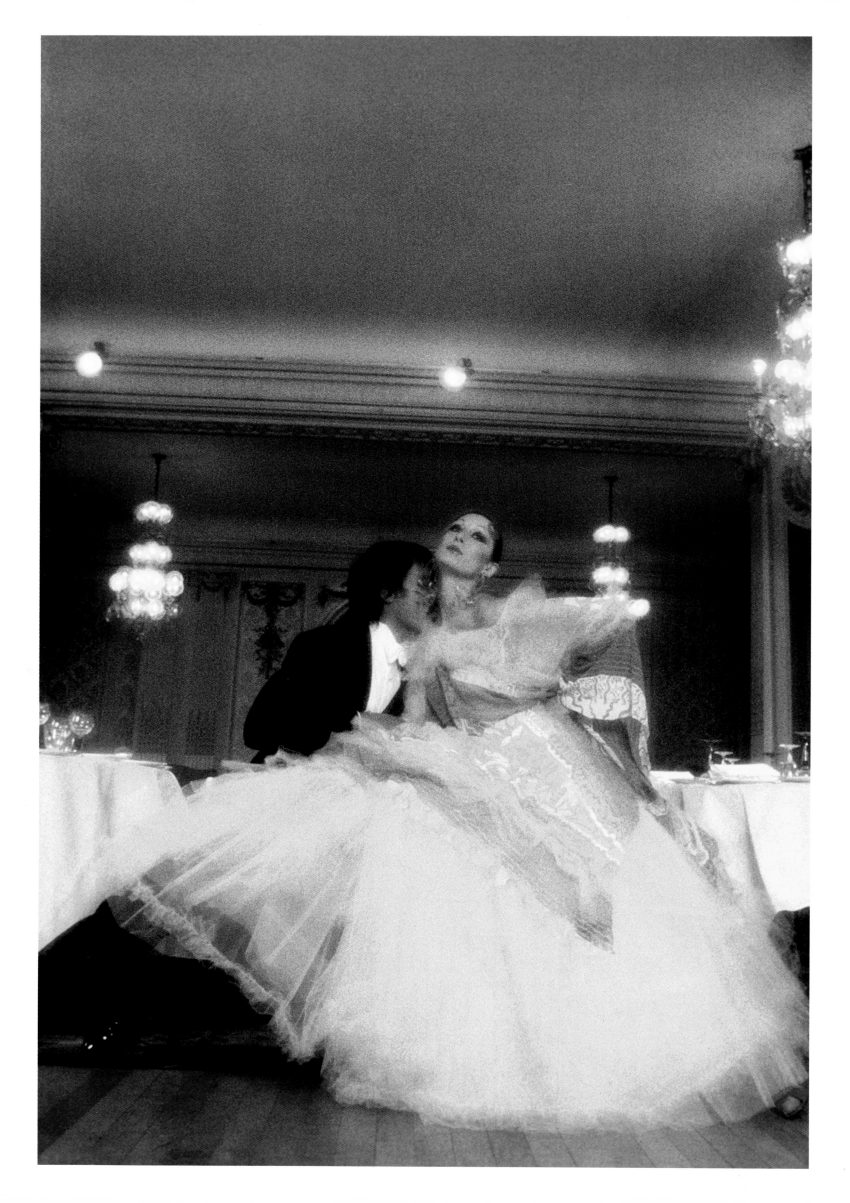

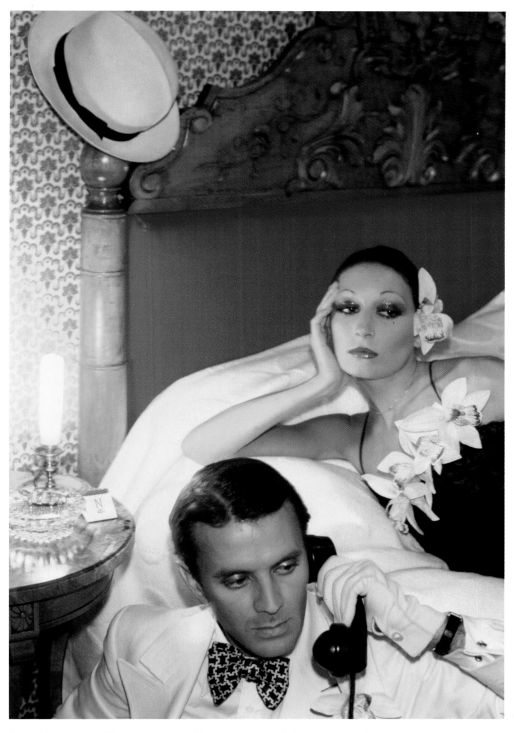

(above) **Nice: Hotel Negresco (Anjelica Huston and Manolo Blahnik)** *Vogue* January 1974

(opposite) **London: Hyde Park Hotel (Anjelica Huston)** *Vogue* September 1st 1973 (variant published)

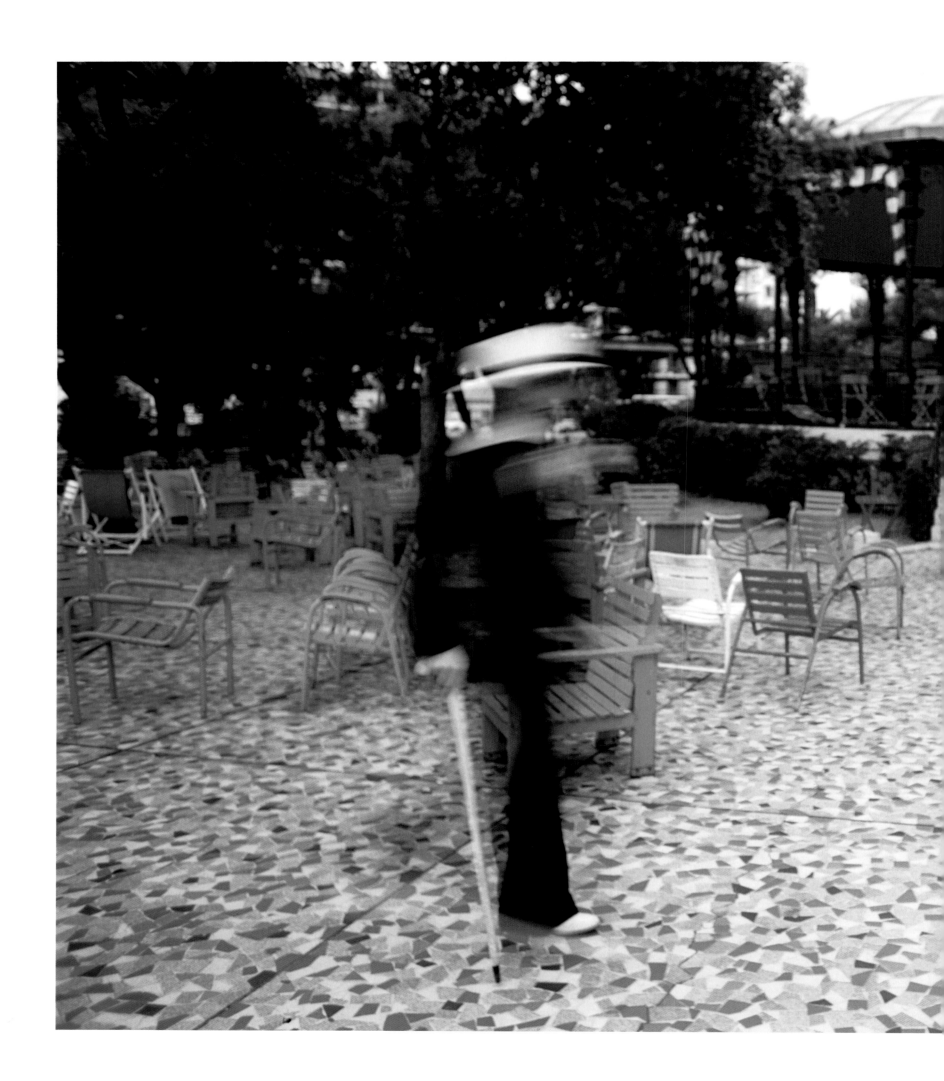

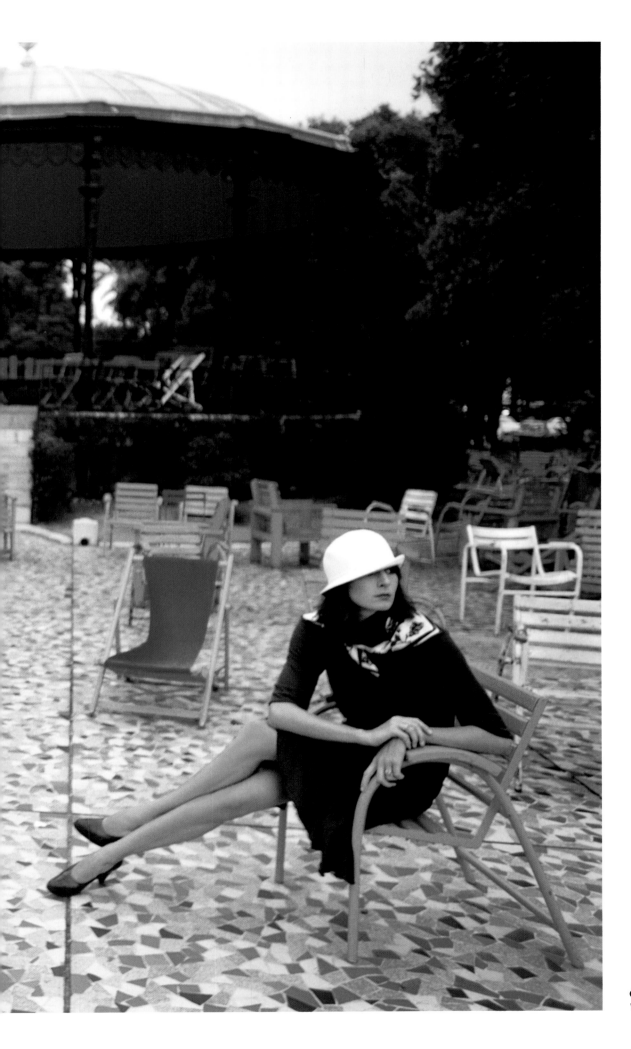

Corsica: (Toscani and Anjelica Huston)
Vogue September 1st 1973 (unpublished)

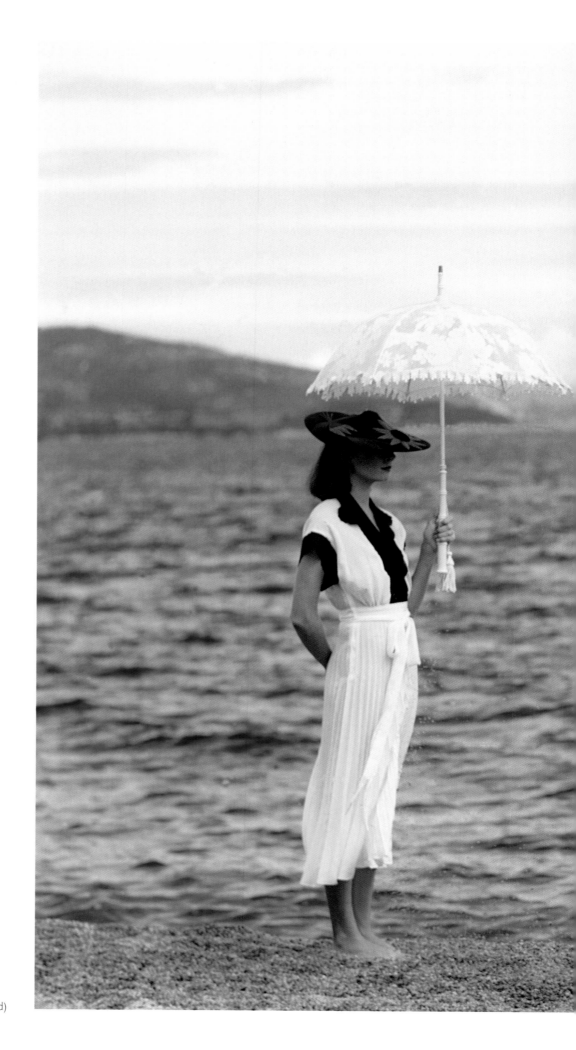

Corsica: Sagone *Vogue* January 1974 (variant published)

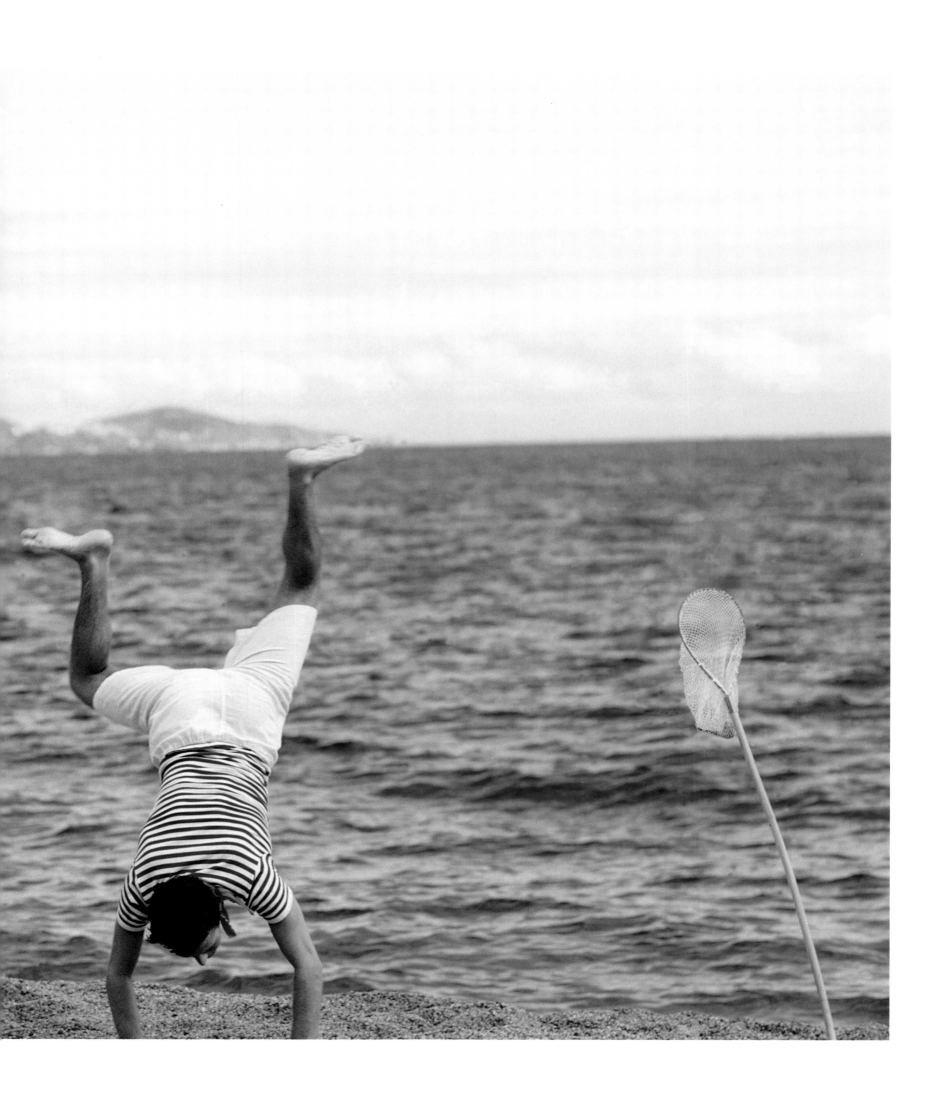

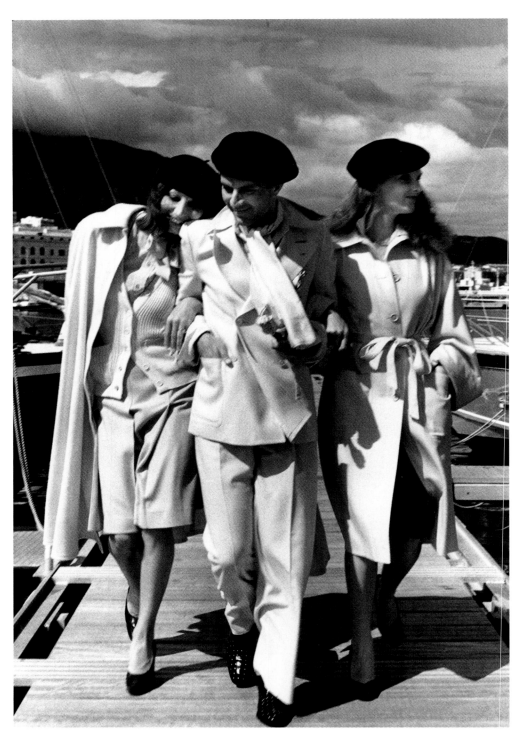

(above and opposite) **Corsica: Ajaccio harbour (Anjelica Huston, Manolo Blahnik, Grace Coddington)**
Vogue January 1974

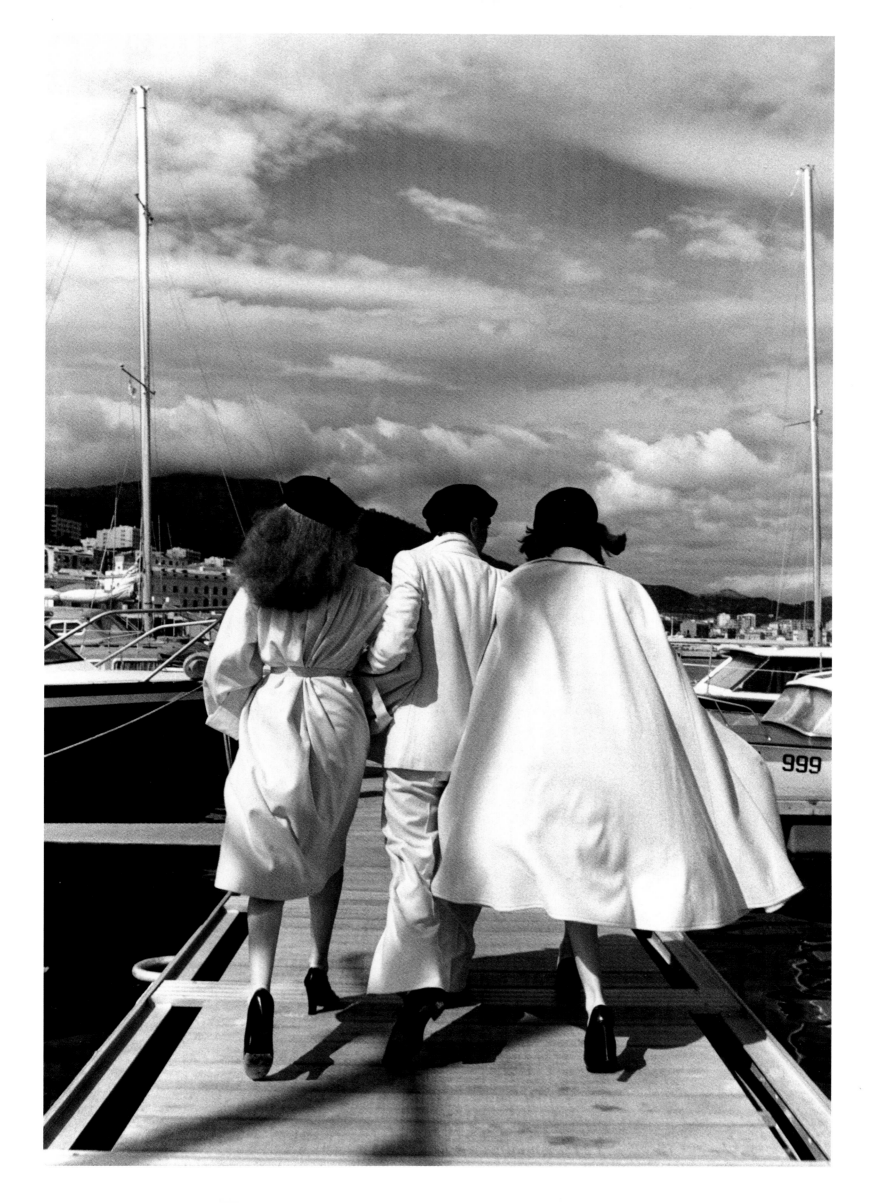

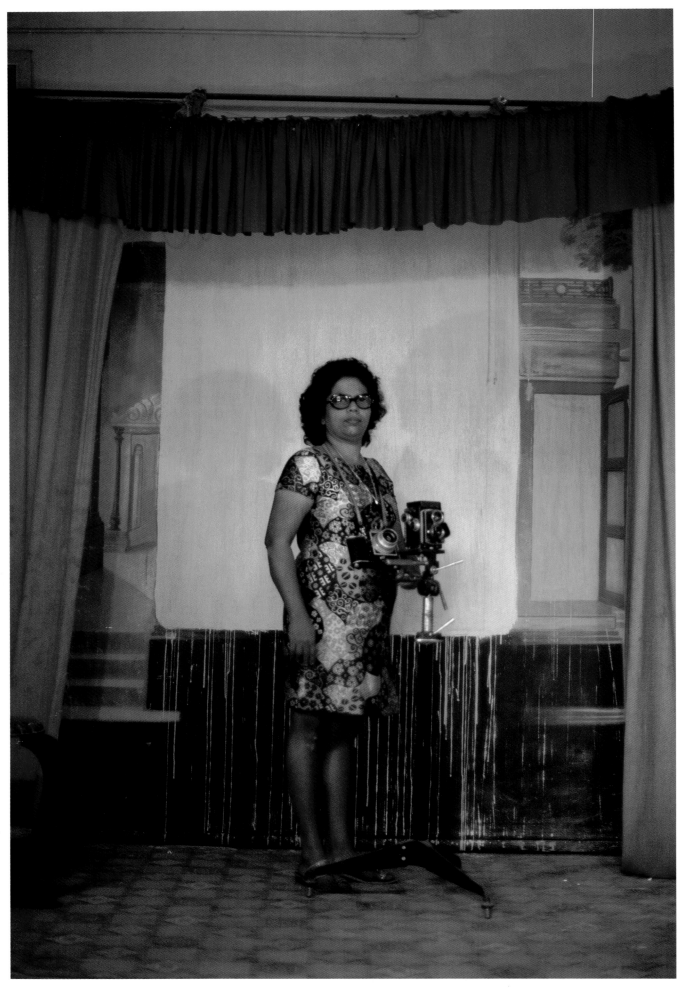

Goa: portrait photographer Mrs Palmira Coutinho, Hollywood Studio 12/1974

Flying

Brazil 1/1974

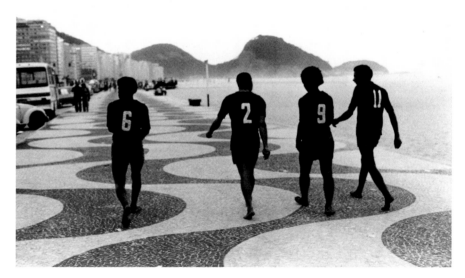

Brazil 1/1974

For a child growing up in East Ham in the 1940s, Bailey had cultivated unconventional heroes – the naturalists Frances Pitt and James Fisher and the Victorian explorer Sir Richard Burton. As an undiagnosed dyslexic, the ability to observe and identify a sparrow or a moorhen was crucial in developing his visceral response to visual stimuli, as well as formulating a personal taxonomy of visual types. Bailey's natural curiosity and the piercing scrutiny of those vaunted dark eyes were later transposed to his gaze on a fashion model, a portrait subject under the glare of studio lighting, or a New Guinea tribesman. In the Seventies, although he liked to divide his photographs into 'seeing pictures' and 'constructed pictures', within his expanding iconography there were no other sharp categorical distinctions – they were all subsumed into his collective anthropology of the peoples of the world.

He made no pretence about uncovering lost frontiers, with the qualified exception of Papua New Guinea, which at least had not succumbed to Western influence nor, as he put it, 'been seen to death'. He wrote in the introduction to his New Guinea anthology, *Another Image* (1976): 'For me this was a schoolboy dream, that there is a place left in the world where one might meet someone who has never seen a caucasian, or been corrupted by missionaries and their stupid ideas of covering up every part of the body with European rags.' The Catholic missionaries were in fact to be of assistance to him in New Guinea, helping to arrange flights on transport aircraft that distributed supplies to radar stations in then-remote areas of the Western Highlands. He also encountered resistance. He travelled without an assistant, and any illusions he may have harboured about the good nature of inhabitants were

rapidly dispelled. Unimpressed by his photographs, which they regarded as less effective likenesses than a mirror reflection, they nevertheless stole many of them: Bailey took to sleeping with a bowie knife under his blanket. At Mount Hagen he was given an old jeep in which to drive back to Port Moresby, only to discover the hard way that its brakes barely functioned. The main problem he had to circumvent, though, here as in any similar location, was how to escape the regulation tourist sites and penetrate deeper into the country.

The trip he took to Brazil in January 1974 was the first occasion on which he attempted a sustained photo-reportage in a foreign country. As a

Brazil: Amazon 1/1974

Rio de Janeiro 1/1974

Catholic country, it was replete with overt symbols of the faith, and he continually encountered these wherever he travelled. For Bailey, who had come from a relatively secularized environment, or at least one in which organized religion seldom spilled over from the churches onto the culture of the streets, these signs came to form, however fortuitously, a decisive element of the iconography of his photo-documentaries. Understandably prominent in Brazil – for example in the Sao Joao Batista Cemetery in Manaus – as well as in Goa, these signs of religious belief became a recurrent theme in his photographs throughout the decade.

The country with which he became most intimately acquainted, however, was India. He had flown there to photograph for *Vogue* in 1968 and it was not, therefore, entirely unfamiliar territory when he returned in December 1974 (this time with an extended stay in Goa). His familiarity

with the topography and customs was useful in both planning his itinerary and in relating to the people. His impressive photograph of three members of the Kunbi tribe, the rather menacing aspect of their sunglasses rather at odds with their costumes, recalls the aphorism of Bailey's friend Diana Vreeland: 'Pink is the navy blue of India.' When Bailey was photographing a trio of transvestite prostitutes in Bombay, however, his accumulated wisdom did not prevent a group of their less amenable friends attacking him: 'I had to run for it, covered in horse dung that was thrown at me with great force and glee.' What most intrigued him about the brothels in the Cage District was the curiously militaristic arrangement of the prostitutes'

and other relics of the immediate urban past; what he saw in Goa resonated as a parallel kind of innocent Pop Art, transposed to a different culture. The co-existence of Hinduism and Roman Catholicism in Goa – which had only been liberated from 450 years of Portuguese rule in 1961 – presented a very different type of cultural amalgam, which fascinated Bailey equally. His photograph of a surprised nun about to pass a lofty sculpture of a blessing Christ in Brazil, and the airy and decidedly European classicism of the interior space of a Roman Catholic chapel in Goa, are further examples of these unexpected conjunctions; similarly, his photograph of the veneration of the shrine of St Francis Xavier, who was the first Jesuit

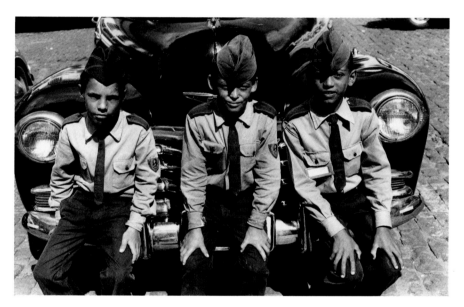

Brazil 1/1974

Brazil 1/1974

cubicles – a geometric counterpoint to the human element in his photographs. The reality of what went on inside these seamy rooms – the selling of sex with often obviously under-aged girls – places these among the more uncomfortable of Bailey's images, though paradoxically their bleakness is partly undercut by the rapport he was clearly able to establish with the young women. He seems to have broken down any resistance to the invasion, armed with cameras and flash equipment, of their privacy, for they appear to be reasonably amiable in most of the photographs, and obviously co-operated in the event and even played up to the camera.

In Goa, Bailey was struck by the density of ad hoc street graphics, the impromptu, free-hand advertising slogans that were often, to his surprise, written in English. Some of the earliest photographs he had made in London's East End were of similar folk art *objets trouvés*, shop-fronts

to arrive in the East, is a poignant metaphor for Goa's complex religious and social history.

In Calcutta, in distinct contrast to what he had witnessed in Bombay, Bailey found himself confronted by even more harrowing subject matter when he became friendly with Mother Teresa. Mother Teresa had been sent to India as a novitiate at the age of nineteen, but in 1946 received 'the call' to live and work among the poor; four years later the Pope sanctioned her order, the Missionaries of Charity. She persuaded Bailey to photograph the sick and dying patients in her hospice, which he did in a typically stark, unflinching manner, and some of these photographs were used by Mother Teresa in a pamphlet that she had printed to help raise funds.

(both pages) **Brazil** 1/1974

Brazil 1/1974

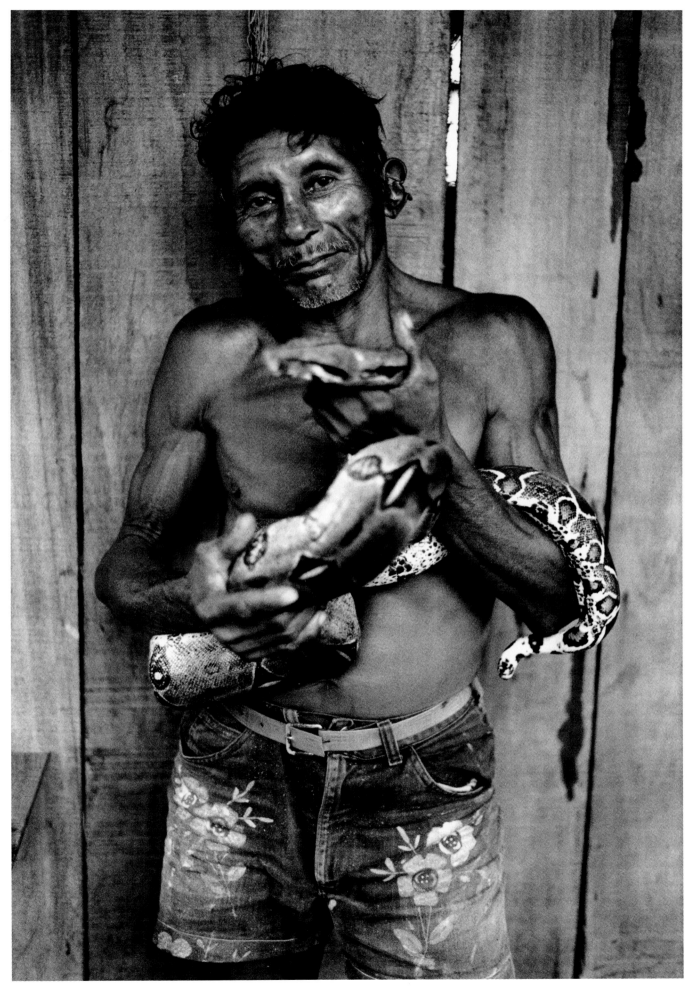

Brazil 1/1974

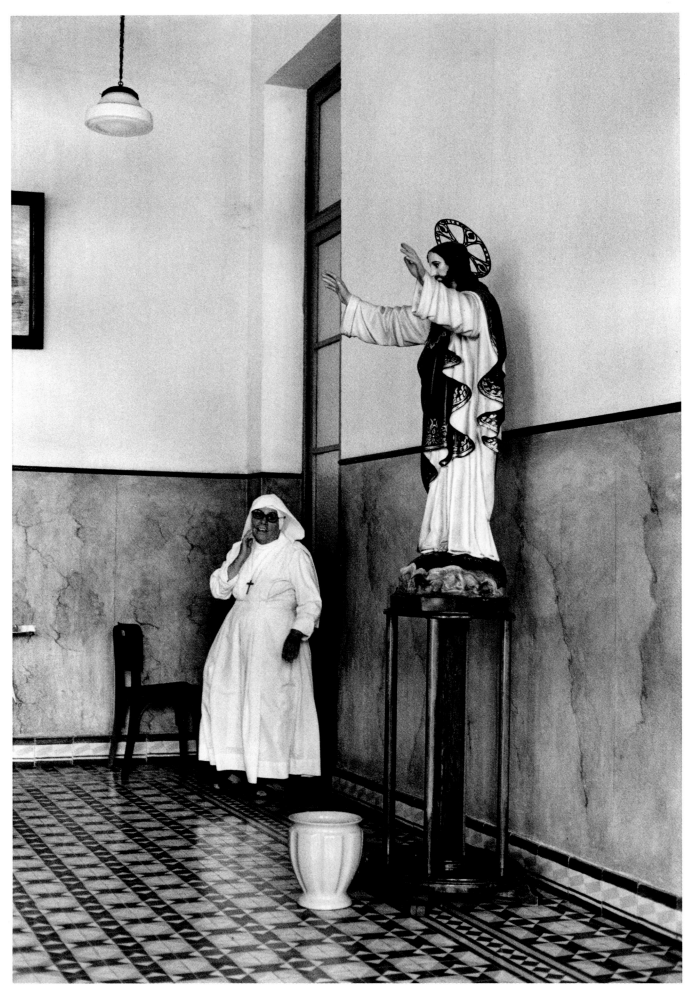

Brazil: convent, Manaus 1/1974

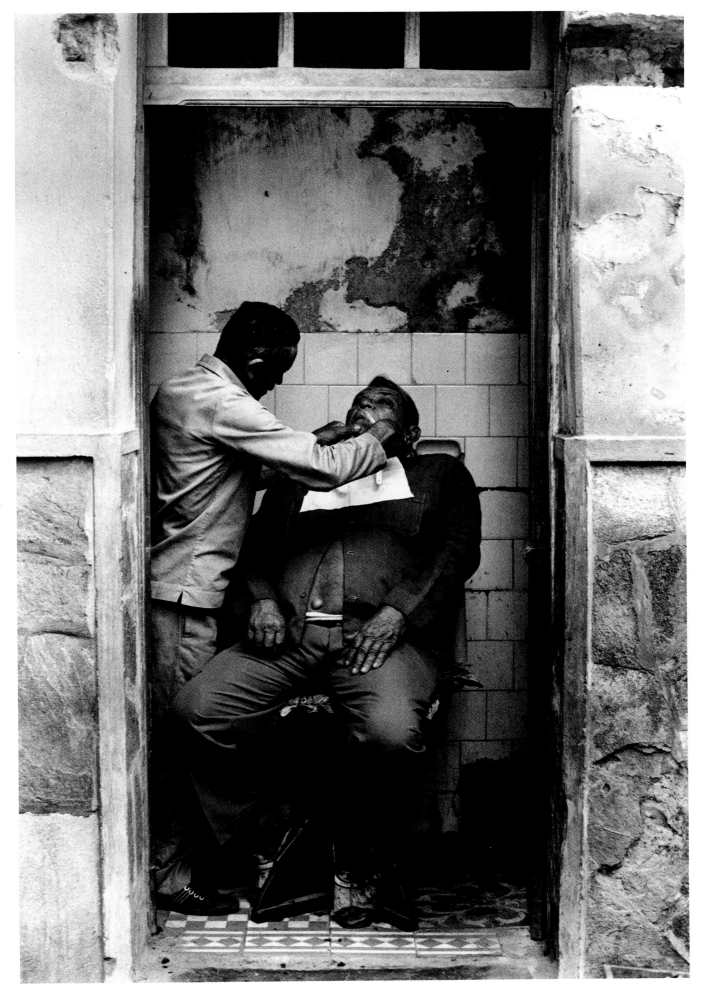

Brazil 1/1974

Brazil: tomb in Manaus cemetery 12/1974

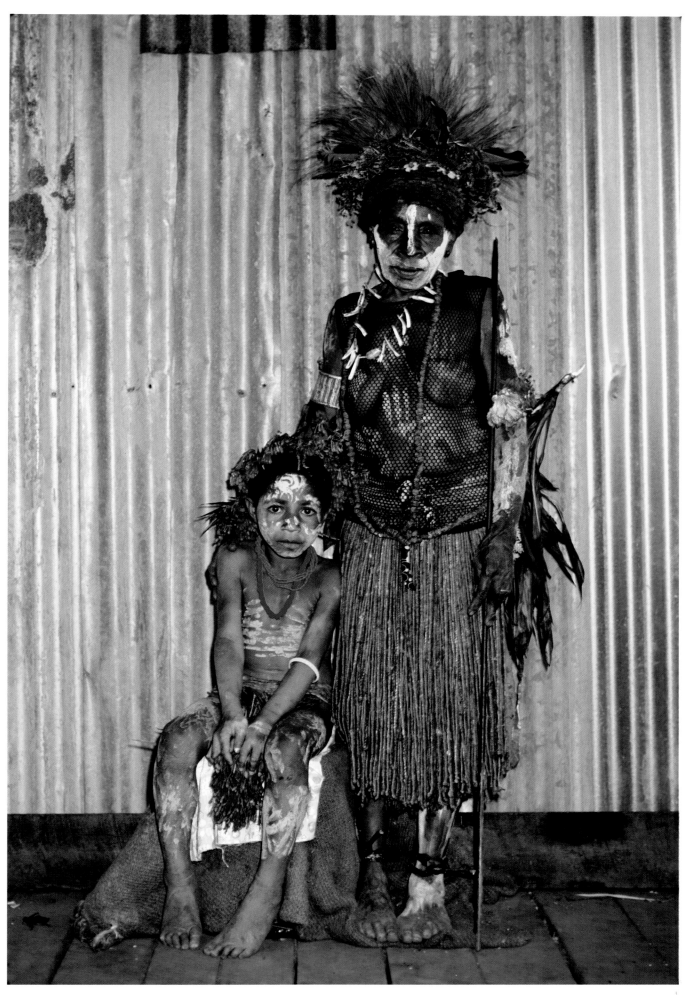

New Guinea 9/1974

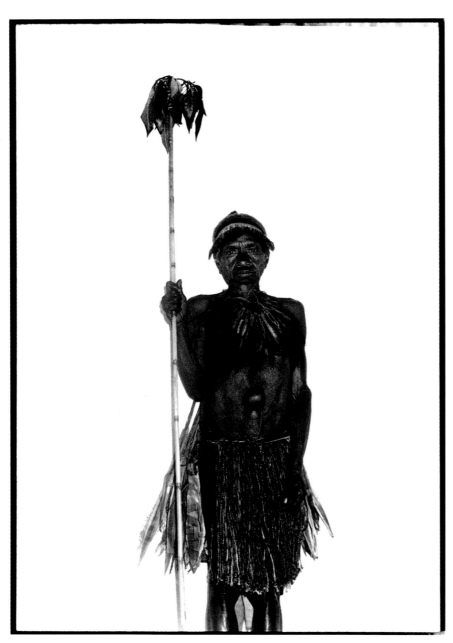 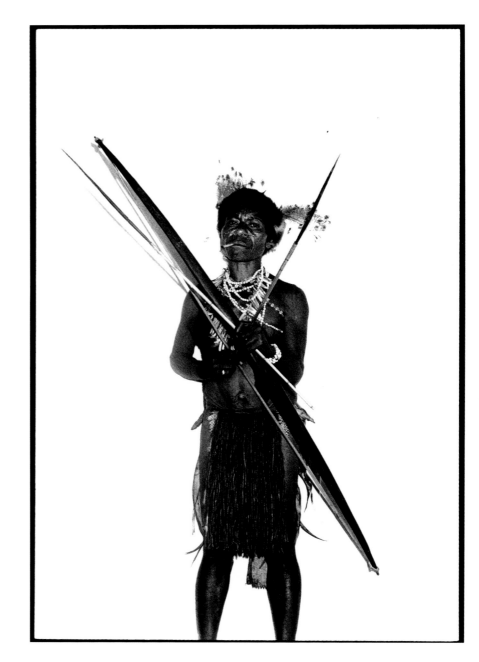

(left to right) **New Guinea: tribespeople** 9/1974

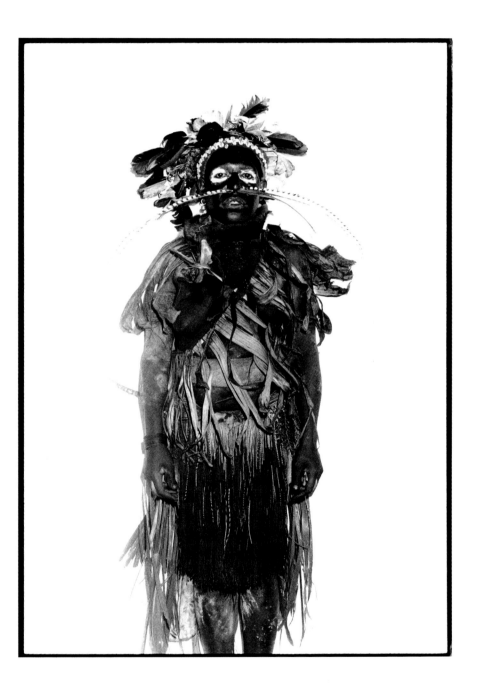

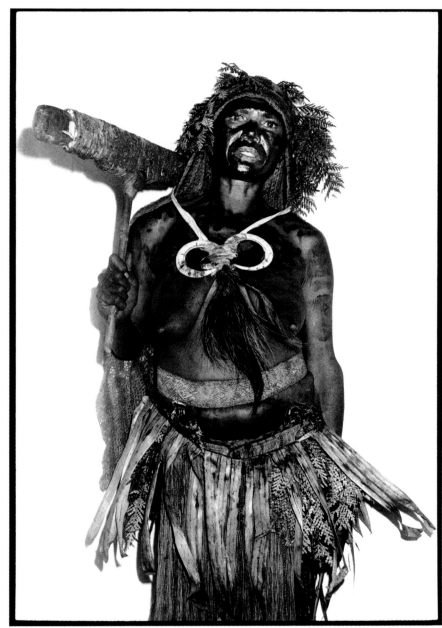

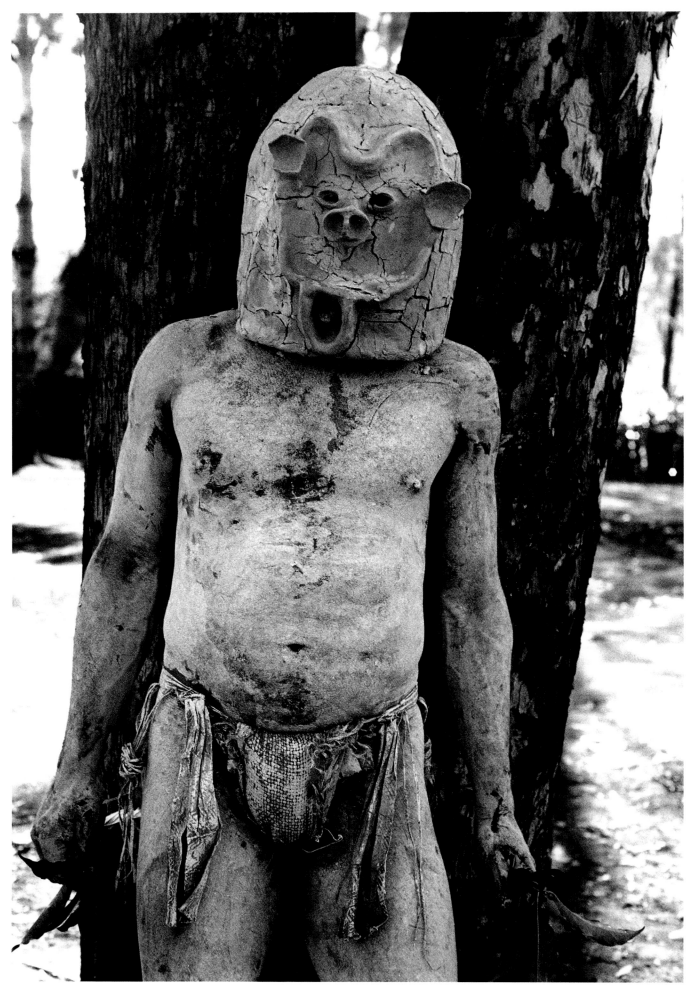

New Guinea 9/1974

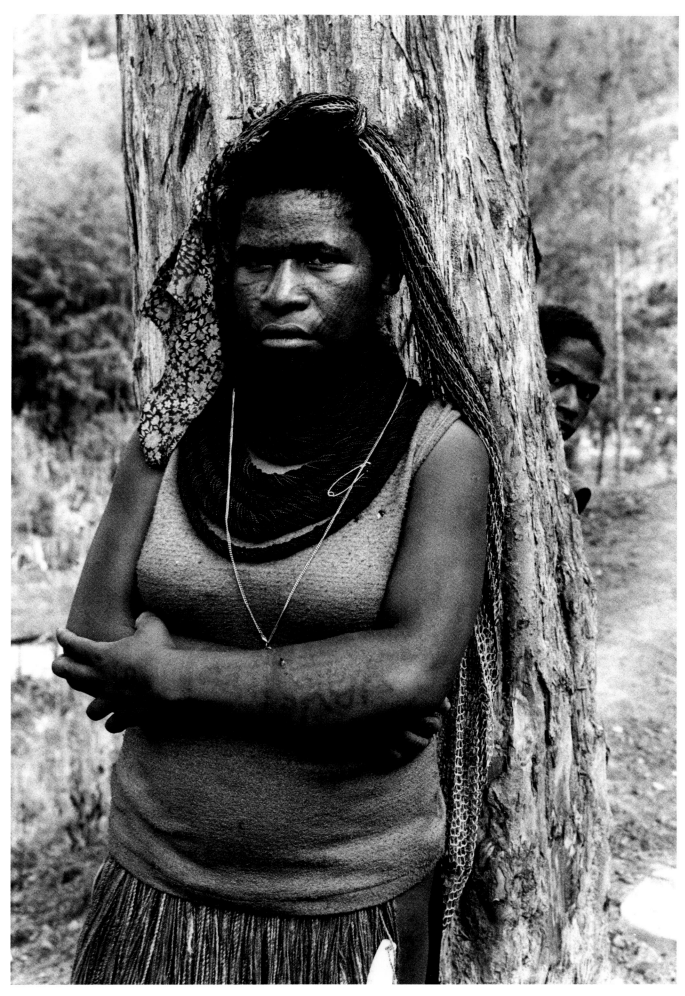

New Guinea 9/1974

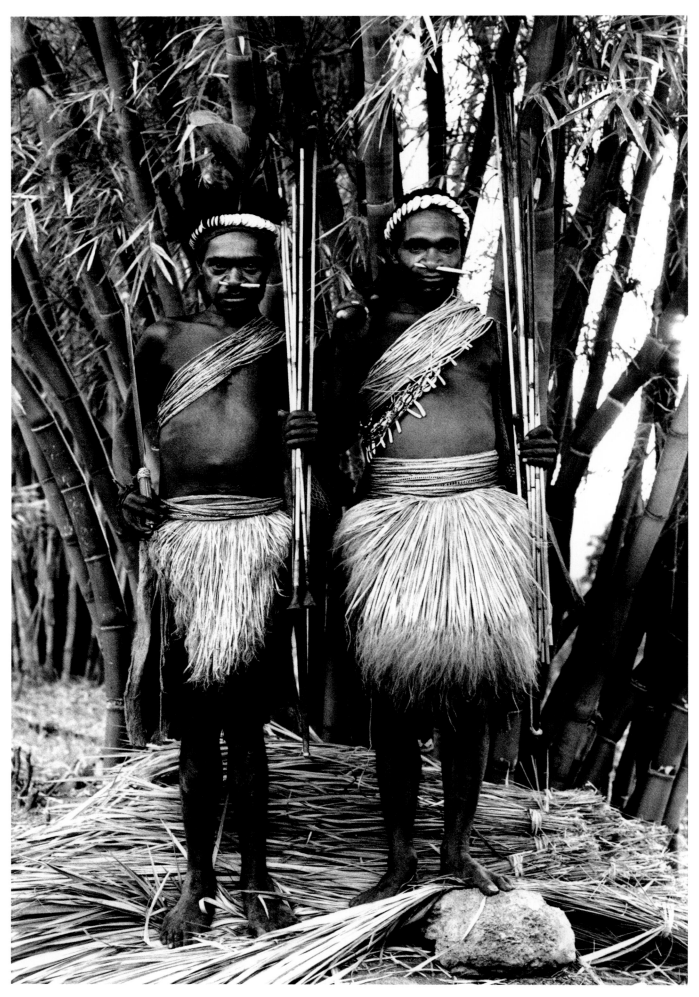

New Guinea 9/1974

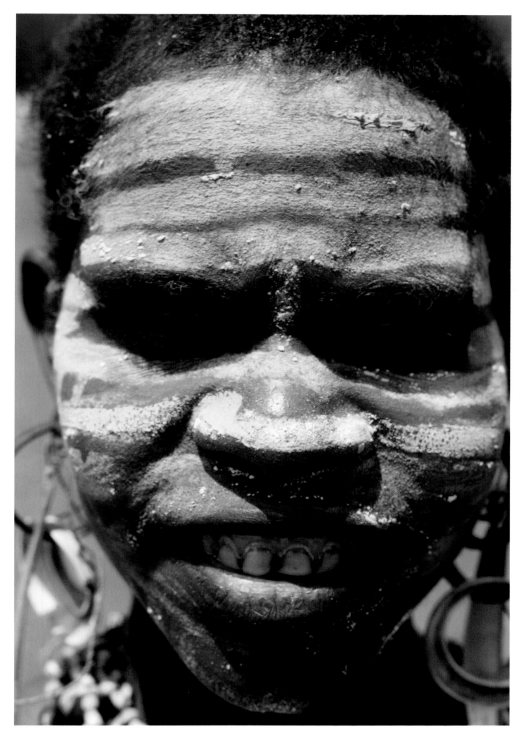

New Guinea 9/1974

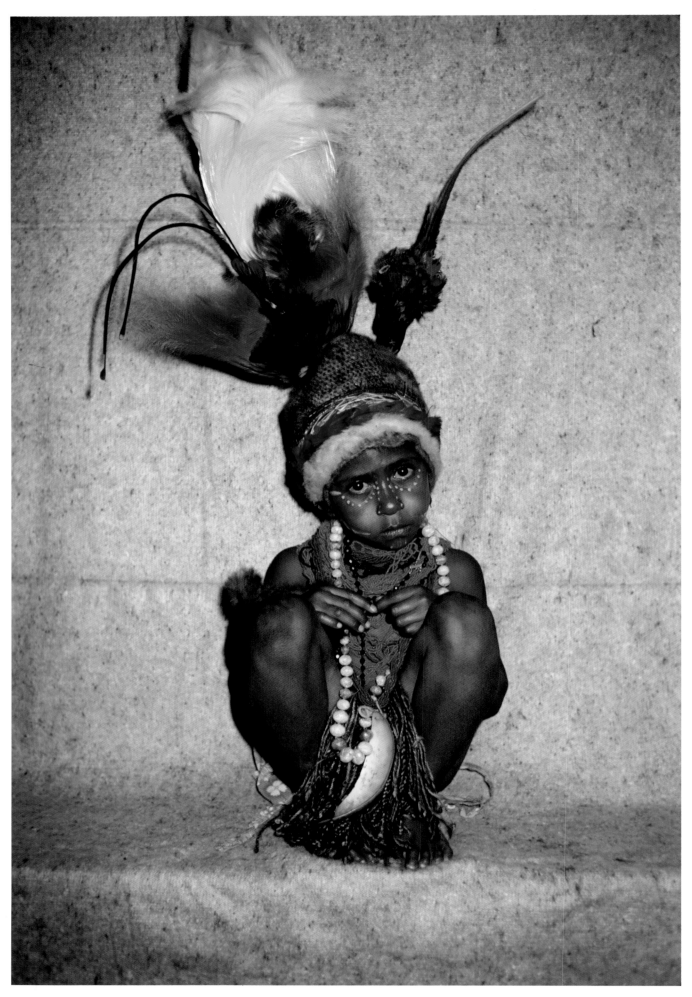

New Guinea: Chimbu boy 9/1974

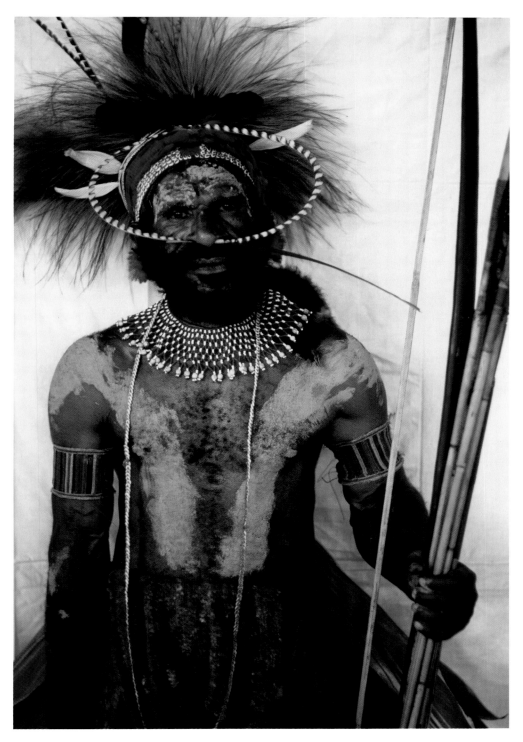

New Guinea 9/1974

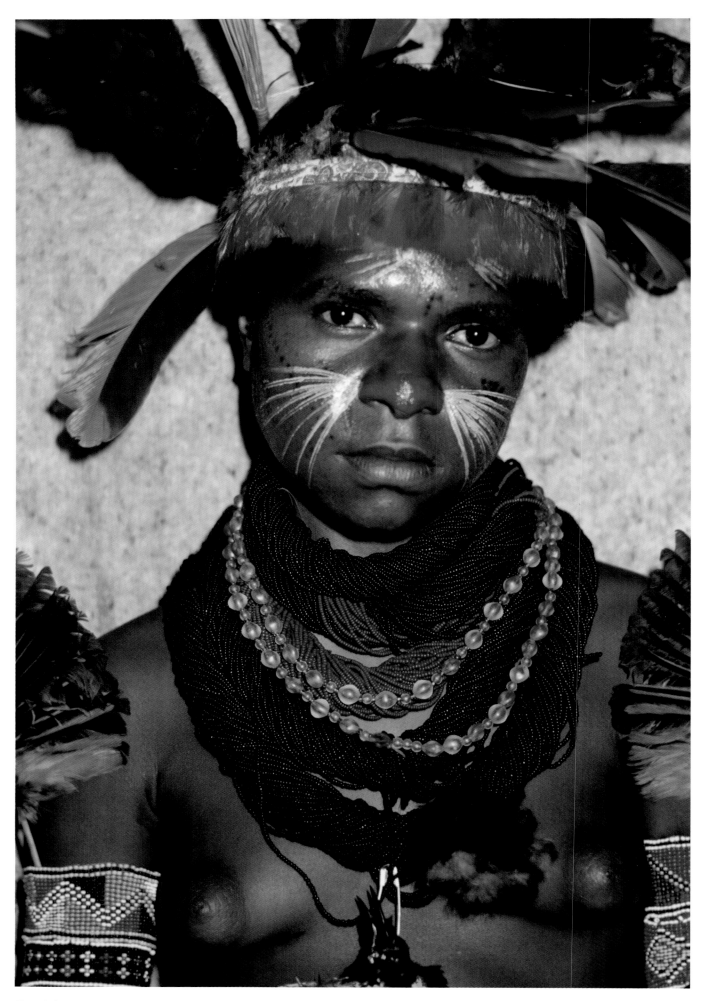

New Guinea 9/1974

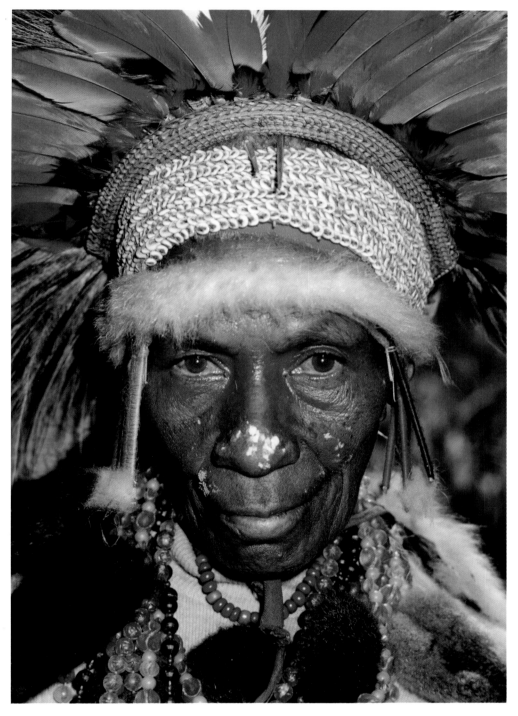

New Guinea 9/1974

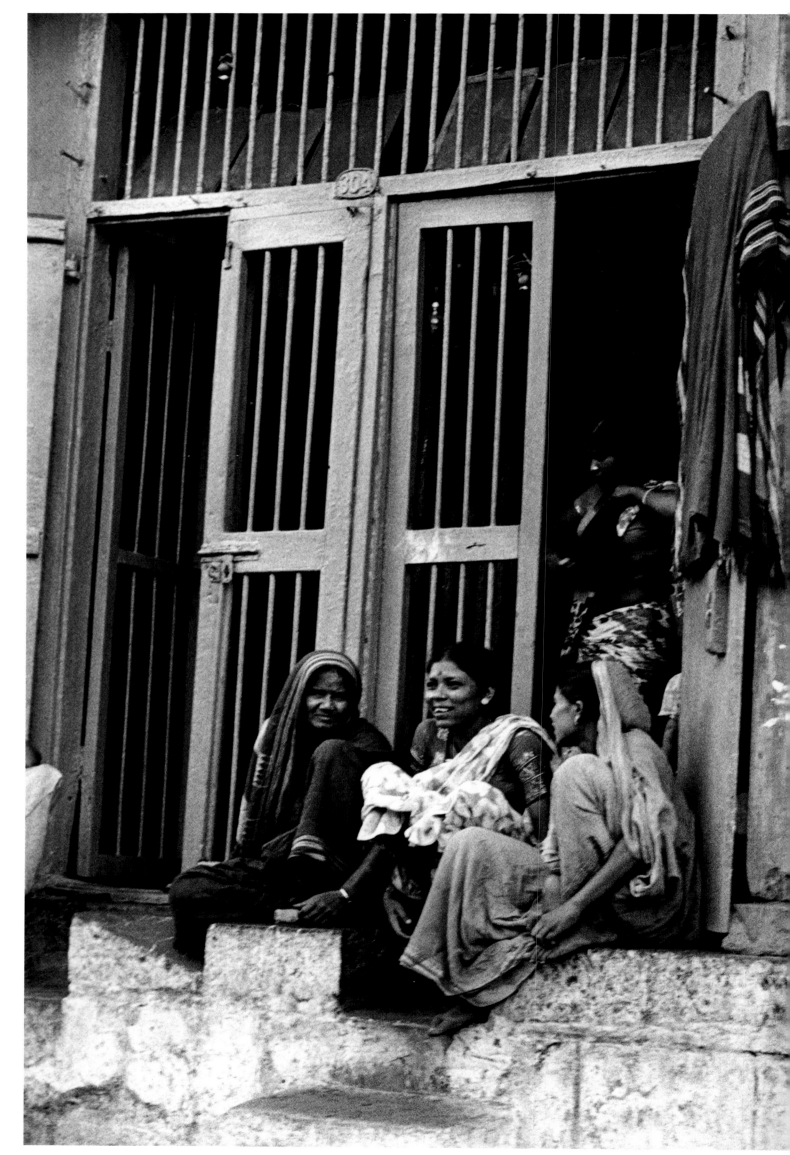

Bombay: the 'Cage District'

12/1974

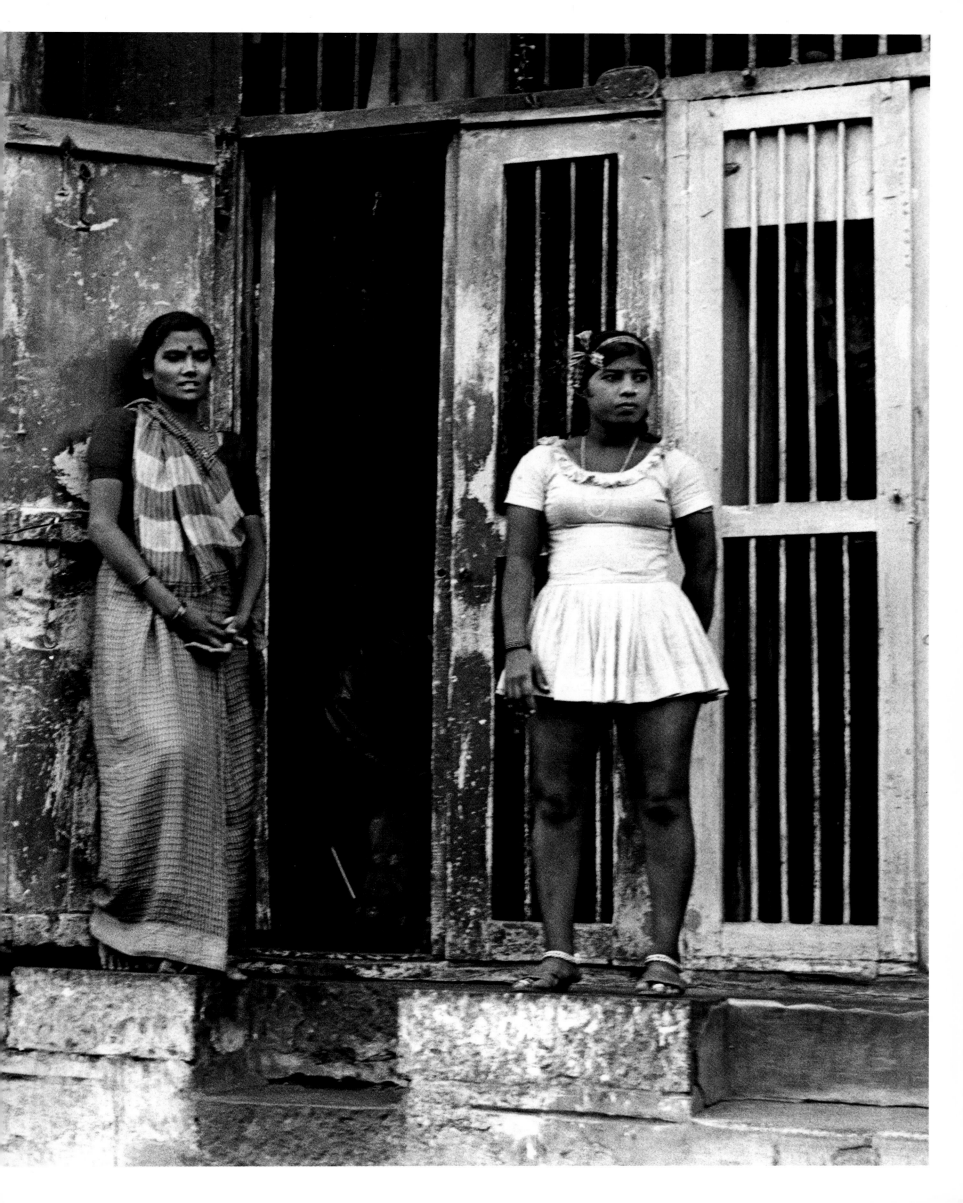

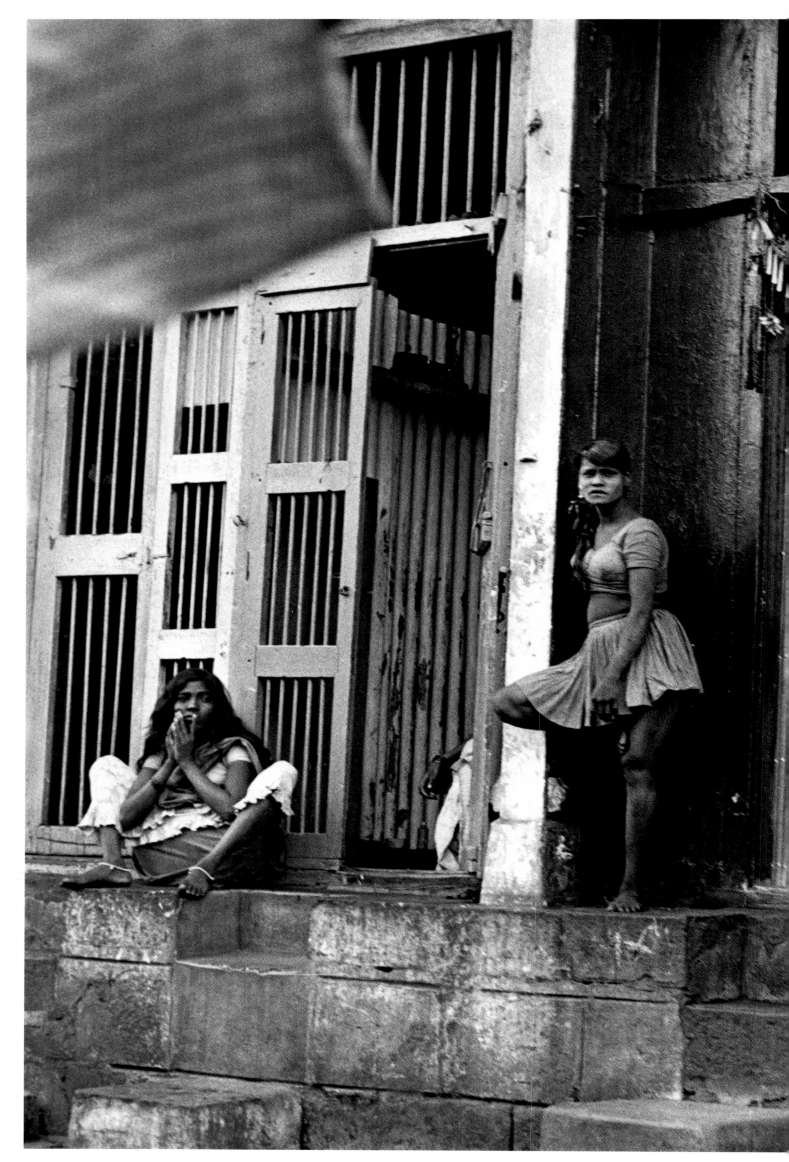

Bombay: the 'Cage District'
12/1974

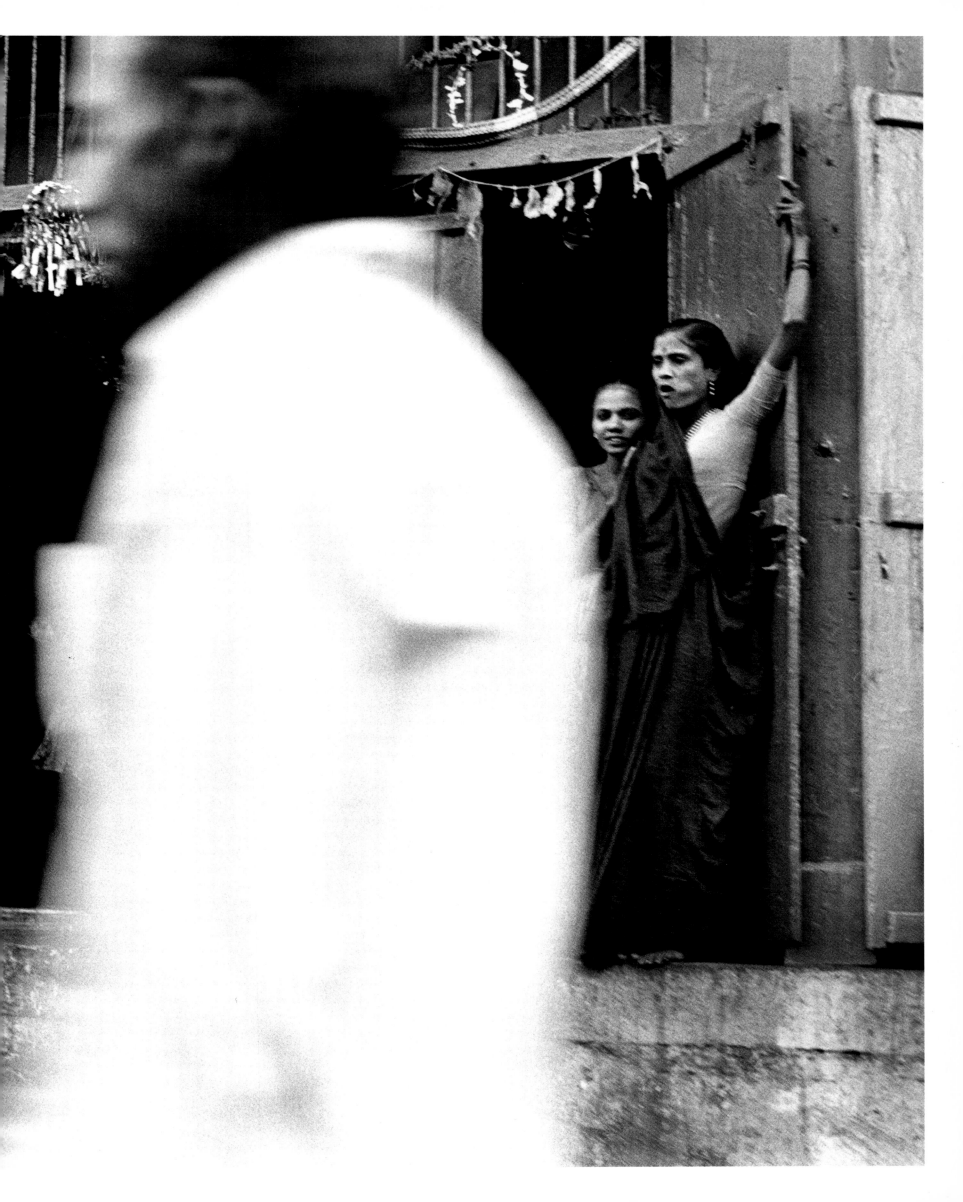

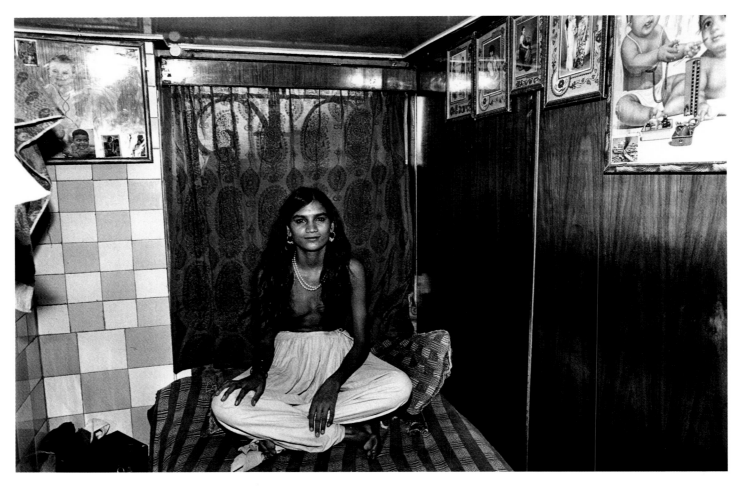

Bombay 12/1974

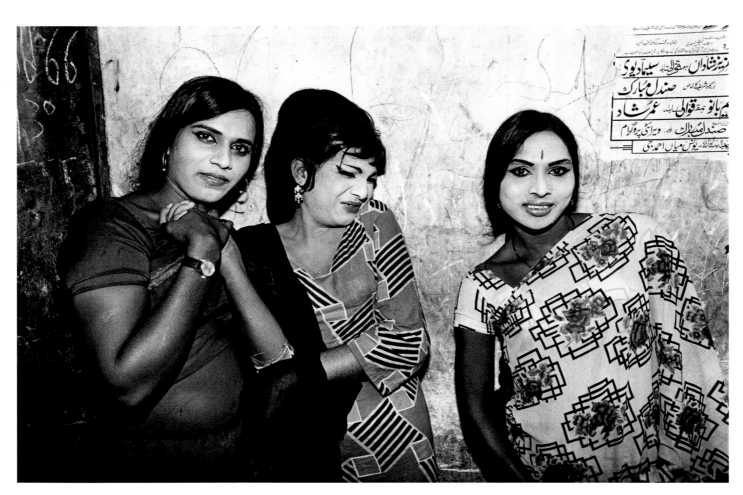

Bombay 12/1974

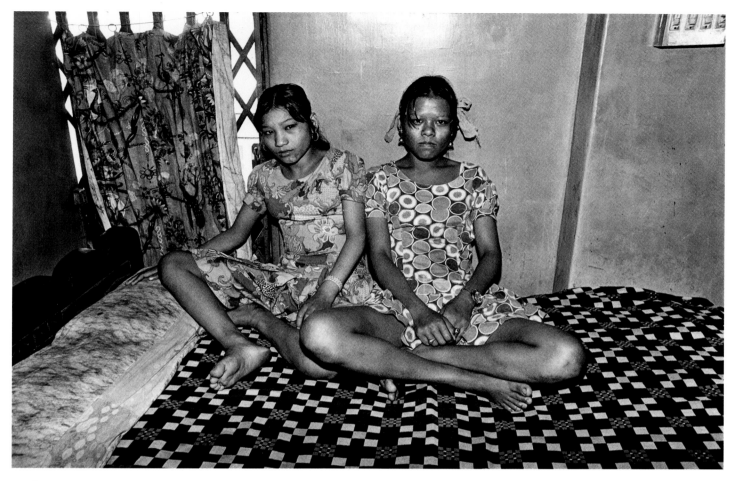

Bombay 12/1974

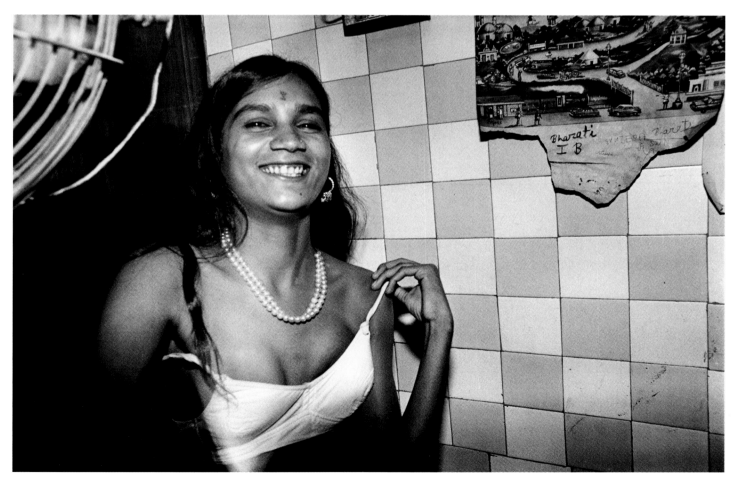

Bombay 12/1974

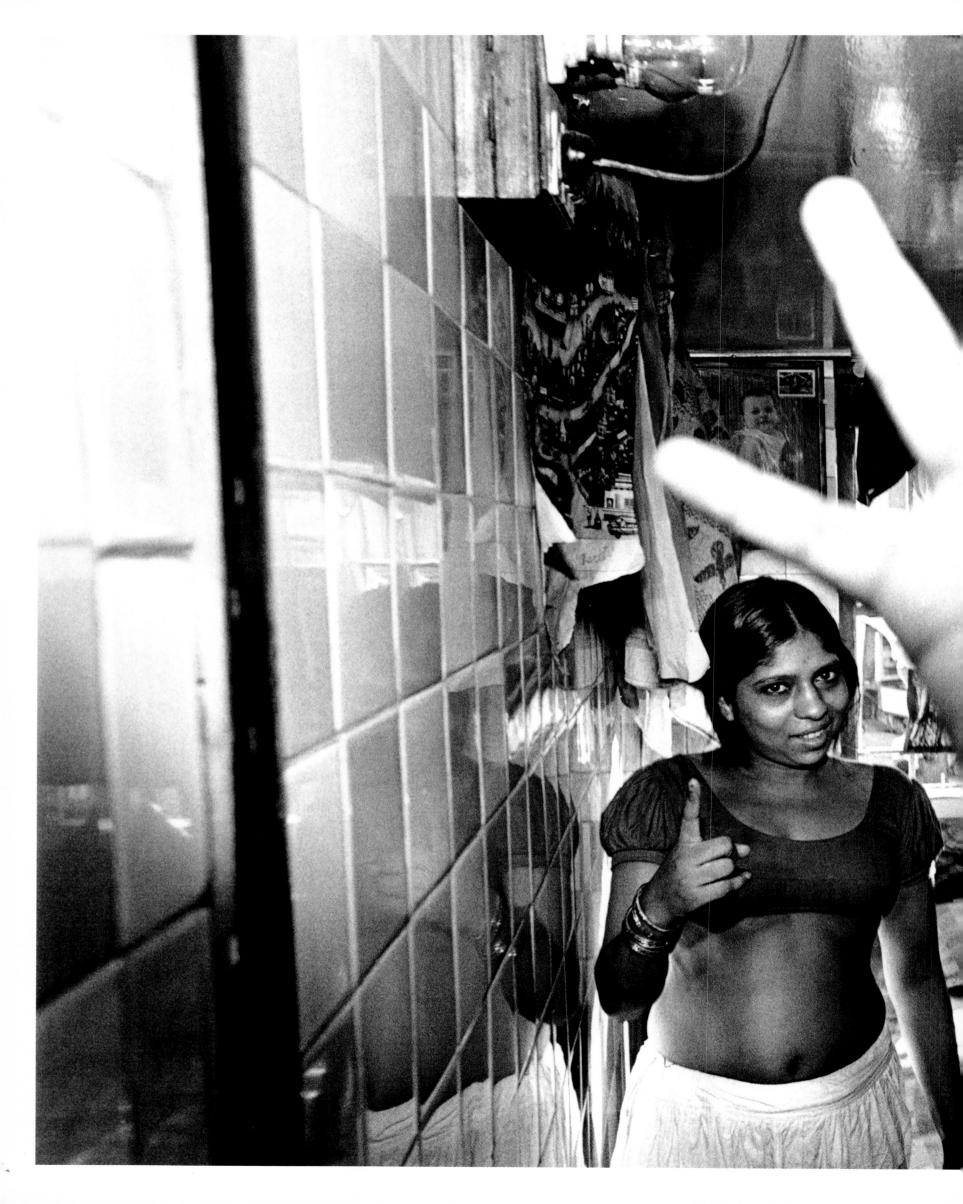

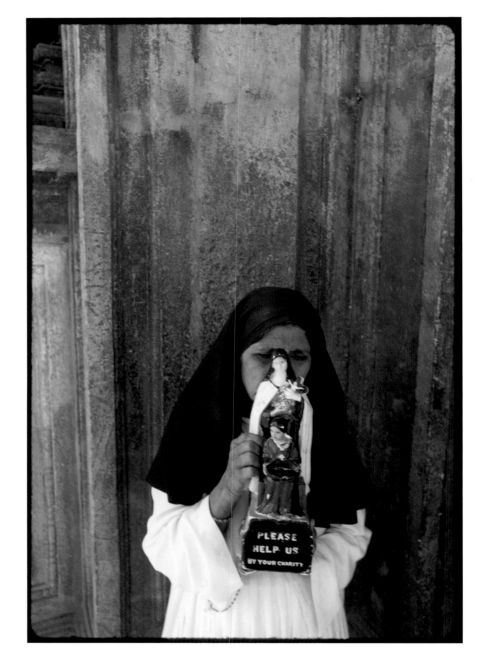

(left to right) **Goa** 12/1974

Goa 12/1974

Goa 12/1974

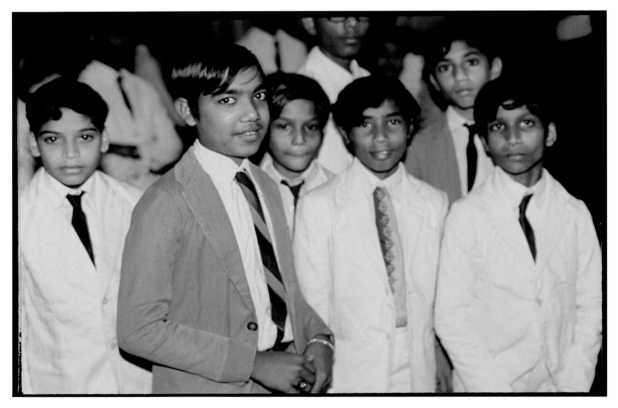

(above) **Goa** 12/1974

(opposite) **Goa: Kunbi tribesmen** 12/1974

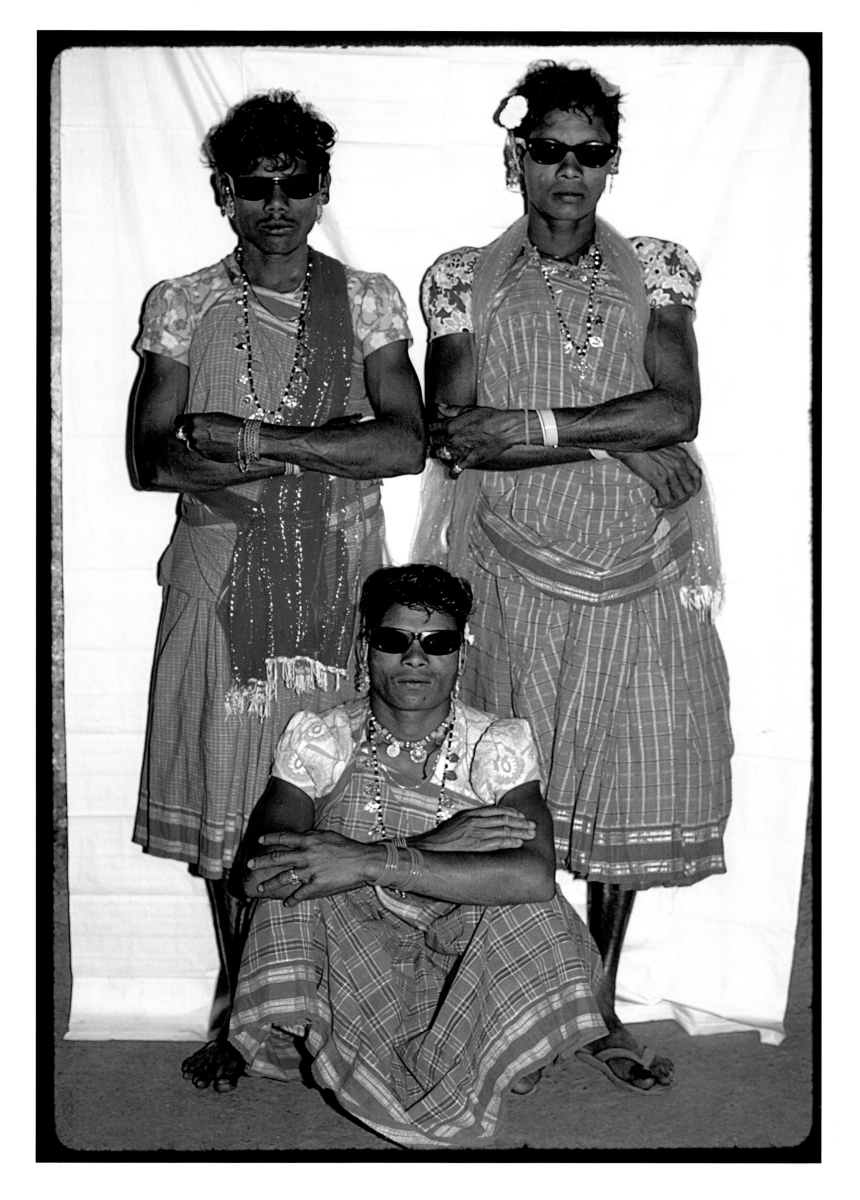

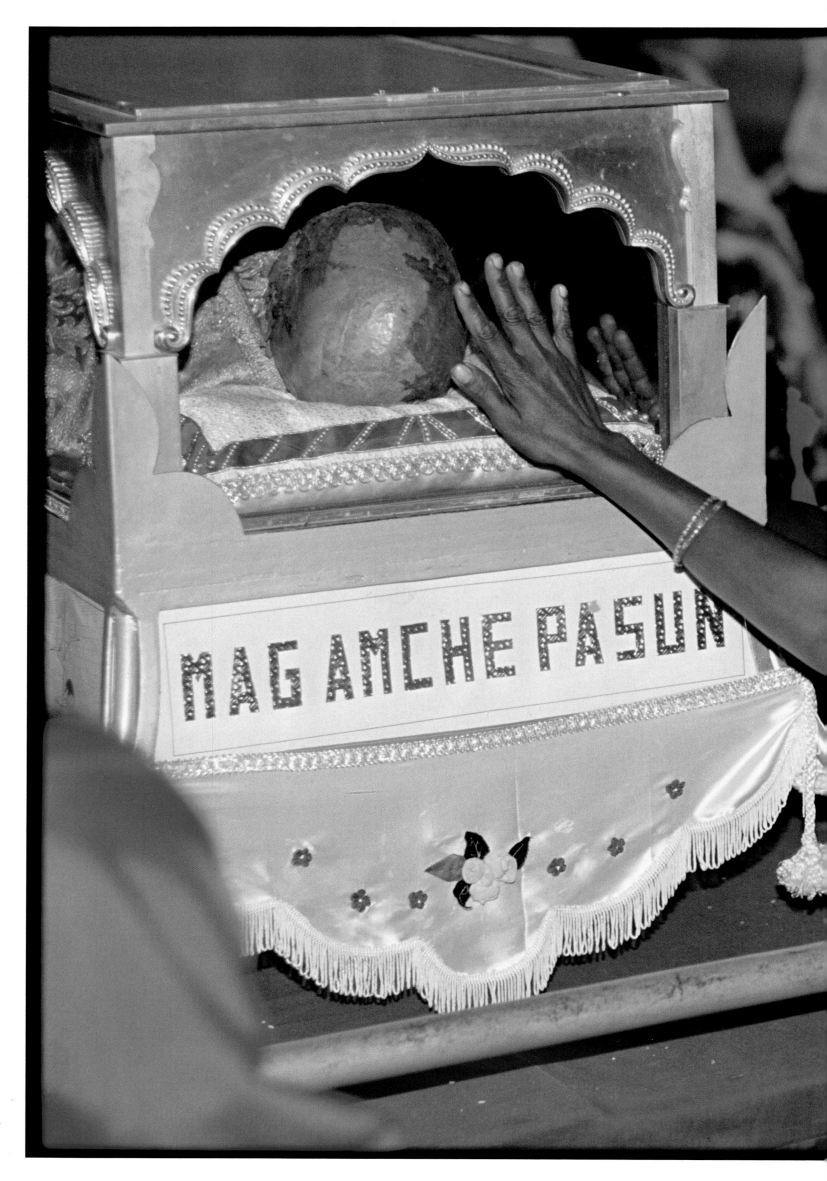

**Goa: the tomb of
St Francis Xavier**

12/1974

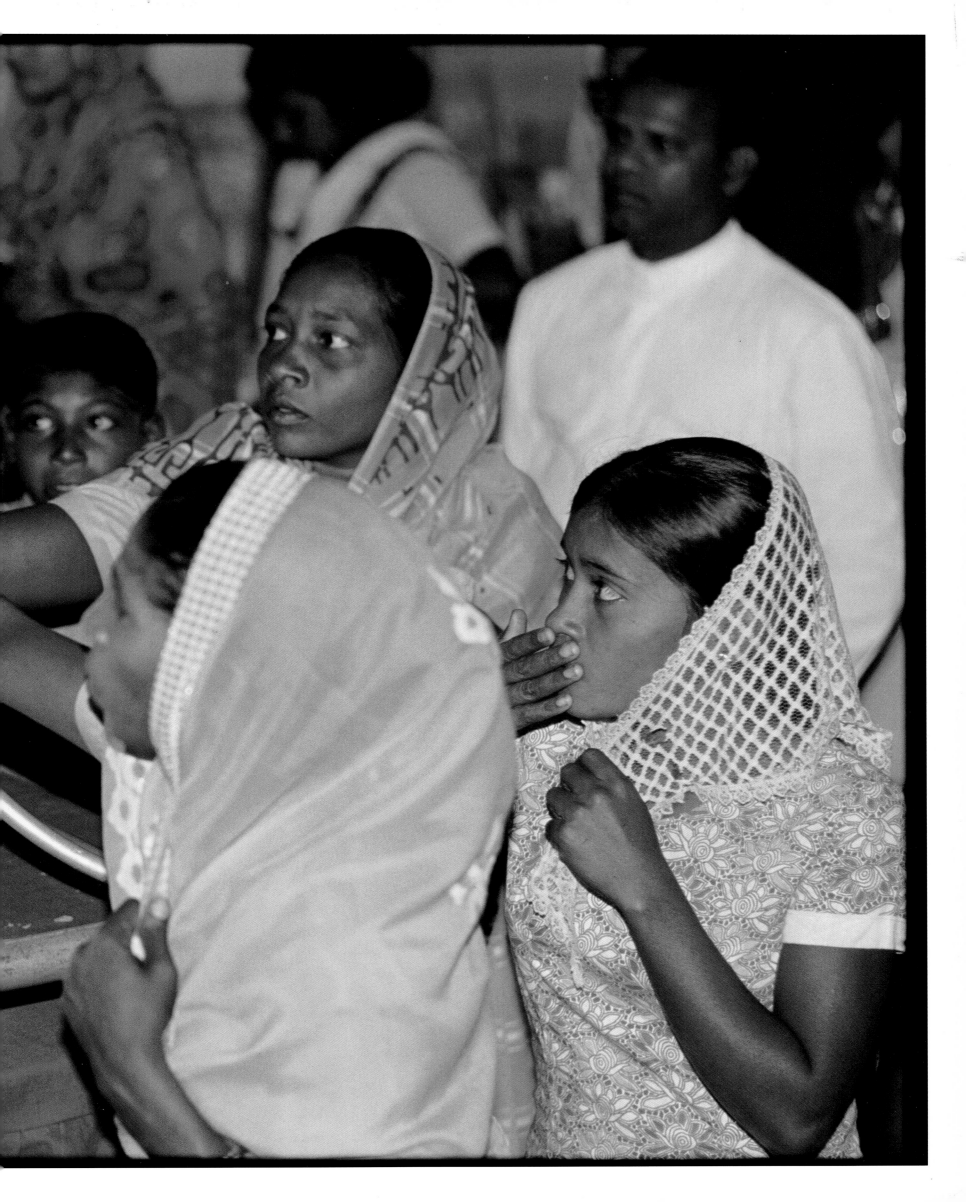

Goa 12/1974

Goa 12/1974

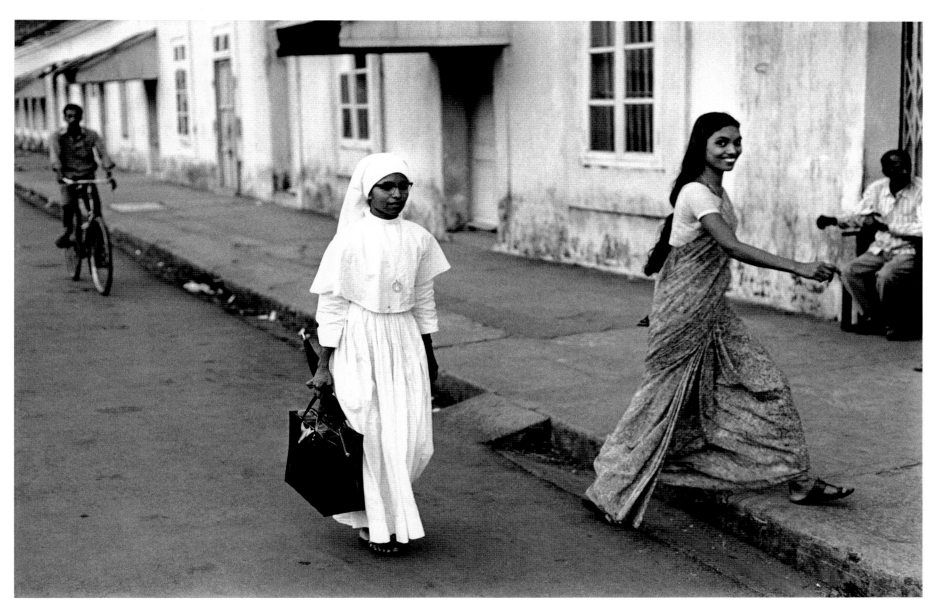

Goa 12/1974

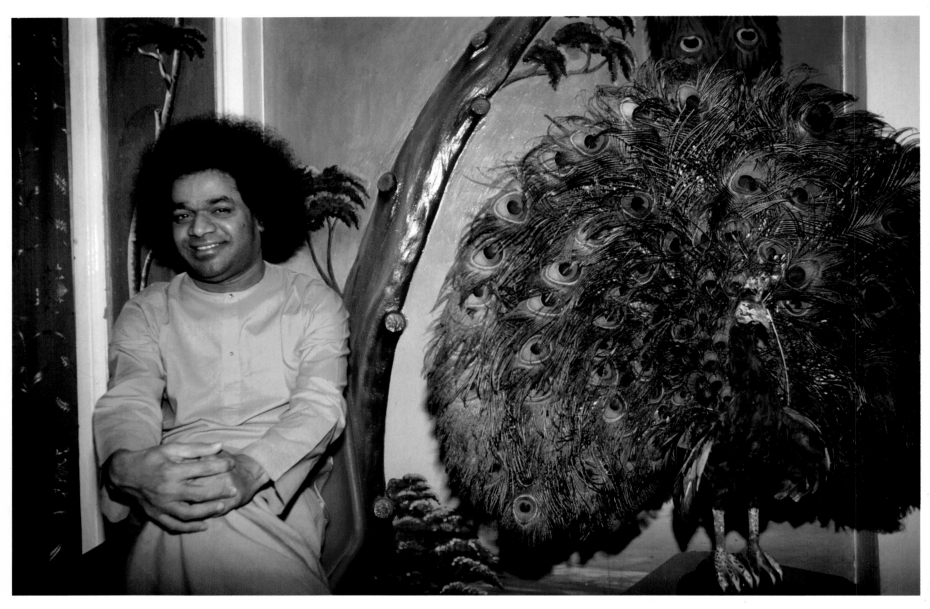

Sathya Sai Baba 12/1974

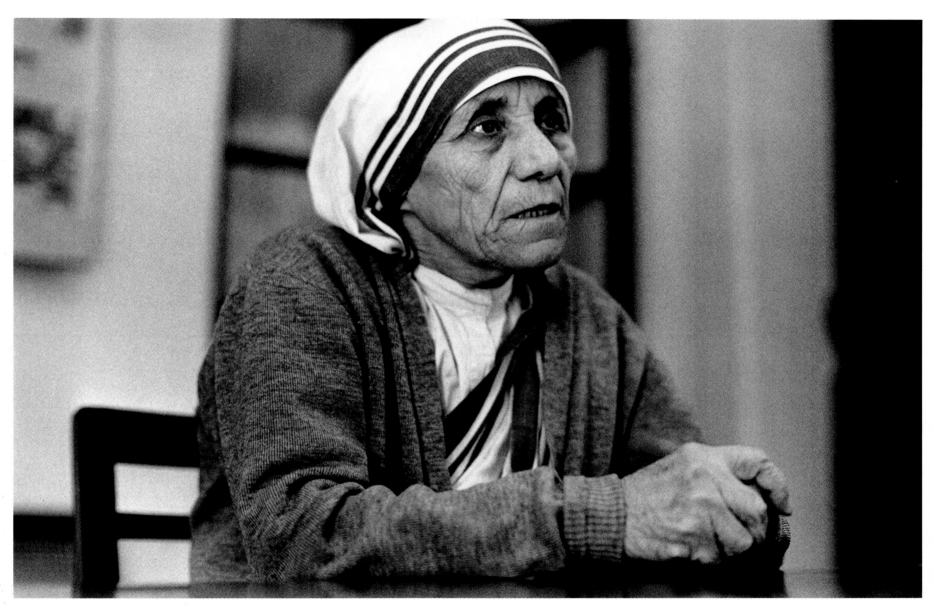

Calcutta: Mother Teresa 12/1974

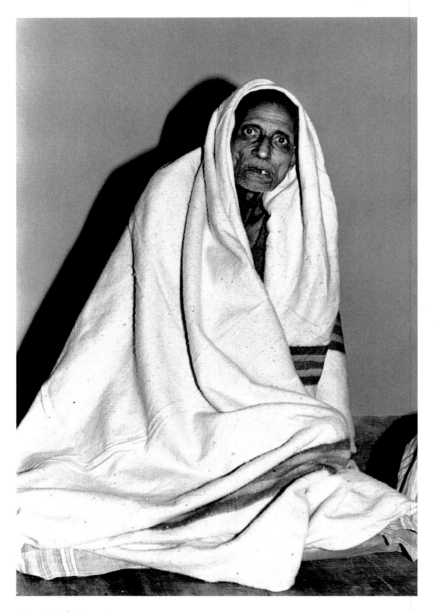

(above) **Calcutta** 12/1974

(opposite) **Goa** 12/1974

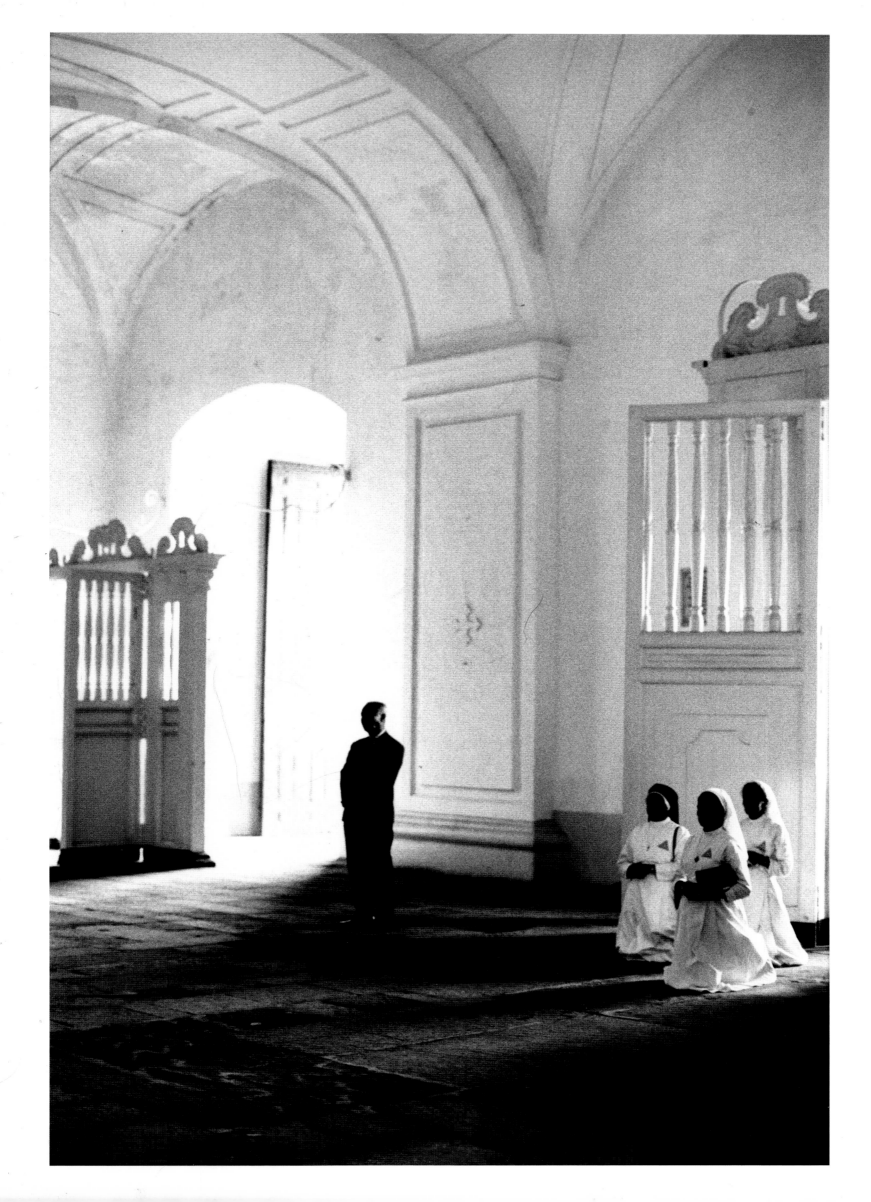

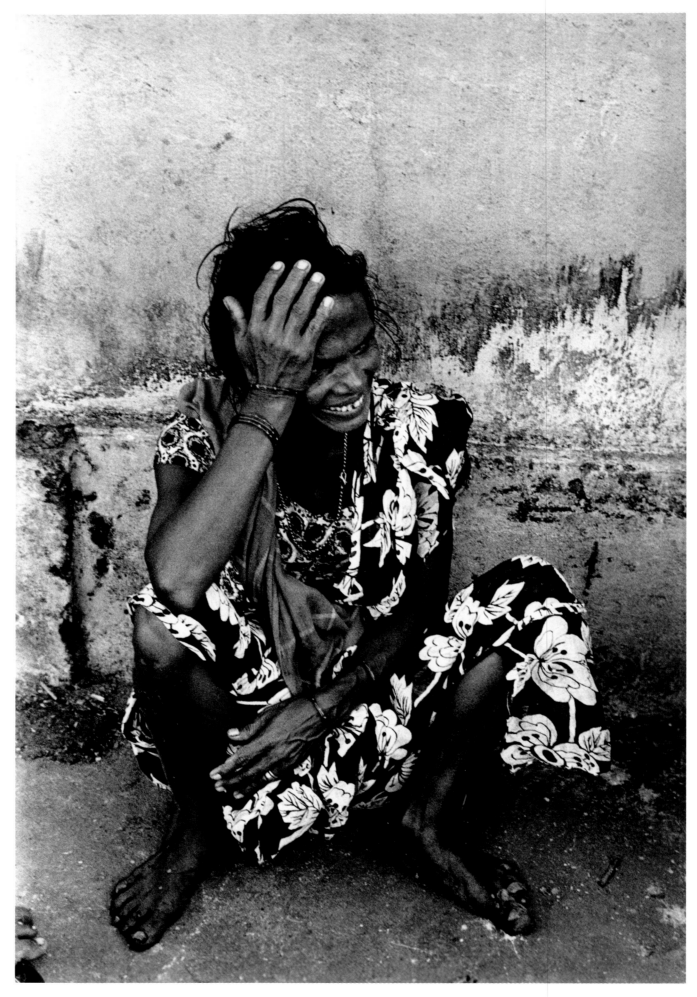

Goa 12/1974

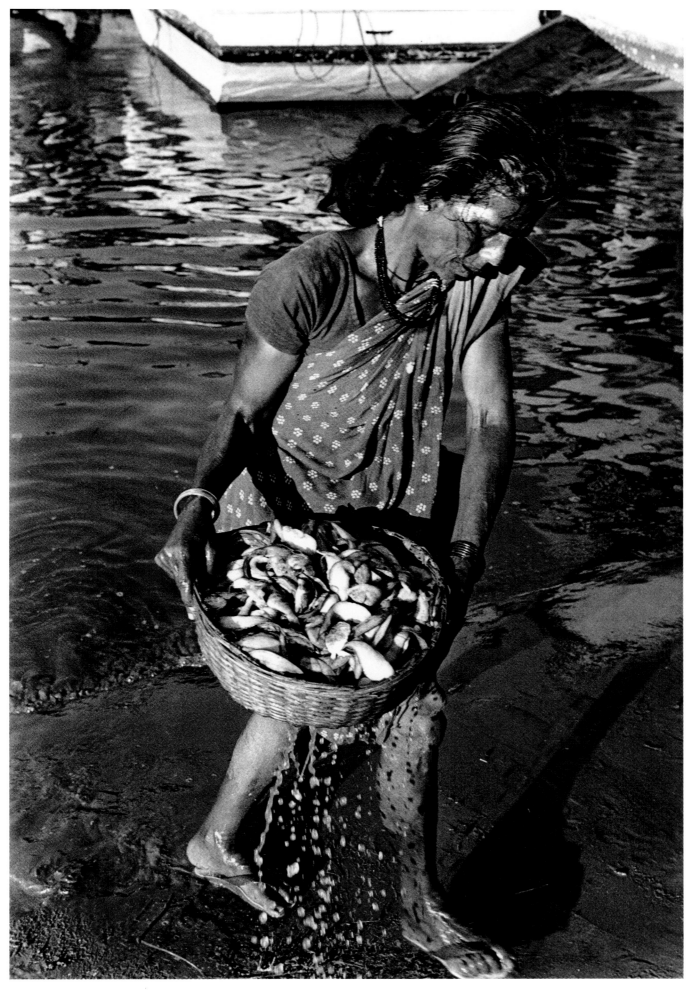

Goa 12/1974

Tokyo:
Kishin Shinoyama
11/1975

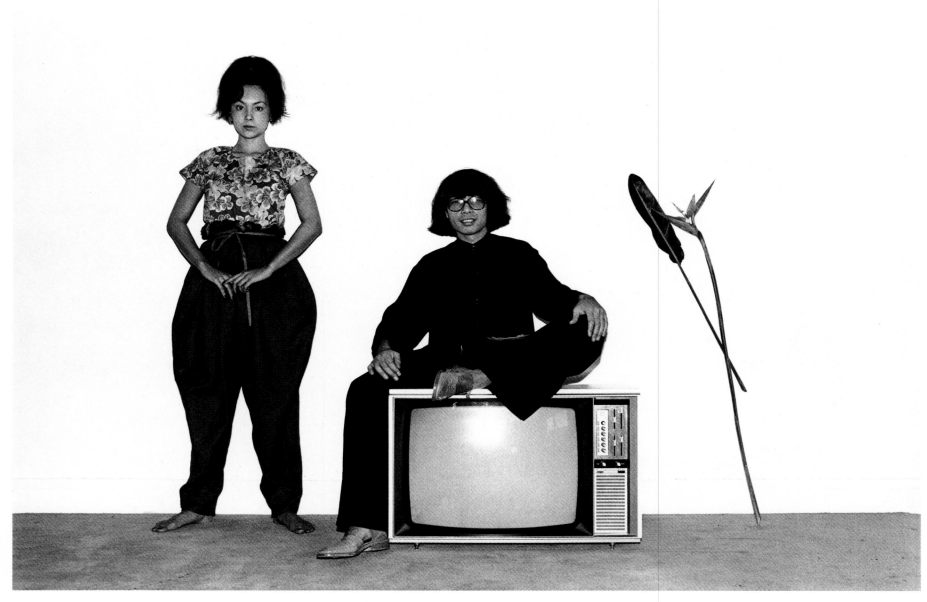

Paris: (Kenzo and Marie Helvin) *Vogue*, March 1/1976

Yokohama: Mitsuaki Ohwada (Horikin 1) 11/1975

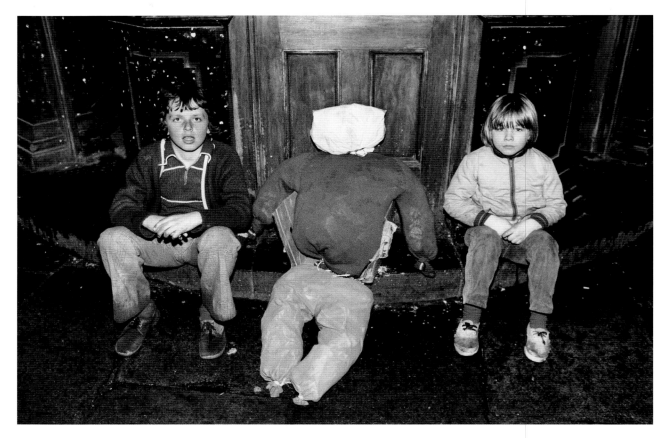

London: Guy Fawkes Night 11/1974

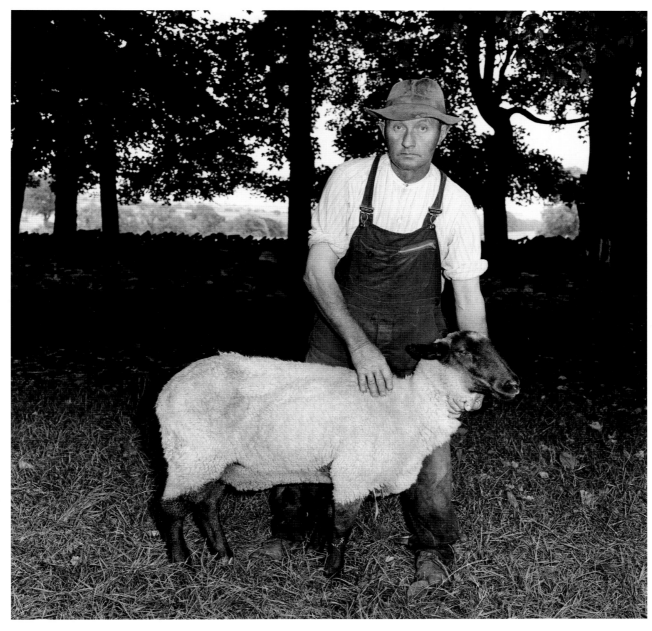

James Herriott country 8/1975

Bailey was photographing abroad for most of the mid-Seventies, and it is understandable that on the rare occasions he was back in his London studio his thoughts turned to signs of Britishness. The American edition of *House & Garden* magazine, in the first wave of popularity for James Herriott's novels, was responsible for the assignment in Yorkshire to illustrate suitably rural pursuits. Left to his own devices, Bailey stalked London for similar signs of quintessential Englishness, such as the photographs of boys with their Guys.

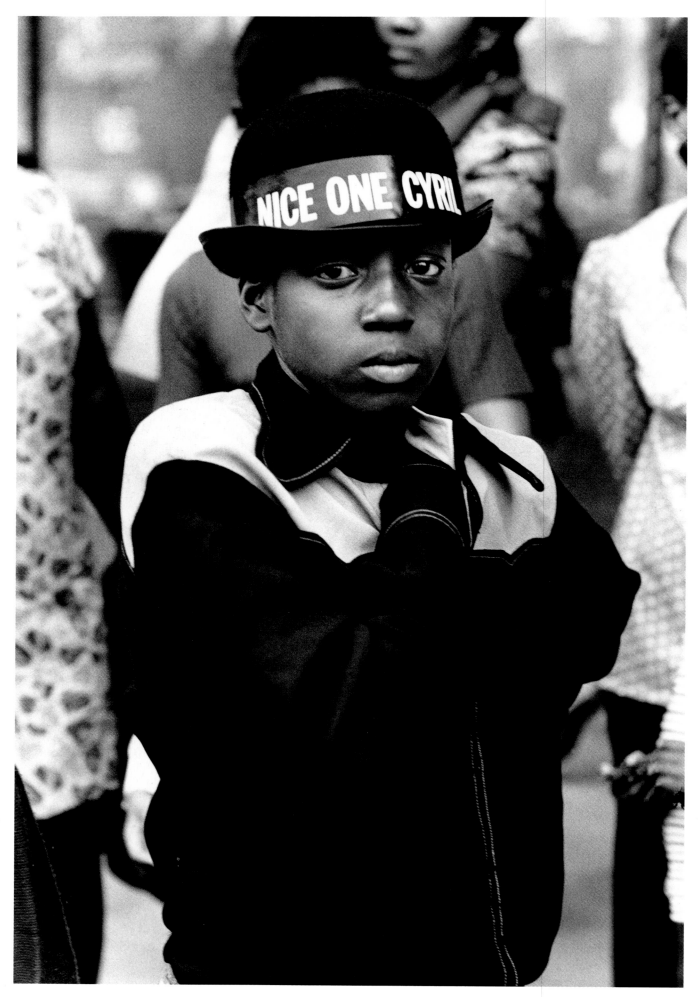

London: Notting Hill Carnival 8/1973

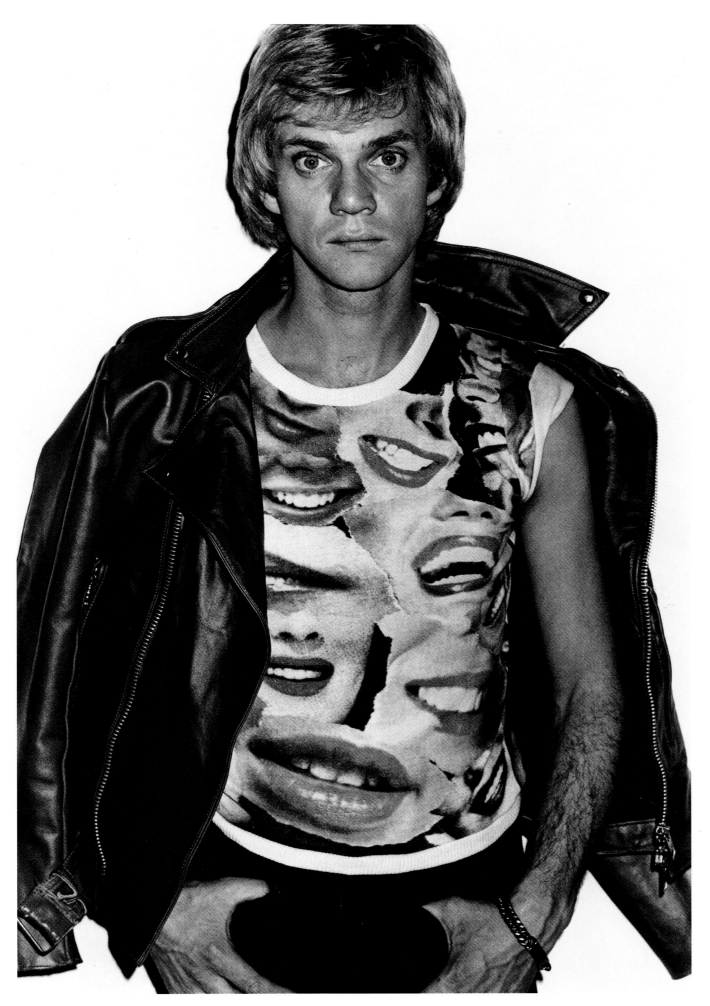

Malcolm McDowell 5/1975

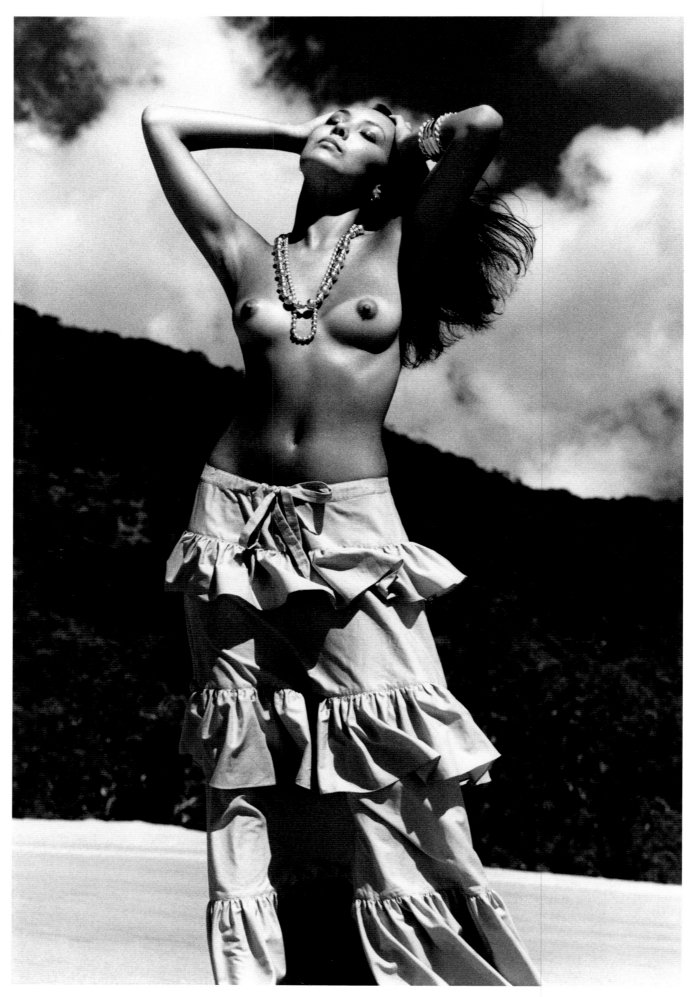

Australia: Pretty Beach (Marie Helvin) *Vogue* January 1975

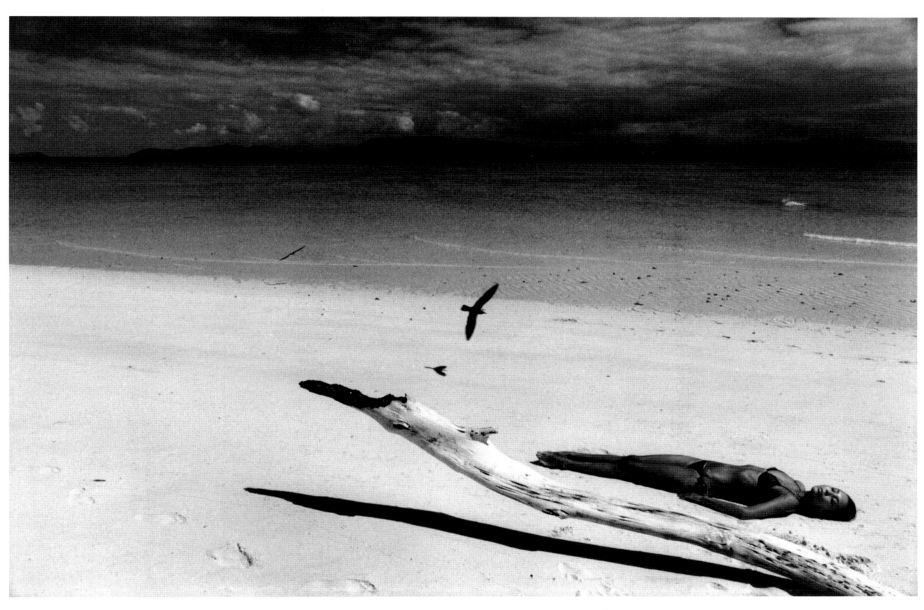

Australia: Port Douglas Beach (Marie Helvin) *Vogue* January 1975

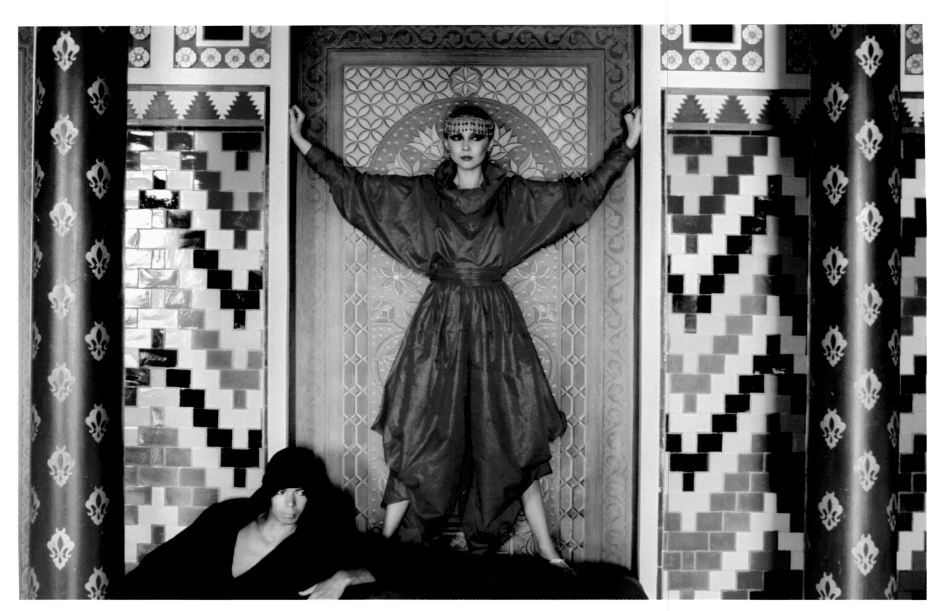

Italy: Castello di Sammezzano, Leccio (Marie Helvin and Michael Roberts) Italian *Vogue* December 1975 (variant published)

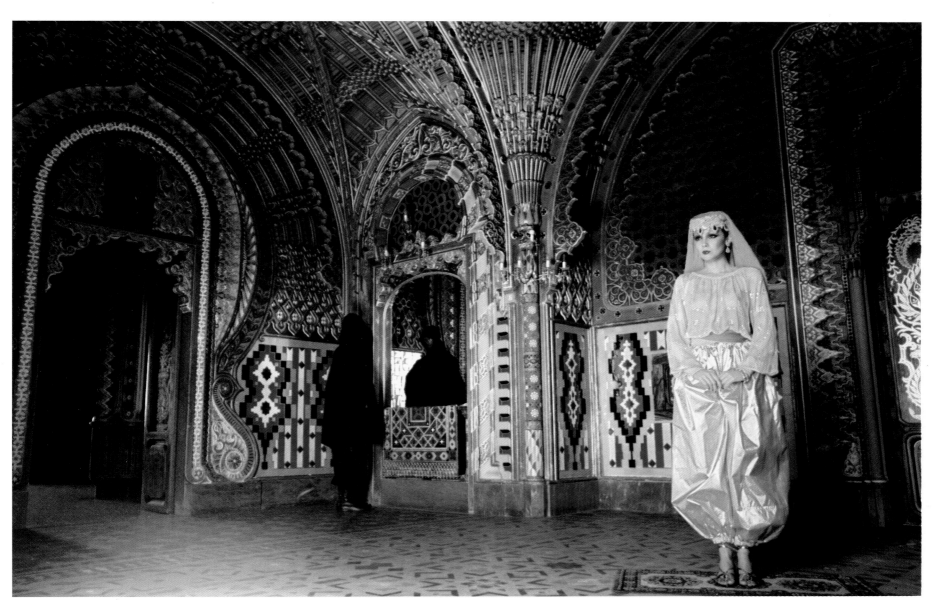

Italy: Castello di Sammezzano, Leccio (Marie Helvin and Michael Roberts) Italian *Vogue* December 1975

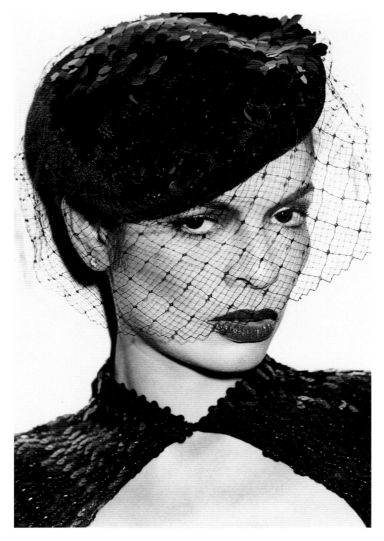

Bianca Jagger *Vogue* December 1974

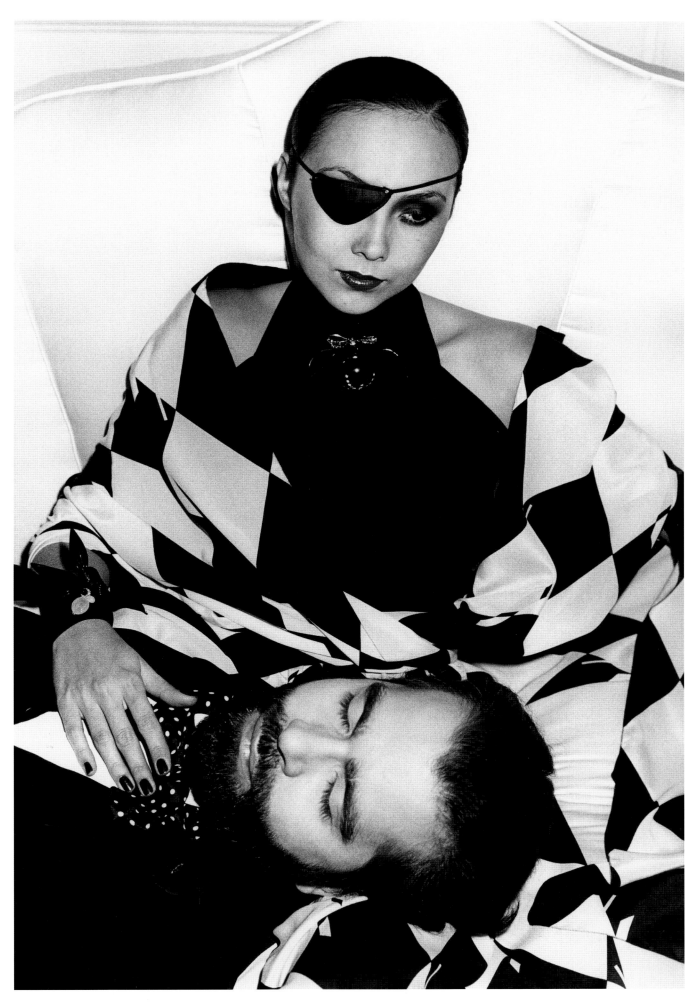

Paris: (Karl Lagerfeld and Marie Helvin) *Vogue* March 1st 1976

Marie Helvin *4/1975*

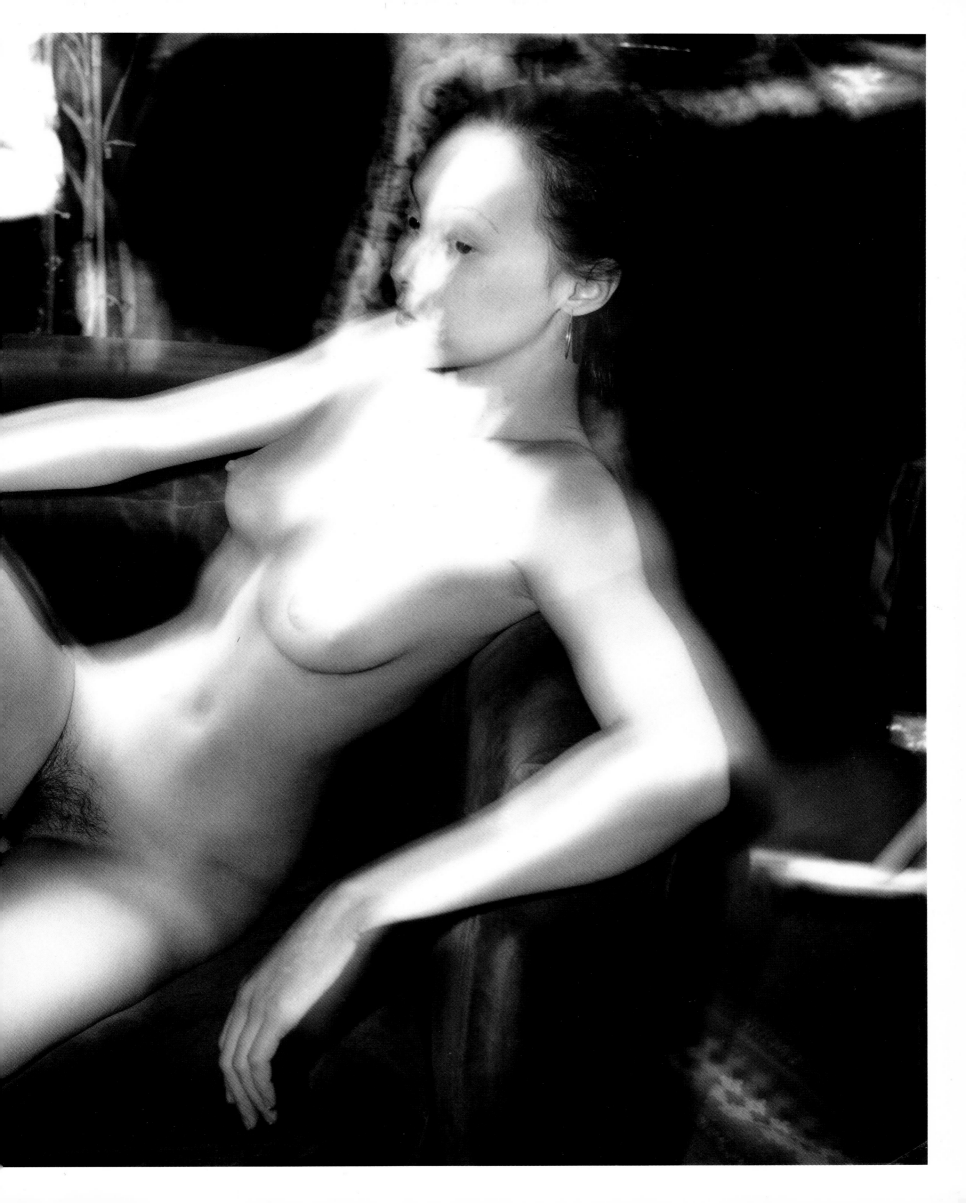

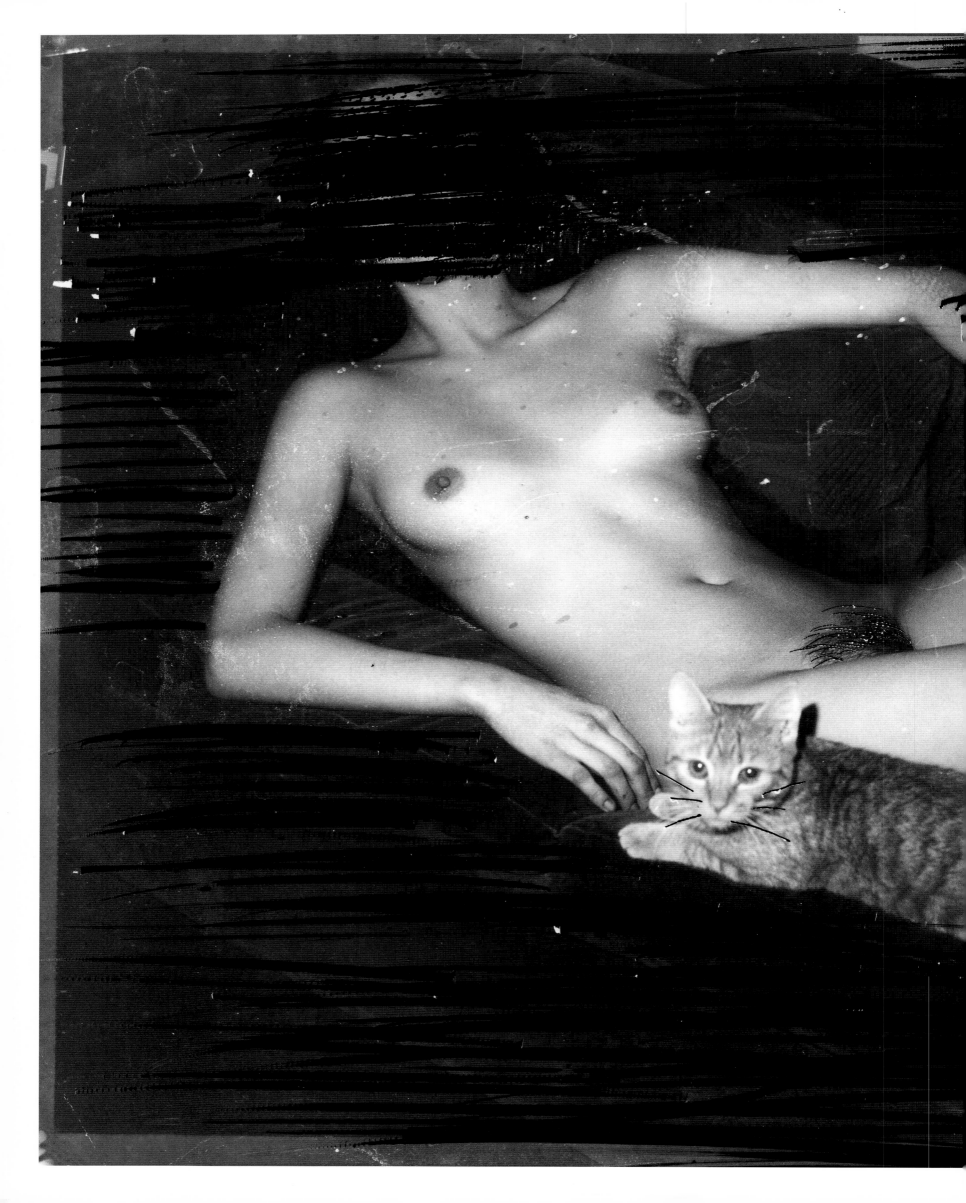

Marie Helvin 4/1975

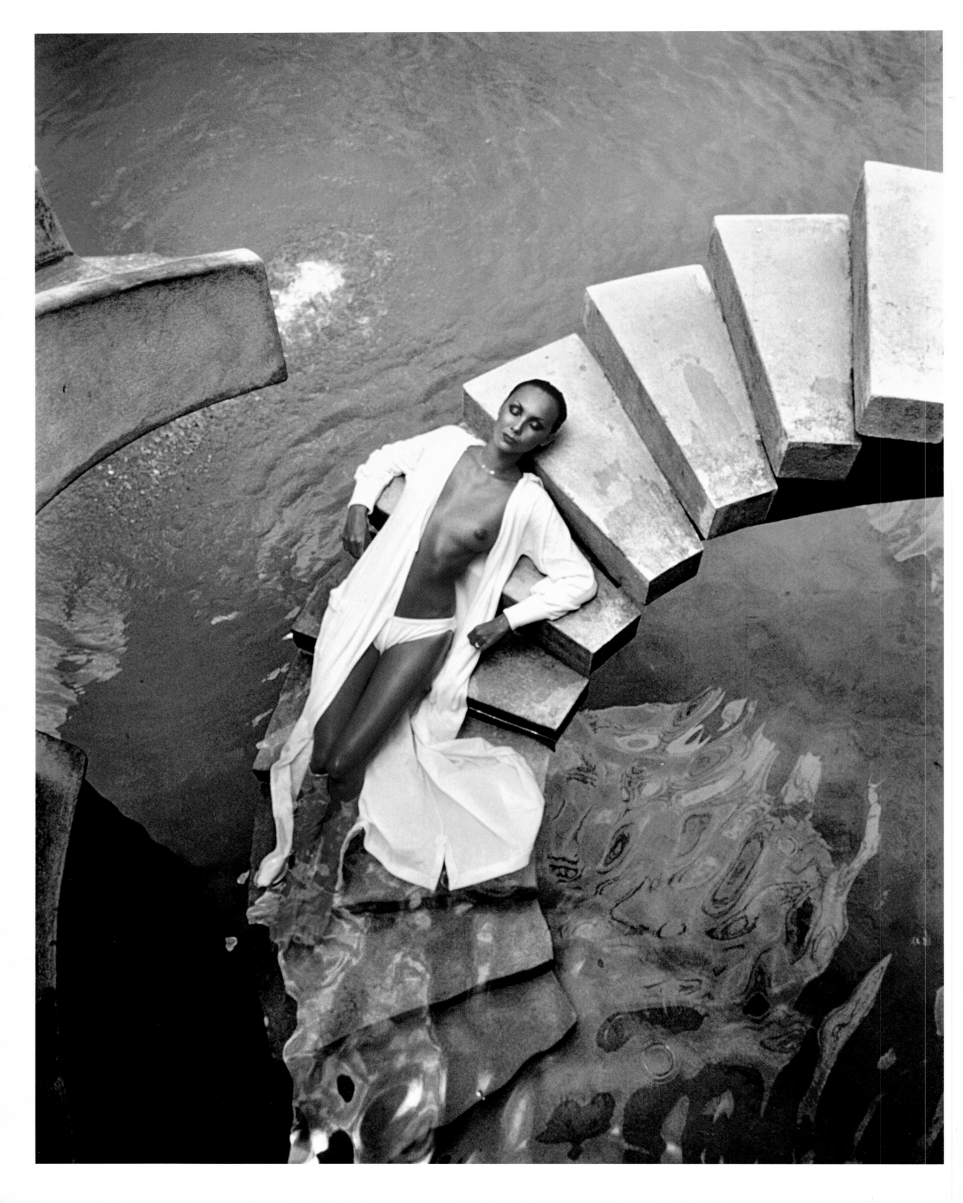

Ritzing

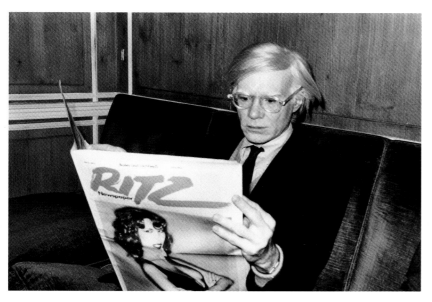

Rome: Andy Warhol reading *Ritz* 1/1977

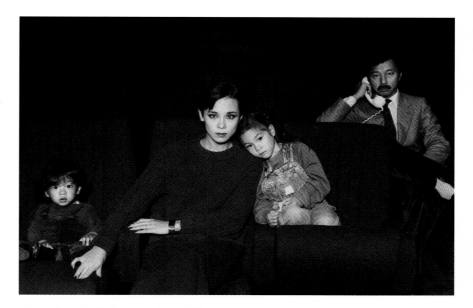

Tina and Michael Chow and their children 9/1978

The high-pressure fashion business is run by sensitive egos, and clashes of creative temperaments are far from uncommon. But since 1960, though their relationship was occasionally fraught, Bailey and *Vogue* had maintained a mutual respect and loyalty. In 1976, however, their relationship was potentially placed in jeopardy when Bailey announced his intention to launch a new 'fashion, style and gossip' newspaper, *Ritz*. Co-produced by Bailey and David Litchfield, the first edition of *Ritz* was published in December 1976. *Ritz* was modelled jointly on Andy Warhol's *Interview*, which had first appeared in 1974, and on *Rolling Stone* magazine. Its appearance did not in fact lead to the severance of Bailey's contract with *Vogue*, but there was inevitably a cooling-off period following its success as the organ of chic London; paradoxically, his collaborations with Italian *Vogue* continued, and were even strengthened. Bailey had been Photography

Consultant to an earlier venture of Litchfield's, a photography and design journal, *The Image*, of which twenty-two issues were published between 1971 and 1975. Indeed *Ritz* itself was originally intended as a quarterly photography journal, rather than an interview magazine, and Bailey was unhappy with the increasing superficiality and acerbic tone of some of the interviews it published. The generous page size of *Ritz* provided a lavish showcase for many other photographers besides Bailey, and its gossipy back pages, which were filled with the work of London's first paparazzi, such as Richard Young, anticipated the later popularity and rise of magazines such as *Hello!*

For Bailey, one of the most positive aspects of *Ritz* was that it provided a forum to publish more of his portraits. Often the sitters were also his friends, such as Jack Nicholson, Tina Chow, Jerry Hall and Alan

Tahiti: Morea (Marie Helvin) 3/1976 (for Italian *Vogue*)

Parker. The opportunity to photograph Fred Astaire – whose 'camp chic', as Bailey once described it, had made him one of his earliest heroes – was especially welcome. Diana Vreeland, who after she was fired by American *Vogue* in 1972 was made Director of Fashion at the Metropolitan Museum of Art, continued to be a close friend and ally of Bailey's. At the 1977 Paris collections a photograph that gave him particular satisfaction captured the edgy relationship between Vreeland and Alexander Liberman, Creative Director of *Vogue*. Liberman wanted photographs that 'enhanced reality', Vreeland always looked for 'allure', but, Bailey recalled, 'You could never be in both of their camps at *Vogue* – they were at war.' New names emerged

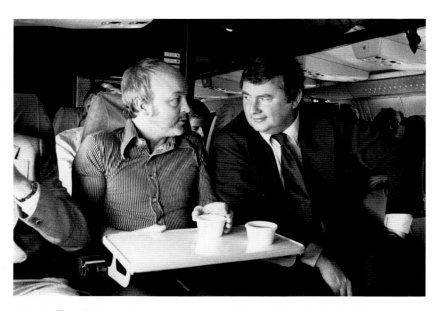

Brian Duffy and Terence Donovan en route to Cologne (Photokina) 9/1976

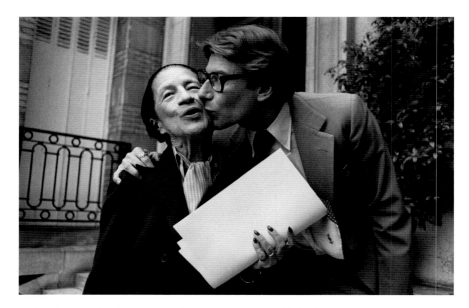

Paris: Diana Vreeland and Yves Saint Laurent 8/1977 (published in *Ritz* no. 9, 1977)

to be photographed, especially after the Punk movement. Bailey may have had reservations about Punk, but he coped with alacrity, as two of his finest portraits from this period, of Bob Marley and Patti Smith, testify.

Ever alert to technical innovations that might also infuse shock value into his fashion photography, Bailey experimented with infra-red film, and anamorphic and panoramic lenses. He continued to photograph in remote and exotic locations, now placing Marie Helvin in pared-down compositions driven primarily by adroit juxtapositions of colours, in which she became a graphic cipher. Concurrently, however, he also photographed his wife in black and white in the more intimate project begun in 1975, which he had begun to envisage as accumulating into an anthology. The photographs were published as *Trouble and Strife* in 1980, a book which was an outstanding commercial success but drew a mixed critical reaction.

Trouble and Strife was widely perceived as more glamorous than erotic, and the range of techniques and styles that Bailey explored possibly confused those who expected a single stylistic theme. It appeared, of course, at the height of feminism, but before the impact of post-modernism. Consequently, many critics appeared to overlook that in the most clichéd images, those with stocking tops, faux bondage, cats or rubber as props, Bailey – who was, after all, no naive in this territory – was being ironic in his over-statement. Even the cockney rhyming slang of the title evokes Bailey's sardonic wit, since any trouble his mannequin was causing him is not readily apparent.

In July 1979 Bailey's relationship with the camera firm Olympus (with whom he had become associated in 1975) entered a new phase. The company opened a photographic gallery in London and the opening exhibition, 'Elements', featured the work of ten photographers who had stayed together in the South of France in the autumn of 1977, a trip that provided the opportunity for Bailey to discuss photography with old friends, such as Jacques-Henri Lartigue, Helmut Newton, Brian Duffy and Don McCullin, and to make new ones, such as Ralph Gibson. At a time when photographic discourse was expanding its parameters, the informal debates at meetings like these assumed even greater importance for Bailey and his peers.

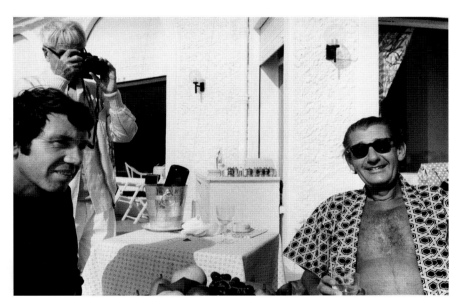

Antibes: Don McCullin, Jacques-Henri Lartigue and Helmut Newton 10/1977

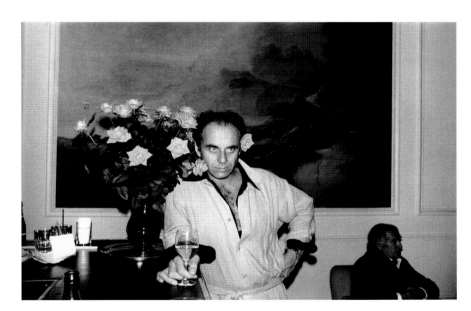

Antibes: Ralph Gibson 10/1977

Today, part of the renewed appeal of the Seventies is predicated on its disregard for 'good taste', and the most provocative photographs in *Trouble and Strife* not only resonate again, they appear decidedly *au courant*; nevertheless, it is probably the starker, simpler images that will prove the most enduring. In 1975 Bailey began to scratch and score the surfaces of his negatives, a Picasso-esque violation that aimed to intensify graphic impact and that anticipated his nudes of the 1980s.

Bailey's collaborations with the French and Italian editions of *Vogue* helped to sustain his commitment to fashion photography in the late 1970s. His photographs were frequently laid out on double-page spreads, and the 'landscape' format encouraged him to conceive his photographs as mini-series of theatrical events, as in his famous homage to René Magritte.

Bailey's collection of photographs encompassed not only his distinguished predecessors in the commercial field but also British pioneers of the nineteenth century, such as W. H. Fox Talbot, Roger Fenton and Julia Margaret Cameron. The influence on his work of some of the obsolete chemical processes was not manifested until the early Eighties, but his interest in early still-life photography was evident in a series he made in 1978, partly to express his ambivalence about meat. 'But about a month later,' he says, 'I was visiting the Museum of Modern Art in New York and I found that Frederick Sommer had copied me forty years earlier!' The rediscovery of photographers like Sommer and Ralph Eugene Meatyard, until then virtually unknown in Britain, would have a profound influence on Bailey's own photography in the Eighties.

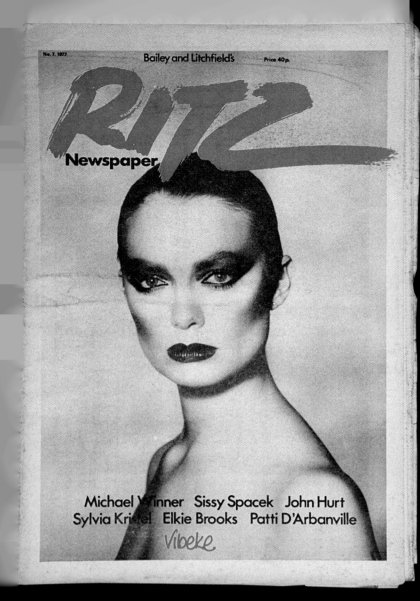

No. 7. 1977 Bailey and Litchfield's Price 40p.

RITZ
Newspaper

Michael Winner Sissy Spacek John Hurt
Sylvia Kristel Elkie Brooks Patti D'Arbanville

Vibeke

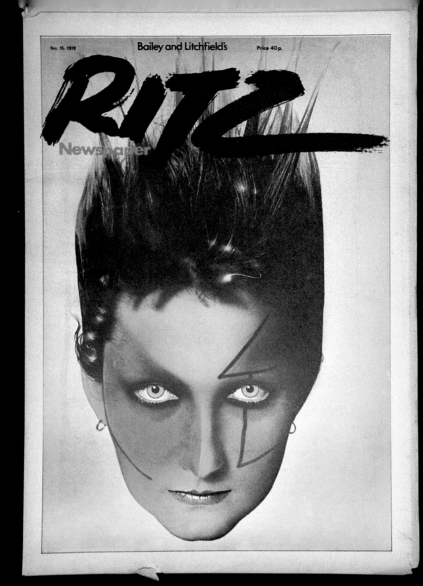

No. 15. 1978 Bailey and Litchfield's Price 40p.

RITZ
Newspaper

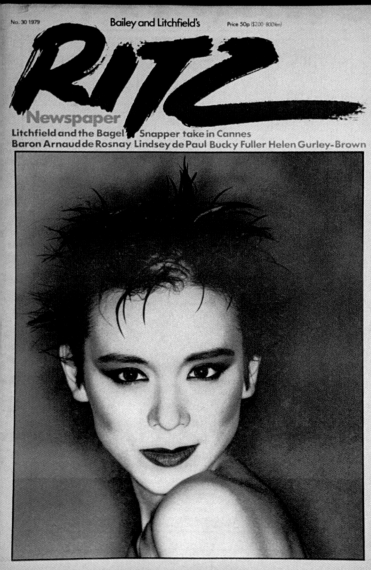

No. 30 1979 Bailey and Litchfield's Price 50p ($2.00 800km)

RITZ
Newspaper

Litchfield and the Bagel Snapper take in Cannes
Baron Arnaud de Rosnay Lindsey de Paul Bucky Fuller Helen Gurley-Brown

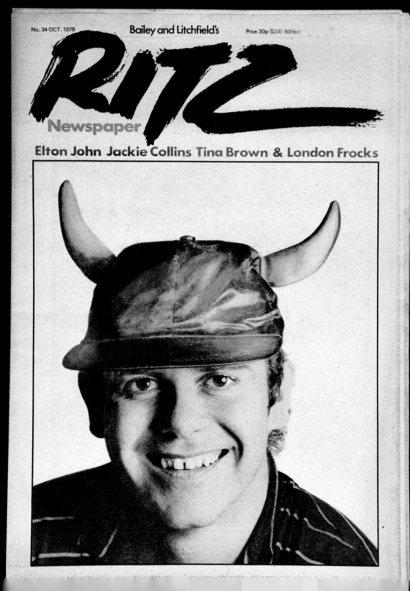

No. 34 OCT. 1979 Bailey and Litchfield's Price 50p ($2.00 800km)

RITZ
Newspaper

Elton John Jackie Collins Tina Brown & London Frocks

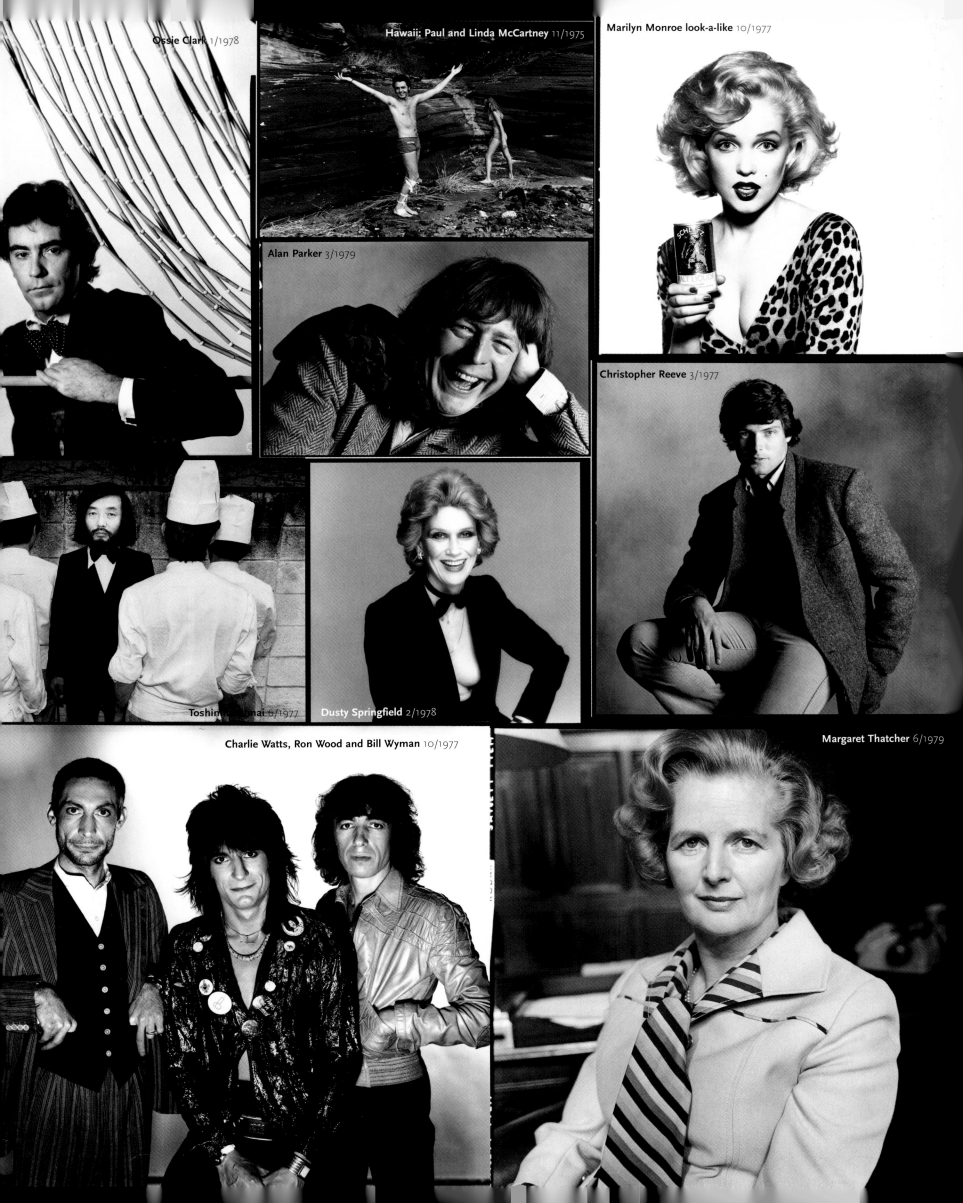

Ossie Clark 1/1978

Hawaii: Paul and Linda McCartney 11/1975

Marilyn Monroe look-a-like 10/1977

Alan Parker 3/1979

Christopher Reeve 3/1977

Toshimi Honai 6/1977

Dusty Springfield 2/1978

Charlie Watts, Ron Wood and Bill Wyman 10/1977

Margaret Thatcher 6/1979

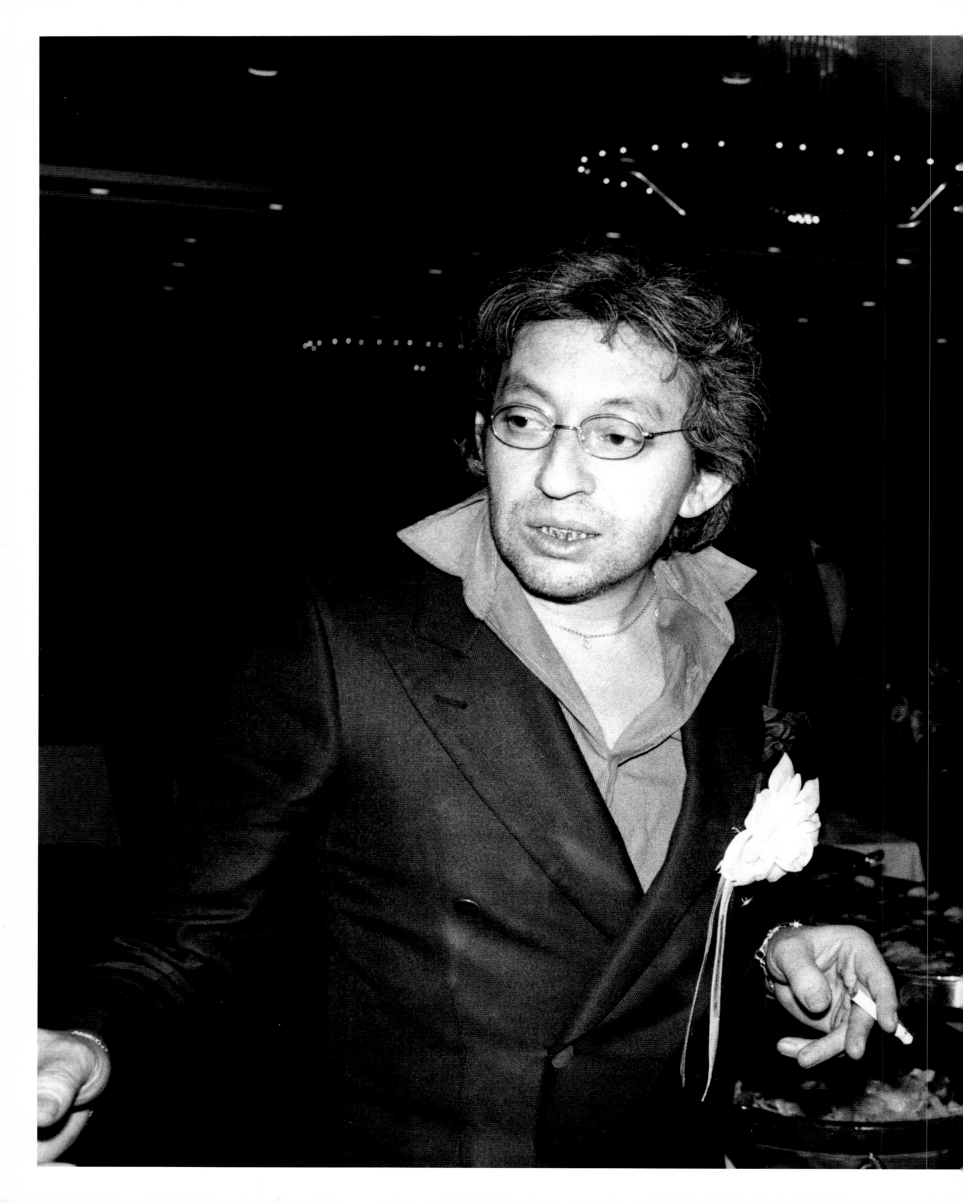

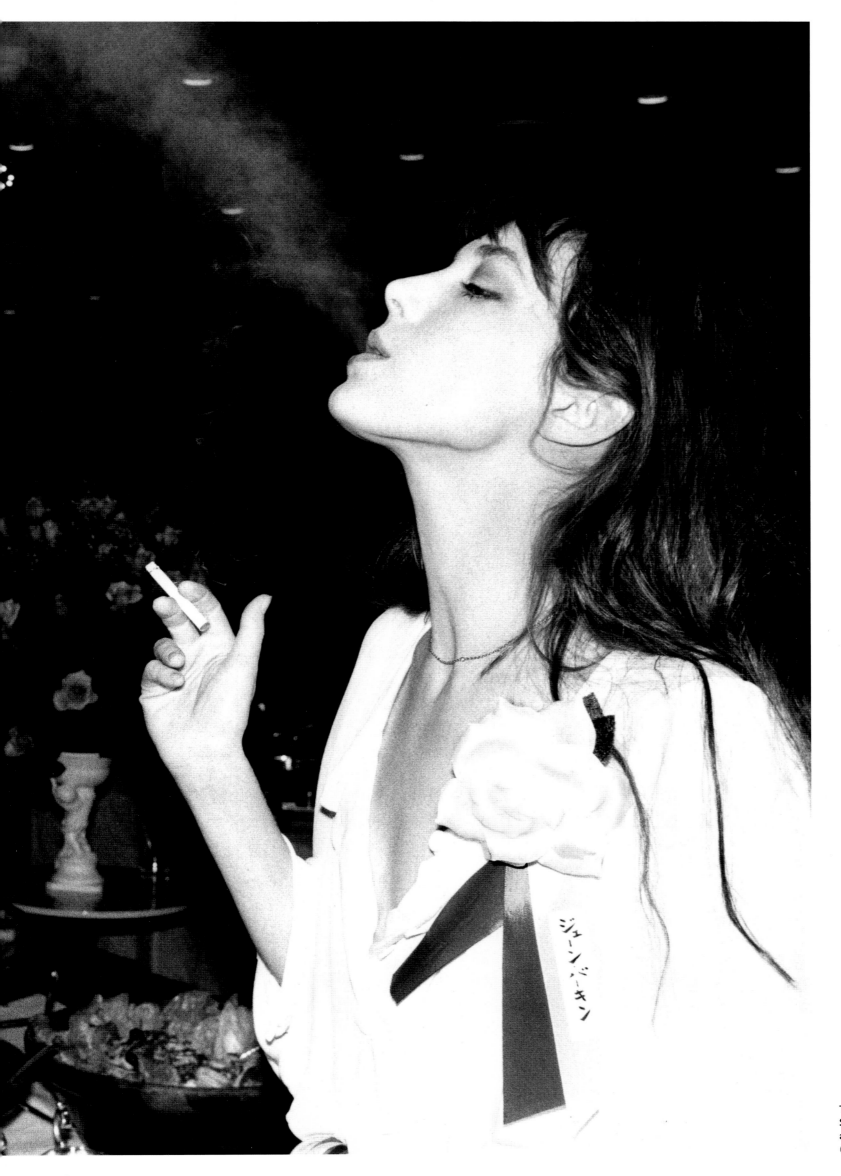

ジェーンバーキン

Tokyo:
Serge Gainsbourg
and Jane Birkin
6/1977

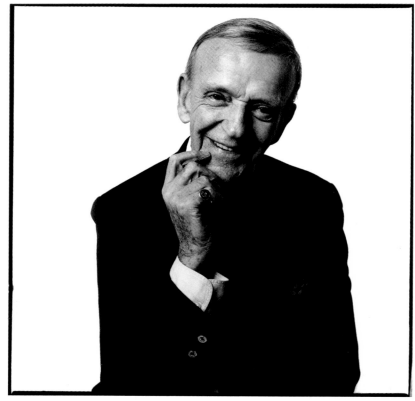

(above) **Fred Astaire:** *Ritz* no. 25, 1978

(opposite) **'Come Dancing'** 6/1978 (for *Sunday Times Magazine* – variant published)

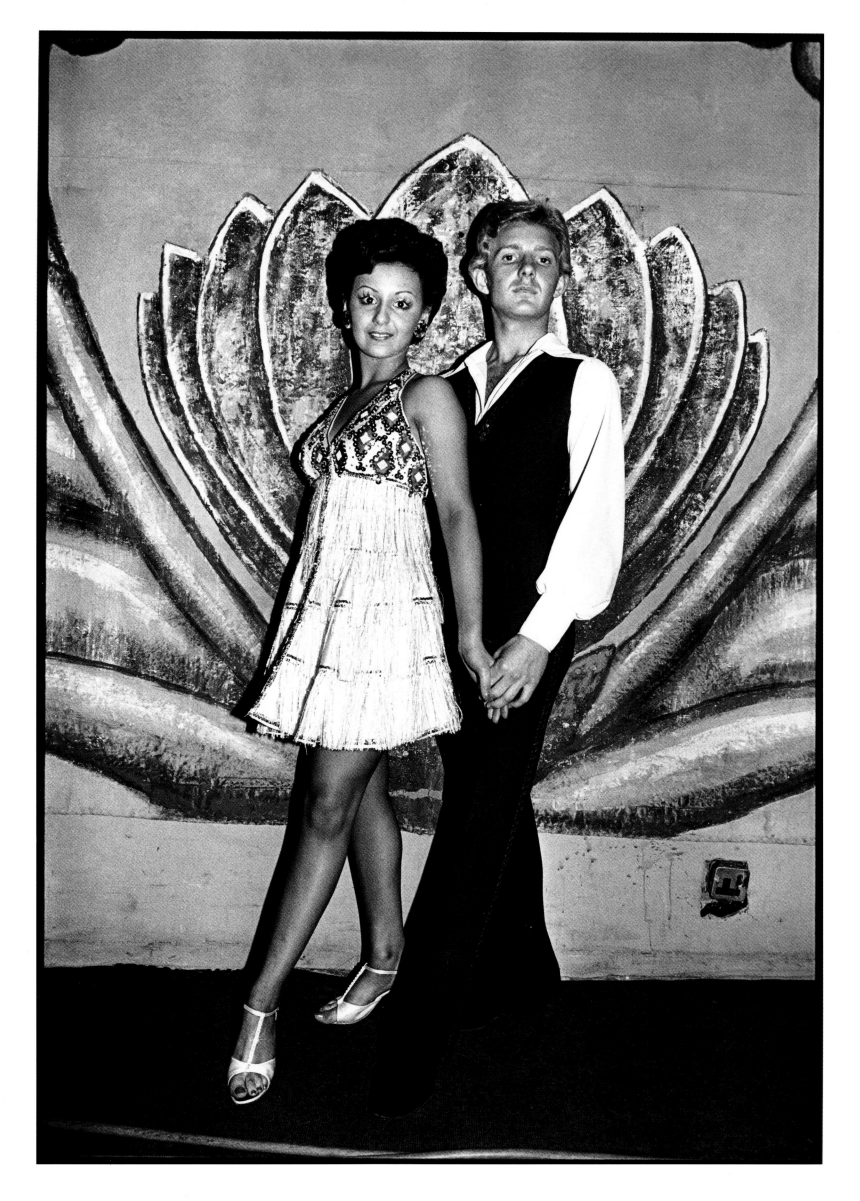

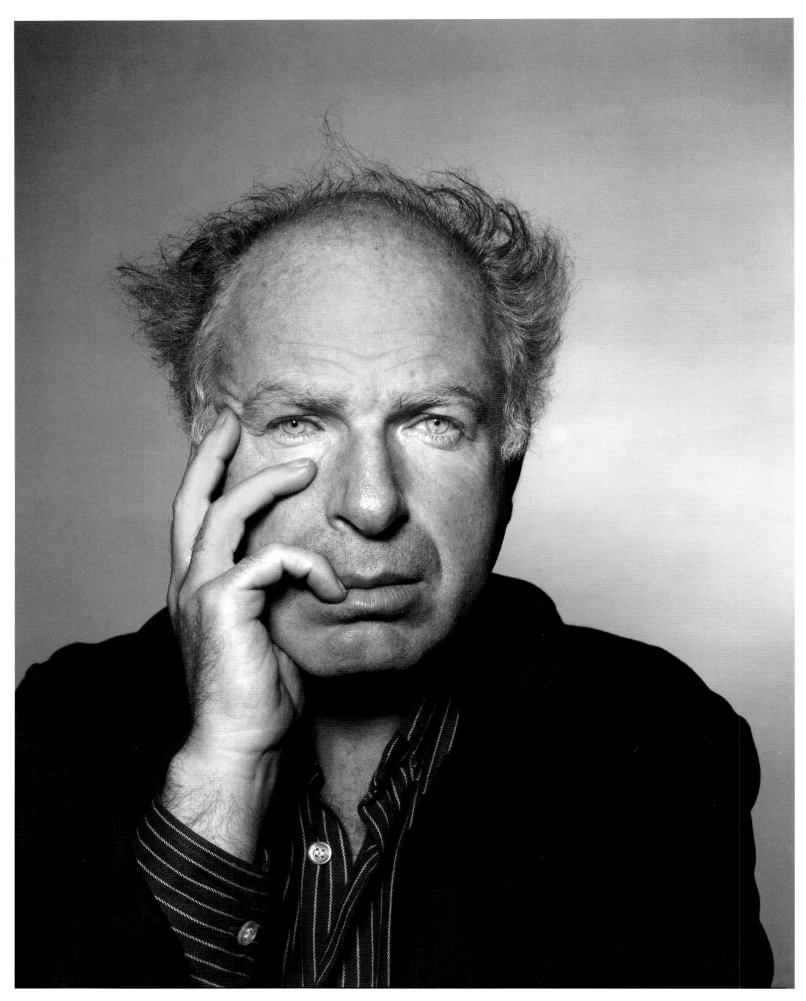

Peter Brook *Ritz* no. 9, 1977

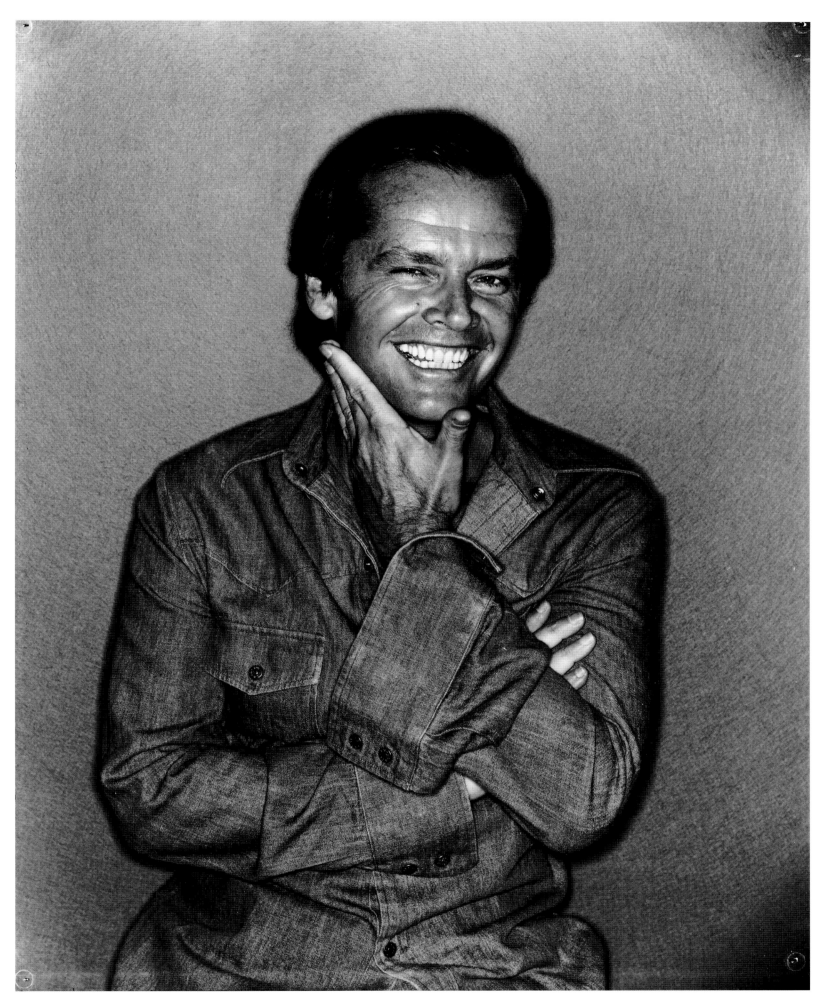

Jack Nicholson *Ritz* no. 18, 1978

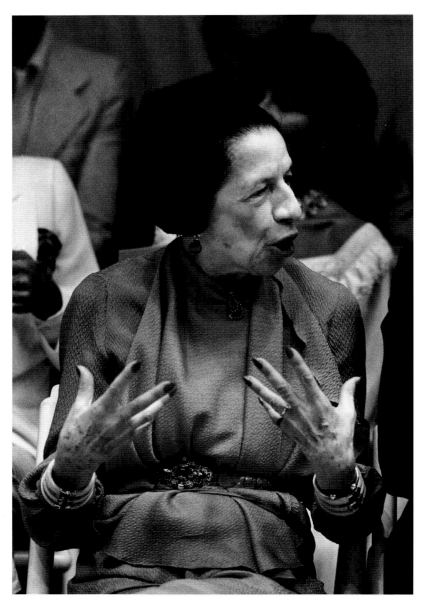

Paris: Diana Vreeland 8/1977

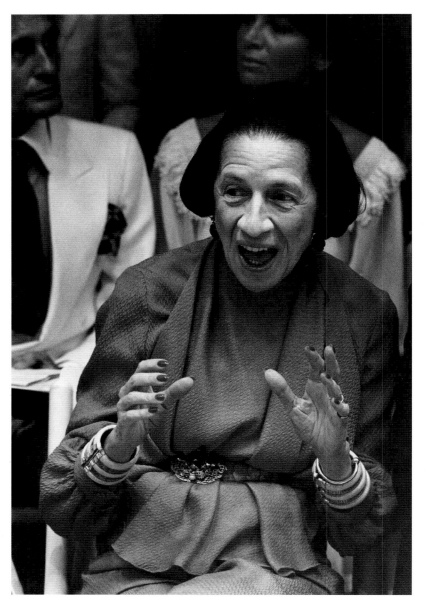

Paris: Diana Vreeland 8/1977

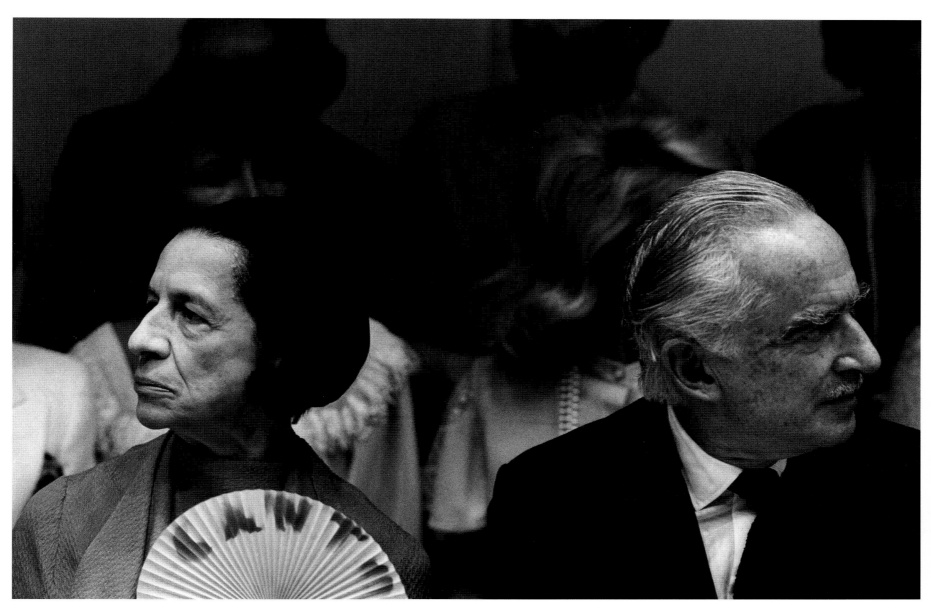

Diana Vreeland and Alexander Liberman 8/1977

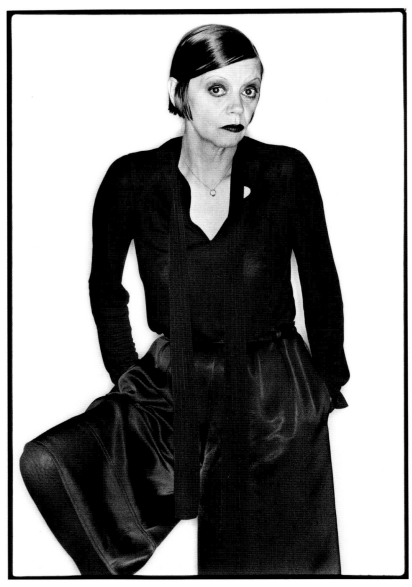

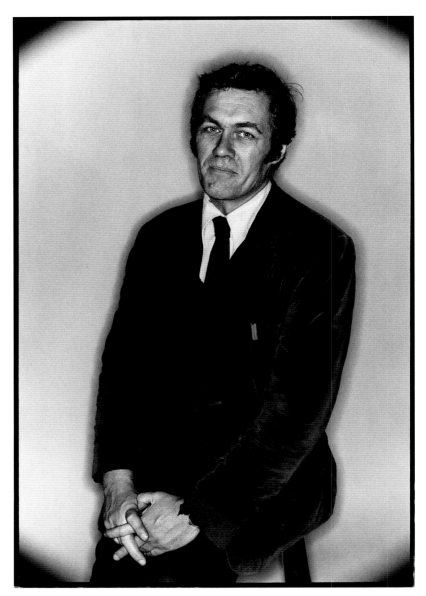

Jean Muir 10/1976

Richard Ingrams 10/1976

(opposite) **Gilbert and George** 2/1976 (for *Sunday Times Magazine*)

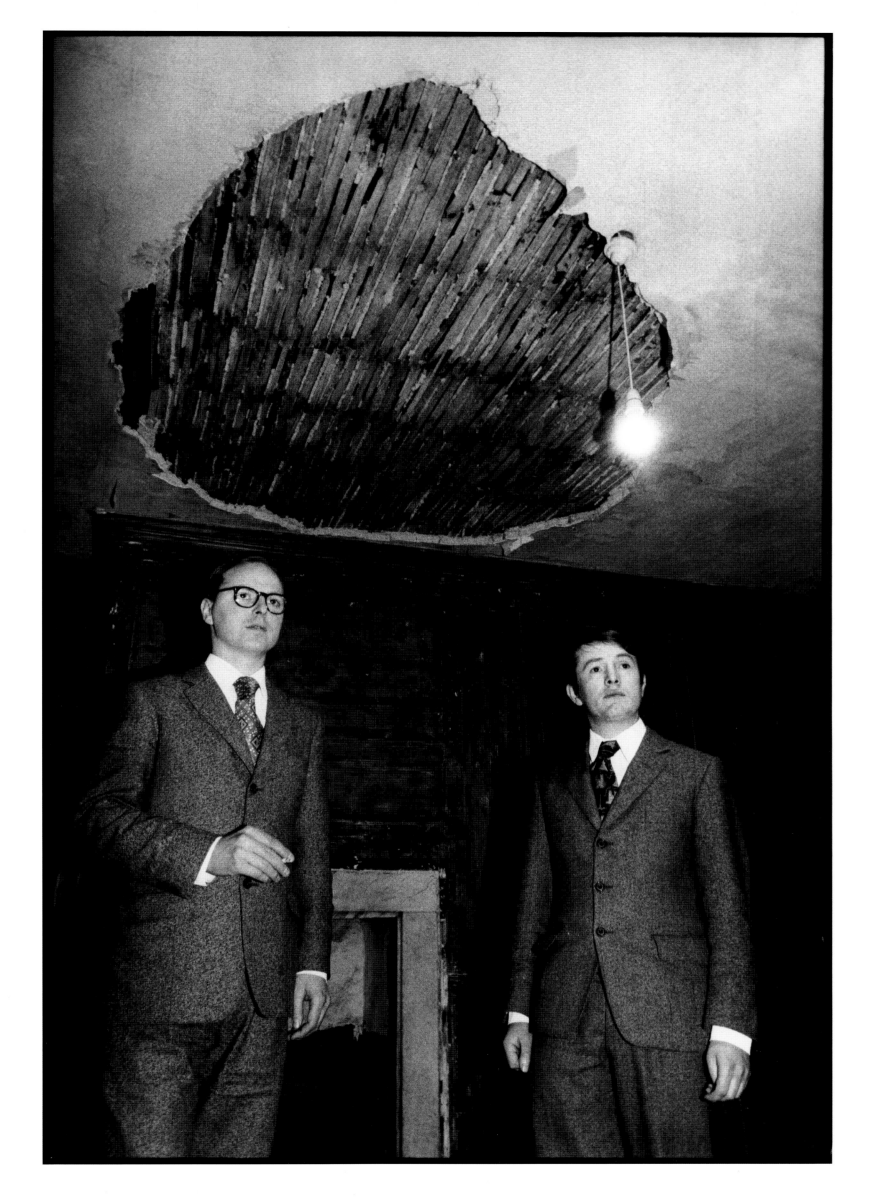

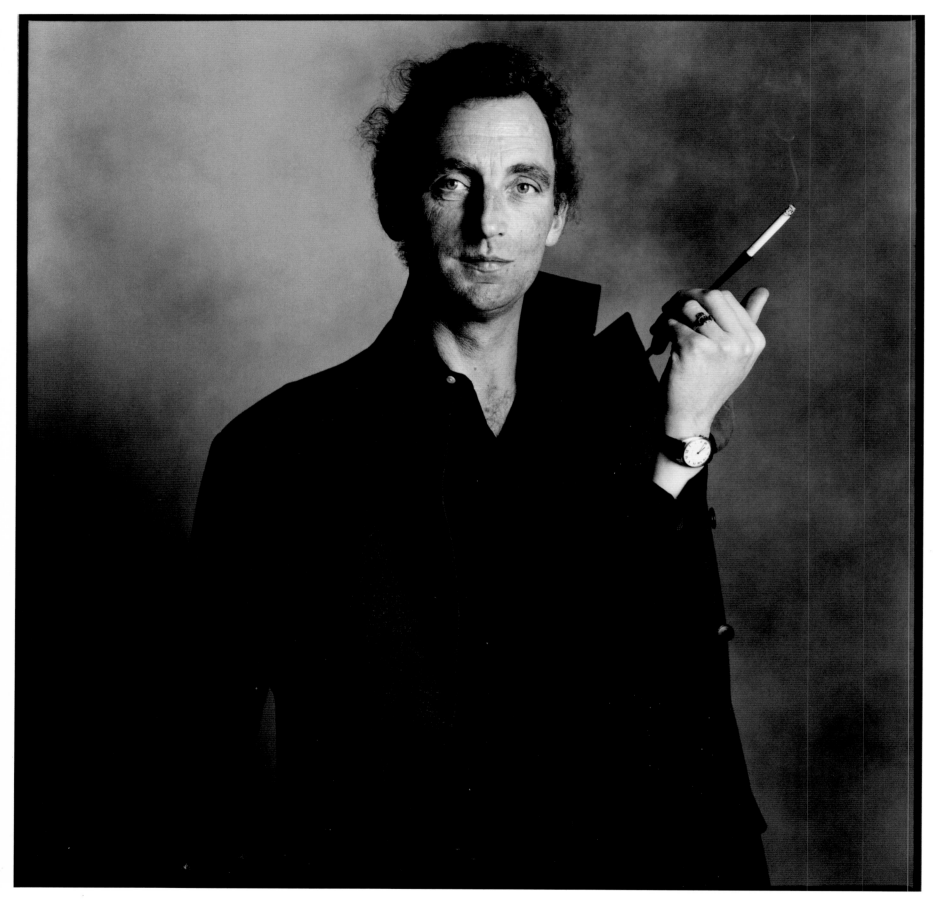

Patrick Procktor 11/1978

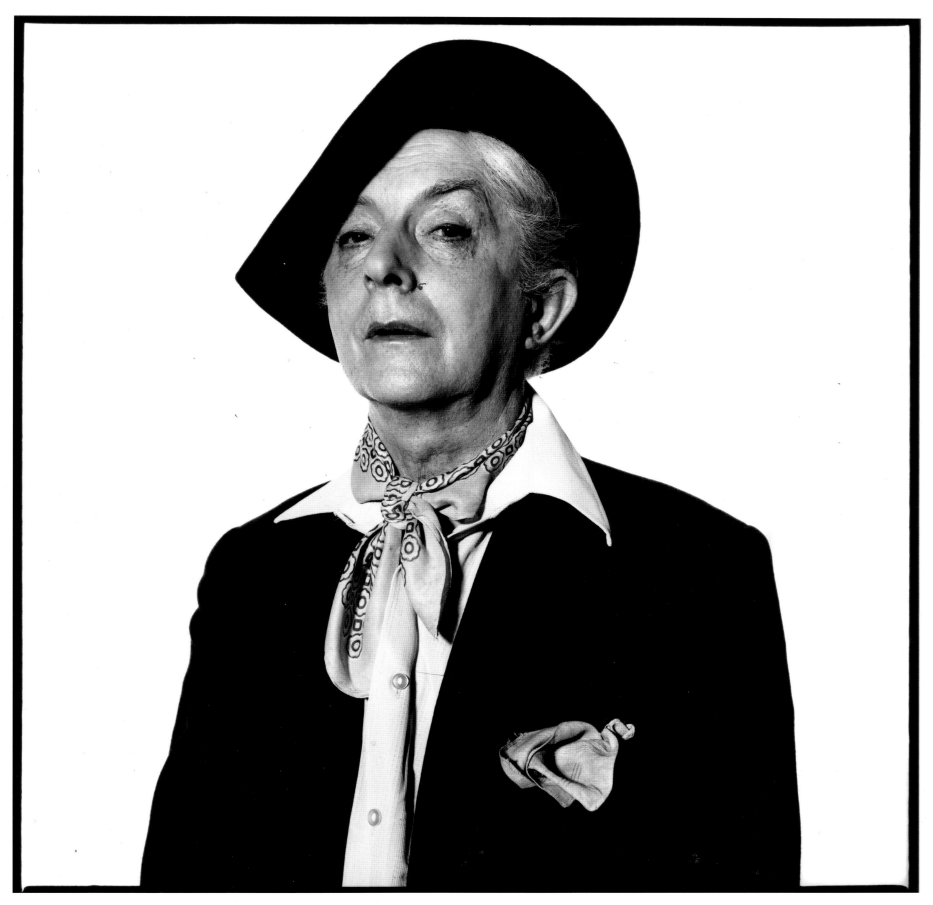

Quentin Crisp 5/1978

Gladys Bailey (Bailey's mother) 8/1976

Stephen Tennant *Ritz* no. 14, 1978

(above) Italian *Vogue* April 1977

(opposite) **Haiti** 3/1976 (for French *Vogue*)

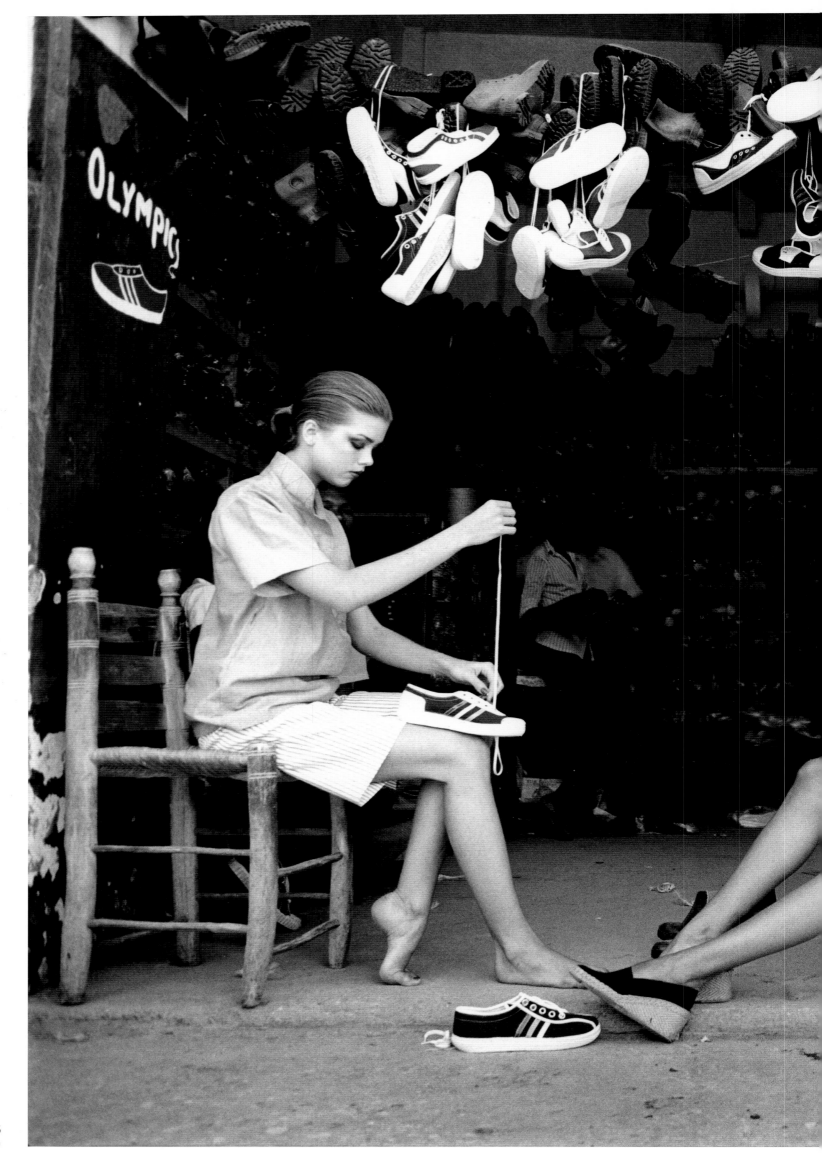

Haiti 3/1976
(for French *Vogue*)

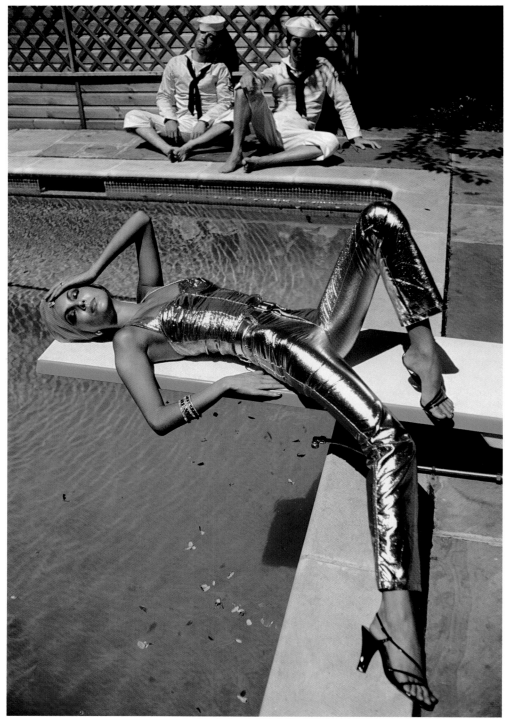

(above) **Italy: Como (Marie Helvin)** 7/1976 (for Italian *Vogue*)

(opposite) **Tahiti: Morea (Marie Helvin)** Italian *Vogue* May 1976

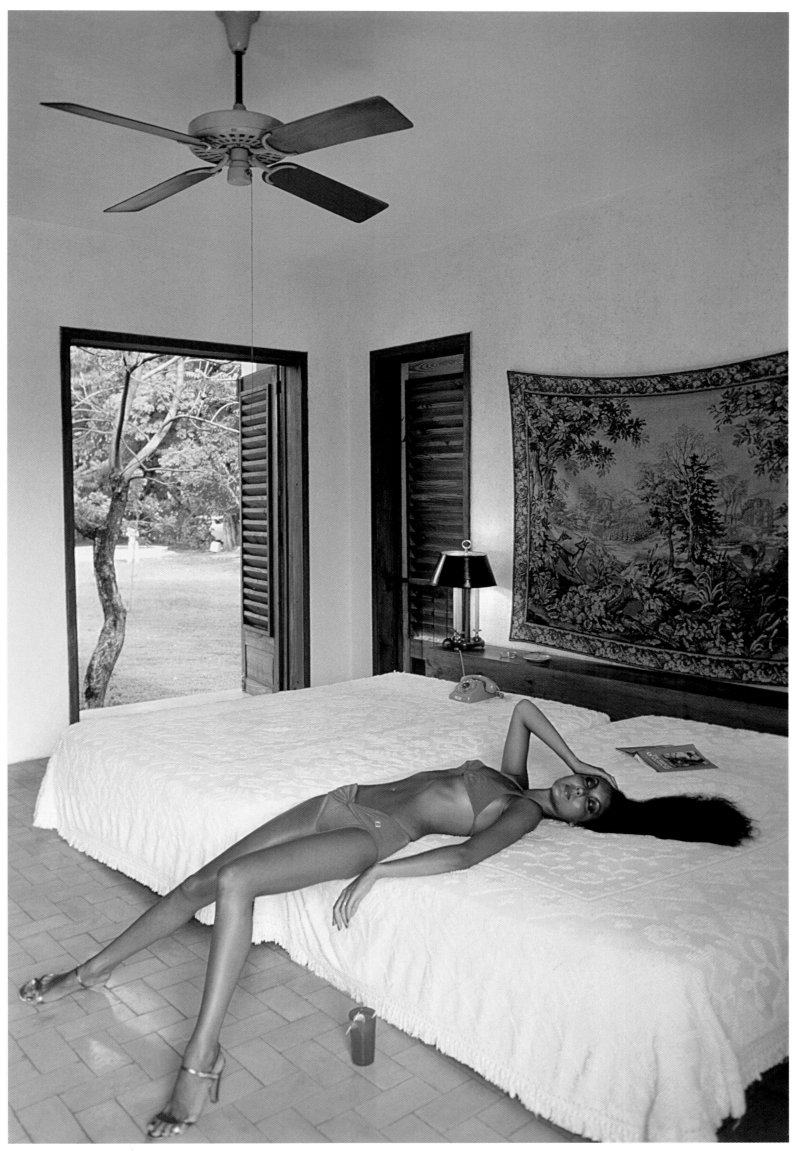

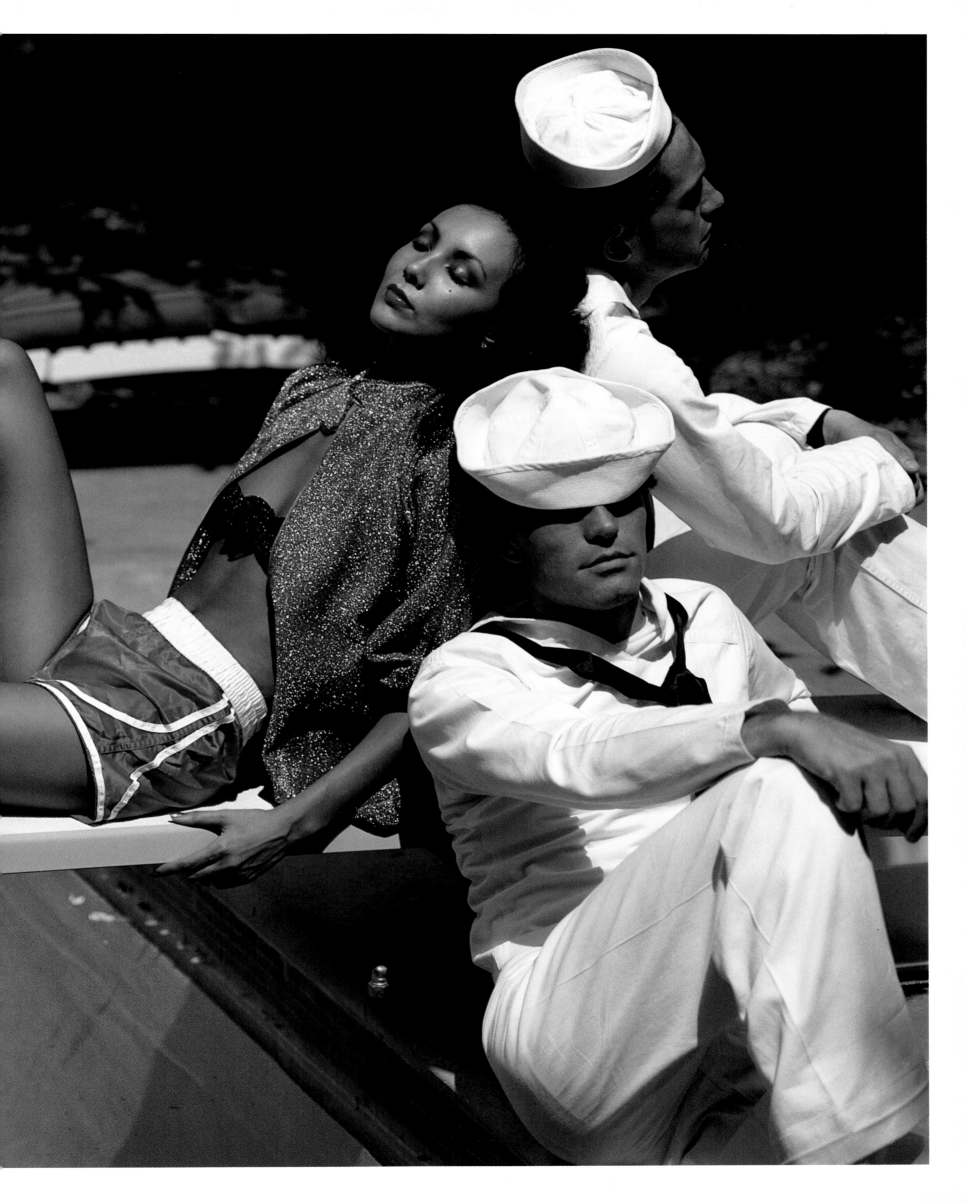

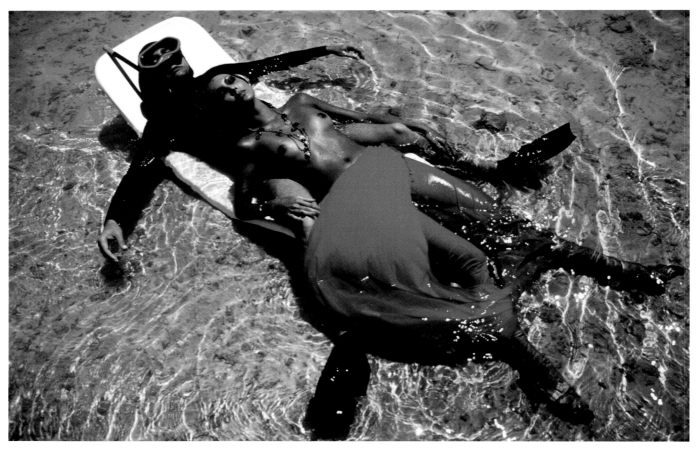

Tahiti: Morea (Marie Helvin) Italian *Vogue* May 1976

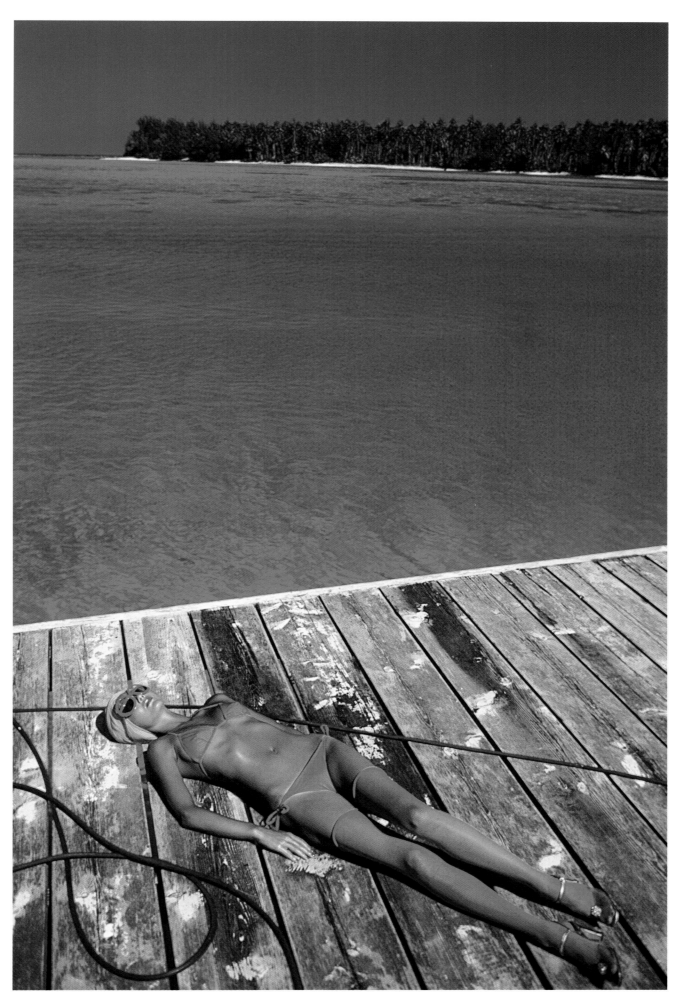

Tahiti: Morea (Marie Helvin) Italian *Vogue* May 1976

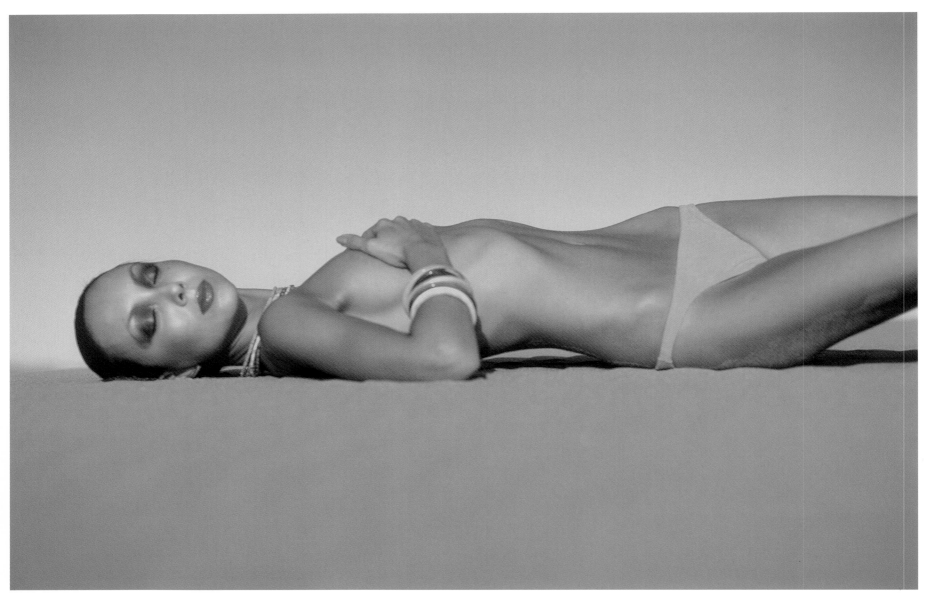

Australia: Pretty Beach *Vogue* January 1975 (variant published)

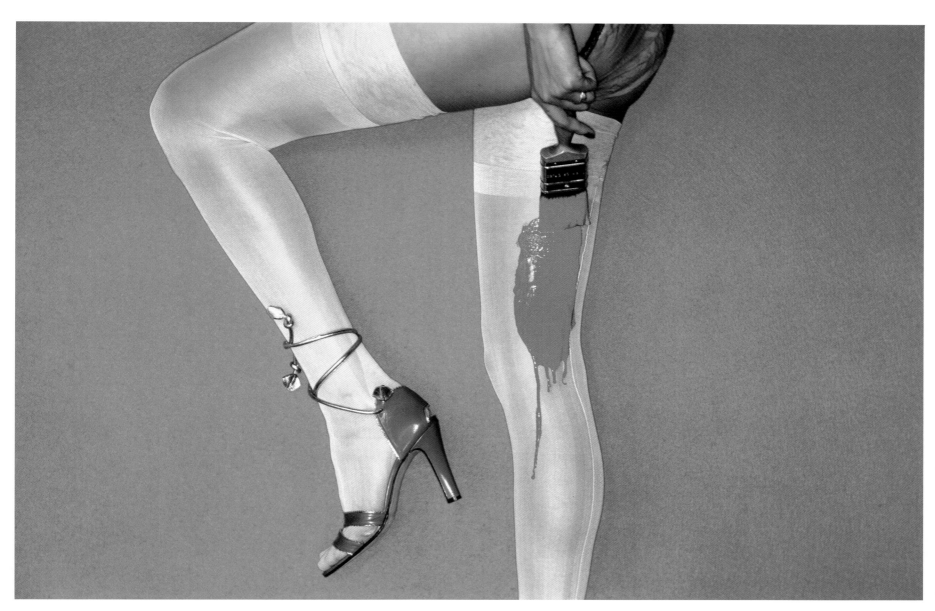

Morocco (Marie Helvin) 1/1976 (for *Vogue* – unpublished)

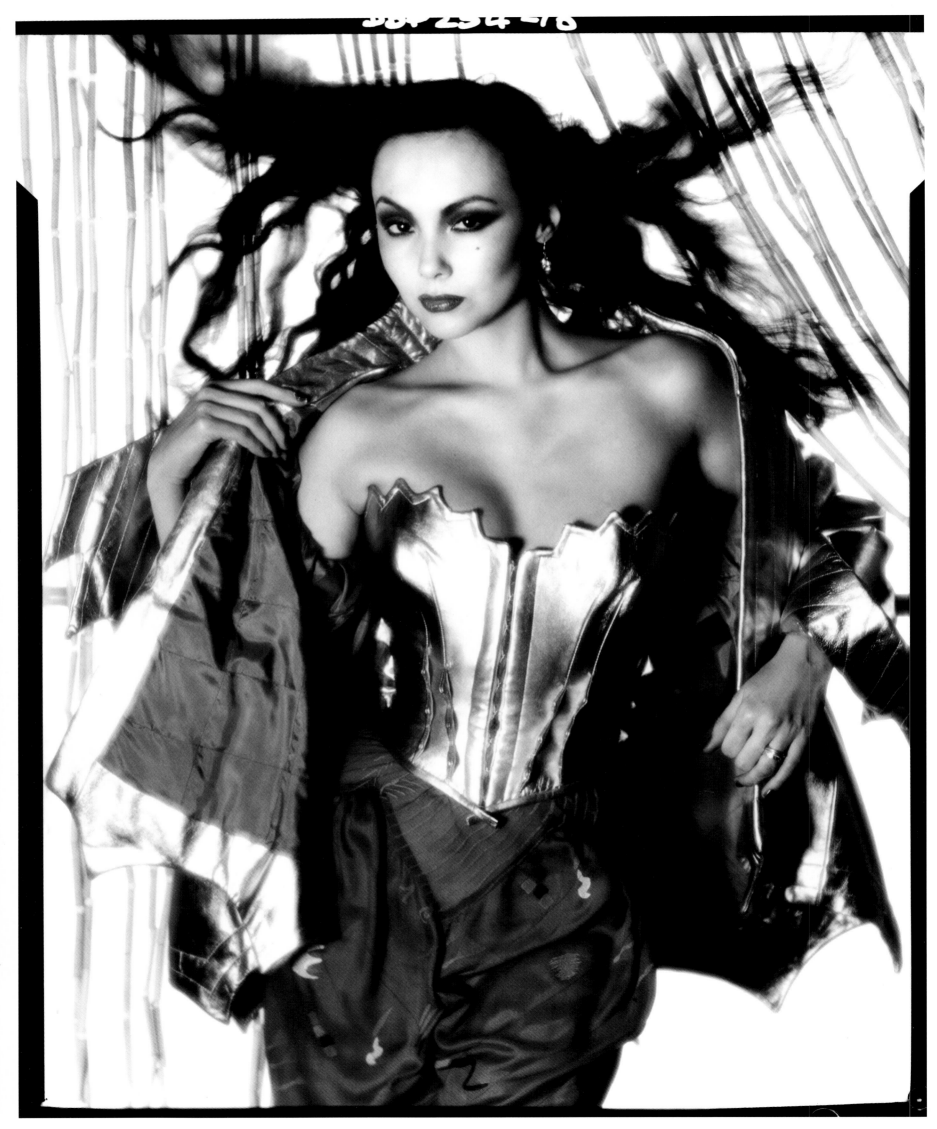

Marie Helvin *Ritz* no. 14, 1978

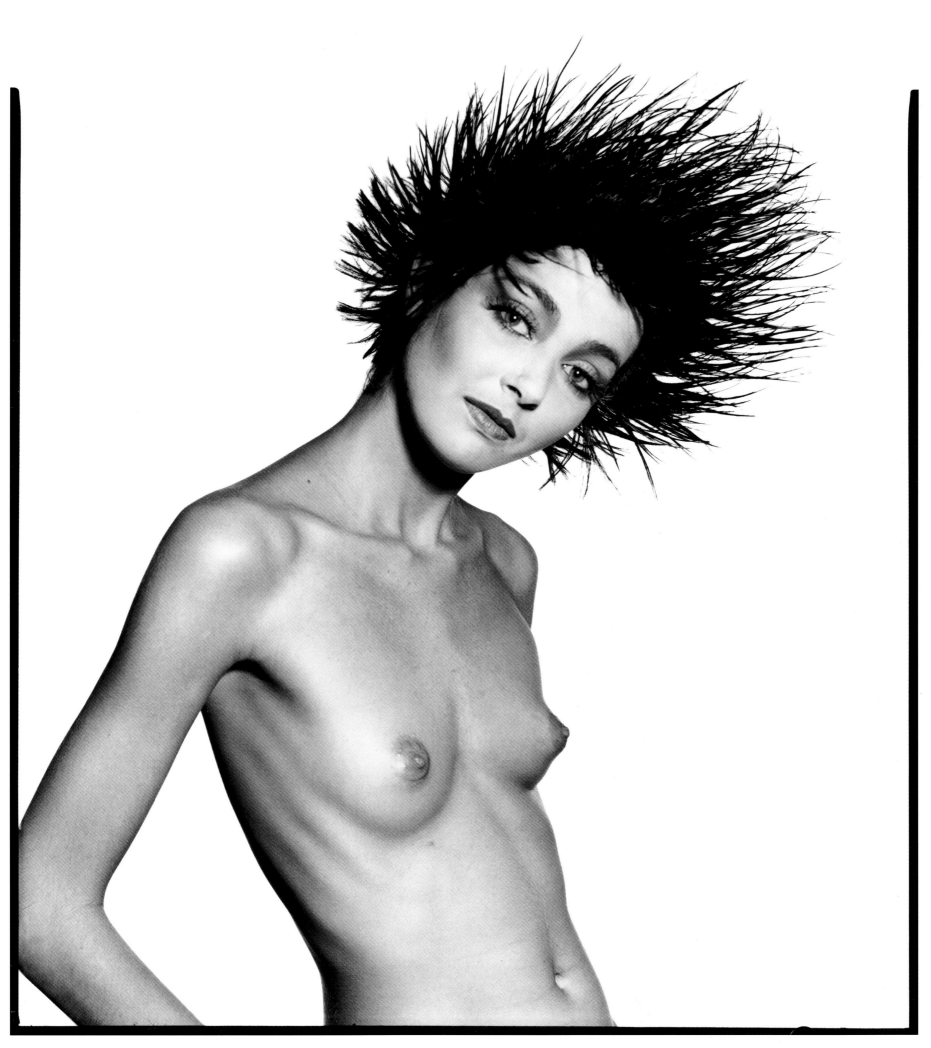

Jorden *Ritz* no. 23, 1978

Kim Harris 4/1979 (for Italian *Vogue*)

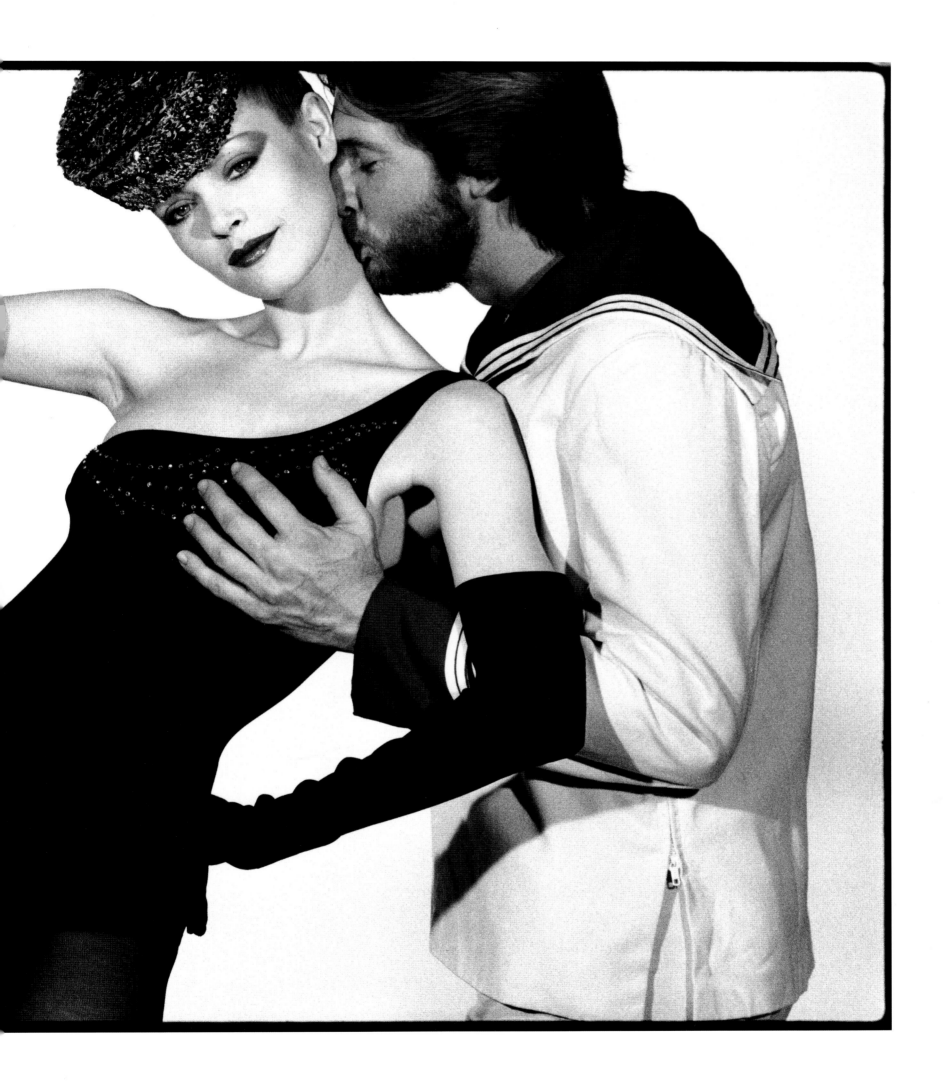

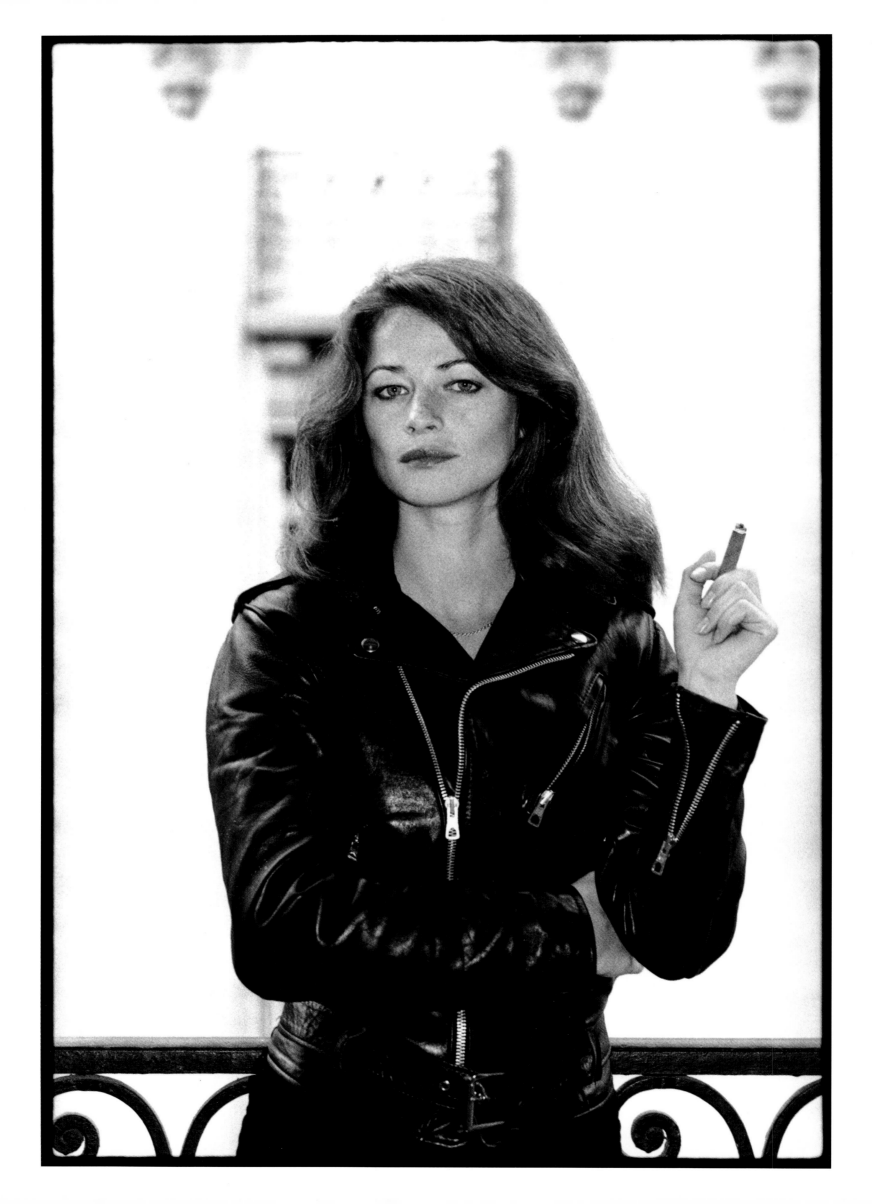

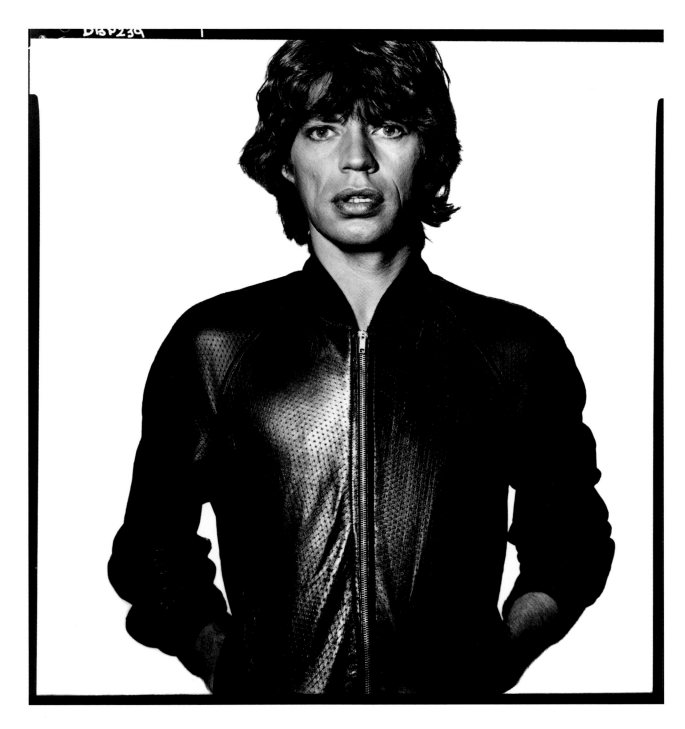

(above) **Mick Jagger** *Ritz* no. 10, 1977 (variant published)

(opposite) **Charlotte Rampling** 10/1976

Jerry Hall and Bryan Ferry 6/1976

(following page left) **Patti Smith** 9/1978

(following page right) **Bob Marley** 4/1977

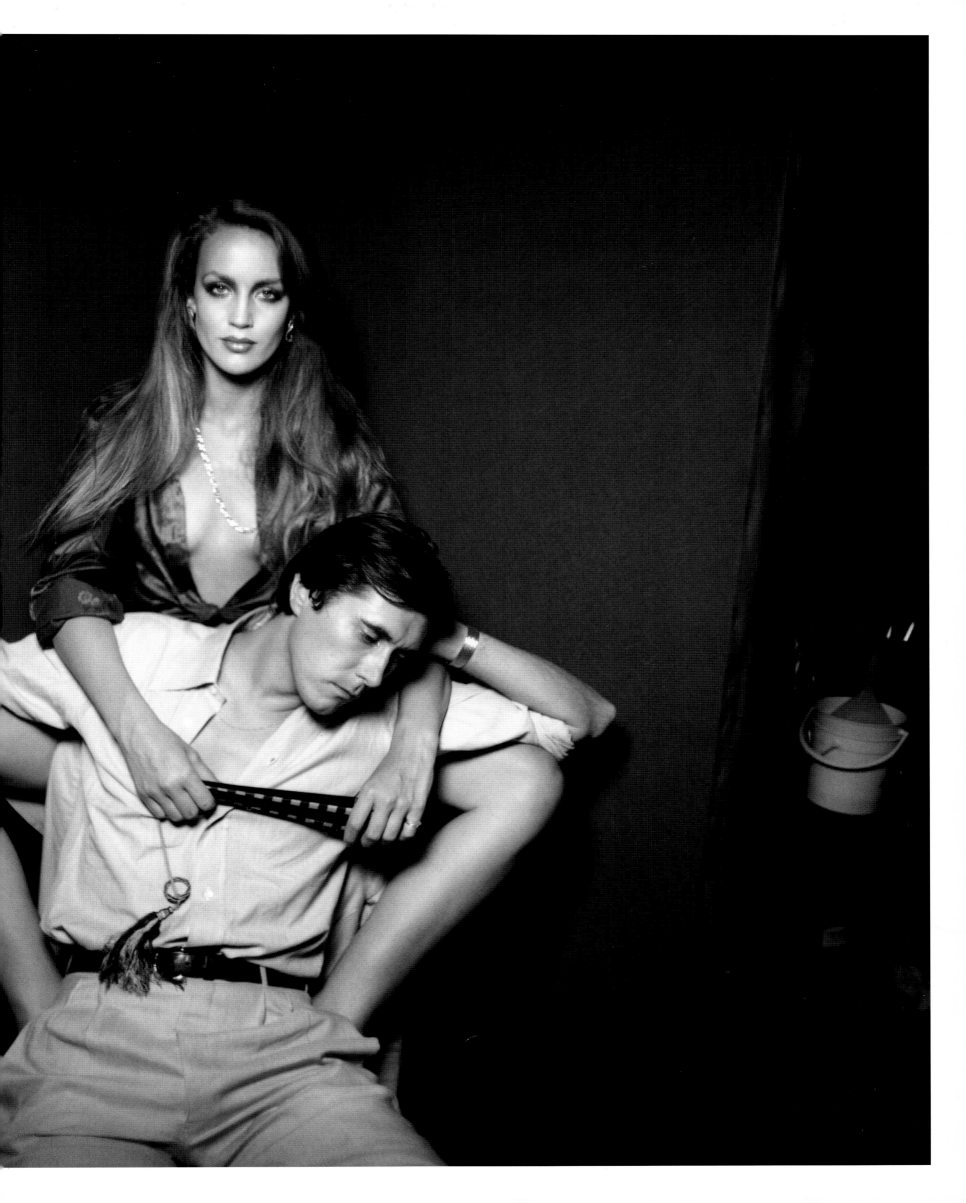

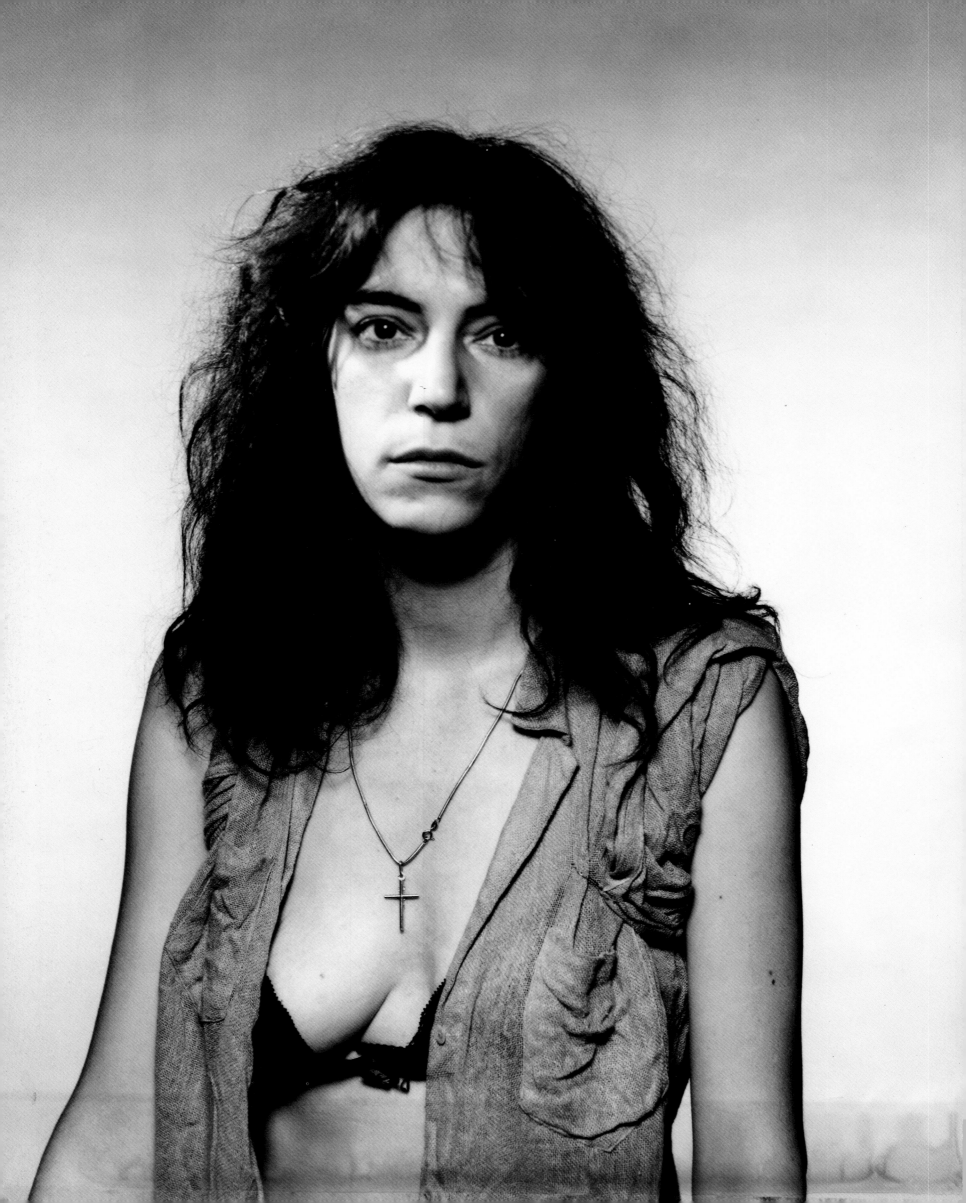

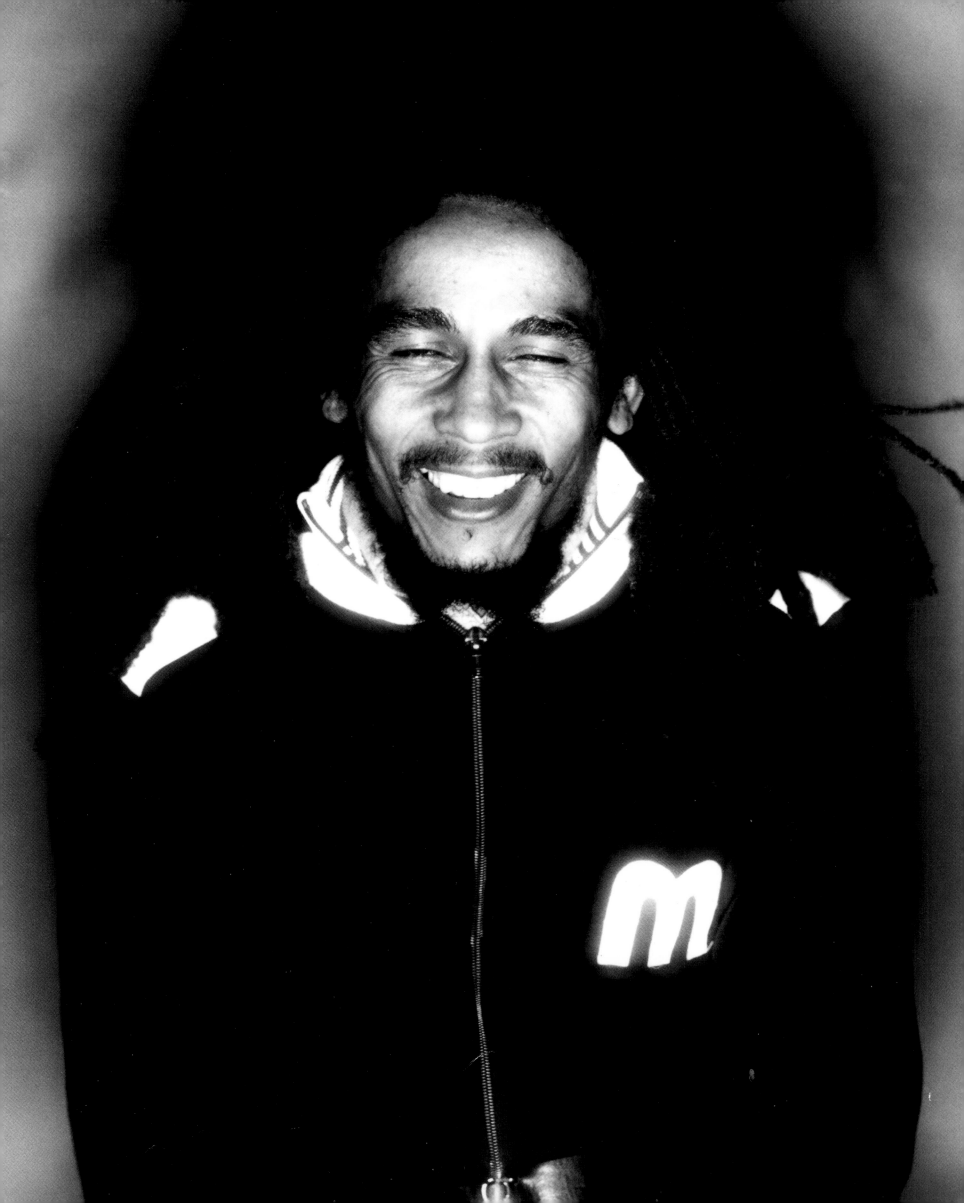

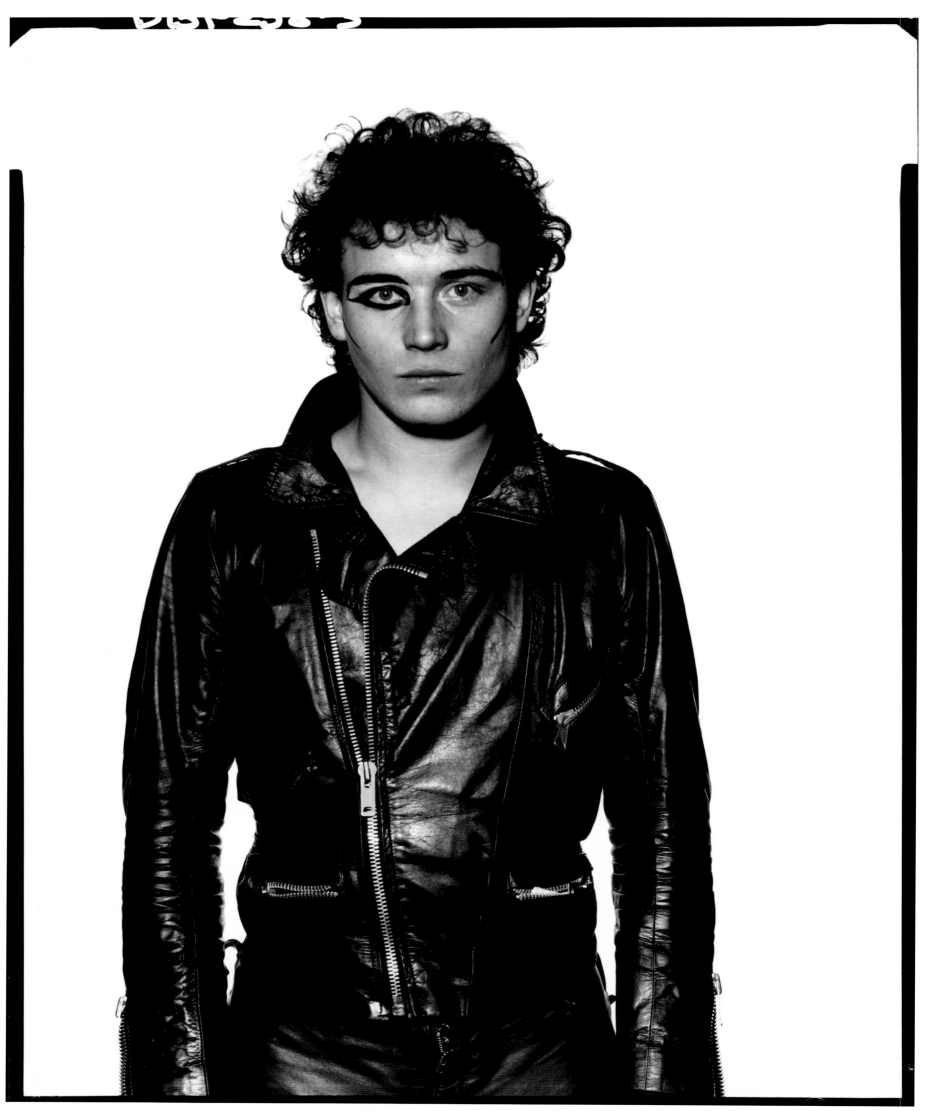

Adam Ant 1/1978

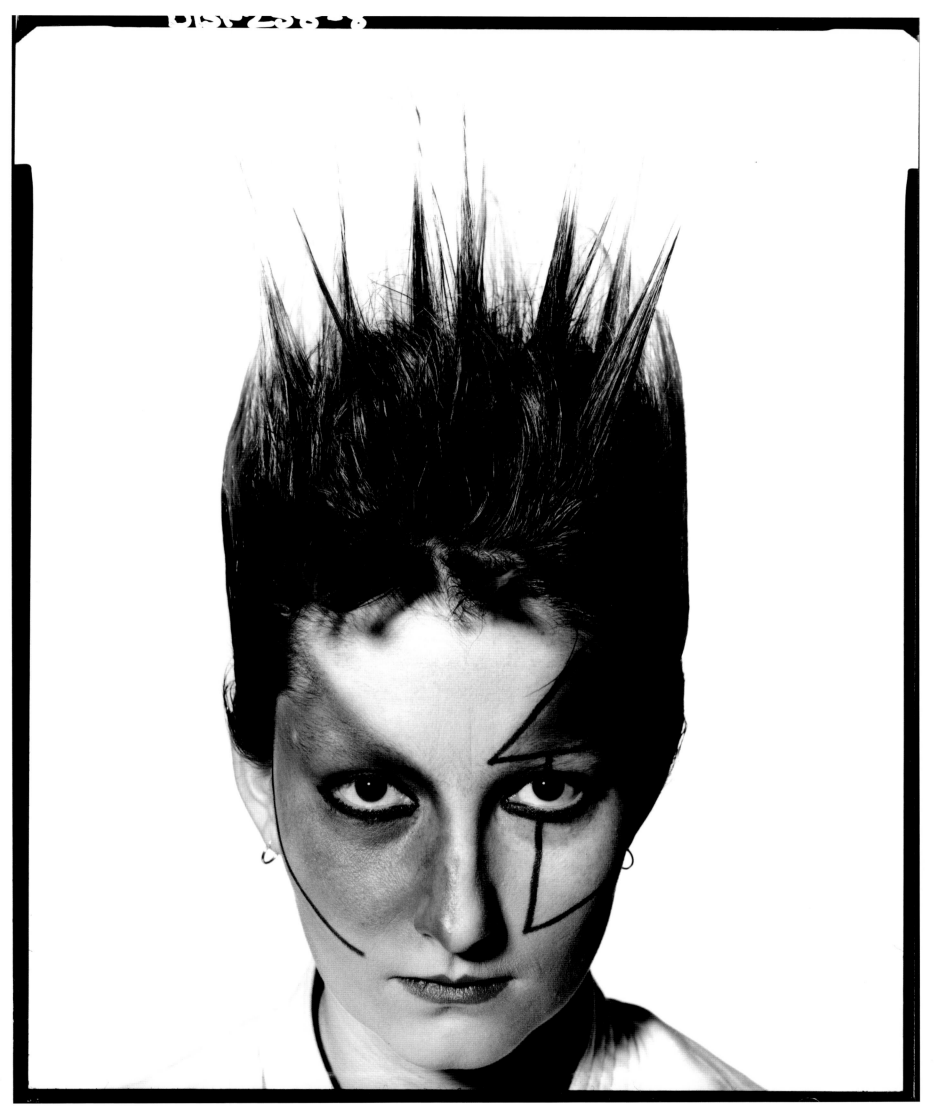

Jordan 1/1978

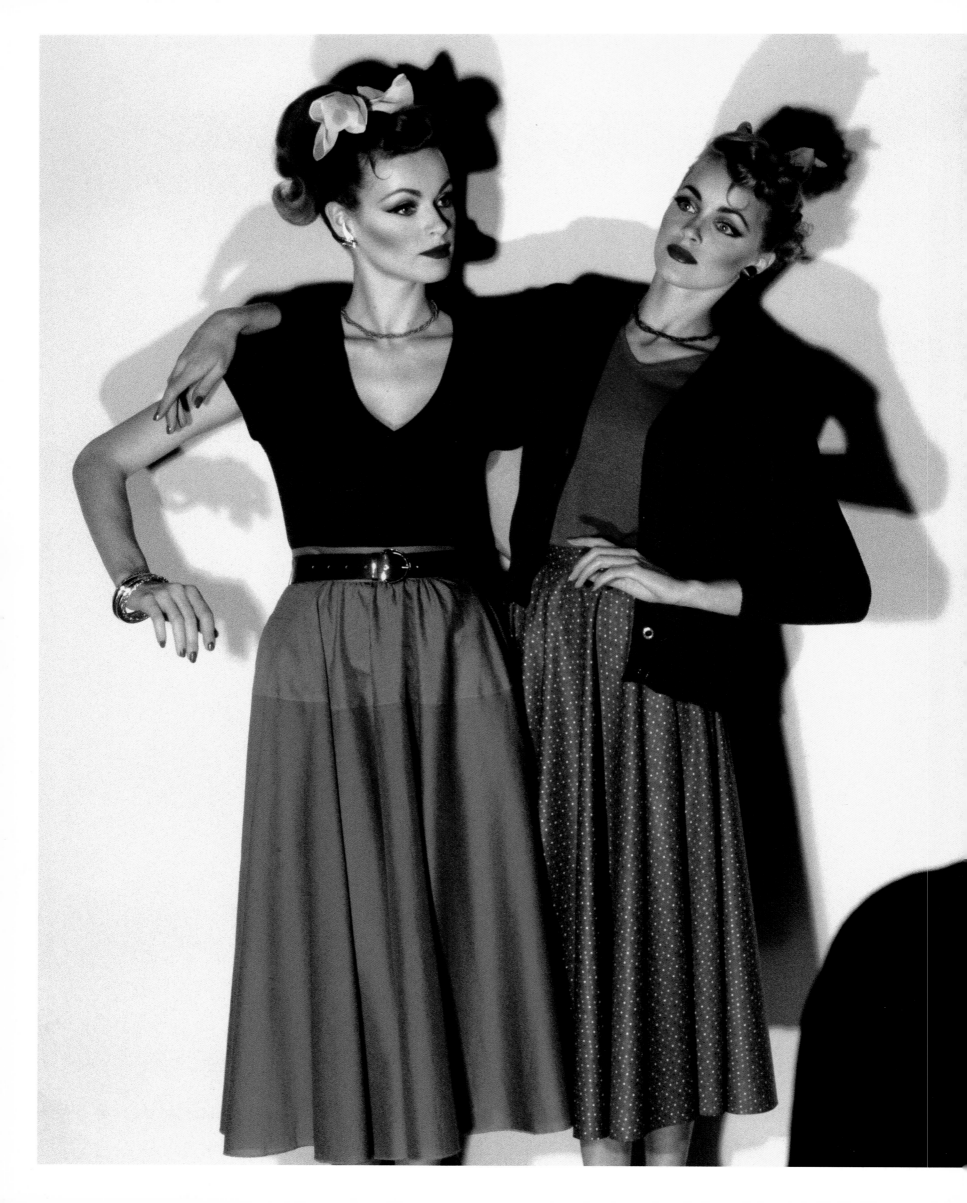

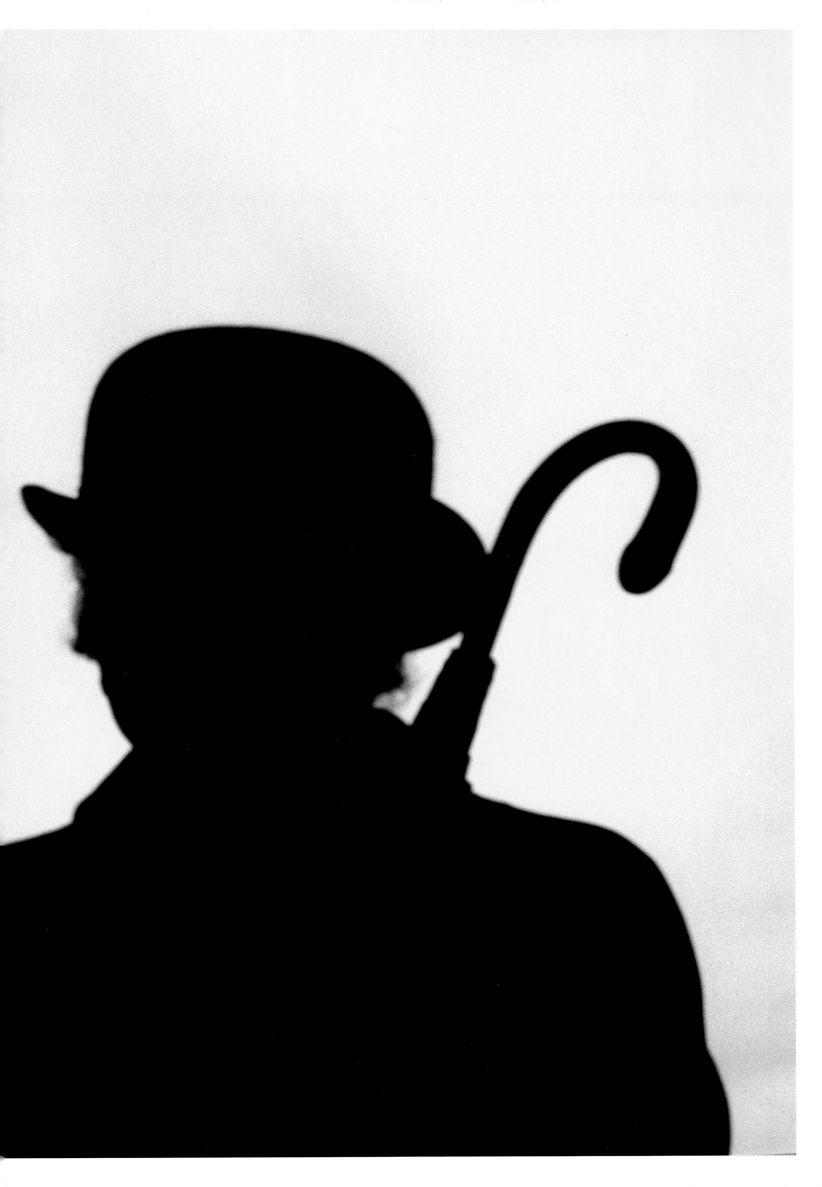

Italian *Vogue*
March 1979

Ritz no. 36, December 1979

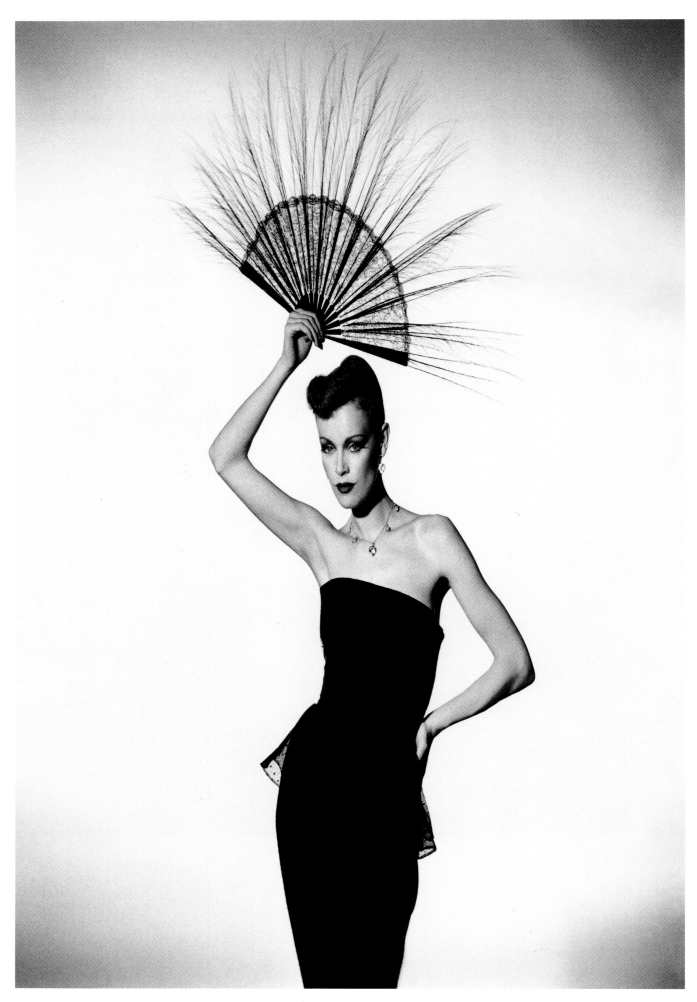

Italian *Vogue* September (1) 1979

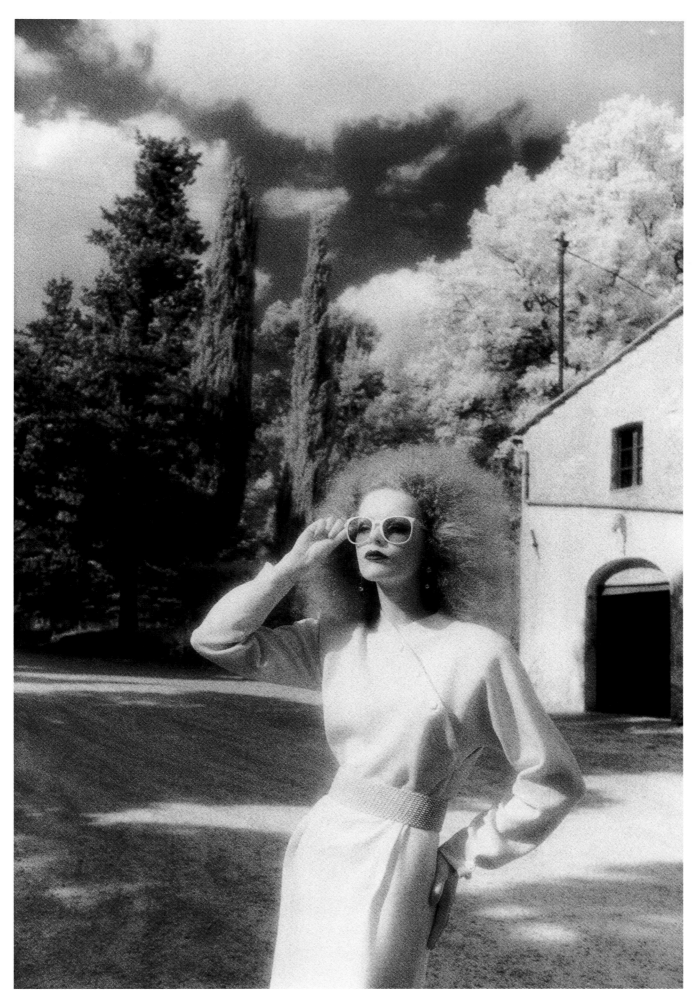

Italian *Vogue* September (2) 1979

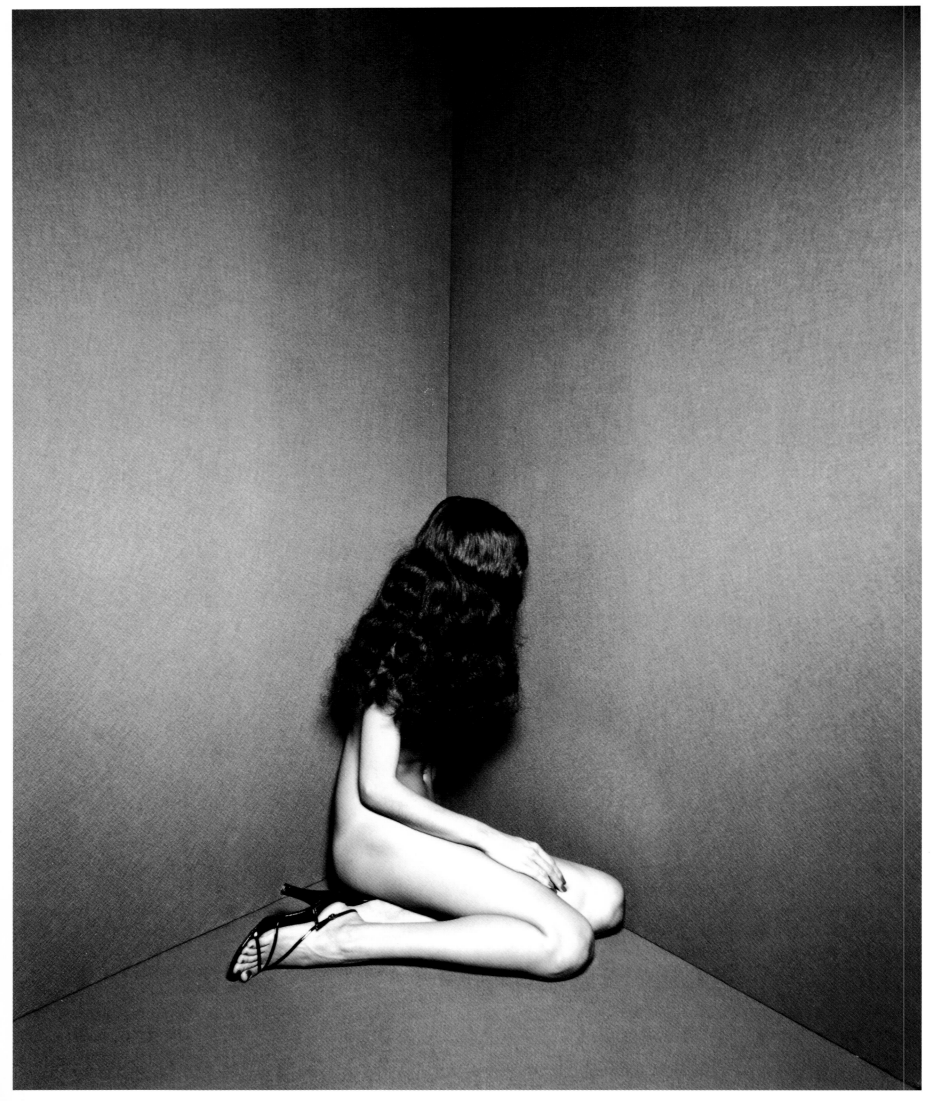

Marie Helvin 6/1976

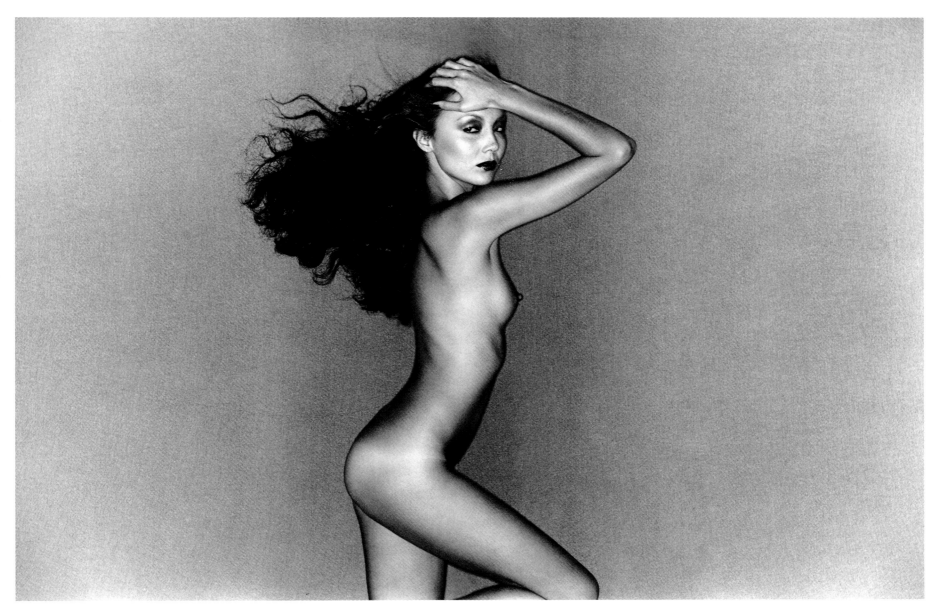

Marie Helvin 6/1976

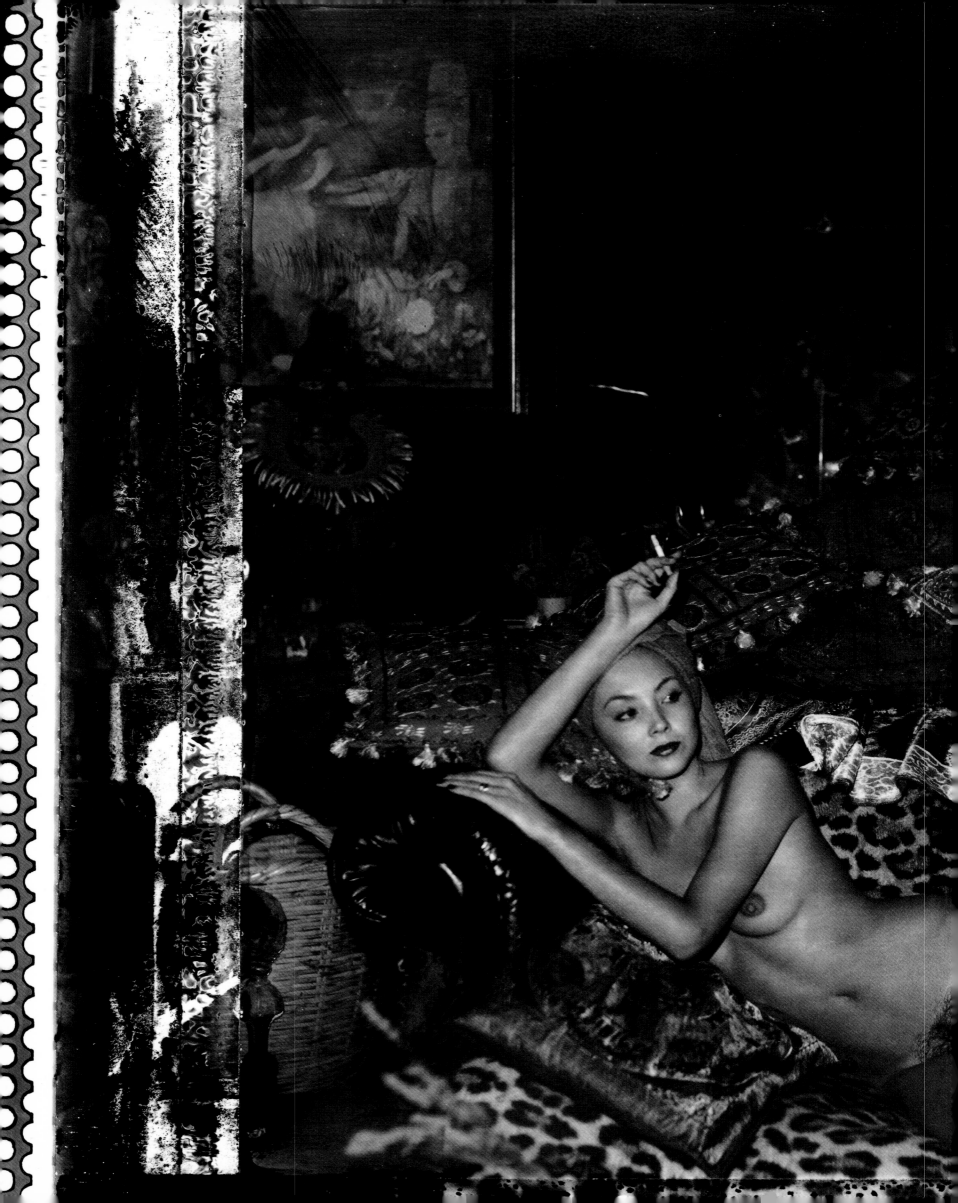

Marie Helvin 8/1979

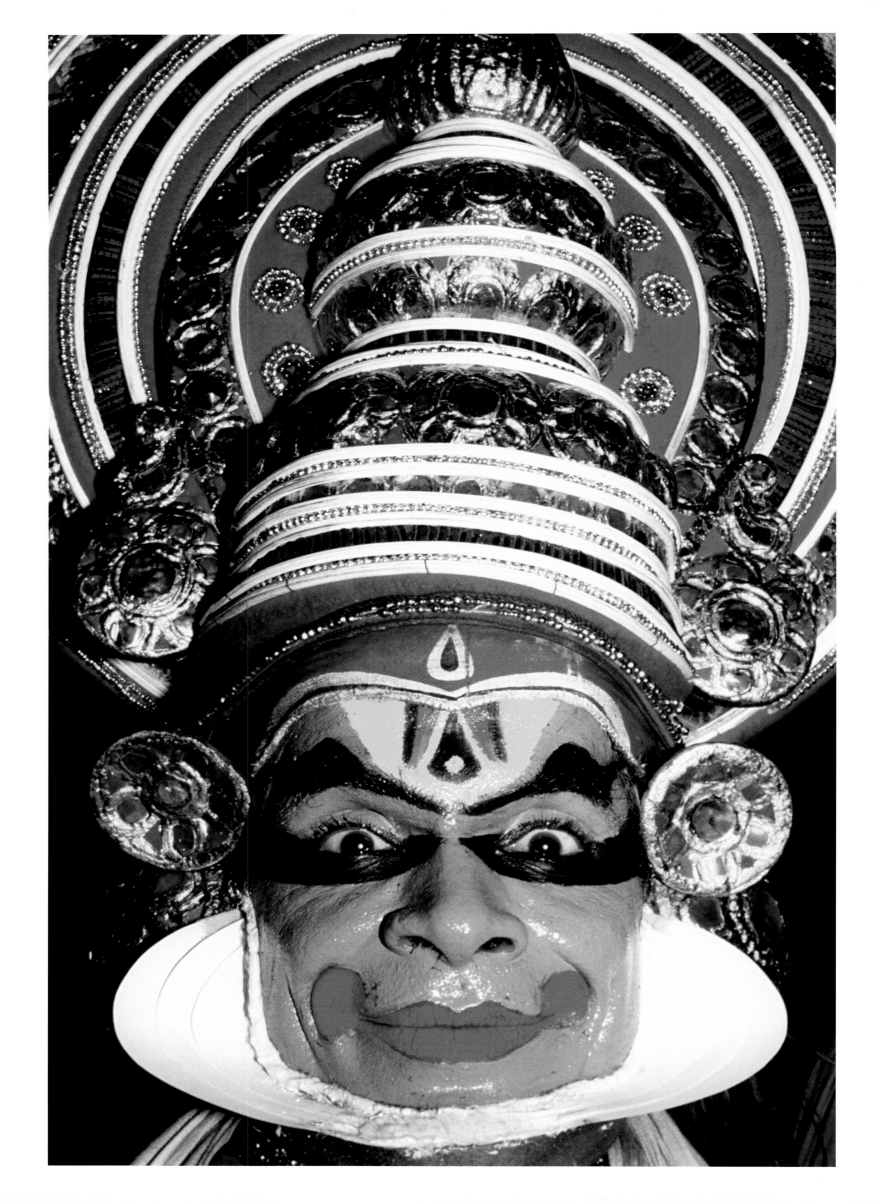

Relocating

Haiti 3/1976

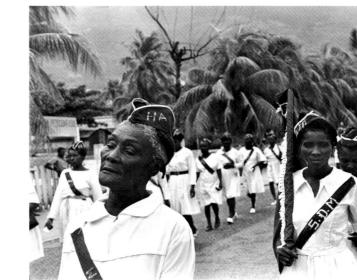

Haiti 3/1976

If a single factor most clearly differentiated Bailey's photography in the Seventies from the preceding or succeeding decades, it was its wider geographical scope. His broader range was also informed by the rapid changes in the photography scene in Britain. At the outset of Bailey's career, in 1958, the accessible photographic references had been almost invariably within the commercial sphere, led by the Americans Penn and Avedon: now the expanding bibliography was filling in major gaps in the history of photography. Bailey's interest in the medium's early history was reflected not only in his avid collecting but in his public backing for an appeal to keep Julia Margaret Cameron's Herschel album in this country (the then considerable sum of £52,000 was successfully raised, and the album is now in the collection of the National Portrait Gallery), and he contributed an interesting article to *Vogue* December 1976 in praise of a

recently discovered album by a talented Victorian amateur photographer, Reginald Vane-Tempest-Stewart, who had died aged only nineteen.

On location in Haiti for French *Vogue* in 1976, Bailey spent every available off-duty moment photographing the inhabitants of the Caribbean island, where again he was intrigued by the formalized expressions of the country's culture as demonstrated in its ceremonials and its religious life. It is probably significant that on a similar trip to Australia for *Vogue* in 1974, he had been less concerned with the extra-curricular photography of the country and its people, no doubt because it appeared less remote from his own culture, (though he made an extended tour of Australia for precisely that purpose in 1984).

In his continuing relationship with Eastern mysticism he had photographed Sathya Sai Baba at his ashram near Bangalore in 1974

India: Kathakali dancer, Kerala 6/1979

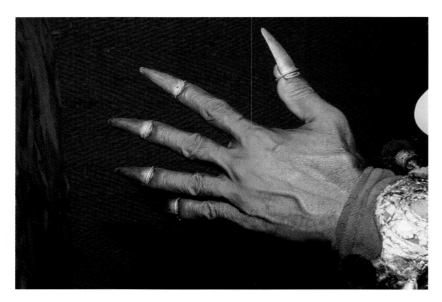

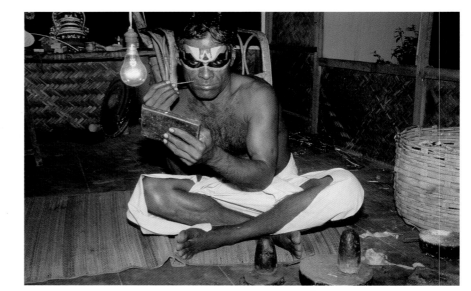

India: Kathakali dancer, Kerala 6/1979

India: Kathakali dancer, Kerala 6/1979

(p. 158), and returned to Kerala in southern India five years later to photograph the Hindu classical dance-dramas of the Kathakali, their gestures and their herb-based make-up more elaborate than any *Vogue* model's.

Refugees from the Vietnam war had begun to arrive in Hong Kong in 1975. Four years later the temporary camps were holding around fifty thousand of the Vietnamese 'Boat People' at any one time. In July 1979 Bailey flew to Hong Kong to record the plight of the refugees still awaiting resettlement, amid concern from the Hong Kong government at waning international interest in the humanitarian crisis. The ultimate aim of the exercise was to raise awareness as well as money for the Caritas Refugee Fund from sales of Bailey's photographs: an exhibition 'The Boat People' became Bailey's first one-man show at the Olympus Cameras Centre in February 1980. The most impressive and effective of the photographs showed dense maelstroms of humanity, powerfully conveying their predicament and the scale of the problem.

Alongside his burgeoning career as a director of TV commercials, Bailey was the subject and the linchpin of the advertising campaigns of Olympus Cameras, in which the ironic pay-off lines of their award-winning advertisements ('Who do you think you are? David Bailey?') played on his celebrity. For his contribution to Olympus's 'Elements' exhibition in July 1979, Bailey provocatively showed still-lifes of butchered animals. They signified an abrupt end to his pursuit of exotica in the Seventies, and were prescient of his non-commercial photography in the Eighties, a decade which he began in a more sombre, dramatic and introspective mood.

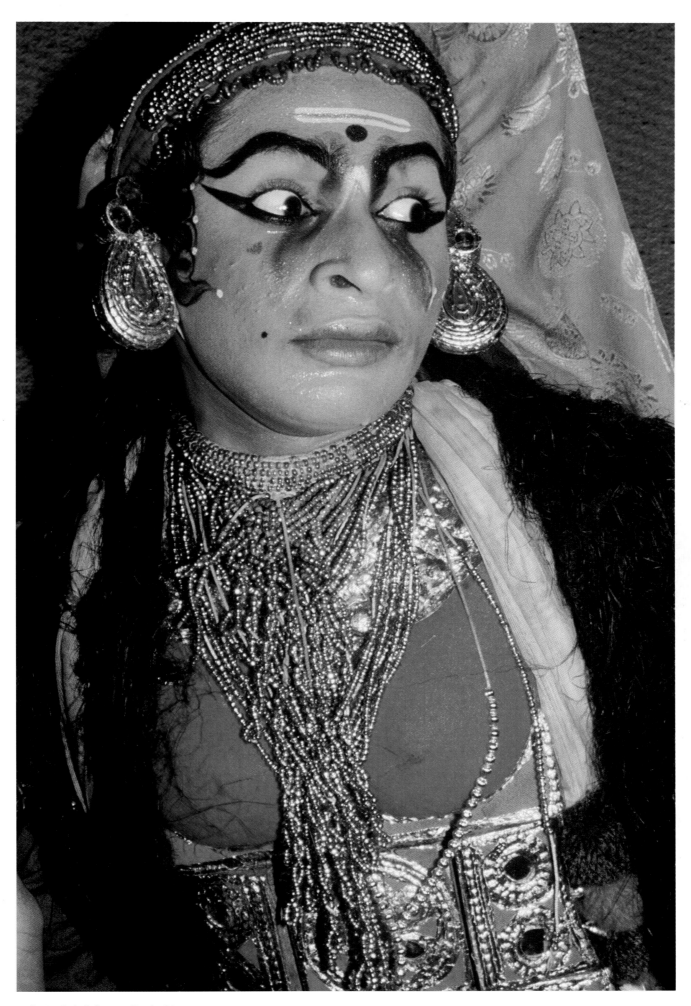

India: Kathakali dancer, Kerala 6/1979

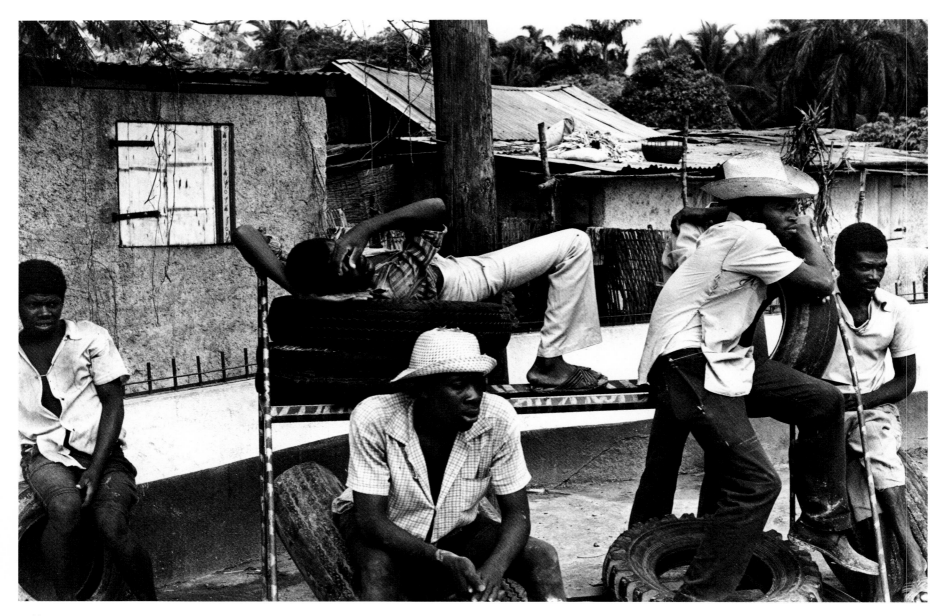

Haiti 3/1976

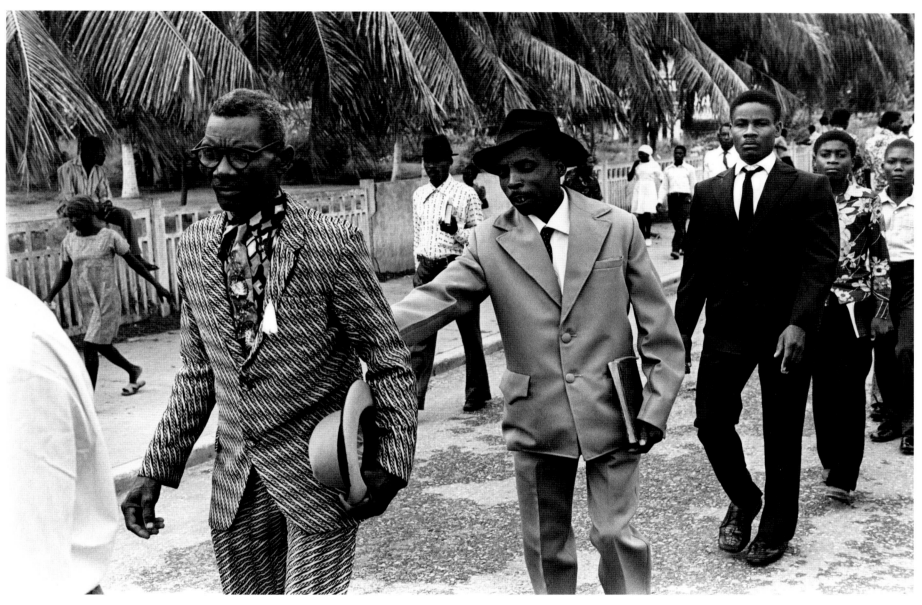

Haiti 3/1976

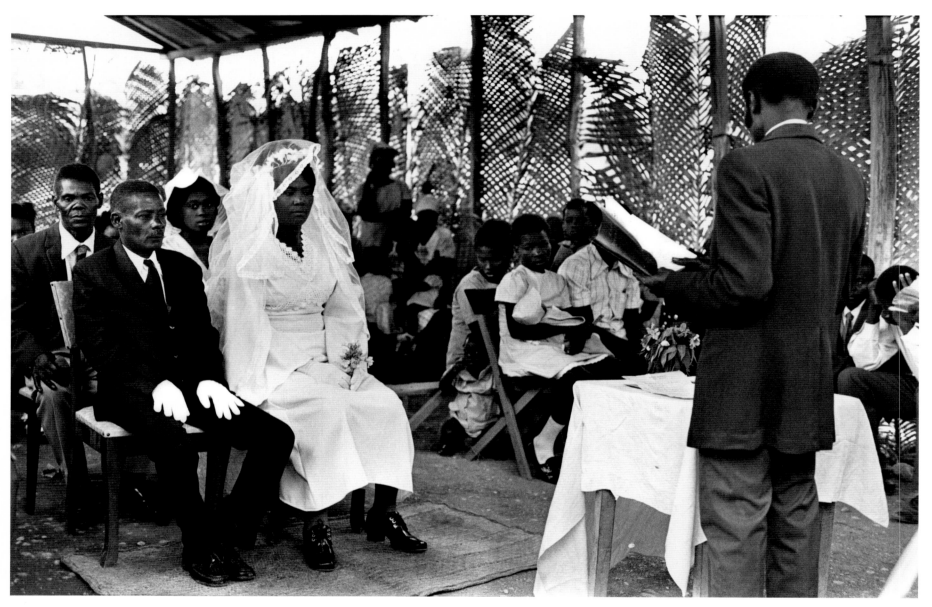

Haiti 3/1976

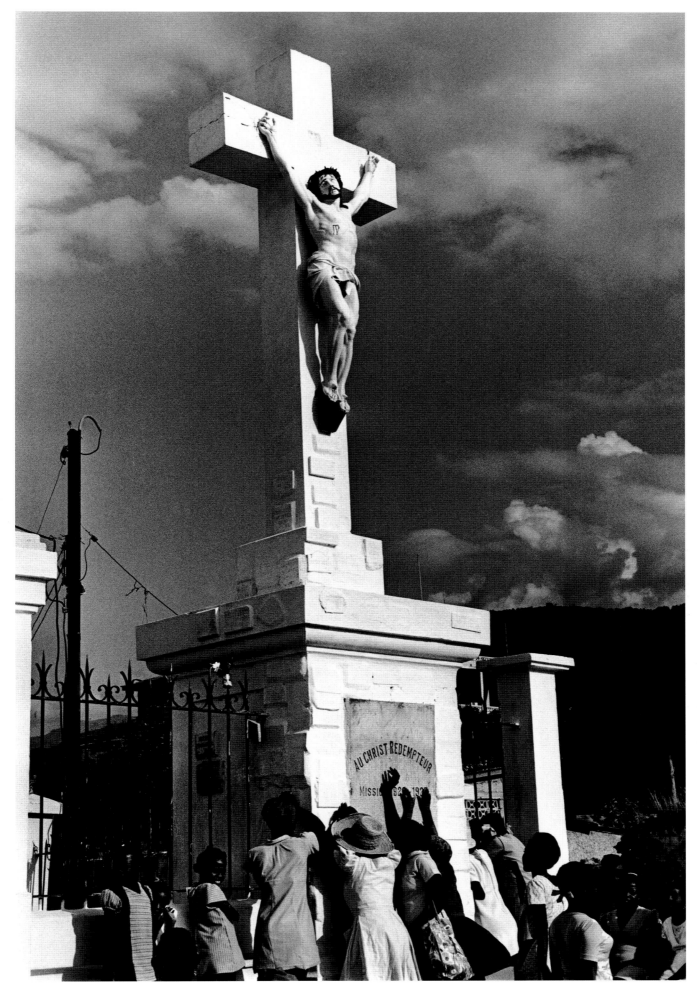

Haiti 3/1976

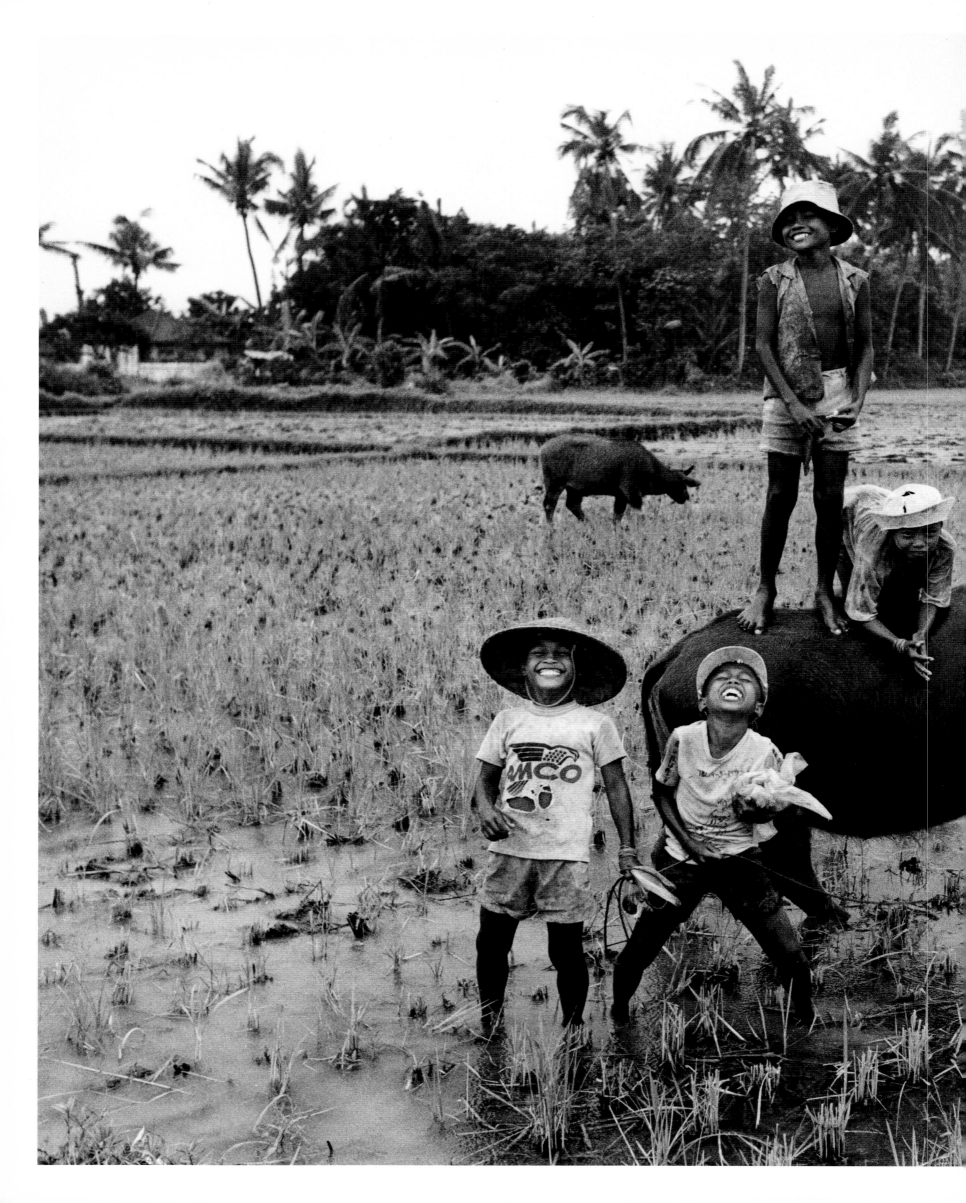

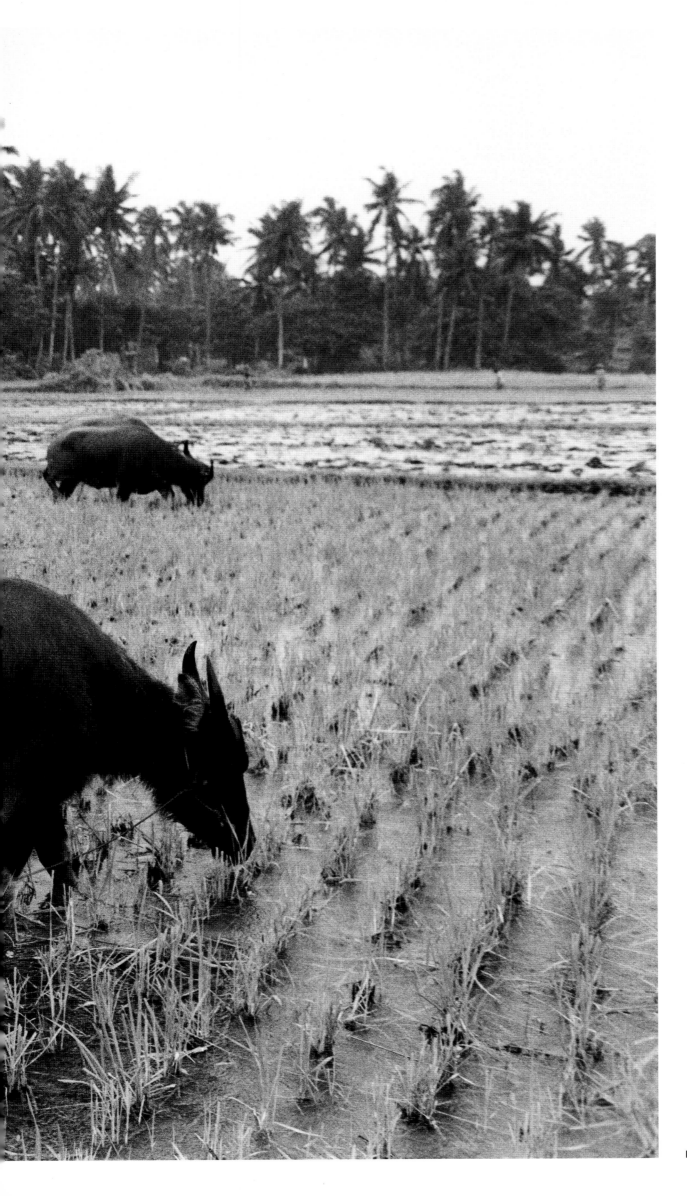

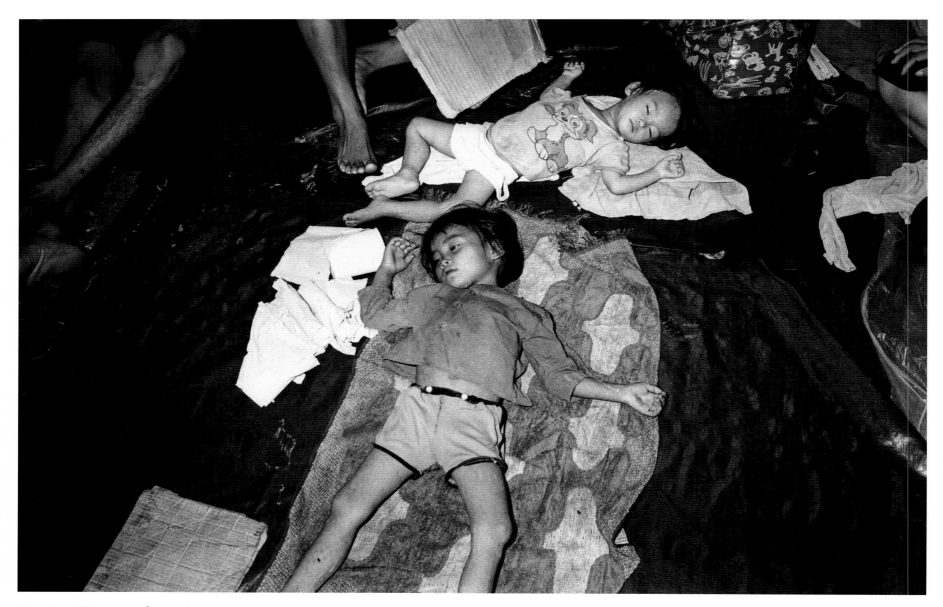

Hong Kong: Vietnamese refugees 7/1979

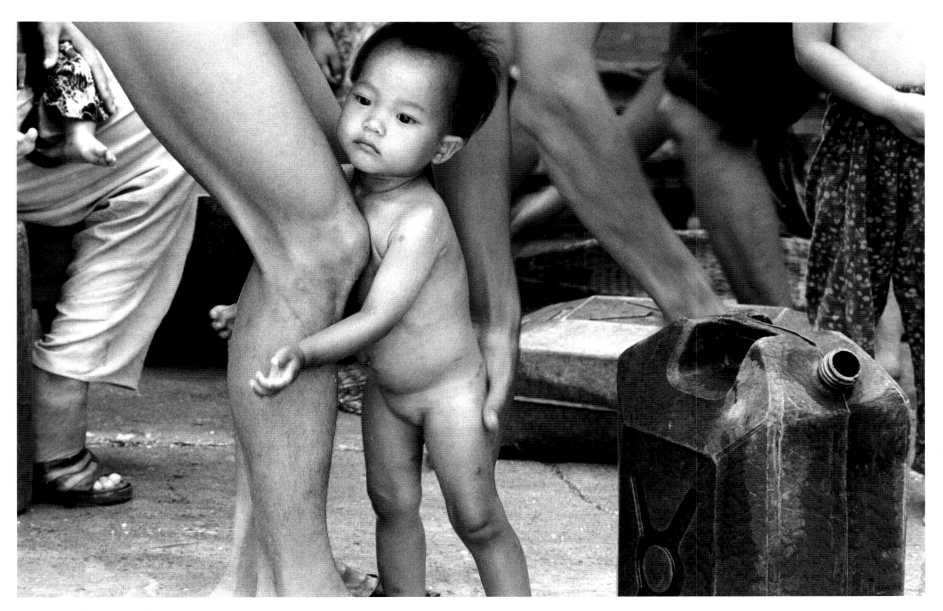

Hong Kong: Vietnamese refugees 7/1979

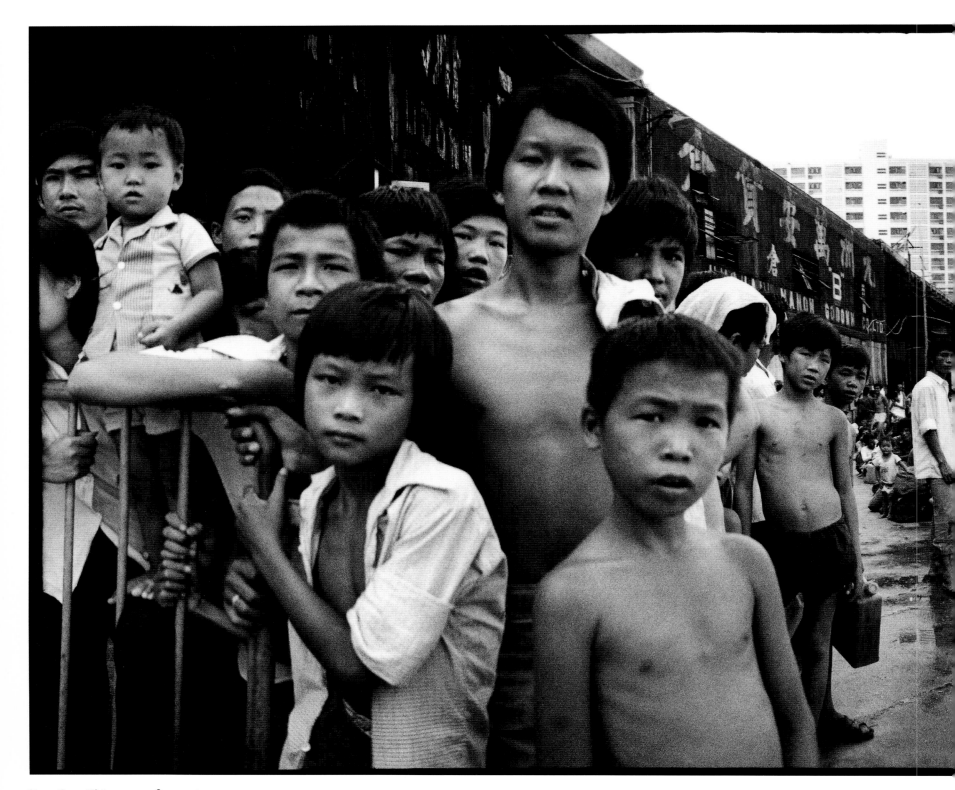

Hong Kong: Vietnamese refugees 7/1979

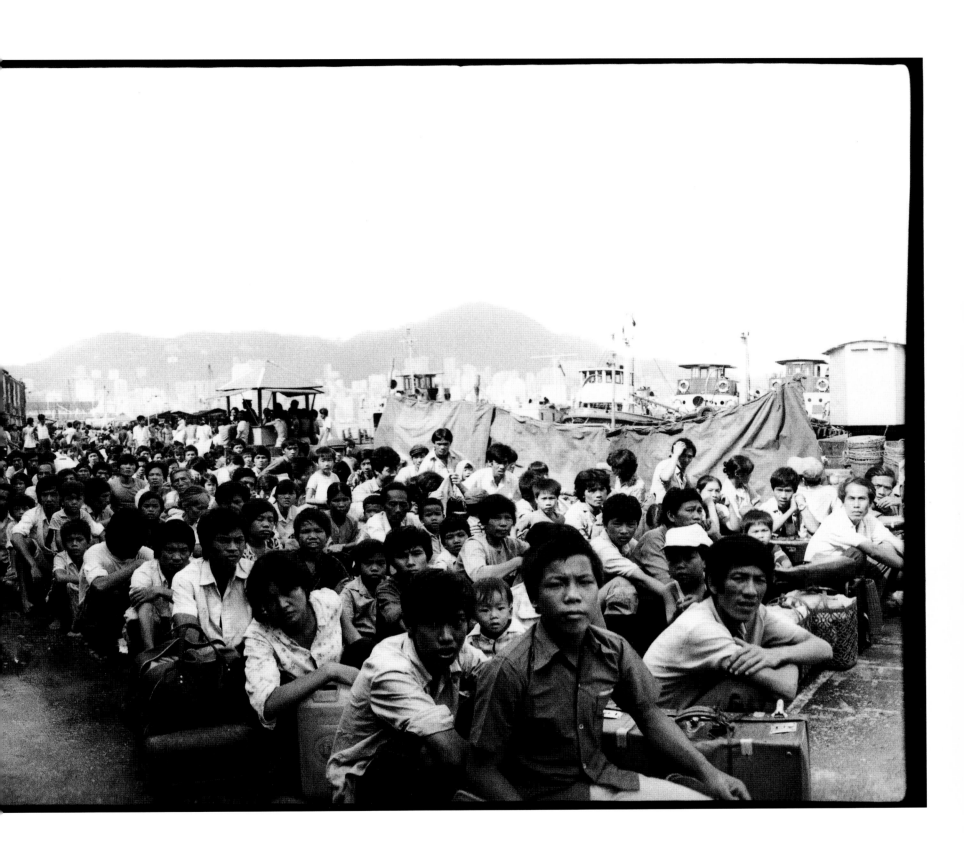

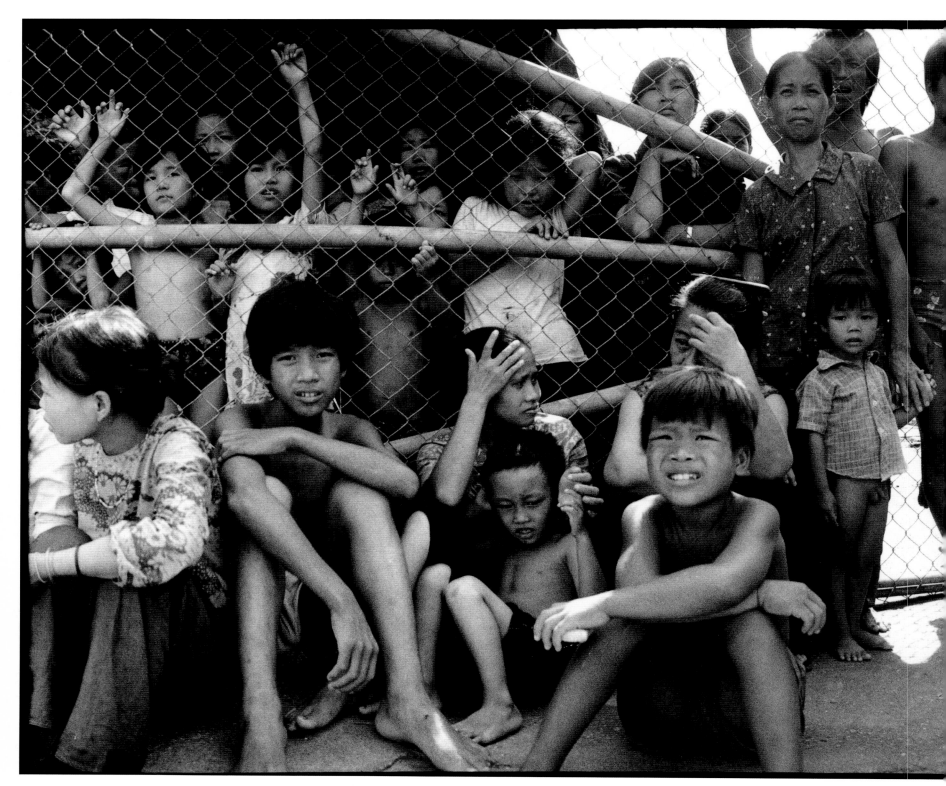

Hong Kong: Vietnamese refugees 7/1979

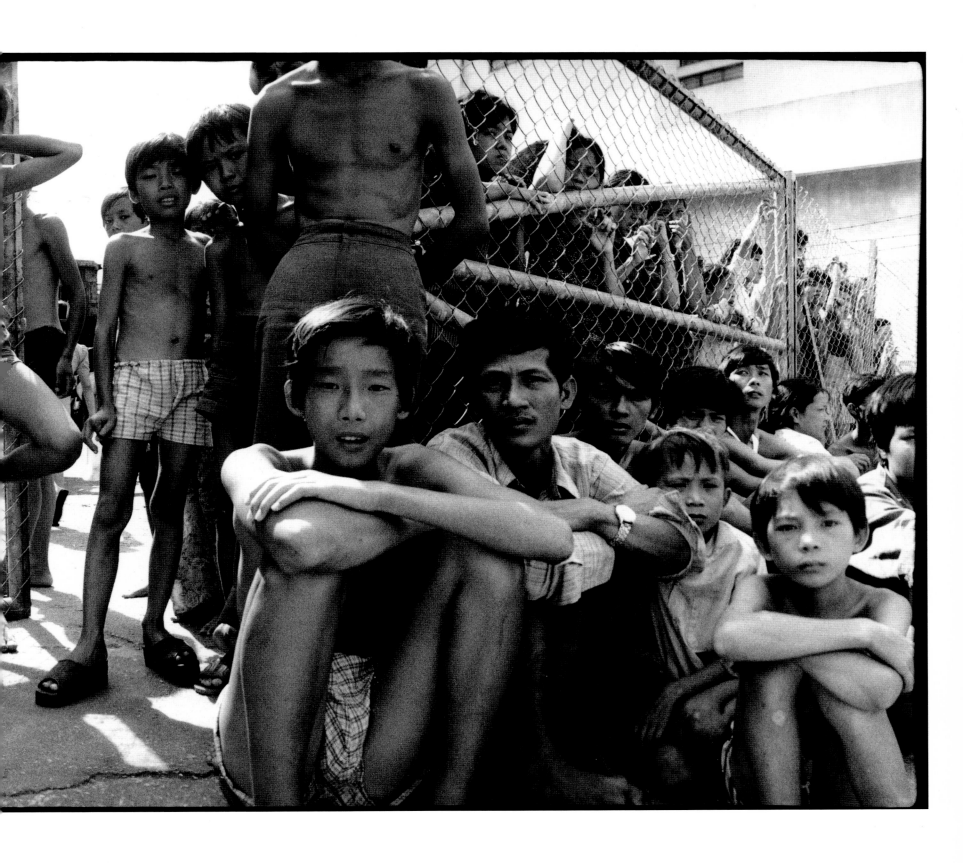

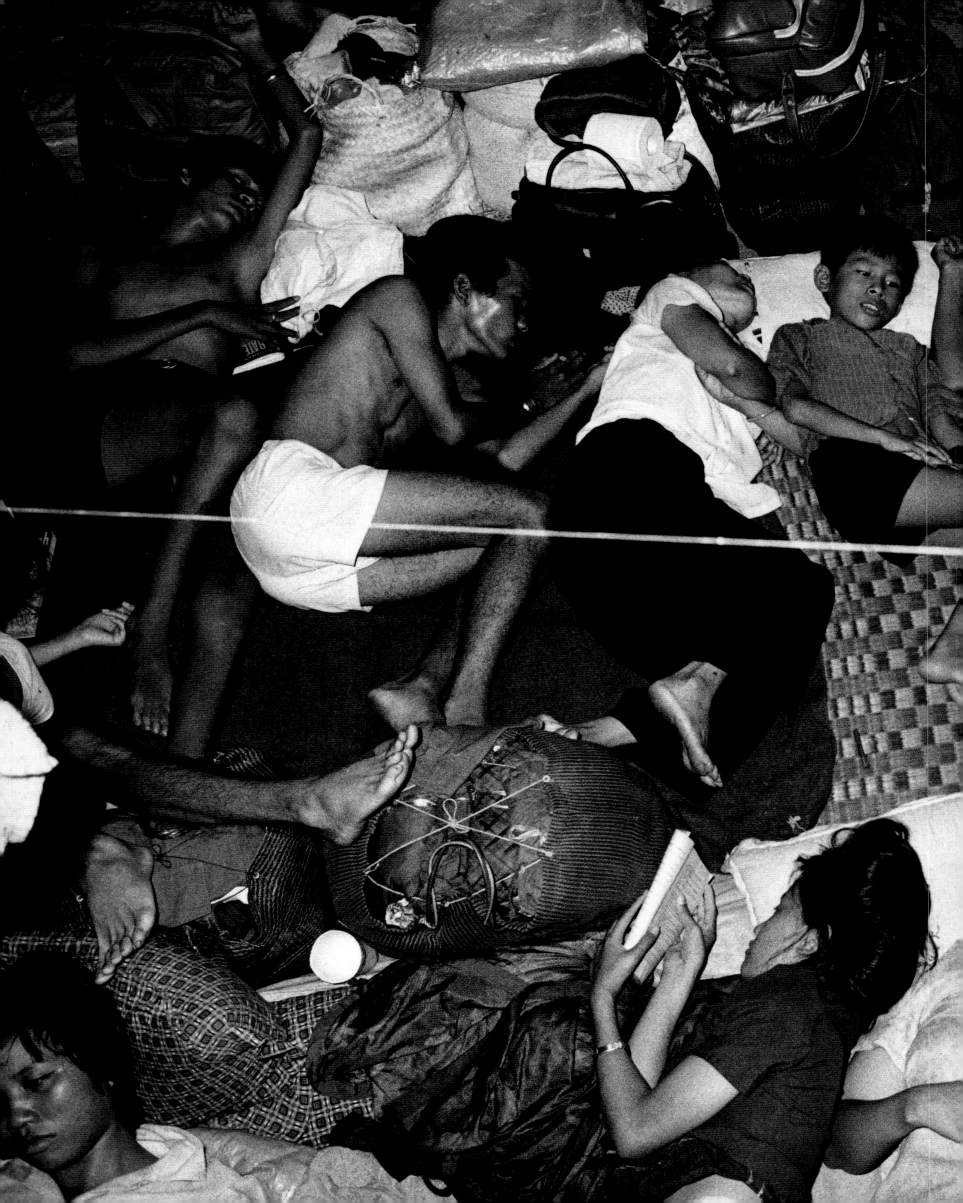

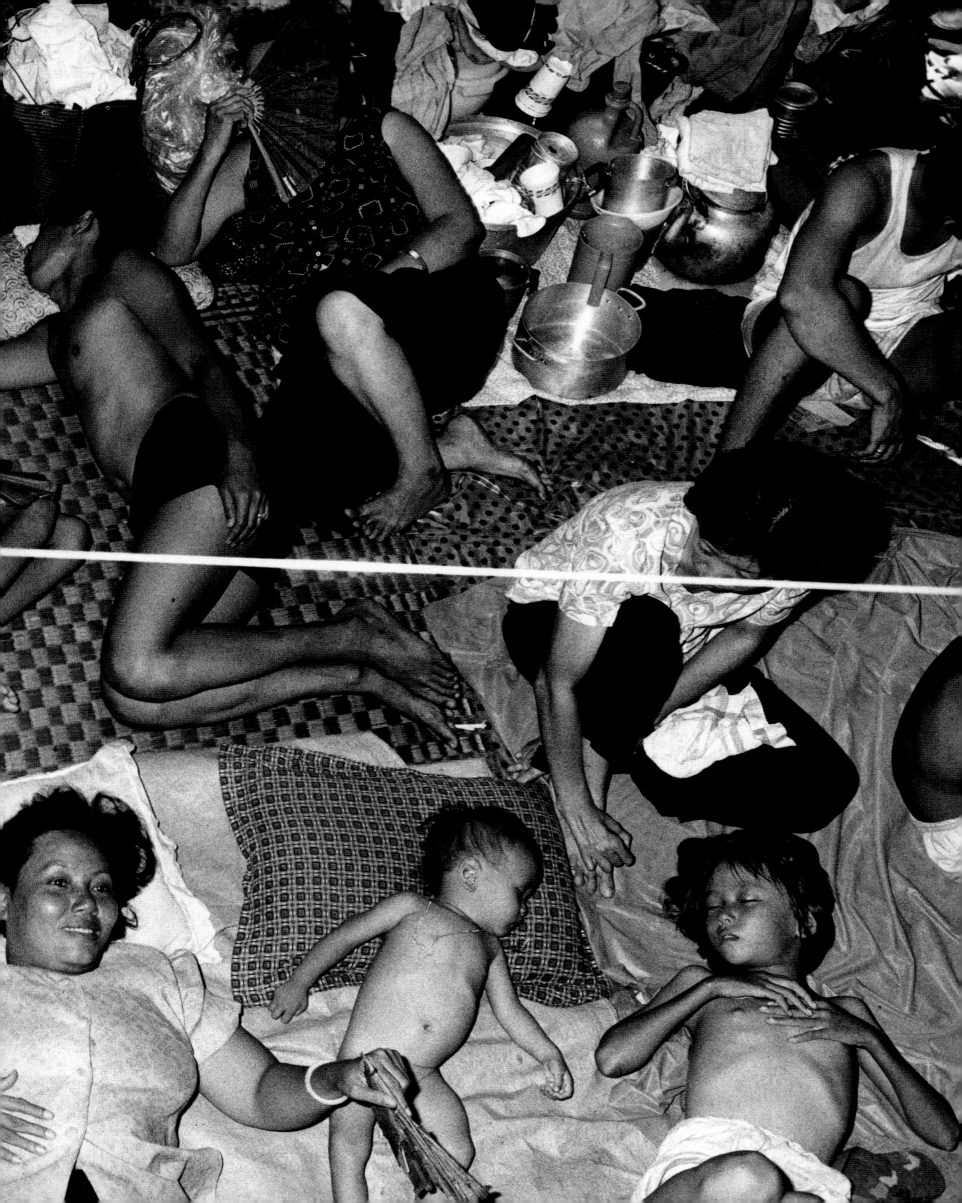

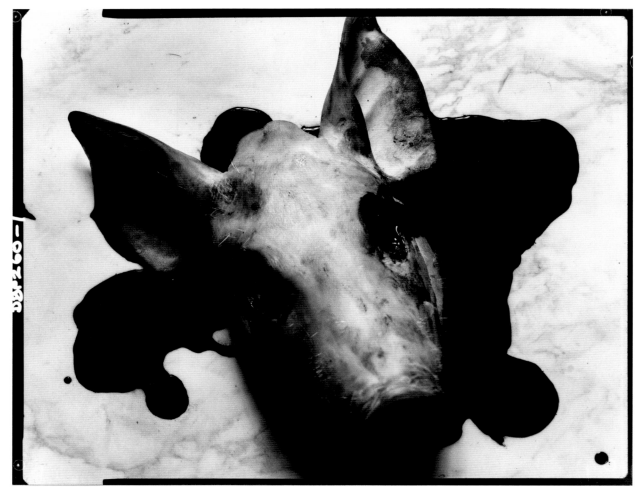

Nature Morte 1/1978

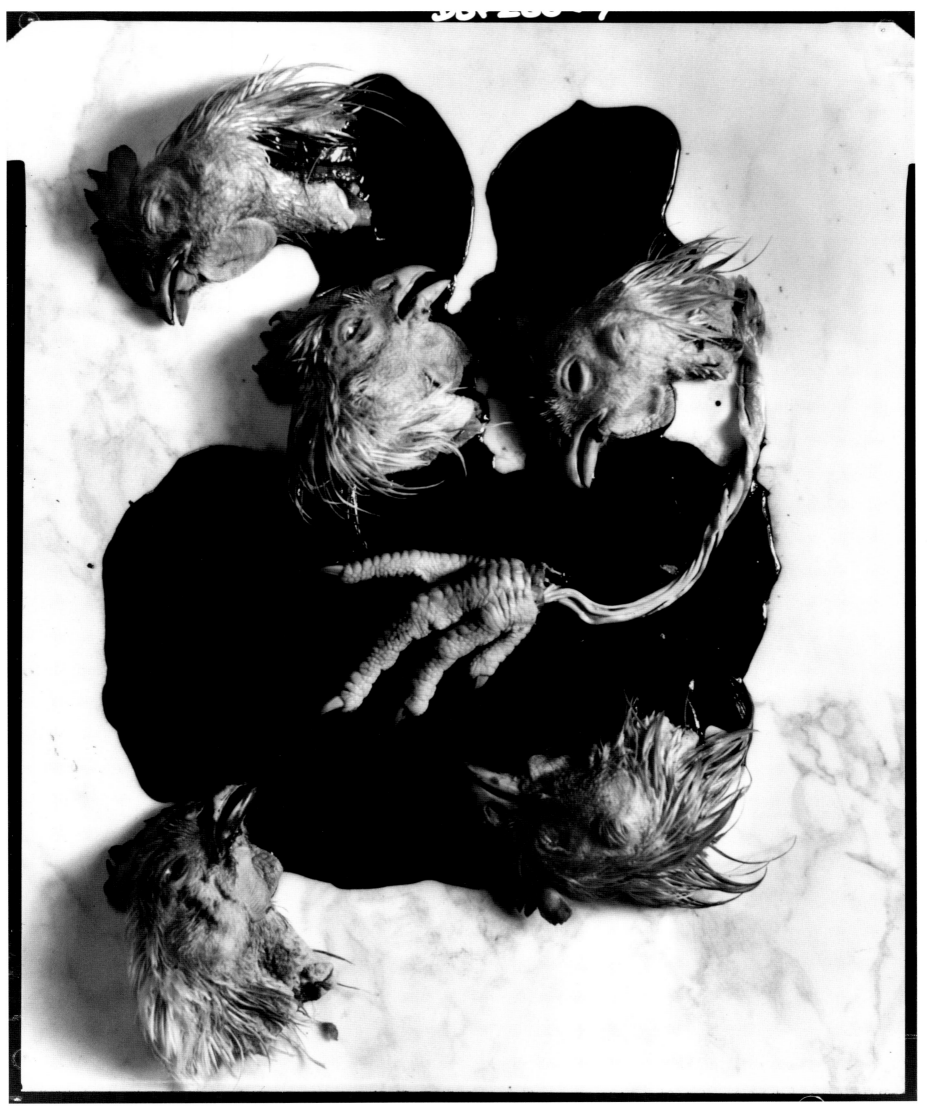

Nature Morte 1/1978

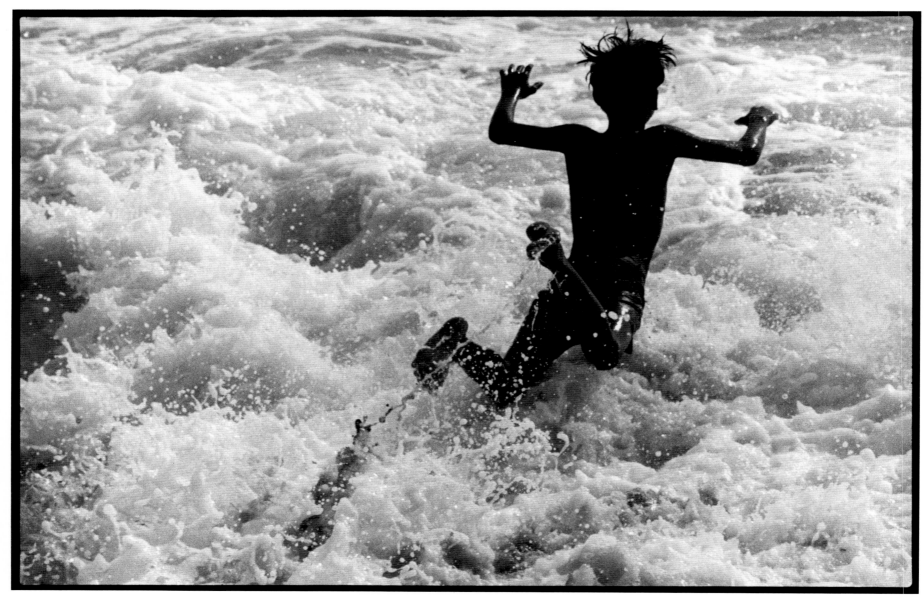

India 6/1979

Acknowledgments

To my two dedicated assistants Iain Mills and William Davidson for all their professionalism and patience. To all the editors and staff at Condé Nast. To Olympus for all their continuing support. To my wife Catherine for all her love and enthusiasm. And as always to Martin Harrison for his insight.

Special printing and production credits to William Davidson for all the excellent black and white prints, and to Iain Mills for production.

David Bailey

I would like to thank Janice Button (Condé Nast Library, London), Marie Helvin, Nicola Seare and Elaine Shepherd.

Martin Harrison

Index

Numbers in *italic* refer to illustrations

Ajaccio, Corsica *116, 117*
Alternative Miss World *84, 85*
Amazon, Brazil *120*
American *Vogue* *52, 53,* 184
Andresen, Bjorn *75*
Another Image 119
Ant, Adam *224*
Antibes, France *185*
Arequipa, Peru *31, 32–3*
Artificial Princess, The (La Princesse Artificielle)
 16, *57*
Astaire, Fred 184, *190*
Australia 63, *172, 173, 212,* 237

Bailey, David *61, 62, 72, 79, 88*
Bailey, Gladys *200*
Bailey Until Now 14, 15
Bali *244–5*
Beady Minces 15
Beard, Peter 63, *105*
Beaton by Bailey 61
Beaton, Cecil 61, **72,** *72, 73*
Berger, Helmut 61, *77*
Birkin, Jane *188–9*
Blahnik, Manolo *111, 116, 117*
Blanch, Lesley *76*
Bogarde, Dirk *74*
Bombay, India 121, *140–41, 142–3, 144, 145, 146–7*
Boulting, Ingrid 16, *34, 35*
Bourdin, Guy 16
Bowie, David *82*
Brazil 63,*72, 119, 120,* **121,** *121, 122, 123, 124, 125,*
 126, 127, 128
British *Vogue* 13, *13,* 15, 16, *17, 20, 21, 22, 23, 24–5,*
 26–7, 28, 29, 31, 32–3, 34, 35, 36, 37, 42–3, 49, 54,
 55, 60, 61, 63, **72,** *74, 75, 78, 86, 88, 89, 90, 91,*
 92–3, 101, 108–9, 110, 111, 112–13, 114–15, 116, 117,
 120, 166, 172, 173, 176, 177, 183, *212, 213,* 237
Brook, Peter *192*
Burton, Sir Richard 13, 119

Cage, John 63, *67*
Calcutta, India 121, *159, 160*

Cameron, Julia Margaret 185, 237
Capote, Truman 15
Cartier-Bresson, Henri 72
Castelli, Leo *65*
Chow, Michael *183*
Chow, Tina 183, *183*
Clark, Ossie *187*
Coddington, Grace 63, *116, 117*
Como, Italy *206, 208–9*
Connecticut, USA *44–5, 46–7*
Cooper, Alice *54, 59,* 63
Corsica *112–13, 114–15, 116, 117*
Courrèges, André *48*
Coutinho, Mrs Palmira *118*
Crahay, Jules-François *48*
Crisp, Quentin *199*

Dalí, Salvador 16, *62,* 63, *65, 69*
Darling, Candy *62, 68*
Dartmoor, England *28*
Death in Venice 74, 75
Deneuve, Catherine 14, *59*
Dinesen, Isak 63
Donovan, Terence *184*
Duchamp, Madame *67*
Duff, Euan 15
Duffy, Brian *184, 185*

Egypt 15, *24–5, 26–7*
Erté (Romain de Tirtoff) 63, *87*

Fenton, Roger 185
Ferry, Bryan *220–21*
Fiji *35*
Firbank, Ronald 16
Fisher, James 119
Fox Talbot, W. H. 185
Frank, Robert 15
French *Vogue* 16, *57,* 185, *203, 204–5,* 237
Friedlander, Lee 15

Gainsbourg, Serge *188–9*
Galway, James *58*
Geldzahler, Henry 63, *65*
Gibson, Ralph 185, *185*

Gilbert and George *197*
Goa *118,* 120, 121, *148, 149, 150, 151, 152, 153,*
 154–5, 156, 157, 161, 162, 163
Goodbye Baby and Amen 13
Grade, Lew 62
Grande Eugène, La 81
Guibourgé, Philippe *48*

Haiti *203, 204–5,* **237,** *237, 240, 241, 242, 243, 245*
Hall, Jerry 183, *220–21*
Harris, Kim 16, *216–17*
Hawaii *187*
Hawkins, Jack *58*
Helvin, Marie 8, 16, 63, *92–3, 166, 172, 173, 174,*
 175, 177, 178–9, 180–81, 182, **184,** *206, 207, 208–9,*
 210, 211, 213, 214, 232, 233, 234–5
Herriott, James 169
Hockney, David 14
Holzer, Jane *65*
Hong Kong 13, 238, *246, 247, 248–9, 250–51, 252–3*
Horst 63, *67, 102*
Hotel Negresco, Nice *111*
House & Garden 169
Hughes, Fred *65*
Huston, Anjelica 16, 63, *86, 88, 89, 101, 108–9,*
 110, 111, 112–13, 116, 117
Hyde Park Hotel, London *110*

Imai, Toshimitsu *187*
India *236,* 238, *239, 256*
Ingrams, Richard *196*
Italian *Vogue* 16, *51, 174, 175, 182,* 185, *202, 206,*
 207, 208–9, 210, 211, 216–17, 226–7, 230, 231
Italy *174, 175, 206, 208–9*

Jagger, Bianca *176*
Jagger, Mick *59,* 63, *63, 95, 100, 219*
James, Maudie *30*
Johnson, Jay *80*
Johnson, Philip *46–7*
Jordan *225*
Jorden *215*

Kalfus, Jordan 16, *44–5*
Kenya *58, 105*

Kenzo *166*
Kerala, India *236*, **238**, *238*, *239*
Kertesz, André 15
'Kitsch Fashion' 16, *38–9*, *40–41*, 63

Lagerfeld, Karl 63, 101, *177*
Lake District, England *36*
Lake Windermere, England *37*
Lartigue, Jacques-Henri *104*, 185, *185*
Lear, Amanda 16, *16*, *56*, *57*
Leccio, Italy *174*, *175*
Lennon, John *55*
Liberman, Alexander 184, *195*
Lichtenstein, Roy 63, *66*
Lieberson, Sandy *8*
Litchfield, David 183
London, England *13*, 14, 15, 16, 17, *42–3*, 59,
 60, 63, *84*, *85*, *86*, *88*, *89*, 121, *168*, *170*
Longford, Lord *13*

Machu Picchu, Peru *29*
Madame Tussaud's, London *13*
Manaus, Brazil 120, *126*, *128*
Marley, Bob 184, *223*
Mastroianni, Chiara 14, *59*
Mastroianni, Marcello 14
McCartney, Linda *187*
McCartney, Paul *187*
McCullin, Don 185, *185*
McDowell, Malcolm *171*
McWhirter, Ross 14, 62
Meatyard, Ralph Eugene 185
Metropolitan Museum of Art, New York 184
Milan, Italy 16, *51*, *108–9*
Mitchell, Donna 15
Mixed Moments 15
Moon, Sarah 63, *103*
Morecambe, Eric *49*
Morocco *213*
Mountbatten, Earl of *13*
Muir, Jean *196*

National Portrait Gallery, London 14,
 61, 237
Natures Mortes *254*, *255*

New Guinea 119, *129*, *130*, *131*, *132*, *133*, *134*, *135*,
 136, *137*, *138*, *139*
New York, USA 15, 61, *69*
Newton, Helmut 16, 185, *185*
Nice, France *111*
Nicholas and Alexandra 58
Nicholson, Jack 183, *193*
Notting Hill, London 15, *59*, 170

Ohwada, Mitsuaki *167*
Olympus 185, 238
Ono, Yoko *55*
Out of Africa 63

Paris, France 14, 16, *50*, 56, *59*, 62, 63, *81*, 87,
 101, *104*, *166*, *177*, 184, *194*, *195*
Parker, Alan 184, *187*
Parkinson, Norman *59*
Perelman, S. J. 58
Peru *29*, **30**, *30*, *31*, *32–3*, 58
Photographers Gallery, London 14
Piaggi, Anna 58
Pitt, Frances 119
Polk, Brigid 62, *65*
Pork 60
Procktor, Patrick 83, *198*

Queensland, Australia *92–3*

Rampling, Charlotte *218*
Reeve, Christopher *187*
Rio de Janeiro, Brazil 120
Ritz 13, 183, *183*, *186*, *192*, *193*, *201*, *214*, *215*, *219*,
 228–9
Ritz Hotel, London *65*
Roberts, Michael *174*, *175*
Rolling Stones 63, *94*, *96–7*, *98–9*
Rome, Italy *183*
Royal Photographic Society 14

Sagone, Corsica *114–15*
Saint Laurent, Yves *48*, 184
Sarawak, Ranee of *78*
Sathya Sai Baba *158*, 237
Savoy Hotel, London *86*, *89*

Scarfe, Gerald 14, *17*
Shinoyama, Kishin *164–5*
Shrimpton, Jean 15, 16, *24–5*, *26–7*, *106*, *107*
Smith, Patti 184, *222*
Snap! 14, 61
Society of Industrial Artists and Designers 14
Solanas, Valerie 61
Sommer, Frederick 185
Springfield, Dusty *187*
Strong, Roy 61
Sudeley, Lord *59*
Sunday Times Magazine, The *79*, *81*, *191*, *197*
Szafran, Sam 16, *50*

Tahiti *182*, *207*, *210*, *211*
Tennant, Stephen *201*
Teresa, Mother 121, *159*
Thatcher, Margaret *187*
Tokyo, Japan *164–5*, *188–9*
Toscani *108–9*, *112–13*
Tree, Penelope 16, *51*, *65*, *66*, *83*
Trouble and Strife 16, *184–5*
Turkey 12, 13, 15, 16, *20*, *21*, *22*, *23*

Vane-Tempest-Stewart, Reginald 237
Vietnamese 'Boat People' 13, 238, *246*, *247*,
 248–9, *250–51*, *252–3*
Visconti, Luchino 61, *77*
Vreeland, Diana 15, 121, 184, *184*, *194*, *195*

Warhol, Andy 14, *60*, 61, *61*, 62, 63, *63*, 65,
 66, *67*, *70–71*, 183, *183*
Watts, Charlie *187*
Wembley, London *96–7*, *98–9*
Whitehouse, Mary 62
Wise, Ernie *49*
Women's Liberation rally 14
Wood, Ron *187*
Wyman, Bill *187*

Yokohama, Japan *167*
Yorkshire, England 169, *169*
Young, Richard 183

Zambia 34, *58–9*

This book is dedicated to Catherine Bailey